WOLF TRACKS

CARIBBEAN
STUDIES
SERIES

Anton L. Allahar and Shona N. Jackson
Series Editors

WOLF TRACKS

Popular Art and Re-Africanization in Twentieth-Century Panama

Peter Szok

www.upress.state.ms.us

The University Press of Mississippi is a member of the Association of American
University Presses.

Copyright © 2012 by University Press of Mississippi
All rights reserved
Manufactured in the United States of America

First printing 2012

∞

Library of Congress Cataloging-in-Publication Data

Szok, Peter A., 1968–
Wolf tracks : popular art and re-Africanization in twentieth-century Panama /
Peter Szok.
p. cm. — (Caribbean studies series)
Includes bibliographical references and index.
ISBN 978-1-61703-243-1 (cloth : alk. paper) — ISBN 978-1-61703-244-8 (ebook)
1. Panama—Civilization—African influences. 2. Panama—Civilization—20th
century. 3. National characteristics, Panamanian. 4. Folk art, Black—Panama—
History—20th century. 5. Folk artists—Panama. 6. Artists, Black—Panama. I.
Title.
F1563.8.S96 2012
972.8705—dc23 2011040429

British Library Cataloging-in-Publication Data available

For Cameron

CONTENTS

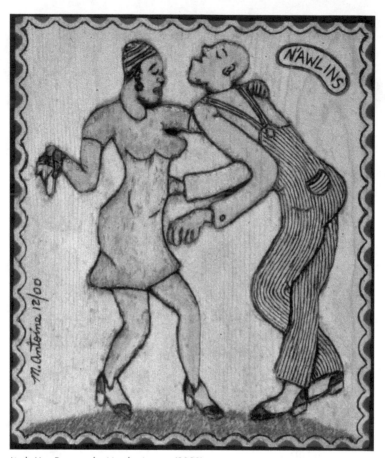

Lindy Hop Dancers, by Murphy Antoine (2000).

ACKNOWLEDGMENTS

Ph.D. in New Orleans

The inspiration for this book probably comes from my years at Tulane University, where through most of the 1990s, I pursued a degree in Latin American history—or, as my New England mother once drily observed, I earned a "Ph.D. in New Orleans studies." New Orleans has been described as our "most European city," and indeed, the French and Spanish legacies are everywhere apparent: in the street names, the city's food, its dark-roasted coffee, and its architecture. Nevertheless, I experienced New Orleans primarily as another place, as I lived closely, for the first time, among a majority African American population and worked for two years at Xavier University, a historically black and Catholic institution. Like many transplants to South Louisiana, I became fascinated by its African-based popular culture, and I threw myself into a regular routine of blues, zydeco, and brass band performances while becoming deeply familiar with New Orleans's varied neighborhoods, restaurants, stores, churches, and street characters. For me, New Orleans boasted an inspiring ethos, as it seemed to contradict the then widely held logic that somehow we had reached the "end of history" and that, as so many members of my generation feared, our destinies lay in the hands of Walmart.[1] I was intrigued with how New Orleans seemed to exploit the commercial, subvert it, and create something original, like a talented musician giving life to an old cover. In this regard, I am especially appreciative of the time I spent with Murphy Antoine, a self-taught carver, whom I met in the French Quarter and whose eye-catching reliefs had a newspaper quality, chronicling the personages and events of the period and cannibalizing them in a sense of rhythm and performance. Erykah Badu, Hulk Hogan, and even a Popeyes Chicken ad might appear unexpectedly in his imagery. Murphy became my friend and a trusted adviser in the study of black proletariat art.

If Murphy and New Orleans taught me the richness of wandering, it was in Panama where I first employed this tactic in my academic pursuits. With support from TCU and Eastern Kentucky University, along with a series of grants from the Fulbright program, I traveled annually to Panama for nearly

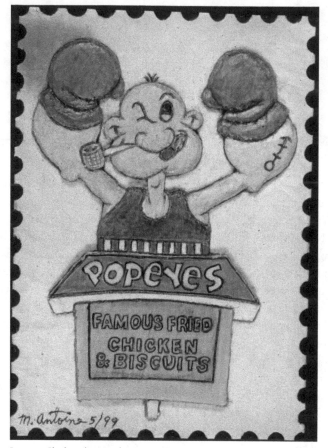

Popeyes Chicken, by Murphy Antoine (1999).

a decade, conducting research on artistic traditions in nightclubs, restaurants, buses, and barbershops, among other points of "black nucleation."[2] Naturally, I became indebted to a host of taxi drivers, street vendors, doormen, waiters, and other ramblers for their aid in helping to locate individuals, paintings, and other things related to my study. Maps and phone books are, to some extent, irrelevant, particularly in Panama's low-income areas, where it is necessary to depend on the goodness of strangers in orientating oneself and determining directions. The staff of the Hotel Las Vegas in El Cangrejo, the long-term base for gringo academics in Panama, fielded hundreds of questions about the capital, Colón, and the surrounding areas. Bus employees were also extraordinarily accommodating. They occasionally transported me to artists' homes, and they frequently engaged me in discussions about the merits of certain decorations,

their purposes, and the men who had fashioned them. On the sides of roads and in the *piqueras* (terminals), these conversations took on the tone of lively seminars. Of course, I am very grateful to the painters, who often took time from their work schedules to share with me their lives and their vocation. I especially wish to thank Teodoro de Jesús "Yoyo" Villarué, Ramón Enrique "Monchi" Hormi, Héctor Sinclair, Víctor Bruce, Justino "Tino" Fernández Jr., and Andrés Salazar, who taught me so much about their creations and their function in Panamanian society. The late Jorge Dunn was equally gracious, and his nephews, Errol and Eugene Dunn, went to great lengths to offer their knowledge about popular art.

The histories of these masters are the basis of my investigation and were complemented by long days of research at the Biblioteca Nacional, the Museo de Arte Contemporáneo, the Biblioteca Simón Bolívar, and several other institutions. I appreciate the staffs of these places, who were tolerant of an occasionally rushed and overeager investigator who benefited so much from their assistance. I also wish to recognize the support of a number of colleagues in Panama and the United States. At TCU, my dean, Andrew Schoolmaster and my department chair, Peter Worthing, provided a generous subsidy to publish the color photographs in this volume. My friend David Sims spent long hours helping me to arrange the digital images. At the University Press of Mississippi, Craig Gill and his coworkers guided me skillfully through the publication process. My writing group, headed by Bonnie Frederick, was also a source of direction and encouragement. Bonnie is one of TCU's treasures and a pillar of wisdom for our students and faculty. In Panama, Alfredo Figueroa Navarro has been a valuable and longtime mentor. Indeed, Alfredo has been counseling me about my research since I first traveled to Panama in the early 1990s. Likewise, Carlos Guevara Mann has been a good friend, arranging many of the academic panels on which I presented my ideas and received advice. To complete this project, I spent five months in the country, working at the national university in the first half of 2008. There, my conversations with Mario García Hudson, Celestino Andrés Araúz, Francisco Herrera, Miriam Miranda, Agatha Williams, and Fernando Aparacio allowed me to understand more completely my topic, track down resources, and clarify my arguments. Gerardo Maloney and Melva Lowe de Goodin offered equally important insights, as did the late George Priestley, whose writings inform the final section of this study. Finally, I would like to thank my family.

My parents' home was my first gallery, and the variety of objects on display there prepared me well to appreciate the *diablos rojos*. My mother and father took me to flea markets. They dragged me to public murals, garage sales, and museums and encouraged a wide-ranging understanding of beauty.

I am appreciative of their wanderlust, their openness, and their curiosity and for the edifying experiences they constantly offered me. I carry these forth like the most precious inheritance to be bestowed on my daughter. More recently, my wife, Cameron, has also broadened my perspectives. Patient and supportive of an eccentric *panamólogo*, she has enriched my life with her own pursuits and interests. In Panama, we have shared some of our most joyful moments, like crossing Isla Colón on two rickety bicycles and climbing Cerro Ancón in the early morning to enjoy its freshness, flora, and wildlife and to gaze out on the awakening city. Cameron is my most cherished friend, and I dedicate this book to her.

WOLF TRACKS

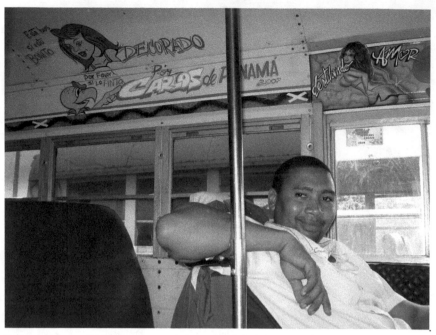

Colón and Panama City's buses are operated almost exclusively by men and serve as an important venue for popular art. Colón driver relaxes in front of paintings by Carlos Benjamín Álvarez Espinosa (2008).

INTRODUCTION

This book examines Panamanian black proletariat culture and its contribution to the country's sense of identity in the second half of the twentieth century. My study looks at sports, music, and politics; however, its focus is a group of mostly self taught painters who despite their social and economic marginalization, affected the development of Panamanian nationalism. Proletariat or popular culture is an imprecise concept, and the debates surrounding its meaning have elicited a plethora of scholarship. Here, I propose to narrow the definition and will concentrate on these mostly autodidactic painters, who were largely excluded from Panama's museums and galleries and instead devoted themselves to commercial production for the country's bars, restaurants, and barbershops and who for decades have decorated Colón's and Panama City's buses. In addition, I will utilize the ideas of Néstor García Canclini, who views popular culture as a kind of arena in which local and global forces vie with one another for dominance, with both inevitably affecting the final outcome. From this perspective, popular culture is rarely an antiquated practice that human societies have preserved carefully over generations. Instead, it must be seen as a "system of production" in which the creators may be tied to the customs of an ethnic community but are also subject to changing social and economic influences and hence are not fixed in permanent patterns.[1] In Panama, both factors are evident in the lives of the artists who became prominent during World War II and who have since reproduced and plastered their works across the country.

The subjects of my study belong to a self-identified group that has been closely associated with the country's Afro-Antillean population and has been emboldened by its connections to the broader diaspora. In fact, many of the older painters are of Afro-Antillean descent and had previously formed part of the Canal Zone's labor force. A long string of apprenticeships ties these pioneers to their successors and has fostered continuities in techniques and abilities beyond the initial artistic group. In recent times, Andrés Salazar (1955–) has been the most important mentor, helping to shape the careers of dozens of

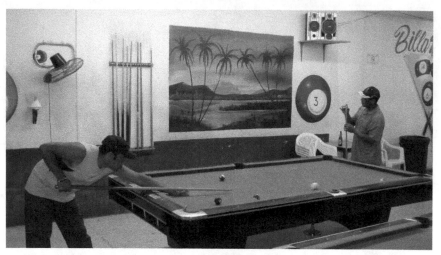

Anonymous landscape in Billar Lolo, Avenida Central (2011).

younger men. I should add that this type of painting has evolved as a patently masculine discipline and is characterized by the showmanship, self-assertion, and boastfulness typical of working-class Afro-Caribbean expression. Indeed, people have often compared the art form to boxing, one of the region's most important sports, to emphasize the intense rivalry among its practitioners. Their creations first emerged in cantinas and garages, and even today, few women venture into these areas, as they are prescribed as male spaces in Panamanian society (plate 1). Salazar and his disciples, however, have never stood alone. Despite their swagger and insistence on independence, they have never been divorced from wider influences. Some of the first painters sharpened their skills in the Canal Zone, making signs for the U.S. sector, while others did similar work for Panamanian beverage companies. Numerous artists have also undertaken formal study, while a select few have had the opportunity to go abroad. More typically, books and correspondence courses have offered a means of education and have tied this art to broader aesthetic standards. Finally, the mass media and black music have continually affected its production, as bars and clubs have been one of its most characteristic settings. Popular art in Panama is a commercial venture and has served as a long-standing means of advertisement.

For decades, Panama's stores, offices, and restaurants have hired street painters to embellish their buildings with signs and murals that use African diasporic elements and that beguile and capture the attention of patrons. Brilliant sea scenes and landscapes have been some of the most popular

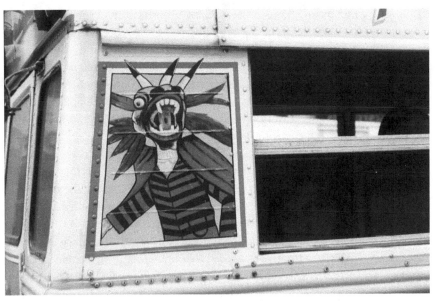

Devil dancer on a red devil by Buenaventura "Ventura" Tordesilla (2007).

compositions. They often appear alongside luminous still lifes, iconic intellectual portraits, syncopated zigzags, and religious subjects (plate 2). Dominican academic Silvano Lora noted in the early 1970s that it was "not necessary to descend to the lowest cantinas and brothels in order to witness this cultural phenomenon."[2] In fact, art by self-taught painters is everywhere in Colón and the capital, and while it adorns the walls of the red-light areas, it can also be seen in the cities' banks, hotels, supermarkets, and even their fire stations. During Panama's recent centennial celebrations, bright murals emblazoned the exterior of the National Police Headquarters, and I have also encountered pieces in Panama City's most prestigious hospital. Again, the function of these works is to advertise. In Panamanian slang, they are *pifiosos* (cool); they are designed to be flashy, loud, and sometimes even threatening, as they call attention to themselves and the interests they serve (plate 3). The painters are a lot like boxers. They bob, weave, and impress the audience while attempting, in Salazar's words, to "kill the others with beauty."[3] Another important venue are the so-called "red devils" (*diablos rojos*).

The red devils are the private passenger buses of Colón and Panama City, whose interiors and exteriors are covered with similar imagery and which are the most extravagantly decorated vehicles in all of Latin America. According to one observer, they even "put Guatemala's chicken buses to shame."[4] The red

devils are owned by small businessmen who hire the painters precisely to attract attention, in the hopes of gaining a larger clientele. Public transportation in Panama is a competitive industry, and it is thought the more *prity* (pretty) a vehicle is, the more customers it will gain. "No one wants to get on an ugly bus," explained Salazar, the most prominent *decorador* of the 1980s and 1990s.[5] The name *red devils* is derived from a series of dances that the Spanish introduced to promote Christianity on the isthmus and that continue to have an important function in the country's cultural and spiritual life. In La Villa de los Santos, on Corpus Christi, the devils march through the streets as part of the religious festivities. They snarl, prance, and lunge at the onlookers and attempt to block an archangel's entrance into the town's church. The dances on the Atlantic coast are even more spectacular and reflect the region's Afro-colonial history. Dressed in showy costumes and wearing satanic masks, the devils represent the Spanish settlers. During their performances, they race about the community, and they whip the escaped slaves who are known as *congos*.

Colón and Panama City's buses are similarly theatrical. They speed down the main thoroughfares, from stop to stop, and recklessly frighten those drivers foolish enough to get in their way. Vibrant paintings and slogans cover their exteriors, while their base color is red, suggesting a connection to hell. The decorations themselves are also captivating and present an example of "alternative modernity," or what Paul Gilroy has defined in the field of black Atlantic studies as a "counterculture of modernity." William Rowe and Vivian Schelling have also focused on this process by which non-Western artistic traditions link themselves to global capitalism and consequently thrive in commercial environments. Modernity does not inevitably doom a local culture to extinction, nor does it always relegate an imaginative mind to complacency.[6] García Canclini has developed this concept further. He discards the Western fixation with origins and purity, and by insisting that popular culture is a "system of production," he demonstrates how vernacular and outside forces interact with one another to create something different.[7] The bus artists appropriate personalities from broader society, including movie stars, singers, and even professional wrestlers, and they place these idols into visually striking scenes. Indeed, who could disregard Salazar's portrait of Monica Lewinsky standing next to a sheepish President Clinton, staring out from the back of a bus? Likewise, who would not be moved by César Córdoba (1966–) and his more disquieting depictions of villains and outlaws, including an unsettling representation of Osama bin Laden. The artists use their talents to draw in the public, an effect augmented by the buses' thumping reggae, their screeching brakes, sirens, lights, and booming horns, which on numerous occasions have sent me scurrying to the sidewalk.

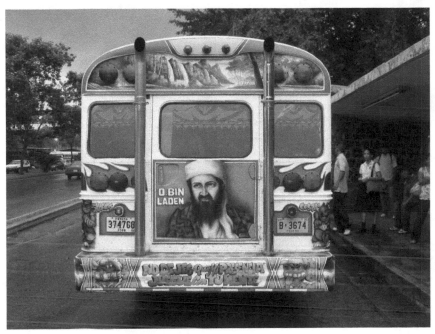

Osama bin Laden by César Córdoba (2008).

The red devils reached their heyday during the 1970s and 1980s and remained one of the most visible aspects of the urban landscape until the first decade of the twentieth-first century. Indeed, visitors have frequently commented on these extraordinary buses and their conspicuous and almost overbearing presence in the capital. A recent web post referred to them as "transportation beasts," while a journalist in the mid-1980s described them appropriately as "masculine machines" and marveled at how they were the "owners of the street."[8] My thesis is that the red devils and other aspects of Panamanian popular art have contested the markers and monuments of official nationalism. Through their bombastic and forceful presence, they have forged an Afro-Panamanian identity and have compelled the state to reconsider its older conception of the country as a purely Hispanic and mestizo (European/indigenous) nation. Of course, the painters have not done this alone but rather have formed part of a broader process, affecting fields as varied as religion, sports, politics, music, and education. "Re-Africanization" has occurred in many areas, although I will concentrate on its artistic manifestations, which characteristically have demonstrated little interest in creating essentialist notions about the past but instead have focused on the formation of a contemporary sense of

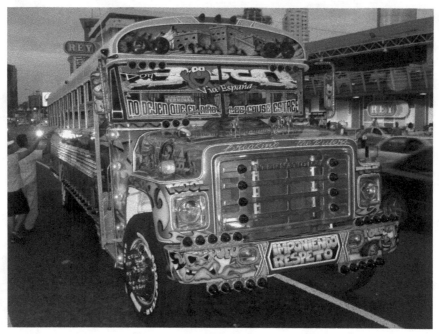

"Imposing Respect" by Rolando González Baruco (2008).

blackness, drawing strength from things such as rumba, Afro-Brazilian soccer stars, reggae, hip-hop, and soul music. "Black Atlantic" culture has been critical in helping to ignite the process of re-Africanization. Especially among the younger generations, who look to the present for their inspiration, these foreign elements have offered a viable means of strengthening blackness in Latin America, where the idea of mestizaje has been so dominant and where it has often appropriated and absorbed the legacies of African culture.[9]

I should also note that a number of Afro-Panamanians have become successful studio artists, and while their stories are equally interesting, they generally do not fall within the context of this study, except perhaps to illustrate the dynamics behind the rise of their less prominent companions.[10] The creative life has been difficult for many Panamanians but especially for those of African descent, who have faced racism and generational poverty as well as a lack of institutional support. Héctor Sinclair (1926–) recalled in an 2008 interview how his colleague Isaac Benítez (1927–68) died in misery before obtaining recognition for his many inventive renderings, now reproduced in glossy and laudatory retrospectives. Benítez's life was an important example for Sinclair and many others of his generation, who opted for a more remunerative path

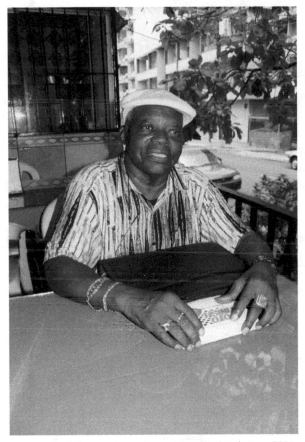

Longtime Canal Zone worker and artist Héctor Sinclair during a 2001 interview. Sinclair exploited commercial opportunities to develop his career as a painter.

and who would use billboards and carnival floats to demonstrate their ingenuity, to challenge their marginalization, and to project their identity.[11] The brassy red devils would emerge as their most important canvas. To contextualize my study of the vehicles and other manifestations of this tradition, I begin with an examination of official nationalism. Chapter 1 traces the evolution of Panama's privileged intelligentsia from the early nineteenth to the mid-twentieth century, when they lost what Ortega y Gasset depicted as the ability to lead and Luis "The Wolf" Evans and other self-taught artists began to plaster their visions on Panama's bars, cabarets, restaurants, and loud, disruptive buses.[12]

TRACKING THE WOLF

To speak of Panamanian nationalism perhaps seems like an anomaly, as foreigners have often portrayed the country as little more than an invention of North American imperialism. Critics argue that there was no basis for Panama's 1903 separation from Colombia, other than the U.S. desire to build an isthmian waterway and Bogotá's obstruction of this strategic plan. Even Panamanians have occasionally forwarded this simplistic argument in books such as Ovidio Diaz Espino's *How Wall Street Created a Nation: J. P. Morgan, Teddy Roosevelt, and the Panama Canal.* Challenging what some have described as Panama's "black myth," I assess nationalism in the nineteenth and twentieth centuries as conceived by the social elite in reaction to ideas emanating from more popular sectors.[13] Panama has always had a "lettered city" which had been proposing forms of autonomy since the early 1820s. Of course, it has also witnessed the rise of numerous plebian movements with their own plans for the isthmus's future.[14] As Ricaurte Soler and Alfredo Figueroa Navarro have argued in other publications, the oligarchy's sense of identity was historically liberal and was designed to reform the legacies of the Spanish colony while protecting the existing social structure. Nationalism emerged from the ranks of the merchant class as a hope to exploit Panama's geographic position, particularly in the face of Colombian indifference to the construction of an interoceanic route. Leaders such as Justo Arosemena (1817–1896) regarded this project as critical to assure the "civilization" of the isthmus and to address the demographic imbalance that seemed to threaten their position. As a white minority, they felt insecure among Panama's dark-skinned population, which had become politicized by the 1850s and was pressing for conceptions of "popular republicanism."[15] In response, elites saw foreigners as the solution to their cultural and economic "stagnation."[16] They proposed to leave Colombia on numerous occasions and to link themselves to greater powers through neocolonial arrangements.[17] The events of 1903 thus were not an aberration but rather the culmination of trends that had been building for numerous decades.[18] Unfortunately for the oligarchy, modernization was more difficult than expected and did little to mitigate plebeian political activism; the same sector consequently tempered its enthusiasm for liberalism.[19]

Over the next years, elites became intent on controlling change, particularly the disruptions that were associated with the canal and that revived conflicts over the definition of the nation. These included U.S. military and economic impositions and the large-scale immigration of Afro-Antillean laborers,

who constituted the majority of the interoceanic project's workforce and who would not remain indifferent to public life. Blacks and not whites largely came to the isthmus as a result of the international waterway. Their arrival coincided with the growth of a labor movement, feminist organizations, and new political parties. Tom Nairn and other scholars of national identity have argued that upper- and middle-class intellectuals "invite the masses into history" when faced with such challenges to their dominance. They launch a broad-based, populist movement to unite their population and to shore up their place in society.[20] My inquiry, however, shows that the Panamanians responded differently. In the face of growing tensions, they excluded the masses by advocating a Hispanic and mestizo vision of the country. Panama became a Hispanic and mestizo nation despite its large Afro-Antillean community and its long history of African slavery. This agenda became manifest in Panamanian literature, architecture, history, art, and monuments. Writers and artists fled into the colony, which they erroneously regarded as devoid of African culture. Similarly, they tended to romanticize the countryside. They set many of their works in the Azuero Peninsula and depicted it as more moral than the terminal cities, with their large, darker-skinned populations.[21] These ideas culminated during the presidency of Arnulfo Arias Madrid (1940–41), who stripped Afro-Antilleans of their citizenship and attacked other so-called newcomers who were becoming the isthmus's majority. The lettered city suffered from nostalgia, and even when it insisted on liberalism and progress, it fixed its gaze longingly on narrow episodes of the past and refused to acknowledge the realities of modernization. To illustrate these tendencies further, I provide a case study utilizing Doris Sommer's notion of "foundational fiction."

In her seminal work, Sommer argued that nineteenth-century Latin American elites wrote patriotic romances to unify their societies in the decades after independence. These texts became closely identified with national histories and eventually became part of educational curriculums.[22] Chapter 2 examines *Núñez de Balboa* (1934), a portrayal of the Spanish conqueror by Octavio Méndez Pereira (1887–1954) and a novel similarly used in Panamanian classrooms.[23] Méndez Pereira was a prominent leader of the school system, and while a liberal and enamored with the idea of change, he deeply resented certain aspects of modernization, particularly the international criticism of Panama's separation and its widespread image as a traitor to Latin America. Equally troubling were the massive Afro-Antillean immigration and the arrival of other foreigners who were affecting Panama's political life, economy, culture, and social structures. In response, Méndez Pereira wrote a love story based on the conquest in which his country appears not as a passive U.S. colony but rather as the distribution point of Spanish culture in the hemisphere. Panama was

vital to the European settlement of America, but more importantly, the book reconciles tradition with modernity. The narrative minimizes class, ethnic, and gender tensions and instead presents Panama as a progressive Hispanic nation with a homogenous population and a stable patriarchal order. Balboa and the indigenous woman, Anayansi, are the novel's central characters, and their relationship offers a sense of a Europeanized, mestizo country in which blackness and other rival identities have no meaningful presence. Blacks had been the "dominant" demographic group during the colony; nevertheless, Méndez Pereira and other intellectuals chose to ignore them.[24] They did not, as Nairn suggests, "invite the masses into history."[25] Rather, the masses would have to break the door down and storm the palace with their own agendas. This process is the subject of my next chapter, "Rumba and the Rise of Black Proletariat Art."

Chapter 3 chronicles the emergence of a rival sense of nationalism, an "alternative modernity" encouraged by the isthmus's social and economic transformation, which utilized popular art to challenge the state-sponsored conception of Panama.[26] It is important to note that this was an urban and plebeian movement, and while it was closely connected to the Afro-Antillean community, it arose apart from its professional leadership and quickly spread to other working-class sectors. Panamanian scholars traditionally have studied black ethnic groups by separating them neatly on the basis of their roots. They categorize them as *colonial* or *Antillean* in origin and tend to situate them in particular geographic areas. *Afro-colonials* are the descendants of the Spanish-era slave population and of the *cimarrones* who rebelled and established independent black villages. The Afro-colonials speak Spanish and practice Catholicism, and they have been situated in places such as Colón's Costa Arriba and in the small towns east of capital, in the Panama and Darien provinces. In contrast, *Afro-Antilleans* tend to live in the terminal cities and in the banana-producing areas of Bocas del Toro. They trace their arrival in the republic back to the massive West Indian immigration, beginning in the 1850s and continuing into the twentieth century, encouraged by construction of the Panama Railroad and the canal and by the establishment of export agriculture. Given their background, Afro-Antilleans are traditionally Protestant, and even today, many maintain their English-language skills.[27]

The purpose of this book is not to suggest that these identities are now irrelevant. Research by Sonja Stephenson Watson, Dawn Duke, Ifeoma Nwankwo, and others has helped to demonstrate their continued importance, especially among the Afro-Antillean middle class, which in its rise into the professional ranks has faced some of the most blatant forms of discrimination and which has led the fight for black equality.[28] Organizers in the community have long accepted the validity of the Afro-colonial/Afro-Antillean separateness.

Nevertheless, these same conceptions have in a way obscured the broader African legacies, segregated blackness in defined areas, and encouraged the myth of a mestizo (European-indigenous) nation. Panama's black presence is more evident in certain places but also pervades the entire country and is not always tied to people who define themselves simply as Afro-Antillean or Afro-colonial. To demonstrate this, I show popular art to be a fluid and diasporic expression that has incorporated brown-skinned people of many different backgrounds as well as European and Asian immigrants who fell under the influence of black proletariat culture. Popular art, in this sense, is "Afro-Panamanian." It defies the older notions of black identity and incorporates individuals of many different backgrounds who shared ideas and friendships and who collaborated in the formation of a plebeian artistic genre. The genre became increasingly evident in the early 1940s, just as President Arias was disenfranchising the Afro-Antillean sector. Critical to its emergence were several transnational factors that scholars of the black Atlantic as well as Latin America have seen as critical to the deterioration of official identities.[29]

In Panama, these disruptions included the outbreak of World War II, the massive U.S. efforts to protect the interoceanic waterway, and the impact of the international radio and entertainment industries. Tropical and exotic themes were in vogue during these years and prevailed in the period's commercial music and movies. During the conflict, Panama City was awash in money and soldiers, and dozens of theaters and clubs opened in response. Rumba musicians arrived to perform in Panama, and Afro-Antillean artists were employed to decorate the new venues. They usually chose subjects with Afro-Caribbean content and reflective of the booming Cuban music scene. Luis Evans or "The Wolf" became especially prominent. The Wolf (El Lobo) was the son of Haitian immigrants and a theatrical street figure in the 1940s. Forged on the margins and in conditions of poverty, his showmanship and paintings inspired a host of followers beyond the original Afro-Antillean circle, and soon his aesthetic sense spread to other sectors, most significantly to the capital's growing bus system. To attract customers, public buses adopted tropical music and images, and these vehicles ultimately became an important symbol of the country, rivaling the artistic production of elite intellectuals. The Wolf and his progeny have left their tracks on the country. Their African diasporic culture has established its presence and to some degree has even supplanted the concept of Panama promoted by Arosemena, Arias, and Méndez Pereira. My central thesis is that non-elites can alter the development of nationalism, especially as a country undergoes rapid modernization.

Chapter 4 further develops this main idea by examining the style of popular artistic expressions and contrasting it with older forms of nationalism,

with their emphasis on mestizaje, tradition, and patriarchy. The chapter title comes from an interview with Andrés Salazar, who defined the bus aesthetics as "100% prity," appropriating the showy name of a trendy television program and illustrating several aspects of its Afro-Caribbean nature.[30] Popular art is representative of black "plebeian culture" shaped by the experiences of racial injustice.[31] It is an inheritance of African festival traditions and the experience of challenging slavery and its legacies through the "assertive occupation of public space."[32] Masquerading and parading are two closely related disciplines used by Afro–Latin Americans of earlier periods to question authority and resist oppression. The first of popular art's tactics is hybridity, or what Cuban writer Antonio Benítez Rojo referred to as the Caribbean's "supersyncreticism."[33] If Méndez Pereira used history to create a static vision of society, popular artists acknowledge this conception of the past; however, they alter it by constantly incorporating new elements.[34] They look to contemporary movies, radio, and television and integrate the most fashionable trends into their paintings, reflecting a regional tradition of "creolization."[35] More importantly, this visual lavishness is connected to rhythm, another critical aspect of the genre's Afro-Caribbean nature. Artists situate their images within "metarhythmic" structures.[36] They eschew the tranquillity evident in Méndez Pereira's novel and instead weave cadences through the buses' movements, colorful designs, music, and linguistic expressions. The effect is to create a "multisensorial" experience, so engaging that it demands the viewers' attention and attacks the hierarchies of official nationalism.[37] The Caribbean artist is often a dazzling showman who "desacralizes the canons of classical beauty" and incorporates the audience like an eager dance partner.[38] Other canons, in fact, have arisen on the isthmus and have forced the recognition of Panama's mainstream intellectuals.

My book concludes with an examination of the recent decline of the bus art tradition and the continuation of its style in several other forms. Some of these manifestations are now connected to the government and have in fact become part of the official discourse, demonstrating what Florencia Mallon sees as nationalism's "open-ended" nature and the role that average people play in its formation.[39] To show this influence, I titled chapter 6 "*Chombalízate*," a command taken from the bumper of a showy red devil which was recently seen working the streets of the capital and instructing onlookers to turn themselves into *chombos*. This word is a derogatory term for Afro-Antilleans in Panama and an insult evidently transformed into a badge of honor. Its use in this manner illustrates the growth of black identity as well as its persistently multiple configurations: its Afro-colonial and Afro-Antillean variations and its increasingly Afro-Panamanian form. In the last years, such reversals

have not been uncommon as thousands of people of color have insisted on re-Africanization, encouraged by trends in the international media and by the ethnic struggles of South Africa and the United States. These Panamanians have come to embrace their black heritage and have put into question the established racial conceptions. As a consequence, Panama is no longer a mestizo republic but rather seems to be a divided nation, split between the homogenizing directives of the old lettered city and the influences of rising elements, among them the country's indigenous and African diasporic communities. These tensions remain evident in the realm of art but also are apparent in sports, politics, and music. Some of the sharpest conflicts have emerged on the airwaves and in Panama's parks, empty lots, and stadiums between those musical forms and sports associated with mestizaje and those connected to the black, urban population, its historic marginalization, and its tactics of resistance. In these cultural wars, the insurgents seem to be winning key battles and are encouraging the rise of a consciously black identity and the conception of Panama as a pluralistic society.

My book closes with a list of some of the warriors. My appendix provides biographies of dozens of popular artists ranging from the most prominent to the least known figures. The painters, as I suggest, have formed a "Wolf Pack." They have linked themselves together by a lineage of apprenticeships and continue, even today, to leave their tracks across the isthmus.

1. FROM WHITENING TO MESTIZAJE

The Panamanian Official Identity, 1821–1941

Panama has suffered from a long-standing reputation of being an invention of North American imperialism rather than a nation with legitimate roots in history. This idea rests largely on Panama's independence—its controversial separation from Colombia in November 1903, which occurred with decisive U.S. assistance. The Colombian Senate had recently rejected an agreement that would have allowed the United States to build a canal through the isthmus and to connect the Pacific and Atlantic Oceans. With the aim of securing the strategic route, Theodore Roosevelt's government encouraged Panamanian patriots to rebel and to establish their own republic. U.S. warships supported this separatist movement. They blocked the arrival of Colombian reinforcements, while diplomatic representatives quickly arrived at an agreement for the construction of the interoceanic waterway. Panama became a U.S. protectorate, and the North Americans established themselves in the Canal Zone and remained there until the end of the twentieth century. Over the next years, Panama suffered repeated U.S. interventions, most recently in December 1989, when a large invading force removed General Manuel Noriega from power and revived the image of a bogus country. *Panama: Made in the U.S.A.* is the title of a 1991 publication that illustrates this persistent and negative perception.[1]

The criticisms have not been lost on the Panamanians, who long ago formulated an impressive response to what they often refer to as their "black legend." Many of the republic's leading historians have produced studies of the nineteenth century to affirm the existence of various identities that predated and encouraged the 1903 uprising.[2] These authors have demonstrated that the isthmus had had its own "lettered city."[3] This was a collection of merchant-politicians whose fortunes were tied to Panama's traditions of commerce and who had been molding a conception of sovereignty since the 1821 end of the Spanish colony and their incorporation into Gran Colombia. Gran Colombia was largely the vision of Simón Bolívar, who had led northern South America's quest for autonomy and who then pressed for the region's unity after the demise of Spanish authority. The country, which encompassed most of

the area, was launched and dissolved within a decade. The present-day states of Colombia and Panama, however, remained united to form the Republic of New Granada. In 1858, New Granada became the Grandine Confederation; five years later, it was renamed the United States of Colombia under the Río Negro Constitution.

This chapter traces Panama's development through these transitions. It focuses on its growing nationalist sentiments and their evolution following the 1903 revolt against Bogota. The chapter underlines the influence of nineteenth-century liberalism, with its increasing positivist and social Darwinist qualities and its tendency to link Europeanization with modernization and progress. It also underscores the demographic inferiority of the Panamanian white oligarchy. The oligarchy was based in the capital and was hugely outnumbered by its black-mulatto inhabitants. The *arrabal* or *gente de color* had become politically active and by the 1850s had created a vision of "popular republicanism."[4] Increasingly, they were challenging Panama's hierarchical social structures and presenting their own ideas regarding the isthmus's future. To compensate, the elites fomented an autonomist project that sought to distance them from Colombia and to place them under the more secure protection of the period's leading commercial interests. During these years, they became conjugally and economically tied to dynamic European and North American families, and they repeatedly sought political and even military arrangements with Great Britain, France, and the United States. Most importantly, they became impatient with Colombian indifference to the isthmus's interoceanic mission. The canal, for this group, became a matter of necessity. It was seen as the only way to "civilize" Panama, as it would attract needed outsiders, their wealth, their culture, and their supposed biological assets, which were expected to displace the oligarchy's black ideological opponents. The 1903 separation and the following U.S. tutelage consequently were not historical anomalies, but rather they represented the culmination of the oligarchy's aspirations to whiten the isthmus.

The chapter continues with a description of modernization and the difficulties it presented for Panamanian leaders after the opening of the much-anticipated waterway. From the perspective of the upper class and a nascent middle sector, the canal and independence did not work out as planned and instead seemed to weaken their position, especially in respect to their plebeian enemies. The building of the sea route and presence of the United States invited the entry of economic competitors, who challenged and dislocated national investors while disrupting the country in a number of important ways. Strikes, indigenous rebellions, and feminist mobilization characterized the first decades of the republic, whose political life became sharply fragmented

and beyond the control of the Liberal Party. The domineering U.S. oversight was particularly influential. Its abuses were chronicled in a body of pessimistic literature that questioned the validity of traditional liberalism. The North Americans galvanized a rising group of professionals who had emerged from a new educational system and who were eager to take up responsibilities in the republic but who found a host of U.S. advisers blocking their advancement through the state bureaucracy. Finally, the canal did not whiten or "civilize" the isthmus, but rather it dramatically increased its black population, just as the United States strengthened racist doctrines by imposing segregation in the Canal Zone. The U.S. construction project depended heavily on Afro-Antillean laborers, thousands of whom remained after its completion and who would help revive the traditions of popular republicanism. These and other concerns preoccupied the intellectual class and forced the creation of a mestizo identity.

Mestizaje was a legitimate part of Panamanian history, as the isthmus had long experienced an intense process of racial mixing. However, this phenomenon now took on a political significance. It was chronicled in poetry, songs, paintings, and public monuments, all seemingly designed to control the process of modernization as well as to forge ethnic homogeneity and to maintain the existing social hierarchies. Mestizaje's advocates did not abandon liberalism; however, they balanced it with a sense of nostalgia. They turned their attention away from the black urban areas and suddenly became fascinated with the interior, especially with the Azuero Peninsula, whose light-skinned inhabitants they now depicted as representative of national culture. In addition, they focused on the colonial era. They created wistful depictions of the Spanish period that highlighted the merging of indigenous and European populations and the creation of a harmonious society that was uniformly Hispanic and patriarchal in nature. Africa received no acknowledgment in this "crucible of races" despite its deep and growing presence and the resurgence of black plebeian republicanism.[5] In this sense, Panama's official identity remained closely linked to the themes of previous decades. Nationalism remained a project to "civilize" the isthmus through the introduction of European elements and through the disregard or elimination of its profound African heritage.

COLONIAL FOUNDATIONS OF A BLACK MAJORITY

A prominent theme of Panamanian colonial historiography is the arrival of proportionally large numbers of Africans and their numerical superiority over the country's white and indigenous inhabitants. Small numbers of Africans

participated in the conquest, and their presence grew rapidly through the sixteenth century, especially after the reduction of the isthmus's indigenous population, decimated by the abuses of the European invaders, their slave raiding, and their deadly diseases. Alfredo Castillero Calvo estimates that of the 150,000–250,000 people who had populated the isthmus before the entrance of the Spanish, just 7 to 12 percent remained a decade later.[6] Captives from Senegambia, Lower Guinea, and Kongo helped to meet the resulting labor needs, and they dominated most sectors by the 1550s, when the Crown largely abolished Panama's *encomiendas* and demonstrated the importance of African slavery.[7] The Panamanian economy was comparatively modest, and it never developed dynamic export sectors like those in Peru, Brazil, and Mexico that depended on large numbers of free and forced workers. Nevertheless, slaves were present on the isthmus's ranches as well as in its pearl fisheries, mines, vegetable gardens, and sugar mills. They also played a critical role in its transportation industry. Panama was a key point of the Spanish mercantilist system, designed to protect the bullion of Peru and Mexico and to funnel it safely to the Iberian Peninsula. It served as a land bridge, linking Spain to South America, and it was the designated place of trade for the Viceroyalty of Peru. Slaves moved silver and other goods between the capital and Portobelo, the Atlantic terminus of the commercial network. As a result, they became dominant in this zone of transit, particularly in its urban areas, where they also worked in domestic service and in construction, skilled trades, and small commerce. Slave society in Spanish America was often associated with cities, and in this regard, Panama was an obvious example.[8] Castillero notes that by 1575, there were more blacks than Indians in regions under Spanish control and that within the area of the capital's jurisdiction, slaves outnumbered Europeans by nearly four to one.

Statistics from 1607 are equally useful in revealing the large black population and the position of whites as a minority. By this time, the slave population of Panama City had ascended to 3696, while the whites numbered just 1267. There were also 718 free people of color in the capital, along with twenty-seven indigenous residents. Castillero observes that from this point onward, both the white and slave groups gradually stagnated, and they entered into a steady decline several decades later. The suspension of the isthmus's commercial route in 1739 contributed to this demographic reduction by undermining the economy of the transit area. In the mid-eighteenth century, slaves constituted 9.6 percent of Panama's total inhabitants, falling to 5.7 percent by 1778. In 1851, shortly before abolition, they represented just .4 percent of the country's populace.[9] Nevertheless, Panama City remained an important slave

market through most of the colonial period. It served as the transshipment place for the human cargoes destined for sale in Peru and Central America and other places along the Pacific coast. Omar Jaén Suárez, in another study, emphasizes the impact of the thousands of transients who often spent extended periods in the capital and who constantly reinvigorated its "intense African imprint."[10] More importantly, as in other parts of Spanish America, the deterioration of slavery occurred simultaneously with the remarkable rise of free people of color. In fact, their emergence contributed to slavery's decline by creating a source of inexpensive labor in a time of economic contraction. The *libertos* were an ethnically complex sector whose background reflected the intense racial mixing that occurred in many parts of the isthmus and which in Panamanian towns and along the communication route, incorporated the prevailing African elements. This largely *pardo* or mulatto population exploded in the seventeenth and eighteenth centuries and increasingly challenged the Spanish caste structures, eventually occupying lower positions within the militia and the civil and ecclesiastical bureaucracies. At the end of the colonial period, the ascendant *pardos* vastly outnumbered the capital's Europeans.[11]

In 1790, there were some 7,713 residents in Panama City, 66 percent of whom were free people of color. Slaves made up another 22 percent, while whites and indigenous people represented 11 and 1 percent, respectively.[12] Numerous historians have underlined the impact of these demographic structures on the European minority, which lived segregated within the walled barrio of San Felipe and which suffered, according to Castillero, a general fear of blacks. Such anxieties, he insists, were self-perpetuating. Ignorance and hatred induced repressive measures that only intensified the tension between the two sectors.[13] Afrophobia inevitably increased with the Haitian Revolution, which destroyed the French colony of Saint Domingue and which expelled or eradicated its entire white population. Elites in Panama and in other parts of the Caribbean felt insecure about their numerical debility, especially as they later fell under the influence of liberalism, with its positivist and Social Darwinist qualities. Representatives of the oligarchy responded by fashioning a form of nationalism based on these anxieties and conceptions of civilization.[14] In 1821, they decided to join Colombia, largely as a consequence of Panama's economic decline. However, they quickly became disillusioned with Bogotá's leadership and fomented an autonomist project whose key elements were the revival of the transit route and greater dependency on outside powers, who were expected to offset demographic imbalances and to control rising black political elements. Afro-Panamanians, of course, had their own plans for the isthmus.

BLACK LIBERALISM AND THE HANSEATIC REPUBLIC

In his seminal work, *Formas ideológicas de la nación panameña*, Panamanian historian Ricaurte Soler explains the development of Panamanian nationalism and the decision of the country's fathers in 1821 to join Gran Colombia rather than strike out on their own. Analyzing the issue from a Marxist perspective, he posits that Panamanians elites determined the isthmus's destiny and that they were too weak in this period to sponsor the creation of a separate country.[15] "They had insufficient military forces, and . . . were internally divided," notes another important study of the period.[16] The oligarchy was a group of merchants and urban property owners whose fortunes had been tied to the colony's traditions of commerce and who had suffered a prolonged deterioration since the suspension of the Portobelo fairs. Some of the most prominent families had actually emigrated, while several fires gutted the capital in the mid-eighteenth century. Spanish officials had added to the decline by eliminating the isthmus's *audiencia* in 1751. Soler underlines the ideological impact of the elite's socioeconomic decay. He notes that while universities in other parts of the region were undergoing changes and revising their curriculums, there was an "infirm" attempt on the isthmus to establish an institution of higher learning; however, it was born and collapsed within the "framework of orthodoxy."[17] At this point, the Panamanians lacked the cultural infrastructure as well as the resources to establish their own nation-state.

Consequently, when patriots announced their determination to follow the broader region's example and to declare their freedom from European colonialism, they proceeded with a measure of caution. Rather than create their own republic, they agreed to seek out another protector and swore their allegiance to Colombia. Soler and others, however, have long insisted that Panamanians made their own decisions and that these reflected the isthmus's geographic isolation, the relative autonomy of its colonial institutions, and the long-standing influence of a merchant class that saw its fortunes tied to interoceanic commerce.[18] The Panamanians decided their future without outside influence and secured their transition in a particular fashion, as another writer indicated several decades later to help illustrate the local identity. These pragmatic businessmen defeated their enemies with "intrigues and gold" rather than with more violent methods.[19] Even in their apparent admission of weakness, they demonstrated a clear sense of independence, evident in the 1821 proclamation. While recognizing that the "Isthmus belongs to . . . the State of Colombia," the

document also affirms the Panamanians' right to "formulate the laws necessary for their internal government" and to "take the economic provisions required to maintain public tranquillity."[20] In the future, the Panamanians would become much more assertive. They would strengthen their sense of distinctiveness based on their liberal-mercantilist ideology, their anxiety regarding their precarious social and political situations, and Bogotá's failure to address their perspectives.

Indeed, as early as 1826, a council of notables in Panama City declared that the isthmus was a "Hanseatic country" and that its security should be guaranteed by foreign interests to allow it to flourish as a zone of transit. The Panamanians were under pressure from Simón Bolívar, who was attempting to bolster his political position via the establishment of a more centralist constitution that would have ceded him dictatorial powers. In response, the isthmus's leaders swore their allegiance to the Liberator, and they even underlined his role in fomenting stability. The Panamanians denied that they had seditious intentions. However, they also "converted the action into a petition" and a means of communicating their feelings of particularism.[21] "We occupied ourselves with proposing laws . . . that were necessary for the growth of intermaritime traffic," insisted Mariano Arosemena (1794–1868), a legislator of the period who had played a key role in the 1821 independence movement and who soon became a critic of Colombian tutelage.[22] Arosemena came from a family of entrepreneurs who had emigrated from Basque Country in the late seventeenth century and who had earned their fortunes on the isthmus by linking themselves to its traditions of commerce.[23] In 1834, Arosemena published a poem, envisioning his "fatherland" as a "peregrine land" that would extend its "generous and tolerant hands to the merchants of every nation."[24] The Panamanian upper class was predominantly liberal and hoped to modernize and Europeanize the isthmus through trade and through the influence of newcomers. The members of this social sector were not overly concerned about the potential loss of sovereignty. Instead, they thought that like the Hanseatic cities, Panama could benefit from benevolent foreigners whose investments, culture, and physical presence would contribute to the isthmus's prosperity and who would dilute its dominant black elements. Arosemena wrote in an 1824 article that a plan to revive the transit route would provide "luxury materials, civility, and population."[25] "The isthmus will give nothing," he insisted several years later, "and will receive everything in return."[26] As in other parts of the region, it was the Enlightenment that partly fomented this xenophilia and that, in this case, fueled the Panamanians' concerns regarding their relationship with Bogotá.

The Enlightenment had played an influential role in the rise of the region's independence movements, and it continued to affect many leaders, encouraging them to adopt a critical attitude toward Spanish rule and its legacies. Panama, according to Arosemena, had been a "degraded colony." Under Spain, it had been "deprived of representative government, its civil liberties, and political rights, and despite its role in connecting the two oceans, it had been impenetrably closed to . . . foreign contacts."[27] In general, Latin American elites in the nineteenth century turned away from Spain and its social and political models, and they now looked elsewhere for ideological inspiration, especially to France, Great Britain, and the United States. As a consequence, they attempted to implement democratic principles, to end the colony's caste and ethnic distinctions, and to open their region to investment and commerce. They also hoped to encourage capitalism through the elimination of communal land patterns, by lowering taxes and state regulations, and by improving ports and other transportation infrastructure. Liberals frequently advocated the modernization of judicial systems, schools, universities, and other public institutions, and they sought the abandonment of older ideas associated with the deposed Spanish order. They often attempted to weaken the church, whose economic, political, and intellectual influence they came to regard as an obstacle to progress and to the creation of a more rational society. According to his biographer, Arosemena was a devout Christian; however, he was also an enemy of "religious fanaticism and of the excessive benefits that the clergy enjoyed to the detriment . . . of civil government."[28]

Over time, the liberals fell under the influence of utilitarianism and the subsequent and closely related doctrines of positivism and social Darwinism. These philosophical schools, which also originated in Europe, privileged economic over political advancement. They justified the establishment of elitist governments by indicating that democratic reform was nearly impossible without dramatic material changes, such as the building of roads and rail networks, the expansion of trade and foreign business, and the growth of public health and education. Latin America could not expect to become democratic without first undergoing these and other transformations. At the same time, these beliefs heightened bigotry in Latin America. They suggested that its large African and indigenous populations were a biological drag on the aspirations for development and would have to be replaced by European immigrants. Arosemena's son, Justo (1817–96), followed him into politics. He occupied numerous legislative and diplomatic posts, and he used them to press for Panamanian autonomy, while becoming evidently influenced by these European philosophies.[29] Most of his important essays predate the growth of scientific racism,

associated with social Darwinism and the late nineteenth century. Nevertheless, his writings are infused with many of its perspectives and a strong sense that Panama was hindered by its cultural backwardness and by an unfavorable biological composition.

In an 1846 article on "our material interests," Justo Arosemena described Colombia's black, indigenous, and Spanish inhabitants as the "three most indolent races," and he insisted that they were further corrupted by their geography which, according to Arosemena, allowed for easy subsistence and provided no stimulus for thrift and industry.[30] He even lamented, in his most famous publication, that the Scottish had not succeeded in settling the Darien during an effort in the late seventeenth-century: "Let us consider what might have been," he wrote in this essay, "if the English government . . . had allowed its subjects' genius to take hold. . . . The Scottish . . . might have absorbed the Spanish population and saved the isthmus from the terrifying reign of the Bourbons."[31] Justo Arosemena and other liberals forcefully called for immigration to "improve our race" and to ensure whitening and to "advance" their countrymen along "the path of civilization."[32] Alfredo Figueroa Navarro has done much to document these attitudes and their broader manifestations in the elite's consumption patterns, in its tendency to ape European norms and fashions and to tie its future to the presence of newcomers. Foreigners had become an essential part of the oligarchy's domestic strategy. He argues that this xenophilia rested, to a great extent, on the social class's demographic insecurity and its tenuous political position in the mid-nineteenth century in the face of urban, plebeian mobilization.[33]

In the early 1850s, Panamanian society became more tumultuous as an increasing number of the capital's black and mulatto residents now competed for control of the government. As Aims McGuinness has demonstrated in an important study, this group had become infused with its own sense of liberalism, which was more classic and egalitarian in its principles and determined to defend the rights of the *arrabal* (the slums) against the pretentions of the *intramuros*, the white-skinned inhabitants of the barrio of San Felipe.[34] This popular ascendance resulted from the expansion of suffrage, the termination of slavery, and the many disruptions caused by the construction of the Panama Railroad and the flood of humanity then racing to California via the isthmus's new steamship connections. The California Gold Rush was welcomed by the oligarchy. It brought major new investments and revived the zone of transit, and it even fostered Colón's erection as the Atlantic terminus of the U.S.-owned railway. However, it also ignited startling inflation and imposed economic hardship on many Panamanians, while exposing them to cholera and other epidemics and to the contempt of the North Americans, who suffered

from the period's severe racial prejudices. William Walker and other filibusters were also active in the region, and their exploits further unsettled many Afro-Panamanians and stoked their fears of a potential U.S. annexation and the reestablishment of slavery on the isthmus. The 1850s were consequently years of violence, especially as foreign entrepreneurs set up their businesses and pushed locals out of the profitable transportation industry. Panama City's masses responded in 1856 by laying siege to the capital's rail station and by tearing up its tracks, telegraph, and other infrastructure. They simultaneously organized into a political movement and sporadically governed the isthmus over the next three decades.[35]

Between 1855 and 1885, Panama experienced what Figueroa Navarro describes as the rise of the "Black Liberal Party." This was really less of a party and more a faction within the liberal organization that occupied the state presidency on several occasions. While its leaders rejected overt racial categories, they insisted on defending the interests of the pueblo and were critical of the oligarchy and old patriarchal attitudes. Politics became fiercely contested in this period, especially as the isthmus adsorbed heightened racist attitudes and fears of a possible caste war. In response, elites sought allies in foreigners and international trade and became conjugally and economically linked to the outsiders. Figueroa Navarro's research shows the rising number of U.S. and European investors and the many surnames of non-Hispanic origin that were becoming integral to the Panamanian oligarchy. He also notes the various U.S. interventions that occurred from the 1850s forward and which occasionally were solicited by Colombian or Panamanian authorities.[36] In 1856, during a bitter electoral dispute, many of San Felipe's residents fled to the safety of a U.S. warship. Conspicuous among the white refugees were Mariano Arosemena and other members of his family, who, despite their affiliation with the Liberal Party, feared its many dark-skinned members. Race trumped political affiliation, as McGuiness suggests in his examination of the intervention.[37] For Arosemena and other members of the oligarchy, the key to survival had become the North Atlantic economy, and as Colombia proved inept at developing the interoceanic route, separatism grew steadily among this minority group.

The Panamanians, in fact, rebelled as early as 1830. They revolted a second time just a year later, and they attempted to establish an independent republic in 1840–41 and again in 1861. The organizers of these efforts were largely consistent in explaining their desire for self-government. They cited Colombia's turbulent politics and its neglect of the isthmus's supposed destiny to become a center of international trade. "To enter into relations with all the nations of the earth," was the aspiration of isthmian society, according to the conspirators of the 1831 uprising.[38] Panama had been "privileged by Divine

As dynamic newcomers became incorporated into the oligarchy, their surnames appeared in the Panama City cathedral. Tombs of Helena and Luis Enrique Lewis.

Providence," insisted the head of the subsequent movement, which began after the outbreak of another war in Colombia. This leader envisioned the isthmus optimistically as an "emporium of universal commerce" that would prosper under the influence of foreigners. "It is also certain," he wrote assuredly, "that such an occurrence will never take place as long as the isthmus remains part of New Granada."[39] The patriots depicted Colombians as too tumultuous and distant and too rooted in conservative and colonial attitudes to understand Panama's liberal, cosmopolitan culture. Colombians lacked what another independence pronouncement described as an appreciation for the isthmus's "vital questions." Moreover, their wars imposed human and economic burdens and acted as an "obstacle to the march of progress."[40] These perceptions were also

responsible for the creation of the Federal State of Panama (1855–86) under the leadership of Justo Arosemena. Arosemena proposed this project while serving in the New Granada Congress, and he later headed a constitutional convention and helped to create the extreme form of federalism that prevailed in Colombia from 1863–86. In his writings, Arosemena offered the most elaborate justification for the need of greater autonomy based on a desire for progress and Europeanization and a hope of suppressing black political mobilization.

In *El Estado Federal de Panamá* (1855), Arosemena blasted what he depicted as a tyrannical colonial convention, the Spanish tendency for political centralism and Colombians' adoption of this governmental system. Citing examples from ancient history, Arosemena insisted that the municipality was the true basis of popular sovereignty, and he defined the isthmus as a separate nation, underlining its isolation from the rest of the country. "We have no land communication with the adjoining . . . provinces," wrote the legislator to make his point.[41] Arosemena noted that few Colombian leaders had been to Panama and that five lawmakers from the isthmus had died as a result of the grueling, three-month trip to represent their constituents in Bogotá. Moreover, Panama was a coastal and maritime society, and it could not be administered from the "heart of the Andes" or tied, as he suggested, "to the slow cart of other sections."[42] Arosemena offered many concrete examples of the central authorities' incapacity to legislate for what he depicted as this more modern and progressive region. In addition, he pointed to Panama's tradition of autonomy and its hope to encourage, with outside assistance, its historic role as a place of commerce.

Arosemena emphasizes that for most of the colonial period, Panama was governed independent of Colombia or the Kingdom of New Granada, as it was then called. The Spanish had established an *audiencia* in Panama (1539) ten years before Bogotá had a similar institution, and officials in the New Granadan capital were never able to overcome geography and submit the Panamanians to their authority. Stronger ties were established only in the mid-eighteenth century, when the Spanish created the Viceroyalty of New Granada (1740) and suspended Panama's *audiencia* and trading system. During the colony's final decade, however, even these links were disrupted, and officials loosely oversaw the isthmus's affairs directly from the Iberian Peninsula. Arosemena underlines in his essay how the Panamanians then broke their ties to the monarchy entirely through their own efforts. As evidence, he cites a letter from Bolívar congratulating the patriots for their actions, and he relates the course of subsequent independence movements, carried out to assure Panama's commercial destiny. The elite still hoped to revive this function and actively sought the help of foreigners. It is clear that in proposing this federalist

project, Arosemena was motivated partly by these outside interests. He hoped to connect them to his country and to benefit from what he perceived as their civilizing influence while stifling the activism of urban, black elements.

Arosemena was keenly aware of the instability that the California Gold Rush had provoked on the isthmus and the necessity of creating greater order to assuage the newcomers' preoccupations. "It cannot be presumed," wrote the leader, "that interested parties will agree to as much business while they see their investments . . . compromised by a lack of police and justice."[43] Arosemena discusses the prospects of outright independence, and he warns about the possibility of U.S. annexation if his federalist system were not created. He also argues that while the completed railroad would be of enormous benefit to the Panamanians, it would not solve their social and economic problems. It would not, as some hoped, entirely transform the isthmus and could actually heighten some of its dilemmas, as it seemed to encourage the importation of products while discouraging local industry and funneling most of the profits into the hands of alien businessmen. In other articles, Arosemena harshly criticized the foreign entities and their tendency to ignore regulations and local taxes and to use extralegal means to address their problems.[44] Some Panamanians have interpreted such statements as an indication of Arosemena's anti-imperialism. These scholars emphasize that Arosemena later proposed a South American league to counteract U.S. and European influence, and while it is clear that Arosemena was troubled by certain developments, such as William Walker's intervention in Nicaragua, his more general goal was an isthmus where European and North American immigrants would be welcome and where they would play a role in correcting the perceived cultural and political imbalances.[45] In *El Estado Federal de Panamá*, Arosemena repeatedly mentions the foreigners' presence, and he cites their economic and marital ties to Panamanians as an important justification for greater regional autonomy. By strengthening local authority, Arosemena hoped to accommodate these elements and to convert Panama into what he described as the "road and inn of all people."[46]

It is notable that Arosemena, his father, and many others periodically suggested the creation of a protectorate that world powers would administer in the interest of interoceanic transit. Faced with the emergence of popular republicanism, the Panamanians remained uncertain about their capacity for self-government, and annexationist ideas flourished in this period. Mariano Arosemena advocated union with United States in an 1856 letter to his son.[47] Months later, the younger Arosemena presented a similar proposal before his colleagues in the New Granada Senate. His plan called for the creation of a country that the United States, Great Britain, Sardinia, and France would

defend for a decade. The foreigners would station their war boats off the isthmus and would even land their troops to safeguard "universal commerce."[48] The leaders of the 1840–41 movement fashioned very similar proposals. While acknowledging the possibility of reintegration under a new federal system, they also authorized a representative to seek security from the United States as well as from France and Great Britain.[49] Patriots in 1861 took an almost identical position. They called for a U.S.-European intervention to replace the rule of the now-discredited Colombians. "Populous and rich nations," assured their proclamation, "have not felt degraded under the protection of others." Besides, "honest and hard-working foreigners" were "one of the great necessities of the country."[50]

Such sentiments grew over the following years, especially after the failure of the French Canal effort (1880–89) and the passage of the 1886 Constitution, which reverted Colombia to a conservative and centralist system and drastically reduced the autonomy of Panamanians. The Panamanians grew distraught over their diminished authority and participated in liberal efforts to depose the government. The War of a Thousand Days (1899–1902) particularly ravaged the isthmus, as hundreds of locals fought and died in the rebellion. In its aftermath, the Colombian Senate rejected the Hay-Herrán Treaty (1903), which would have provided for a U.S.-built waterway. The 1903 rebellion, then, was not a historical anomaly. Independent Panama was more than a fabrication of North American imperialist interests. It was also the culmination of long-held aspirations, forwarded by the isthmus's "lettered city," with its fears of rising black political activism. This group envisioned Panama as a progressive country that would advance under the protection of outsiders, whose investments, knowledge, and physical presence would act to modernize and Europeanize society. In a publication written shortly after the rebellion, Ramón Valdés (1867–1918), a future president of the republic, denied that his country was a Yankee creation. He outlined many of its liberal precedents while lauding the United States as the "admirable protector of all oppressed peoples."[51] For Valdés and others of his social class, there were still no obvious conflicts between their freedom and neocolonial structures.

Such misunderstandings remained even after independence, as the formation of the next intellectual generation was similarly based on assumptions that Panama and Spanish America were culturally and biologically backward and had to adopt foreign models to assure their progress. Official nationalism remained tied to the Hanseatic commitment to whiten and "civilize" the Panamanian people; however, with time, the canal and enormous U.S. presence provoked disillusionment, leading to an adjustment of this agenda. This would be an alteration, and not an abandonment, of the program for lightening

Panama. Especially critical were the thousands of Afro-Antilleans who immigrated unexpectedly during the construction period and who defied the long-held logic that the interoceanic route would increase the number of Europeans. In fact, the isthmus was becoming decidedly more black, and it experienced political and economic disruptions that dwarfed those of the Gold Rush years. In response, the lettered city began to embrace the past. It fled into the countryside and into visions of the colony that ignored slavery and its African legacies and highlighted instead Panama's indigenous and Spanish populations and their unity through racial mixing. *Mestizo* had been an uncommon word among Panama's nineteenth-century residents, who had generally used *casta* to describe people of interethnic heritage.[52] Nevertheless, *mestizo* now became a part of the national identity, as this new leadership attempted to control modernization and to eliminate its many unexpected consequences, including the strengthening of Afro-Panamanian republican traditions.

LIBERALISM AND INDEPENDENCE

Following the country's separation from Colombia, Panama continued to define itself as liberal, as many of its writers and statesmen were educated abroad and became even more enamored with Western-style development and with the positivist and social Darwinist doctrines that were so influential at this moment. The Panamanian government rejuvenated the lettered city and became the most important patron of cultural and intellectual activities. It funded the foundation of an art and music academy, a state press, and a national theater, and it sent dozens of young men on diplomatic missions and gave scholarships to others to earn foreign degrees. The earliest stipends were awarded in 1904 and provided academic preparation for twenty-four Panamanians, two of whom later became their country's chief executive.[53] In addition, Panama erected its own educational institutions, which had been inadequate under Colombian tutelage. At the time of its separation, Panama had no public secondary academies and just 126 primary schools for its 320,000 inhabitants. In response, the new government created a mass instructional system that was secular in its orientation and that endeavored to cover the entire country. Initially, it was placed under the guidance of North Americans and later came under the direction of foreign-educated Panamanians, who worked diligently to revise teaching methods and to reduce the influence of the clergy. Student enrollments leaped twelvefold during the first two decades, and the Instituto Nacional became especially influential in expanding conceptions of liberalism and lightening.[54]

The Instituto was a selective secondary academy and served as a precursor for a national university, which was eventually created in 1935. The high school was founded in 1909 with the intention of consolidating several secondary programs and increasing the formation of badly needed teachers. In 1911, the school moved into a massive neoclassical structure next to the sprawling U.S. Canal Zone, with its waterway and other examples of modernity. For years, the Instituto relied heavily on foreigners. Edwin Dexter, a former commissioner of the Puerto Rican educational system, was one of the early and influential rectors. Instructors from Europe and the United States as well as from various South American countries arrived to teach in the Instituto's classrooms. Their perspectives fomented a sense of exceptionalism, a conviction among the students and the faculty that they were the enlightened elements of society and were primarily responsible for its advancement. "You are the men of the future," insisted the secretary of Public Instruction in an inaugural address at the academy, which began to admit female pupils in 1920 and which added college level classes in 1912.[55] A law degree followed in 1918 and surveying and pharmacy programs two years later.[56] In his speech, the secretary adamantly rejected the idea that the school was to support the Liberal Party. He denied that the institution had any "sectarian ends." However, he also admitted that the curriculum was carefully designed along a "scientific plan" and that students were to receive a "baptism of tolerance" that would mold them into "perceptive and impartial thinkers."[57] Inevitably, what emerged was a new generation of liberals who were eager to shape the republic's future and to move it beyond its African-influenced heritage and toward the examples of the United States and Europe.

Instituto graduates and foreign-educated Panamanians took up the established lettered city's perspective that the isthmus would prosper in the measure that it could place itself under outside influences and abandon its supposedly irrational and backward practices. They extended the isthmus's historiographical literature, and in books and essays, they justified independence and glorified Justo Arosemena and other nineteenth-century patriots. Two biographies of Justo Arosemena appeared after Panama's separation, and they present him as an "expert legislator" and a patriot whose actions and progressive agenda constitute what one calls the "exemplary life."[58] The authors especially laud his xenomania. They praise his desire to develop the interoceanic route and to attack the remnants of the colony, which they associate closely with Colombia and its distant and tradition-bound capital. The Colombians generally appear in these narratives as a war-prone and conservative people who are too removed from the currents of modernization to understand the isthmus's historic mission. Their abuses culminated during the so-called

The Teatro Nacional was inaugurated in 1908 with a performance of Verdi's *Aida*. Italian G. N. Ruggieri designed the building as well as the Municipal and National Palaces and the Instituto Nacional.

Regeneration (1886–1903), when Colombia reestablished a centralist constitution and governed the isthmus just as the "Spanish administered . . . Puerto Rico."[59] Catalino Arrocha Graell (1893–1985) wrote the most convincing treatise on the background to independence. The author was typical of the republic's "second generation."[60] Like many of his colleagues, he graduated from the Instituto before continuing his studies in the exterior. Arrocha Graell earned a teaching degree in Chile and later worked for the consular service in England.[61] In his writings, he uses the liberal values, seemingly developed through his education and travels, to criticize the Colombians and to distinguish them from Panamanians.

The Panamanians were constantly seeking progress, as depicted in his and other accounts. They were continually trying to advance their country through their adoption of imported models and via investment, immigration, and their plans for the opening of an interoceanic route. "This work," wrote Arrocha Graell, "was of incalculable transcendence for their economic, cultural, and political projections. The most important Panamanians," continued the author, "always associated . . . the canal with this land's independence and prosperity."[62] In their own lives, representatives of the new intelligentsia attempted to implement this long-established logic. They produced a plethora of books and

essays designed to encourage the isthmus's advancement through foreign-inspired programs and further internationalization. Jeptha Duncan (1885–1977) and José Daniel Crespo (1890–1958) had also undertaken studies in the exterior and later became involved in education. In the early 1920s, they served simultaneously as the secretary and assistant secretary of public instruction. In their writings and work, they took aim at the school system: its rigidity and dogmatism and reliance on outdated curriculum and its vulnerability to disruptive political interventions. They and others insisted on democratizing pedagogy and implementing what John Dewey called "new education."[63] Likewise, Crespo and Eusebio Morales (1865–1929) promoted the modernization of the economy. They argued for improvements in the financial and transportation systems and for a more balanced plan of national development.[64] Constitutional expert José Dolores Moscote (1879–1956) pressed for the "total revision" of the 1903 charter, after his examination of comparative law and government. Moscote specifically called for greater state intervention. He insisted that Panama move beyond its classic interpretation of liberalism and incorporate more socialist principles into its legal structure. "This country," he asserted, "is subject to the laws of interdependence" and would have to accept its "clear international character."[65]

While the isthmus's scholar-statesmen offered these arguments, monumental structures appeared around Colón and Panama City. In the first decades, the state erected a series of buildings, most of which followed the neoclassical pattern employed at the Instituto Nacional with its cornices and arches, its impressive exterior relief, columns, and bronze and marble statues. The National and Municipal Palaces and numerous other constructions arose like the Parthenon in the tropical capital. The National Theater was completed in 1908 and was loosely modeled after the Paris Opera House. French-trained painter Roberto Lewis (1874–1949) decorated the interior with classical allegorical figures whose pale and languid bodies represented the "Birth of the Republic."[66] Such architecture and murals bolstered a European identity and separated the capital from its majority black inhabitants. Belisario Porras (1856–1942), who occupied the presidency during much of the period, spoke at the 1924 inauguration of the National Archives. Porras was fascinated by the ancients and tended to cite them in his florid speeches. In this address, he suggested that the newly completed edifice "could rival any of . . . Greece's beautiful temples." He also insisted that the Panamanians had almost no consciousness of the importance of saving documents and that they had tended to toss them ignorantly into the sea. His trips to the United States and to Europe had convinced him of the necessity of creating the institution and of putting an end to what he depicted as this traditional and foolish practice.[67]

Porras was a native of Las Tablas, a small town and seat of the Los Santos province. He had been educated in Bogotá and in Europe, and according to one observer, seemed more like a Swiss citizen than a native of the Azuero Peninsula.[68] Porras spoke with the cadenced clarity of the Colombian *altiplano*, not with Panama's more coastal accent, and he often criticized his country-men openly about their supposed limitations. In a memoir published in 1922, Porras recalled his return to the interior during the War of a Thousand Days, when he led a Liberal army through Panamanian villages he now described caustically as "submerged in ignorance" and whose inhabitants were "natu-rally slow in all things."[69] "It is impossible," he stated in a National Assembly address, "to create an exemplary police force in a place whose citizenry leaves so much to be desired."[70] Positivism and social Darwinism informed Porras's perspective, and consequently, he continued to promote immigration. He constructed a railroad and other infrastructure projects to connect rural so-ciety to "civilizing" influences, and he employed a host of foreign advisers to occupy the most technical positions in his government.[71] "It is not the time," he wrote shortly before assuming the presidency, "to take precautions against the North Americans. . . . What is of importance is that we should take advan-tage of their wealth and power."[72] Meanwhile Panamanian poets praised the benefits of independence and of opening their country further to the exterior. These writers rapidly created a body of patriotic verse, which was based partly on Spanish American modernism and its exotic and cosmopolitan impulses, its ornate language, and use of French symbolism. Of "peace and progress," sang Rodolfo Caicedo (1868–1905) in one of these early optimistic pieces.[73] Other Panamanians, however, were not as confident. In fact, even those who praised and pressed for modernization began to view the process as difficult.

Modernization, as many scholars have noted, often functions in the so-called peripheral areas to weaken rather than support elite social groups.[74] On the isthmus, the construction of the interoceanic waterway clearly complicated the position of the oligarchy. It fomented a host of economic and cultural diffi-culties while disrupting the political order and subjecting the Panamanians to international criticism and to reinvigorated racist doctrines. Social Darwinism was now plainly implanted in the Canal Zone, in its rigidly segregated profes-sions, in its school system, stores, hospitals, and housing.[75] At the same time, independence frustrated a rising middle sector and pushed other groups into the republic's public life. These include workers, indigenous people, and women as well as the isthmus's black population, with its well-established practices of political insubordination. Panamanian literature reveals the anxiety which the elite and professional classes suffered in the period and their conviction of the necessity of creating greater cohesion, especially at the popular level. In 1916,

Detail from interior of the Teatro Nacional.

Eusebio Morales remarked on the "almost total absence of a nationalist senti-
ment in the mass of Panamanian people." Morales attributed this supposed
deficiency to the isthmus's independence, to its easy and bloodless separation
from Colombia, and to the consequent lack of solidarity. In response, he called
on officials to "awaken . . . and ennoble the national spirit" through schools
and other educational programs. "We must form," he wrote, "a powerful group
to complete the fundamental labor of . . . the nation and outline the pathways
on which it must march to transform itself into a prosperous country."[76]

Morales and others acknowledged the benefits of the waterway. They
praised the sanitation of Colón and Panama City; the construction of new
roads, schools, and medical facilities; and the imposition of political peace by
the North Americans. However, they also observed that the economy weak-
ened after termination of the waterway and that foreign companies had come
to dominate key sectors, such as banking, agriculture, and domestic com-
merce. In an article on Colón at the end of the nineteenth century, Morales
recalls the city's dirty streets, its lack of a sewerage system, frequent fires, and
mosquitoes, but he turns suddenly nostalgic when remembering the local busi-
nesses which had since closed and had ceded their places to the more dynamic
outsiders. "The Panamanians have lacked the valor, industry, and sagacity to
maintain their . . . preponderance," wrote Morales, who in other publications

lamented that the canal had not significantly affected the interior and that much of this region remained in its "primitive conditions."[77] The sea route had neither assured Panama's prosperity nor secured the transformation of the country, confirmed a 1929 study commissioned by the national government.[78] Also problematic were the U.S. commissaries, which were designed to serve the North American colony but which in practice flooded the domestic market with their cheaper, imported products. Another writer observed with obvious bitterness that "there is almost no worker from our Afro-Antillean barrio, who does not sell cigarettes and sugar from the commissaries."[79] A more alarming alleged problem was the growing presence of foreigners, especially English- and French-speaking blacks from the Caribbean, who would not remain indifferent to the republic's affairs.

As postulated by Arosemena and other nineteenth-century nationalists, the canal was supposed to whiten the isthmus. It was supposed to encourage European immigration, quell black mobilization, and secure the oligarchy's position. Instead, it fostered the sudden arrival of 150,000 to 200,000 Afro-Antilleans. These newcomers came primarily from Barbados and Jamaica but also from Guadeloupe, Martinique, and other islands. They provided the majority of labor for the canal construction project, and they pursued a plethora of professions in the republic. Most traveled individually and without Canal Commission contracts, and more than a quarter of them remained after the route's completion, generally taking up residence in the terminal cities, where hundreds of Chinese, South Asians, and Arabs had also recently established themselves.[80] Panama's population increased from about 316,000 in 1896 to more than 512,000 by 1930.[81] At this point, roughly 10 percent of Panama's residents had been born outside the country. About a quarter of the capital's inhabitants had immigrated from abroad, and nearly half of Colón's population was foreign.[82] Panama's intellectuals expressed alarm about this situation and its impact on their culture. They sensed that they were losing control of the economy as well as their customs, music, religion, and language. "The spectacle of Colón's streets . . . was almost painful for me," wrote one of these distressed intellectuals. "Was it perhaps the silent protest of the past . . . against progress without any tradition? Was it against the oriental bazaar . . . and the jazz and the foxtrot . . . without roots in the earth, the blood, and the spirit?"[83] Members of the lettered city were especially sensitive to the perceptions of their Latin American counterparts, who often portrayed Panama as a "simple Yankee colony" and who were fomenting racist and other negative characterizations.[84] "With the betrayal of the miserable blacks of Panama, the country has fallen into the clutches of American hucksters," wrote Venezuelan Rufino Blanco Fombona in his 1908 history of Hispanic literature. Panama had

become a "nominal *republiquita* of traitors" for Blanco Fombona and for many other figures of Latin American cultural and political life.[85] Such denunciations arose in the midst of growing domestic conflicts as workers and other groups again began to affect national life.

In the 1910s and especially into the 1920s, Panama became a much more contentious society, mirroring developments in the mid-nineteenth century and similarly incorporating large segments of the black population.[86] The period witnessed the emergence of the first national labor unions, student groups, and a vocal women's movement. The National Feminist Party was organized in the early 1920s and pressed for suffrage and similar rights.[87] Other political groups multiplied in number as the younger generations became increasingly disenchanted and fragmented further the country's ideological consensus. The Liberal Party itself splintered during Porras's first presidency (1912–16) and never reunited into a single organization. Even Morales later began to criticize the Liberals, faulting them for their personalistic qualities.[88] Simultaneously, Panama experienced some of the most tumultuous disputes in the country's one hundred year history. In February 1925, the Kuna Indians of San Blas declared themselves in rebellion, and they briefly established the Republic of Tule in response to government efforts to control the region and to eliminate their indigenous culture.[89] Eight months later, Panama City erupted in violence during a mass strike by low-income tenants against an increase in their rents.[90] The government itself proved to be vulnerable and succumbed to an armed uprising in 1931. Finally, as Panama became an official U.S. protectorate and suffered under its oversight and racist influences, a new nationalist generation rose to prominence and disputed the assumptions of Porras and his followers. Modernization proved to be problematic, particularly for the new intellectual class, which was enamored with the notion of progress, but which was appalled by many of its unexpected consequences. "Would it not have been better," pondered one of its members, "for us to remain in our simplicity, ignorance, and barbarism perhaps?"[91]

The North American activities in the early twentieth century included periodic electoral supervisions, monitoring and guidance of Panamanian authorities as well as frequent military interventions.[92] U.S. troops occupied Colón and Panama City several times in the 1910s and the 1920s, and they stationed themselves in Chiriquí province for a two-year period (1918–20) to protect foreign property.[93] Months later, U.S. gunboats rushed to the isthmus and forced the Panamanians to give up the Coto territory in a short border conflict with Costa Rica. Periodically, U.S. officials also pressured the national government to concede further lands for the operation of the canal. In 1904, North American officials encouraged Panamanian leaders to disband their army. Twelve

years later, they seized the National Police's rifles after a series of fracases with unruly servicemen. Meanwhile, the bureaucracy of the new state fell under the guidance of foreign experts whose oversight annoyed the new middle class. These young professionals had often studied abroad and were eager to implement their newfound knowledge. As they returned home, they encountered the racist structures that rigidly segregated the U.S. Canal Zone and that privileged white North Americans over every other ethnic group. More disturbing, they found that their own government was dominated by a host of outside functionaries: fiscal agents, security and educational authorities, engineers, doctors, agronomists, and other specialists.[94] The government had become a "foreign tutelage, very disagreeable despite the good intentions."[95] Frustrations exploded in 1926, when street protests forced the National Assembly's rejection of a new canal treaty negotiated by Porras and his successor.

At this point, the Hanseatic ideals alone were no longer viable. The implementation of nineteenth-century liberalism had created enormous disruptions and tensions and a strong desire to control the process of change, particularly among the most westernized sectors. Foreign-educated professionals became especially influential, and they would continue to press for modernization, even as it had in some ways "taken them by the throat."[96] My own work has defined this development as "nostalgia," an attempt to ignore the realities of the early twentieth century and to restore a past more agreeable to elite groups.[97] Ironically, the republic's privileged sectors now enthusiastically embraced their colonial heritage. They romanticized aspects of the Spanish period while also turning their attention to the interior, especially to the Azuero Peninsula, with its predominantly light-skinned inhabitants and its vibrant folk traditions. What once was considered to be backward and uncivilized now became the bedrock of the official identity. Such efforts sought to create cohesion and to restore a sense of patriarchy and privilege in a society fractured by foreign domination. Nation builders also responded to social Darwinism and to other popular racist doctrines then so rigidly manifested in the Canal Zone and which appeared in the frequent charges that Panama had become a Yankee colony with a majority black and English-speaking population. Masking blackness consequently became central to the state-sponsored conception of nationalism, and in this sense, the movement was typical of the entire region in that it denied the contributions of Panama's African diasporic peoples and instead emphasized the union of Spanish and indigenous populations. Panama, as some suggested, was a "crucible of races"; however, blacks never figured prominently in what was essentially a continued project of lightening the isthmus.[98] This project initially took form in Panamanian literature, encountering one of its most skillful voices in the poetry of Ricardo Miró (1883-1941).

NOSTALGIA, *RURALISMO*, AND MESTIZAJE

Miró was a member of the oligarchy and Panama's most revered poet in the early twentieth century. A colleague described him as a "hidalgo of the Middle Ages, who wandered the twentieth century . . . carrying his conqueror's cape."[99] Miró was born into an old colonial family that had linked itself to French immigrants in the nineteenth century and that exemplified the elite's survival strategy of tying its fortunes to outside elements. Like many writers of his generation, he also benefited significantly from independence. Between 1908 and 1911, he served as Panama's consul in Barcelona, and he later occupied a series of government posts that provided stability for his literary ventures. In Spain, Miró broadened his artistic perspectives. He traveled and met his intellectual counterparts while also encountering the bitter criticism of Panama's 1903 separation from Colombia. Even before his departure for Europe, he had confessed dejectedly of the need "to convince America that we are not becoming Yankees by the minute."[100] According to his son, Miró suffered from the perception that his homeland had become a U.S. colony, and he responded with a poetry of nostalgia that inaccurately depicted the colonial period.[101] Nostalgia was a powerful and manipulative device. It played on the emotions of Panamanians, and it permitted Miró to reshape history and to underline its Hispanic and indigenous aspects while ignoring entirely its dominant African elements.

Miró typically focused on patriotic and romantic themes: the solitude of the countryside, Panama's moonlight and beaches and its crumbling Spanish ruins, which he suggested embodied the essence of the nation.[102] "I have the infinite misfortune," he wrote in one of his poems, "to love what disappears, what goes away."[103] In another case, he described himself as the "the last gull" flying dreamily behind a "distant flock."[104] In his depictions of the past, Miró professed a mestizo identity. He wrote movingly about the Spanish period, and he tied his benevolent representations of the colony to conceptions of interethnic unity. "I don't know if I'm an Indian or a Spaniard," he professed in one of his most famous works, which outlined the process of racial mixing as the meeting of European and indigenous lovers.[105] Interestingly, Miró claimed his indigenous and European parentage but made no mention of Panama's African ancestors, even in a portrayal of Portobelo which had served as a major slave port and whose residents were still overwhelming black. For Miró, Portobelo was a "noble and loyal city," and he venerated its cannons and memories of "Spanish splendor."[106] Such feelings of nostalgia became apparent in other

Neocolonial home typical of the early republic.

works—in short stories, music, and in Panamanian architecture. Other poets followed Miró's example and praised Spain's legacies in their verse.[107] Even Afro-Hispanic writers "subordinated blackness to a white literary aesthetic" and tended to avoid discussions of racial/ethnic differences, preferring to focus on patriotic themes.[108] Literature in general became more romantic and distanced itself from its earlier modernist tendencies. Novelists also turned their attention to the past and presented similar ideas regarding mestizaje. In 1936, Julio B. Sosa (1910–46) published *La india dormida*, which depicts an amorous relationship between a Spaniard and an indigenous woman and suggests that their union constitutes the origins of the nation.[109] In general, elite and middle-class Panamanians ignored their African heritage. They fled from it, hid it, or they disguised it as mestizo, as they erected their nostalgic visions.

As Panama City became filled with Afro-Antilleans and other immigrants, reinvigorating republican plebeian traditions, the old elite and rising middle-class elements abandoned their traditional residences in the capital. In the 1910s and 1920s, they steadily moved out of San Felipe, the long-established barrio of the oligarchy, and they built their "neocolonial" houses in newly created suburban areas that were partly modeled after the Canal Zone with its lawns, spacious parks, and gardens. This was the beginning of what Álvaro Uribe has described as the rise of a "fragmented city."[110] At the same time, many wealthy families began to establish weekend residences in San Carlos,

Antón, and other nearby villages along the isthmus's Pacific coast. President Porras helped to encourage this transfer. As part of a 1914 national exposition to mark the opening of the interoceanic waterway and the four hundredth anniversary of Balboa's trek to the Pacific, his administration subsidized the construction of several neighborhoods. The houses of Bella Vista, La Exposición, and La Cresta were patterned on a "false version of the colonial model, as if wanting to avoid the problems of contemporary life."[111] The pompous and weighty structures had a "profusion of iron bars," red tile roofs, and rounded or square towers that gave them the impression of modest medieval castles. Flower pots hung from their rustic walls, and long eves jutted out over their windows.[112] Porras later remodeled the presidential palace in a very similar fashion. The Palace of Herons took on a Moorish quality, with a fountain and a marble-lined interior and a pair of these birds to wander its patio, featuring pillars with mother-of-pearl shells.[113] A Panamanian architect subsequently blasted the new residences as "disconnected from a factor as objective as our tropical climate."[114] The Panamanian elite disregarded such criticisms and tied itself closely to what it considered to be representative of Hispanic culture. It fled into the countryside and to the suburbs, segregating itself from the dominant black areas while clinging to the hierarchies of an imagined older society. Such nostalgia also became apparent in the new heroes of the republic.

In the early twentieth century, Panama elevated a host of figures to serve as examples for its citizenry. The new state press published a number of biographies, while the precursors' busts and portraits appeared around the capital. Not surprisingly, many of the selected people were liberals from the nineteenth-century. They generally had been enamored with the ideology of modernity and had been opposed to the Spanish-Colombian traditions of centralism while pressing for greater Panamanian autonomy. Justo Arosemena was among the most venerated leaders, and he was honored with a bronze sculpture and with flattering historical interpretations. Today, even the National Assembly building is named after the statesman.[115] Tomás Herrera (1804–54), who had led the 1840–41 independence movement and who later died while opposing a military coup, was the subject of equal glorification. Herrera was an army officer and had fought in the last battles for South America's independence. He received his greatest praise for defending democracy and for adherence to concepts such as self-determination and progress. Herrera was a "great man," insisted his biographer. "He personified legal principle to salvage the constitution and fought for its triumph over . . . dictatorship."[116] The majority of Panamanian icons had similar backgrounds: They were representatives of the commercial oligarchy and had supported the cause of the isthmus's sovereignty. What is remarkable is the simultaneous exaltation

of colonial figures whose lives seemingly clash with the values of this social group. The Panamanians emphasized their ties to prominent Spaniards, with their traditional and conservative qualities, despite their own adherence to liberal nationalism. Through them, the Panamanians attempted to control modernization. They strove to reinforce patriarchal social structures, while also insisting that they were still Hispanic and that they had not become a Yankee or a black colony.

In 1924, Porras erected a modest statue of Vasco Núñez de Balboa (1475–1519) on a globe-shaped pedestal overlooking the Bay of Panama. Balboa was the famous Spanish conqueror who in 1513 had "discovered" the Pacific Ocean and whose leadership had secured the isthmus's colonization and had opened South America to European exploration. Despite his achievements, Balboa had suffered imprisonment and was executed by a rival in 1519. President Porras declared Balboa to be a Panamanian "precursor" and praised him for his skill and his courage and particularly for his role in spreading Hispanic culture.[117] Porras initially hoped that the structure would be as "colossal as the Statue of Liberty" and that it would serve as a "symbol . . . of the *raza*" to underline Panama's historic role within the region.[118] Panama had been the staging ground for the conquest of Peru, and to make this point more obvious to critics who were now depicting the isthmus as a U.S. dependency, the president secured support from fifteen Latin American republics as well as from forty Spanish municipalities. Simultaneously, Balboa was lauded in history textbooks, and his image appeared on coins and postage stamps. Novelists and poets also chronicled his deeds and depicted his supposed union with an indigenous princess. The Panamanians even used the term *balboa* to refer to the U.S. dollar, which they had adopted as their official currency after the separation from Colombia. "Oh hero without equal," spoke Porras before the completed effigy, "may you serve here as a reminder of fecund mother Spain."[119] A year earlier, his government, with the support of Spanish immigrants, had constructed a statue of Cervantes in a park named after the Golden Age figure.

Plaza Cervantes was located in the new La Exposición neighborhood and was ringed by a series of neocolonial buildings which had become fashionable in the early twentieth century. The park had been inaugurated in 1916, to mark the three hundredth anniversary of the famous writer's death. The celebrations had included speeches and patriotic music and an allegorical pageant featuring the daughters of the oligarchy. The young authors of the republic participated in a literary competition and reflected on such topics as "El Quijote as a tie of unity between Spain and Hispanic America," the "preservation of language," and the "maintenance of national independence."[120] "It is indubitable," asserted the first-place essay, "that the independence of a country depends . . . most

essentially on a homogenous culture."[121] Cervantes's sculpture further spoke to this concern, with its placard recognizing the Spaniard as the "luminous beacon of all souls united by the eternal bond of the Castilian language."[122] Cervantes and other Spanish subjects fascinated the Panamanians, whose historic structures now fell under the protection of the government, which sent researchers to Seville and sponsored investigations of the past.[123] What resulted was the rise of a pro-Spanish school of historiography and a strong tradition of romantic literature that tended to focus on rural and light-skinned populations and identified them as most representative of the nation.

Essayist Samuel Lewis (1871–1939) provides an excellent example of the transformation of Panamanian nationalism. His career demonstrates the alteration of the official identity, with its new emphasis on the Spanish colonial legacies and the republic's supposed cultural unity. Lewis came from a traditionally liberal family that had strong ties to the international community and that had actively backed the idea of Panama's westernization and further integration into the North Atlantic economy. His paternal grandfather, Louis (1812–52), was a merchant from Jamaica who lived in Bogotá before settling on the isthmus, where he converted to Catholicism and married Tomás Herrera's sister. Louis Lewis had argued for a transoceanic route, reflecting the aspirations of the nineteenth-century oligarchy, which had wanted to eliminate many of the isthmus's Spanish legacies and transform the country into an international emporium.[124] In contrast, his grandson was nostalgic for the colony and became a member of the Conservative Party. Samuel participated in the movement for independence and subsequently occupied a number of important positions, including secretary of foreign relations (1909–10) and member of the Mixed Commission (1912–15), which addressed land issues arising from the construction of the waterway. Lewis also served on a government committee charged with the preservation of national historical monuments, and he helped to found Panama's Academies of History and Language. Such preoccupations also surfaced in his writings, which tended to glorify the Spanish period and to underline Panama's contributions to the development of Hispanic America. Lewis focused particular attention on the ruins of Old Panama, which had been constructed in the early sixteenth century and which had been abandoned following the 1671 attack by Henry Morgan. "Panama Vieja," he insisted, "was an opulent city, the capital of Tierra Firme . . . and the center of American commerce. Through the isthmus passed the most distinguished men that the Catholic Kings sent to the New Hemisphere."[125] Writers such as Lewis now embraced the colony, and they depicted it as a mestizo society while also setting their sights on rural areas, which they portrayed as Spanish and indigenous in origin and free from the taint of black urban culture. Intellectuals

especially looked to the Azuero Peninsula, with its music and folk traditions, to serve as the face of their Hispanic republic.

In a 1953 essay on the "course" of the Panamanian novel, writer Ramón H. Jurado (1922–78) emphasized the rise of the "ruralist" perspective, which he linked to the difficulties of modernization and to middle-class disillusionment with the interoceanic waterway. "The Panamanian is shaken," he wrote, "before a frightening premonition that the Canal has not been the solution to his problems." In fact, it seemed to have increased many of them. Among the issues Jurado identified with disenchantment were the "scandalous battalions of black Jamaicans," whom he described as parasitic and backward and as "stuffed into the borders of the city."[126] His older colleague, Demetrio Korsi (1899–1957), was even more alarmist. In the introduction to a 1926 anthology of poetry, Korsi suggested that the Afro-Antilleans were "infesting" Panama and he advocated expelling them "just as the Moors were evicted from the Iberian Peninsula in the fifteenth century."[127] The writers were troubled by modernization and blackness and they responded by abandoning their modernist optimism. In the 1920s, they shifted their attention to the interior, which they depicted in an idealized manner and as free from legacies of slavery and African culture. Many of these efforts had the explicit intention of defending what was described as a threatened ethnicity. "The construction and maintenance of the canal . . . have nearly distorted our idiosyncrasy and adulterated our physiognomy," complained José E. Huerta (1899–), the author of *Alma Campesina* (1930).[128] The Panamanians were mestizos, argued Huerta and others, and they had nothing to do with the Afro-Antilleans and Chinese who were now dominating the terminal cities. The real Panama, according to many, was to be found in the interior, a region whose supposedly mestizo inhabitants became the obsession of Panamanian writers.[129] The same notions were also apparent in a powerful folk movement that essentially denied the existence of an urban identity and elevated the customs of the Azuero Peninsula as the Panamanian national culture.

Leading this movement was Narciso Garay (1876–1953), a French-trained violinist who had founded Panama's academy of music and who had twice served as his country's foreign minister. Garay was an aristocrat and an outspoken nationalist, and he occasionally clashed bitterly with the North Americans.[130] In the late 1920s, he traveled through the interior with the intention of recording the region's folk culture. Garay eagerly embraced Panama's indigenous peoples, and he forcefully criticized the efforts to westernize them. In contrast, he generally ignored the black population in what he described as his "baptism of nationalism."[131] His book, *Tradiciones y cantares de Panamá* (1930), proved to be very influential and inspired a number of younger followers.[132]

A more recent example of rural idealization. Mi Pueblito Interiorano was inaugurated in 1994 and remains an important Panama City tourist destination. Intended to represent a colonial village, Mi Pueblito ignores slavery and the interior's African heritage.

His disciple Gonzalo Brenes (1907–2003), began to incorporate folk melodies into pieces of orchestral music. In 1937–38, he collaborated with poet Rogelio Sinán (1902–94) and presented "La cucarachita mandinga" in the Teatro Nacional.[133] Meanwhile, Brenes's contemporaries, Manuel Zárate (1899–1968) and Dora Pérez de Zárate (1912–2001), organized folk festivals around the country. In their writings, they documented the "transculturation" of African practices and their reformation into Hispanic and European elements. The Zárates even noted that dances such as the *tamborito*, clearly tied to Panama's experience with slavery, had now become divorced from this past.[134] Broad sectors of society seemed to accept these premises, and as Panama's Carnival grew over the 1920s and 1930s, its kings, queens, and more plebeian participants adopted peasant outfits as their national dress. Matilde de Obarrio de Mallet (1872–1964) struggled to understand the changes in fashion. In her musings on history and Panama's evolution, this daughter of the oligarchy recalled with some befuddlement that her mother and sisters had never danced the *tamborito* or worn the *pollera* to a social event. "Each epoch," she concluded, "has its own customs and mentality."[135] The oligarchy and middle class were embracing their past, but in a manner that was manipulative and that ignored their dominant black populations.

Nostalgia arrived at its most prominent form during the first presidency of Arnulfo Arias (1940–41). Arias (1901–88) was a Harvard-educated doctor

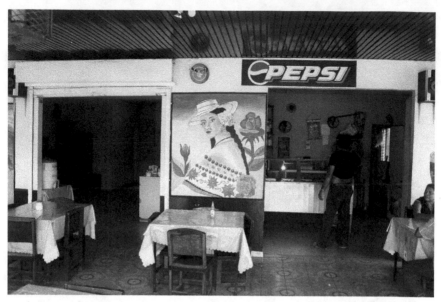

Popular artists are not ideological. They regularly depict the traditional symbols of nationalism even as they embrace new conceptions of their country. A *pollera* mural at Restaurante El Mirador, 24 de diciembre (2007).

who had grown up in the interior and who had become dismayed by Panama's many changes when he returned home in the mid-1920s. Arnulfo followed his older brother, Harmodio (1886–1963), into politics and led a short but consequential government, influenced by his recent diplomatic appointments to Europe and his apparent admiration for Hitler and Mussolini.[136] Arnulfo briefly held power on two other occasions, and he remained Panama's central opposition figure until his death in 1988.[137] Today, the "Arnulfista" or "Panameñista Party" is still one of the country's most important political organizations, and its cultural-ideological impact is considerable. Part of its appeal is a legacy of Arias's program and its ambitious number of initiatives. On the one hand, the president was a social reformer. Governing as an autocrat, he extended voting rights to women and implemented modest economic and labor legislation. Arias moved Panama toward a more social-democratic model while imposing heavy-handedly his agenda of nostalgia.[138] The president challenged the traditional dominance of the United States. He stalled its preparations for World War II and refused to arm Panamanian registered vessels and to provide the North Americans with more military and air defense bases without an agreement for substantial compensation.[139] His government also regulated foreign languages. It banned their use in storefronts and streets and required that

English be restricted to the inside sections of newspapers. Spanish was recognized as Panama's official language, and the state was now authorized to foster its preservation. To this end, Arias created the Department of Fine Arts, which published literature and offered events relating to Panamanian culture.[140] The president embraced the mestizo-ruralist perspective, and during Carnival in 1941, he and his cabinet dressed as peasants for a dinner at the prestigious Club Unión.[141]

One of the most notable acts of the Arias presidency was to issue a Panamanian currency, the circulation of which briefly replaced the U.S. dollar.[142] Arias also took steps to nationalize small commerce and deprived hundreds of Chinese and South Asian merchants of their livelihood. He first used health laws to close their establishments, and later he created an elaborate system of licensing to prohibit foreigners from entering the retail sector. In a wave of xenophobic violence, many immigrant families lost their businesses and left the country in financial ruin.[143] Most importantly, the president attempted to reduce blackness. His new constitution expanded earlier racist legislation and imposed cultural restrictions on immigration and citizenship.[144] It denied rights to the children of "prohibited" immigrants, including those of the "black race whose original language is not Spanish," as well as those of "the yellow race and the races of India, Asia Minor, and the North of Africa." Some fifty thousand Afro-Antilleans were affected by these measures, and many more suffered from the uncertainty of their legal status.[145] Immigrants, assured the leader, were now to "fulfill certain physical and moral requirements."[146] Felipe J. Escobar (1901–66), who served as Arias's attorney general and who viewed his policies as an Afro-Panamanian, described them as an effort to "whiten the race" and to create "racial homogenization" in a country that was "heterogeneous."[147] It is interesting that in the midst of Arnulfo's efforts, this heterogeneity was becoming even more assertive and was continuing to mold a different version of the Panamanians' national identity. Indeed, modernization was giving rise to a rival movement that embraced many aspects of the isthmus's blackness even as Arias was retreating into a fabricated past. Before moving on to this topic, however, my study analyzes further the rise of mestizaje in the early twentieth century. I do this through the examination of an important historical novel by Panama's leading educator, Octavio Méndez Pereira. Méndez Pereira was a representative of the lettered city who deeply felt the ambiguities of Panama's independence and who consequently presented Balboa and his indigenous lover as the progenitors of mestizaje.

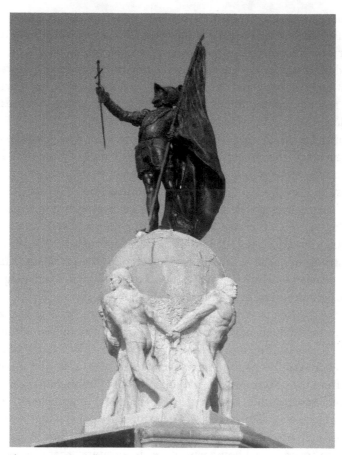

The monument to Balboa completed in 1924. The Porras government had origi-
nally hoped it would be as big as the Statue of Liberty and greet visitors at the
entrance to the Panama Canal. Today the monument is located on the capital's
Cinta Costera, overlooking the Bay of Panama.

2. BALBOA MEETS ANAYANSI, 1934

When the cultured foreigner looks for the Panamanian . . . and walks through our streets of stores, cantinas, and cabarets, and sees the Chinese, Hindus, Jamaicans, Americans, and European Jews, he will exclaim enthusiastically upon discovering our university: . . . From there will come the salvation of this people . . . the mortar of assessment and purification of the race.

—OCTAVIO MÉNDEZ PEREIRA, *Un juramento académico*

"Romantic novels go hand in hand with patriotic history," writes Doris Sommer in her seminal study of Latin American nation building.[1] Sommer, whose investigation examines literature from the nineteenth century, emphasizes the books' emergence in the turbulent decades following the region's independence from Spain. Political and economic instability characterized this period, and the authors of the texts were frequently participating in the conflicts, as liberals pressing for national development. The works of these writer-statesmen offered a rejection of traditional divisions and proffered the elites' hope of a more cohesive community in which "progress" and their own hegemony would be complementary to one another. Indeed, despite their enlightened and liberal orientations, the novels which they produced were strikingly hierarchical. They promoted a sense of political and social reform but within parameters preventing fundamental disruptions. The ideal, as Sommer writes, was an "almost airless culture . . . that made a place for everyone, as long as everyone knew his or her place."[2] This vision became more apparent in the early twentieth century, when threats from abroad again dislocated Latin American society and put into question its traditional order. Modernization and U.S. imperialism revived the "foundational fictions" that now became standard readings for Latin American schoolchildren.[3]

Generations of students subsequently became acquainted with these stories centered on romantic relationships between characters of disparate backgrounds. The protagonists represent opposing groups, whether these divisions

are ethnic, regional, or social in origin. Ignoring the obstacles and conventions that keep them apart, they recklessly follow their passions and fall in love. The objective, as Sommer emphasizes, is not to titillate or to "tease but literally to engender" the birth of new nations.[4] The lovers thus tend to consummate their relationships and as a consequence project the idea of mestizaje and of a prosperous and stable country based on the realization of heterosexual unions. The result is a powerful tool of Latin American nation building, a persuasive literary account practically indiscernible from the official history that preserves the ruling class's position in society through the harmonious consolidation of dissimilar sectors. Not surprisingly, the novels also tend to mask blackness or any other ethnicity perceived to threaten unity. This chapter proposes to use Sommer's ideas to examine the construction of official Panamanian nationalism, the state-led project that arose in the early twentieth century to encourage the "progress" of the isthmus while controlling its effects and protecting the existing social structures. Specifically, this section will treat the writer Octavio Méndez Pereira (1887–1954) and the duality of order and Liberalism in his portrayal of Vasco Núñez de Balboa.

Octavio Méndez Pereira was one of Panama's leading intellectuals and its most important educator during the first half of the twentieth century. He was greatly influenced by Latin American romantic literature, and in 1938, during a visit to Cali, he even publicly honored one of its principal creators by placing a bouquet of flowers before a statue of Jorge Isaacs (1837–95).[5] From the late 1910s into the 1930s, Méndez Pereira occupied a number of influential positions, including rector of the Instituto Nacional; minister to France, Great Britain, and Chile; and secretary of the Department of Public Instruction. In 1935, he spearheaded the establishment of the national university, and he headed this institution almost continuously from its foundation until his death in 1954.[6] While a liberal and deeply committed to the isthmus's transformation, Méndez Pereira was also alarmed by rapid change, and he not infrequently adopted more conservative positions, seemingly in response to these undesired disruptions. He exhibited the typical "Janus-faced" orientation of a developing country nationalist, educated in the West and eager to restructure society but also concerned about tradition and stability.[7] Tradition, in this case, was everything Hispanic and seemingly older than the cultures associated with the opening of the Panama Canal. From an early age, Cervantes had been one of Méndez Pereira's great passions, and he wrote prolifically on the author and Golden Age literature as well as on a variety of other topics ranging from Bolívar and Latin American history to pedagogy and international relations. Grammar and language were two of his other interests, and he composed several of the earliest texts for the country's school system.[8] In many of

these works, a central thesis emerges that Panama was part of broader Hispanic civilization, and it had played a crucial role in its advance through America despite the censure that the isthmus had become a Yankee colony and that its citizenry was increasingly black and English-speaking. In 1934, he published his first historical novel, which also became a standard reading in Panamanian classrooms and which gave greater shape to these ideas. This book was a fictional account of the conquest, entitled *Núñez de Balboa, el tesoro de Dabaibe*.[9]

Méndez Pereira wrote *Núñez de Balboa* amid Panama's tumultuous development following its controversial separation from Colombia. The author was sensitive to the republic's critics and to the repeated North American interventions that seemed to confirm their depiction of Panama as a U.S. fabrication. In addition, he was worried about the widening domestic divisions that had arisen as a consequence of the interoceanic route. Modernization was broadly welcomed by liberals such as Méndez Pereira; however, it was also heightening social and ethnic tensions and separating citizens along generational and gender lines. Particularly important in this regard was the arrival of thousands of Afro-Antilleans, who had been encouraged to immigrate by U.S. authorities and who served as the principal labor force on the construction of the waterway. Their presence had further weakened Panama's old patriarchy and had contributed to what Méndez Pereira described as a "nation of transit," a country without a strong sense of cohesion.[10] For Méndez Pereira, the solution was education, which he repeatedly insisted in his writings was more than the diffusion of "utilitarian" knowledge but should contribute to the republic's moral and spiritual foundation.[11] In this regard, literature was particularly well suited to forward the cause of Panamanian liberalism while assuring the country's social harmony and its legitimacy in the eyes of other Latin Americans.[12]

To fulfill these objectives, Méndez Pereira wrote a novel that presents itself as a history and not as a fictionalized account of the Spanish settlement. The book cites the major chronicles and lists them in a bibliography while tying these authorities to the contemporary situation. Méndez Pereira relates the colony from a present-day perspective, with the effect of converting Balboa into a Panamanian and of linking the republic to the Hispanization of America. From this perspective, Panama was not a Yankee or African outpost but rather the beachhead of Spanish culture in America. More importantly, the narration unites dissimilar sectors and reinforces patriarchic structures. Balboa and the indigenous princess, Anayansi, are the narrative's principal characters, and the eroticism and romance that bond them and other couples provide the reader with a sense of a homogenous nation with a stable and benevolent male leadership. Balboa is critical in this sense, as he is both Spanish and traditional while being entrepreneurial and modern. His relationship with Anayansi produces

"heroic mestizaje," what the author regards as the base of Panamanian nationalism.[13] In this assertion, the book reflects its most critical weaknesses or the "pretty lies" of foundational fictions. In Sommer's words, Balboa and Anayansi are natural "aristocrats" whose union hides Panama's majority black population, especially the thousands of Afro-Antilleans who had immigrated during the construction of the interoceanic canal.[14] They and other Afro-Panamanians find no place in this nationalist conception despite their position as the republic's largest ethnicity. Méndez Pereira set his work at the so-called beginning, before the arrival of large slave populations, and thus he "lightened the (t)races of intervening history."[15] As such, his novel demonstrates the strategies of Panamanian nationalism, its attempts to erase the isthmus's Afro-Caribbean culture and to serve the interests of people such as Méndez Pereira.

MÉNDEZ PEREIRA AND THE "NATION OF TRANSIT"

Méndez Pereira published *Núñez de Balboa, El tesoro de Dabaibe* just over three decades after Panama's separation from Colombia. While its emergence was relatively late in terms of foundational fictions, many of which were written in the previous century, the book must be considered within the context of Panamanian history and the isthmus's delayed achievement of its independence. From this perspective, the novel's tardy appearance is entirely logical, corresponding to a similar phase of national consolidation. Both the nineteenth and early twentieth centuries were periods of political and social tumult in which leaders faced what Tom Nairn calls the "uneven development of history" and "had to contest the concrete form in which . . . progress had taken them by the throat, even as they set out to progress themselves."[16] Méndez Pereira, like his predecessors, was a prominent *letrado* who faced these dilemmas in an intimate fashion. He was a liberal intellectual who sought the destruction of the region's Spanish colonial legacies and the creation of a more democratic society. Nevertheless, in many instances, he also felt threatened by modernization, especially by its divisive economic and cultural effects and its tendency to weaken his social position. He represented what Mary Matossian calls an "assaulted intellectual," a westernized leader in the more traditional periphery who while regarding his or her own country as backward also felt ambivalent about the process of change, especially as it was so dependent on U.S. imperialism and on an influx of Afro-Antillean workers.[17] His novel would attempt to resolve these differences, to provide a sense of a progressive, European country while whitening and unifying what he described as a "nation of transit."[18] The logic of such ambiguities becomes more apparent upon considering the

author's life during the early years of the republic, when thousands of Afro-Antilleans arrived on the isthmus and when Colón and the capital were transformed by their presence.

Like many other nationalists of his generation, Méndez Pereira was raised in the interior, the territory that Panamanians roughly describe as their countryside and that includes everything outside Colón and Panama City. Even today, the interior maintains a more colonial culture and has received fewer immigrants than the isthmus's urban areas. The slave populations of interior towns had been significant; however, they often had been less numerous than those of the zone of transit.[19] This was especially the case in the western provinces, where lighter-skinned inhabitants helped to create the impression that they had no strong connections to Africa and that they were the products of Spanish and indigenous unions. The future author was born in 1887 in Aguadulce, a small Pacific-side town in central Panama, about one hundred miles from the capital. Aguadulce's nearby port served the surrounding region, and it produced salt and cattle for sale in Panama City. Méndez Pereira's father was a successful rancher and merchant, and he participated in local politics as a conservative. A biographer describes him much like Méndez Pereira would later portray his novel's principal character: he was a "patriarch" who "combined in his personality the values of the feudal aristocracy with those of a prosperous businessman." Supposedly, he educated his children with "rigid discipline" and quickly involved them in his commercial activities. During the War of a Thousand Days, when liberal forces surrounded the village, Méndez Pereira's father fled to Panama City, and his son made shoes to help support the family.[20] In assessing Méndez Pereira's life, one must consider his childhood. Did the values of this upbringing come to affect the man who later decried what he saw as the "nation of transit" and extolled Balboa as a model for rejuvenation?[21] And what was the legacy of the area's more traditional culture? Did Méndez Pereira's insistence on Panama's ethnic unity arise from these years in the interior with its supposedly more mestizo population? It is difficult to answer these questions with any certainty, but what is clear is that the author's formation later changed. He soon became exposed to more modern and liberal concepts that undoubtedly affected his vision of the country.

Méndez Pereira attended primary school in his hometown and completed a secondary program in Panama City. In 1909, he won a government scholarship to continue his academic pursuits in Chile, where he enrolled at the Instituto Pedagógico in Santiago. The Instituto was one of Latin America's most progressive centers of learning and one of the primary destinations for Panamanian students, whose government was eager to prepare teachers. As a consequence, young Panamanians traveled for long periods abroad. They took degrees from

foreign universities and steadily become imbued with new ideas. In Chile, Méndez Pereira immersed himself in the teachings of the period, as evidenced by his thesis on Spanish linguistics and his publications on anthropometry, student hygiene, and scientific gymnastics. Also revealing is his specialization in experimental psychology.[22] Through his travels and studies, he developed a liberal outlook that would manifest itself later in his leadership—in his advocacy, while serving as secretary of Public Instruction for the strengthening of a secular curriculum, summer and night programs, and coeducation and the standardization of textbooks and continued professionalization of teachers. "Everything must result from . . . the adaption of things developed in countries more advanced than our own," wrote the dynamic young pedagogue in 1924.[23]

The educator outlined his liberalism in *Fuerzas de unificación*, a text he published three years later while continuing his travels as a diplomat in Europe. Written in his clear and typically direct style, the treatise provides an explanation of what Méndez Pereira believes to be Western culture--a combination of Greek, Roman, and Christian heritages. "Every land that is Romanized, Christianized, and submitted to the Hellenic spirit is absolutely European," asserted the Panamanian author.[24] Méndez Pereira proclaimed himself a member of this community, which he associated with the notions of international harmony, progress, and the abandonment of irrational ideas. *Fuerzas de unificación* expressed his belief in humanity's interdependence and the inevitability of greater cooperation among the world's peoples. In his historical investigations, Méndez Pereira promoted the same values and the conviction that Panama was a fundamentally European country despite the enormous impact of slavery and the arrival of thousands of Afro-Antilleans. The assertion is especially evident in his flattering biography of Justo Arosemena, the nineteenth-century liberal and Panamanian patriot who had attacked the Spanish past as illogical and who had envisioned a modern and autonomous isthmus dependent on trade, immigrants, and foreign investment. In this view, Panama would become both culturally and economically advanced insofar as it could tie itself to Europe and the United States and leave behind Colombia and its conservative, colonial history.[25] In his praise of Arosemena and support of modern education, particularly in *Historia de la instrucción pública* (1916), Méndez Pereira seemed determined to modernize his country and dismantle the vestiges of the old order by linking the isthmus to the outside world. The colony, as he suggested in "Panama, Country and Nation of Transit," had contributed little to development, and Panamanians would have to discard its remnants in favor of a more dynamic and cosmopolitan culture. Indeed, Latin America's progress, he argued in another publication, depended on a "continual demolition of the past and an incessant construction of the future."[26] In the area of literature, he would prove equally xenophilic and

Toward the Light (1954). Statue donated by Octavio Méndez Pereira to the Universidad de Panamá. The figure represents the benighted youth who are transformed by the light of knowledge.

would warmly welcome the arrival of avant-garde tendencies.[27] Much of this attitude had to do with his education, his studies abroad, and his frequent travels. Méndez Pereira was the product of modernization and sought to create a society in which he felt more comfortable.[28] This same dream that he and others nourished, however, was not without its own pitfalls, as he discovered after his return from Chile.

Méndez Pereira arrived in 1913, shortly before the canal was completed, and he soon felt its many disruptive effects, including its invigorated African diasporic presence. In his writings, he acknowledged the positive consequences, but he focused greater attention on the more negative patterns, which he tied to longer, historical trends. The interoceanic route was part of a larger tendency that was connected to Panama's geographical location and that was fragmenting the country along multiple lines. Modernization also occurred within

the context of imperialism and significantly limited the power of people such as Méndez Pereira. The question now became how to balance conflicting interests, including the liberals' desire for the isthmus's transformation and their eagerness to protect their own social position. Their position could not be sacrificed in the tumult of modernity or in the midst of a massive Afro-Antillean immigration. Méndez Pereira quickly saw the necessity of a nation-building effort and the construction of a Hispanic and ethnically homogenous population. Méndez Pereira, whose novel would be the primary outcome of these sentiments, outlined them partly in a 1920 publication that he dedicated to President Belisario Porras.

The article, entitled "Weakness of Our National Organism," acknowledged that the North American presence had encouraged numerous forms of "progress" but also observed the "displacement of national interests in the domain of business and the possession of wealth." Méndez Pereira associated imperialism with plutocracy, and he noted that outside companies were investing heavily in Panama and were rapidly appropriating important sectors.[29] For Méndez Pereira, this situation was not a new problem but rather had long roots in Panamanian history and was fundamentally linked to the isthmus's geography. The Spanish, he later observed in his "Nation of Transit" essay, had also utilized Panama's strategic position within their complex, mercantilist system. The isthmus, in Méndez Pereira's mind, had historically been an emporium, a role revived in the mid-nineteenth century when gold was discovered in California and provoked the construction of the Panama Railroad. Steamships now brought thousands of travelers to the country, along with speculators who occasionally became integrated into the population but who more often left quickly after exploiting opportunities. Méndez Pereira felt that as a consequence, Panama had become a transient society, and its inhabitants had infrequently established anything of lasting importance. He noted that the buildings of the colonial period had largely been made of flimsy materials and that the more solid structures had been things such as bridges, roads, and other transportation infrastructure.[30] The legacy for the Panamanians was a lack of a "sense of traditions" and a tendency to live in an improvident manner, "with one foot on the ground and the other raised to begin a trip."[31] The educator was especially concerned about the "psychological" effects, which he described as a sense of "discontent, depression, and a lack of self-confidence." Ultimately, this "intense, prolonged, and constant penetration destroys," he argued, "the spirit of nationality."[32]

For Méndez Pereira, the country's economic conditions were inhibiting the possibilities for unification by weakening the power of the Panamanian capitalists. Another perceived problem was the actual presence of foreigners,

especially the thousands of Afro-Antilleans who had immigrated during the canal's construction and who, in many cases, had settled permanently after its completion. Méndez Pereira spoke out against "chauvinistic nationalism" and even criticized traditional "blood" notions of citizenship.[33] From an early age, he rejected the eugenic conception of race, and he associated the concept more with history, religion, literature, customs, and shared ideals.[34] Nevertheless, racial-ethnic interpretations permeated his writings and caused him to be alarmed by the influx of newcomers and to emphasize constantly the supposed differences between Anglo-America and the "raza latina."[35] As early as 1916, he underlined the necessity of a "homogenous culture" and urged measures to protect Spanish as a means of ensuring Panama's sovereignty.[36] Cervantes and Golden Age literature fascinated Méndez Pereira, and he and other Panamanians researched Hispanic subjects just as the republic was becoming more Anglophone and black.[37] In 1922, he finished his first edition of a history of Spanish letters, which he augmented and republished twice over the next decade.[38] In 1936, he completed a chronology of "Ibero América," and before his death, he was preparing anthologies of colonial Panamanian and Hispanic American literature.[39] Ironically, this liberal was also a promoter of Hispanic culture, which he embraced in his writings on the "sacred *Madre Patria*." His book *Emociones y evocaciones* (1927) included several essays describing his heartfelt visits to Toledo, El Escorial, Alcalá, and the Museo del Prado.[40]

Nairn notes the ambiguity of the peripheric nationalist, who while embracing westernization seeks to control its effects and who becomes, like the Roman deity Janus, divided between innovative and more traditional values.[41] In this sense, Méndez Pereira also pushed for modern education even as he sought to remove outside experts from the expanding public school system. Méndez Pereira and his colleagues were the products of the republic and had studied abroad or at the new Instituto Nacional. When they came home, they hoped to implement their ideas; however, they found that foreigners were blocking their ascension through many of the new government offices. At the time of Méndez Pereira's return from Chile, North Americans occupied the top pedagogy positions, and as early as 1914, he was calling on authorities to "nationalize our education." His petitions began a decades-long effort to expel the multiple U.S. specialists and to retake the schools and broader government.[42] In 1918, Méndez Pereira became rector of the Instituto Nacional after nearly a decade of German and North American leadership.[43]

If Méndez Pereira was worried about his country's economic development and the political and cultural effects of immigration, he was even more anxious about the perceptions of Latin American intellectuals, who were increasingly depicting the isthmus as an U.S. dependency and as racially distinct from

Spanish America. Méndez Pereira combated such portrayals with incessant articles and by forging close contacts with the continent's intelligentsia. He cajoled, charmed, and sometimes attacked his counterparts in an effort to convince them that Panama was still Hispanic and had not become black or part of Anglo-America. In 1926, he contested a statement by Argentina's Alfredo Palacios, who had disparagingly described the republic as a Yankee colony and who had refused to attend a gathering of Latin American writers organized by Méndez Pereira in Panama City.[44] The conference commemorated the one hundredth anniversary of Simón Bolívar's Panama Congress, and the event had great symbolic value to Méndez Pereira, who told the assembled delegates, "We desired your presence here . . . so that you could see that we remain . . . within the Hispanic community." Méndez Pereira was determined to portray the isthmus as an integral part of Spanish America.[45] His concerns arose amid significant social strife, as new sectors were mobilizing and entering public life and as U.S. officials intervened in the republic and seemingly confirmed its international image as a creation of imperialist objectives. Méndez Pereira was a great admirer of the United States. He was inspired by its social, technological, and economic advances, and he even promoted the idea of a bilingual university that would harness the strengths of the U.S. educational system and serve the cause of Pan-Americanism.[46] Nevertheless, Méndez Pereira was also critical of the United States and supported hemispheric cooperation to curb its abuses. He accepted many of the period's *arielista* premises and saw the United States as an overly materialistic and aggressive society. He was especially critical of the 1903 Canal Treaty and denounced the repeated violations of Panama's sovereignty while pressing for the neutralization of the waterway.[47] In 1922, he wrote the inscriptions for a prominent national monument that honored the French for their earlier and ineffective efforts to secure the opening of the interoceanic passage rather than paying tribute to the more successful North Americans.[48]

Modernization was problematic, particularly for intellectuals, who while enamored and committed to the notion of progress were also appalled by many of its consequences. "Panamá," as Méndez Pereira once wrote, "is condemned to suffer its progress, as the benefits of the country's geographic position hindered . . . its moral and intellectual advance."[49] In general, he felt that the Panamanians had become too dependent on the potent North Americans as well as on Jewish, Chinese, and Hindu immigrants and the sizable Afro-Antillean community. They were too thoroughly subject to the foreigners' influences and as a result could not comprehend their own identity. The Panamanians suffered, in Méndez Pereira's words, from an "indifferent psychology, without a sense of traditions. . . or even a well- understood concept of nationalism." He

proposed that education was the only means to create a "true nation" and to prevent Panama from remaining a simple "conglomerate." "Few countries such as ours," he wrote, "must maintain in its schools . . . the consciousness of the permanent interests and values of nationality."[50] Pedagogy, as he suggested while serving as secretary of Public Instruction, was an inherently political activity and should correspond to the peculiarities of each race and nation, "especially in the first stages of its progressive evolution." Education shaped collective identities and fomented an "equilibrium of culture." Quoting Ralph Waldo Emerson, he insisted that culture "places man among his superiors and equals, . . . and alerts him to the dangers of loneliness and disagreeable impulses."[51] Nationalism was thus to be a deliberate creation, what Ernest Renan described as a willful effort to highlight or forget certain aspects of reality and through this endeavor to bolster hierarchies and unification.[52] To this end, Méndez Pereira offered his 1934 novel, an account of the Spanish conquest of the isthmus through the life of Vasco Núñez de Balboa.

The story begins in 1510 when Balboa, who had previously settled on Hispaniola, clandestinely leaves the early Spanish colony to flee the burden of his mounting debts. He sneaks aboard a ship that is headed for Tierra Firme and that is to provide provisions for San Sebastián, an unsuccessful outpost on the Gulf of Urabá. The stowaway and his dog hide in a barrel, and while their appearance before the crew initially provokes hostility, Balboa quickly becomes the expedition's dominant figure. His ascendance begins amid a violent storm that destroys the Spaniards' principal vessel and provides Balboa with the opportunity to demonstrate his strength, his charisma, and bravery. In the crisis, he outshines the group's incompetent leader, Martín Fernández de Enciso, who becomes one of Balboa's enemies and who will return to Spain to conspire against him and to encourage the appointment of a hostile royal official. At San Sebastián, the men find nothing but ruins, and Balboa urges them to travel westward to the Darién, where he supervises the establishment of Santa María la Antigua and is elected as the town's first mayor. The village becomes Spain's beachhead on the mainland, and it prospers under Balboa's benevolent stewardship. Much of the novel deals with Balboa's direction of the colony and his efforts to pacify its indigenous population and to thwart his European rivals, who are depicted as inept, cruel, and self-serving. Balboa later leads an expedition across the isthmus and "discovers" the Pacific Ocean with the help of local collaborators. He also searches for the Temple of Dabaibe, a legendary golden shrine constructed in honor of a female goddess who is mother of the moon and the sun's creator. The author downplays Balboa's well-documented cruelties, and instead he emphasizes the conqueror's tolerant spirit and his tendency to work with Panama's native peoples even as he seeks to strip them

of their resources.[53] A critical aspect of the novel is his relationship with Anayansi, the beautiful daughter of an indigenous ally who rapidly becomes Balboa's most loyal companion and who protects and advises him in his undertakings. Their union and community, however, soon encounter difficulties when the king's appointed governor arrives to take control.

Pedro Arias de Ávila (Pedrarias Dávila) governs in a brutal and reckless manner and forces the separation of the indigenous-European couple, while destroying the broader pattern of Indian cooperation. Pedrarias is especially hostile to Balboa, whom he despises for his accomplishments and whom he hopes to control through a marriage to his daughter. Their engagement is facilitated by the colony's bishop, and it temporarily halts suspicions surrounding the novel's hero. However, Pedrarias again grows wary when Balboa returns to the Pacific and prepares a fleet to explore the lands to the south. Balboa's enemies suggest that he is planning a rebellion, and Pedrarias orders that he return for a meeting and has him arrested on charges of treason. At the end of the book, the hero is executed; nevertheless, he reappears as a ghost alongside his lover, suggesting that their spirits have transcended their deaths.

What is surprising, of course, is the author's insistence that these events are entirely factual. Méndez Pereira portrayed his writing as a work of history, and in response to the widespread depictions of Panama as a U.S. colony, he exploited the traditions of the region's novels and historiography and linked the Spanish conquest to the isthmus's identity. As a result, the "discoverer of the Pacific Ocean" now became a Panamanian whose efforts, centuries ago, had initiated the birth of a nation.[54] Panama was a legitimate country, according to Méndez Pereira, with strong ties to the past and with connections to Hispanidad. Balboa's ambitions to settle Peru are another of the book's important themes, and as a consequence, the isthmus was neither a corridor of blackness nor a conduit of Anglo-Saxon aggression, but rather it was the cradle of Spanish American culture. Indeed, Panama became the birthplace of Latin American civilization as Méndez Pereira used his narrative to defend the isthmus and create what Sommer describes as "patriotic history."[55]

"PATRIOTIC HISTORY"

"There is nothing in this account that is not strictly historical," wrote Méndez Pereira in the prologue to *Núñez de Balboa*, arguing that the "truth alone . . . is more marvelous than imaginary marvels."[56] The author was seemingly interested in proving this assertion, and while describing the dreams and even afterlife of Balboa, he attached a bibliography at the end of his novel to bolster

its sense of factual accuracy. Prominent in this list are important sixteenth-century chroniclers who in some cases witnessed the Spanish settlement of America. Among the authorities are people such as Peter Martyr d'Anghiera, Gonzalo Fernández de Oviedo y Valdés, Bartolomé de las Casas, and Pascual de Andagoya as well as Juan de Castellanos and Francisco López de Gómara.[57] The author also includes fifteen other sources to add to the book's suggestion of veracity.[58] *Núñez de Balboa* presents itself as based on these writings and regularly quotes them and the correspondence of prominent historical actors. The author repeats the Crown's instructions to the colonists and cites such figures as the isthmus's first bishop, who became deeply involved in its political conflicts. In other instances, Méndez Pereira records long letters from Balboa, in which he uses his antiquated and convincing language to plead his case before the Spanish monarch.[59] The book's chronology is, in a broad sense, accurate. It follows the "fundamental facts from the isthmus's and the continent's history," and the effect is to bolster the narration's status as something more convincing than a mere work of fiction.[60]

A number of researchers have actually classified the book as history, including Ernesto Castillero Reyes (1899–1982), one of the country's most prolific historians. Foreign scholars have also fallen for Méndez Pereira's devices and have occasionally listed his book in their bibliographies.[61] *Núñez de Balboa*, like other foundational fiction, became closely linked to national history even as it rendered the past from an imaginary perspective and projected the dreams and romantic sentiments of its subjects. The chronicles had suggested the existence of Balboa's lover, an indigenous woman whom he met during the conquest; however, they had provided few details about her life and background. Such deficiencies did not discourage Méndez Pereira, who appropriated a name given to her by another writer and who elaborated on her physical traits, her emotions, and her personality.[62] In this sense, history strayed from its most conventional definition and did not, as some have argued, offer an objective reading of the past. Instead, as Vergara and Gasteazoro concluded in an essay on Méndez Pereira, the author conceived of the discipline as an "auxiliary" that served in his meditations on the Panamanian reality: "Like Benedetto Croce, he felt that history is ideally contemporary, as only an interest in the present can move one to investigate the past."[63] In this sense, history was intended to be useful. It was designed to address and resolve current dilemmas, a concept that was not exclusive to Latin American society but seemed well suited for its intellectual traditions.

"The literary practice of Latin American historical discourse," writes Sommer, "had long since taken advantage of . . . the undecidability of history." For the writer-statesman, there was no "epistemological distinction between

science and art, narrative and fact, and consequently between ideal projections and real projects." Sommer notes the influence of Venezuelan Andrés Bello (1781–1865), who, decades earlier, had advocated a descriptive method of history rather than more theoretical or scientific approaches.[64] "When a country's history doesn't exist, except in incomplete, scattered documents . . . the narrative method," he insisted, "is obligatory."[65] For Bello, a recounting of events was the beginning point of memory and was an important means of establishing cultural autonomy. Sommer notes that narrative history had its advantages, including the ability to operate with a "freer hand" and to tie the past closely to a country's identity.[66] Bradford Burns in his studies of the region's nineteenth-century historiography emphasizes precisely this ideological function. He argues that postindependence historians "contributed mightily to . . . a sense of nationality," although one that was "complementary to the interests of the elite" and that was not broadly inclusive.[67] History had acted to foment a sentiment of nationalism, as flawed as it was in including all members of society. Others had pursued similar ends through the writing of literary works. Literature was, in fact, a closely related field and another critical aspect of the nation-building efforts. As Sommer suggests, the advocates of Latin American novels, including Bartolomé Mitre (1821–1906) and José Martí (1853–95), conceivably came to consider the "narrative to be history" and saw little difference between the two genres.[68] For Méndez Pereira, this connection was also apparent, as some of his own sources perhaps served as examples and mixed fiction with history in their patriotic efforts.

 In the introduction to a book, cited by the Panamanian author José Escofet (1884–1944) insisted that his depiction of Balboa integrated several seemingly contradictory elements. It combined "aspects of history with those of fantasy" and did so "without disfiguring the principal events related by the ancient chronicles."[69] Escofet added fictional elements to provide color and to make the original accounts more accessible to his readers. In this regard, Escofet especially considered his educational objectives. His novel, he noted, was to provide "stimulus." It was to ensure that "the youth of Spain and Spanish America could look to their own race for . . . tenacity and serene valor." Escofet argued that no one better exemplified these values than the "Castilian explorers of the sixteenth century."[70] In a similar manner, Méndez Pereira saw his writing as an "evocative work" that would guide Panamanians in a period of national crisis.[71] To succeed, he would have to cross the "lagoons" of history and embark on what Escofet described as "the fragile vessel of conjecture."[72] The conception of the Panamanian novel was itself a wistful event and was imbued with a sense of idealism and imagination.

In 1923, Méndez Pereira had first conceived of his book during a visit to the isthmus by Vicente Blasco Ibáñez (1867–1928). The Spanish writer, in many ways, was a model for the Panamanian. He was a well-known intellectual who also participated in politics and who was a liberal and a staunch defender of Hispanidad. The author of numerous popular fictions suggested a book on Balboa "during a tropical night before the ruins of Panama Viejo."[73] Amidst the starlight illuminating the abandoned city, the two men agreed to work on the project, perhaps inspired by their romantic surroundings. Méndez Pereira was to provide the documentation, while the Spaniard was to do the actual writing. After Blasco Ibáñez's death, however, the entire task fell to Méndez Pereira, who used the chronicle to forge the symbols of his country and to legitimize Panama in the eyes of Latin Americans.[74] In this effort, Balboa served as the most critical element. In Méndez Pereira's narrative, Balboa became a Panamanian whose life and heroism now became the patrimony of the republic. Méndez Pereira exploited previous conceptions of the conqueror to raise Panama's stature in the eyes of Latin Americans and to show its importance to the rest of the continent, especially in the spread of Hispanic culture.

Previous depictions of Balboa had portrayed him as a hidalgo whose character and personality had been formed by the Reconquest and who had helped to "conquer a New World for Spain."[75] In 1913, Ángel Ruíz de Obregón had published another flattering biography in commemoration of the four hundredth anniversary of the Pacific Ocean's "discovery." Ruíz's book, which is also listed in Méndez Pereira's bibliography, emphasizes Balboa's contributions to "humanity" and the impact of his explorations on "commerce and navigation, geography, astronomy, and even theology."[76] Above all, Balboa had been a bold and noble adventurer whose bravery was representative of his country's fighting traditions and who now served as an example for Spain and Hispanic America, especially in the face of repeated North American occupations. Balboa's reputation rose as part of a broad cultural revaluation provoked by the advent of U.S. imperialism and the defeat of Spain in 1898. The Spaniard provided an example for Latin American intellectuals who had previously disparaged their Hispanic colonial legacies but who now saw their significance following these foreign interventions. This perspective was shared by Ángel de Altolaguirre y Duvale (1857–1939), a third writer cited by Méndez Pereira, who described Balboa as a "great captain" and who called attention to the heroism of the Spaniards.[77] Ironically, this theme was echoed by those writing in English and primarily for a North American audience. Arthur Strawn (1900–1989), whose account was also used by Méndez Pereira, ties Balboa to Spain's medieval past and to the efforts to expel the Moors from Iberia. Strawn points

to the effect on the Spanish entry into America and on Balboa's character in particular. The discovery, he wrote, "came just in time to provide a new field of activity for the Spaniards whose chief training for generations had been in the exercise of arms." Strawn, like his Spanish-speaking counterparts, stresses Balboa's individual valor, his leadership qualities, and his talents as a swordsman. He concludes by representing Balboa as a man of "undying fame" and as "one of the greatest captains among the Spanish *conquistadores*."[78] Méndez Pereira's strategy was to exploit this general consensus and to mold it to the benefit of the isthmus. He accepts the basic idea of Balboa as a Hispanic hero, but to contradict the negative image of his country, he also presents the explorer as a Panamanian who played a key role in the spread of Spanish culture. One of the continent's first heroes was a citizen of the republic, a concept that had been developing for some time on the isthmus and that Méndez Pereira strengthened by calling attention to geography.

The author placed his subject in a noticeably Panamanian context, replete with the signs and markers of the country. Panama's earliest settlers were already Panamanians, as they lived and struggled in a recognizably national setting. In this regard, Méndez Pereira was again following a well-established convention, evident in *Enriquillo* and other foundational fictions. The author, in Sommer's words, narrates the "ideal histories backward" in an effort to validate and give shape to the republic.[79] The nation thus appears readily in the colony, some four hundred years before Panama's separation from Colombia. On his trek to the Pacific, Balboa stumbles across the Holy Spirit Flower, which had become a symbol of Panama during the nineteenth century after the romantic writer Tomás Martín Feuillet (1832–62) had composed a poem about its beauty.[80] Balboa uproots the plant "with almost mystical unction" and orders that it be sent immediately to the Spanish settlement.[81] When Balboa himself returns to Santa María la Antigua, he gives a golden replica to Anayansi, who immediately takes him by the arm and leads him directly to the garden. Despite Anayansi's claims that the orchid must be carefully tended, its "thick leaves" are the only ones to have survived an attack of ants, who presumably represent the rapists/enemies of the nation.[82] Similar symbolic and clumsy moments appear regularly in the novel, tying the narrative and its protagonists to the republic. Even Balboa's death is connected to such elements. Before his execution on orders of Pedrarias, Balboa visualizes the future of the isthmus. He imagines the foundation of Panama City and foresees its function as a place of international transit. The Gold Rush and the Panama Railroad materialize in these dreams, as does the construction of the interoceanic waterway with its machinery, workers, and turmoil. Méndez Pereira ties Balboa to the Panamanian identity. He solidifies the conqueror's status as a

citizen while emphasizing his broader importance to Latin America. Through Balboa, the author contests the country's negative international image. He attacks the portrayal of Panama as a traitor to Hispanic America, and instead he suggests that the country is a foundational part of the region's history and culture.

To do this, he also highlights Balboa's plans for the future and Panama's role in staging subsequent explorations. He later described the country as the "center of conquests" and suggested that without Panama, there could have been no Hispanic America.[83] Balboa had heard rumors of the Inca Empire. He and his men were the first to learn of the kingdom and were thus to some extent responsible for its subjugation. Balboa had become aware of the Inca in a conversation with Panquiaco, the son of an indigenous chief who had welcomed the Spaniards to his village in the hopes of converting them into allies. When the visitors begin to fight over the gold that his father had given them, Panquiaco becomes angry with the newcomers, and he explains that there is a better place to satisfy their greed. Méndez Pereira carefully details these interactions, and he outlines the entry of other Spaniards whose efforts would be critical to the wider settlement of America.[84]

Many of these men arrived with Pedrarias and included such people as Hernando de Soto, who would participate in the conquest of the Inca and who would later lead an expedition to Florida and wander through much of the southeastern United States. Also appearing was Bernal Díaz del Castillo, who would accompany Cortés on his defeat of the Aztecs and who would pen a famous account of his experiences.[85] Hernando de Luque and Diego de Almagro are also mentioned in the novel and are described as Pizarro's future partners in the successful occupation of Peru. Arthur Strawn in his earlier portrayal of Balboa had made note of these numerous Spaniards who came to the isthmus before setting out elsewhere. Méndez Pereira repeats Strawn's list almost verbatim to make his point regarding the Panamanians and their role in the creation of Latin American culture.[86] The isthmus was the crux of Spanish American civilization, and through it passed many of the colony's most important personages. In this regard, Francisco Pizarro receives particular attention, given his leading role in defeating the Inca and in implanting the Hispanic presence in South America.

The author introduces Pizarro at the beginning of the novel, as he formed part of the earlier expedition headed by Alonso de Ojeda that had failed to establish a settlement at San Sebastián. The survivors of this effort, now directed by Pizarro, encounter Balboa's party off the coast of Colombia as they attempt to return to Santo Domingo. Like Balboa, "whom he sees almost as a father," Pizarro is a native of Extremadura, and he is tall and severe in his

appearance and is "sober . . . disciplined . . . and certain in his speech." While the author concedes that he cannot read or write, he insists that Pizarro was a skillful warrior and had a "natural talent . . . for commanding men." He also asserts that "Balboa . . . had great affection" for Pizarro and suggests an almost mystical bond between the two Spaniards.[87] When Panquiaco describes Peru to the "Discoverer," Pizarro leans forward and listens attentively, as "his hope sprung directly from that of Balboa."[88] On several occasions, the author describes the conqueror of the Inca as pensively contemplating his own destiny while he participates in the colonization of the isthmus. The suggestion is that Balboa's activities in Panama initiated the settlement of South America and were the groundwork for the region's Hispanic identity. Consequently, the isthmus emerges in the novel not as a black or submissive U.S. colony but as the "receptacle and distribution center of Hispanic and European culture."[89] To further this view, the author describes Panama City, which was founded in the aftermath of Balboa's death and which he visualized in the hours before his execution. With its impressive "palaces, cathedrals, and convents of stone," the capital appears as a well-established community and very distinct from the depiction offered in "Panama, Country and Nation of Transit."[90] In this case, the arguments resemble those of Juan B. Sosa (1870–1920), who had headed a historiographical effort to romanticize the colony and to underline Panama's importance within Spanish America. Sosa argued that the isthmus had been a major part of the empire and that its importance was reflected in its opulent churches, roads, monasteries, and public buildings.[91] Panama had always been critical to the region, first as a base for the European conquest and later as a point of international commerce. The colonial past represented the beginnings of a process that was to provide consensus to a now convoluted society. Utilizing characters Sommer describes as natural aristocrats, Méndez Pereira forges this idea through the book's protagonists.[92] Balboa and Anayansi surpass others in their nobility, and they quickly recognize their exceptionality and almost immediately fall in love. The consummation of their relationship establishes an idyllic community that stands in stark contrast to the contemporary realities of ethnic, social, gender, and political turmoil. Liberalism and order come together in this society whose inhabitants are submissive to their generous patriarch. Harmony materializes, along with mestizaje, which unifies the isthmus's European and indigenous inhabitants without recognizing its dominant black population. Balboa and Anayansi represent this important legacy, which survives even the Spaniard's inopportune death. Romantic failure "is not . . . necessarily pessimistic," writes Sommer, as tragedies tend to "arouse our sympathies" and "implicitly and sometimes openly . . . demand a possible

solution."[93] In this case, the author provides a resolution that forwards his concept of national unity based on the elimination of Afro-Panamanian culture.

NATIONAL UNITY

The central plot of the novel is the courtship of these lovers, whose union, in part, arises from their status as nobles and their apparent appropriateness for one another. Anayansi is the fictionalized daughter of Careta, who was one of the first indigenous caciques to align himself with Balboa and whose domain was twenty leagues from the Spanish settlement. A footnote in the text strengthens its sense of certainty, placing the leader "near the actual Punta de Mosquitos."[94] On the basis of what Méndez Pereira portrays as his interpreter's treasonous advice, Balboa had attacked Careta's village and had imprisoned him and his entire family. The indigenous chief subsequently offered Balboa one of his daughters, to secure his freedom and demonstrate his loyalty to the newly established Spanish authority. "In an instant," writes the author, "Balboa saw the advantages that they could derive from their friendship with the Indians."[95] Méndez Pereira utilizes these events to introduce Anayansi, whom he depicts as a seductive and patrician beauty whose rapid Europeanization confirms her superiority and furthers the themes of patriarchy and national unity through racial mixing and lightening of the republic. As Sommer writes, "heros and heroines appear . . . full blown" and "immutable" and "move the narrative as a magnet moves unanchored metals."[96] The author depicts the "savage princess" as youthful, slim, and athletic. She wears her jet-black hair in two large braids, and her graceful and sensual movements are those of a "domesticated tiger."[97] Balboa quickly falls for the exotic princess, who promptly learns to dress as a European. She soon speaks Spanish and lives in Santa María la Antigua, where she recognizes in Balboa a "superior being" and suggests that he become the "king" of the Indians to show them how to "live like the white men, to worship their god, and work the mines and the land."[98] Anayansi becomes Balboa's most logical companion, as the author emphasizes his aristocratic nature even while discussing his ignominious beginnings.

In the opening chapter, Méndez Pereira acknowledges Balboa's situation on Hispaniola. He explains how the conqueror had fallen into debt and how he escaped his obligations by absconding onto a vessel and hiding himself in one of its casks, along with his dog, Leoncico. The author reveals Balboa's humble background, but he also immediately ascribes to him a noble character, evident in his speech and aristocratic bearing and in his willingness to defend

The name *Anayansi* is common in contemporary Panama. Panama City condominium named in her honor (2011).

himself against the orders for his arrest. Méndez Pereira introduces Balboa as the "knight of the barrel" whose charisma and daring win the reader's sympathy and whose physical strength thwarts the efforts to subdue him. After the group's leader insists that a subordinate detain him, Balboa grabs this aggressor by his waist and collar and lifts him "into the air, like a doll."[99] When a storm then sinks the expedition's principal ship, Balboa again acts to affirm his superiority and outshines all those who surround him. He bravely directs the rescue of the vessel's men and risks his own life to secure their safety. Balboa later gives a speech at San Sebastián, before the ruins of the abandoned settlement, and he inspires the crew to travel westward and to establish another outpost in a more favorable location. Here, Balboa's swordsmanship proves to be critical in crushing an initial assault by the Indians, and he spearheads the foundation of Santa María la Antigua, whose inhabitants reward him by

electing him their mayor and by abandoning Martín Fernández de Enciso. Democratic ideals prevail in the narration; however, their function is to disguise more patrician principles and the dominance of an elite over social inferiors.

Anayansi is also impressed with the Spaniard and comes to see him "almost as a god" while forgiving his assault on her community. Even in this act, she recognizes Balboa's "astuteness," as she herself is the "daughter of warriors" and understands well their reasoning and behavior.[100] In Sommer's terms, Anayansi and Balboa are "distinguished from the masses." They quickly acknowledge each other's exceptional qualities and see the appropriateness of a romantic relationship.[101] "The family," the author had insisted, "was the first image of the Fatherland," and there were essentially no differences, except that the nation was larger.[102] Heterosexual sex is a frequent theme of the novel, as Méndez Pereira portrays indigenous women as erotic and eager to establish relations with the Europeans even after suffering the defeat and enslavement of their communities. They are "curious," he insists, "to offer themselves to a white man."[103] The consummation of Balboa and Anayansi's love follows a provocative dance in which the princess sways her hips and breasts for the conqueror. The harmony and bliss that consequently follow suggest the wisdom of hierarchical social structures, patriarchy, and cultural unity based on mestizaje. Balboa and Anayansi head a successful community in which there is no conflict between economic development and the elements of a more traditional society. The conquest is an essentially progressive event, as Méndez Pereira suggested in many other publications.[104] In the novel, these elements are magically reconciled to provide an example to the tumultuous republic.

If ethnic and class conflict afflicted contemporary Panama, Méndez Pereira depicted the colony as tranquil and as advancing steadily under Balboa's direction. Balboa is portrayed as an aristocratic leader, vastly superior to those around him but also disciplined, practical, and modern. Balboa's preeminence arises partly from these entrepreneurial qualities, which stand in contrast to the idleness of his rivals. Like the author, he seems to be a "Janus-faced" character who combines in his personality both older and enlightened values.[105] While he is a noble and respects conservative principles, he also is a liberal and understands the importance of hard work. In the later sense, Balboa appears as a humble and pragmatic leader who even greets the king's representative in his rope-soled sandals and who agrees to live in a simple *bohío* after offering his home to the governor's family. Balboa dresses and carries himself in an unpretentious manner and devotes himself to the well-being of the colony. As expected, it flourishes under his direction. Indeed, Santa María la Antigua becomes a kind of paradise, with abundant game and fruit trees and a benevolent

soil and climate. The Spaniards initiate trade with the local population, and they skillfully cultivate the surrounding area. They hunt in the nearby forests and fish in the ocean while transplanting to America their European animals. The settlement becomes a thriving community, but its advances do not lead to social conflict. The author repeatedly refers to its residents as content, as he describes their daily lives, festivals, and amusements. The key again seems to be their leader, who oversees his followers like a caring father and who in return receives their absolute devotion. Patriarchy had weakened during the early republic; however, it did not face the same fate in this literary projection, indicating that in the author's mind, it was essential to stability.

In the colony, the "best harmony" reigns among its inhabitants as their leader treats them with kindness and impartiality. He shares the worst hardships with his followers, and when fortune shines, he distributes the rewards fairly among his men. On occasion, he compassionately forgives the treason of enemies, and he tends to the sick with "paternal care." Devotedly he searches for those who have gone missing, and he returns them to the safety of the village. He is "just and impartial with his subordinates," and "everyone [feels] secure and tranquil with him at the helm."[106] Méndez Pereira even suggests that the enslaved Indians happily entertain Balboa with their music. Intellectuals such as Méndez Pereira were eager to encourage modernization; however, they also wanted to maintain their sense of privilege. Like the novel's patrician characters who defy their own deaths, the upper class was to remain dominant in Panama, even in the face of economic and demographic changes. The novel's values, therefore, are those of an older society, as change was to occur within a familiar model and not within new, more pluralistic structures. Particularly crucial was a sense of a homogenous and European culture with no parallel or rival ethnicities. "Whenever two distinct races come into contact," Méndez Pereira would later write in a history of America, "the most strong and civilized conquers the inferior, until it extinguishes it . . . or forces it to assimilate its characteristics."[107]

In the novel, indigenous peoples suffer a rapid death, or they mix quickly with Europeans and instigate what the author describes as "heroic mestizaje." For Méndez Pereira, mestizos are Latin America's most important historical actors and are "later called on to effect the continent's emancipation and the creation of its new civilization."[108] This sense of destiny is also conveyed through the assistance that the indigenous inhabitants provide to the Europeans. Méndez Pereira insists that this "devotion and efficient aid were extremely valuable to the Spanish," and he emphasizes their cooperation on the march to the Pacific, when Indians served as the guides and porters for the expedition and provisioned it with food, water, and even medicines extracted from the

forest's curative plants.[109] The march to the Pacific was a joint effort, although Méndez Pereira acknowledges that it ultimately contributed to the decimation of Panama's indigenous inhabitants. He estimates that some two million Indians died in the wake of the conquest; however, for him, this is not an entirely negative situation, as he is attempting to convey the idea of mestizaje and the disappearance of any independent ethnicity.[110] The author portrays the Indians as melancholy and superstitious, and while they are brave and able to overcome dire physical conditions, they lack the elements of a modern culture. Indians are natural inferiors in the novel, and "only death," Méndez Pereira writes, "could free them from slavery and bring the happiness and rest that they sought."[111] There is no acknowledgment of surviving Native American cultures that resisted the process of colonization and almost no recognition of an African population.

Balboa's comical page is a black man, but he appears fleetingly and only in a stereotypical fashion, smiling incomprehensibly at the explanation of Christian doctrines. Later, the book refers to thirty Africans who accompany Balboa on his last expedition and who were "beginning to arrive to replace the decimated Indians."[112] Africans thus receive the briefest of mentions and are excluded entirely from the conception of racial mixing. The author insists that the isthmus is a European-indigenous nation and that it can trace its roots back to the founding couple, not to the thousands of enslaved Africans whose descendants formed the actual base of the country. It is notable that blacks are largely absent from Méndez Pereira's other publications and that on at least one occasion, he suggested that they were disappearing as a result of their absorption into the broader population.[113] His *Breve historia de Ibero-América* (1936) offers less than a paragraph on the Africans' presence, and while it acknowledges that as many as ten million slaves arrived in America, it confines them largely to Brazil and the Antilles.[114] Blacks have no place in the heterosexual union that Méndez Pereira depicts as the basis of the Panamanian identity. Of course, it is problematic that Balboa is executed and that he and Anayansi never produce the family unit that Méndez Pereira viewed as critical to a stable nation. They fail to provide Panama with an early product of racial mixing. The author's central goal is to depict this supposed merger in the face of what he later described as its massive upheaval: "the complex growth of our population and economy and our coexistence with the men and problems of the Canal Zone."[115] These literary frustrations, however, do not block the ideological project. In fact, as Sommer notes, "every obstacle . . . heightens their/our love for the possible nation."[116]

In this regard, Méndez Pereira utilizes the figure of Pedrarias and his well-known cruelty and ineffectiveness as a leader. Pedrarias's appointment by the

Crown marked a victory for those opposed to Balboa and his ascension in the colony. Historians have often treated the rivalry between these men, but Méndez Pereira relates the story in a particular manner that benefits his vision of national consolidation. Pedrarias essentially makes unity more precious and more the object of readers' yearning. Most critically, his arrival disrupts the fictionalized romance. The new official threatens Balboa and Anayansi's relationship and more generally disrupts the society's consolidation. The governor forces Balboa to become engaged to his daughter with the understanding that these nuptials will resolve their political differences and allow the *adelantado* to undertake the exploration of the Pacific and the conquest of the legendary kingdom.

Méndez Pereira describes the arrangement as a cynical and insincere covenant intended to co-opt a political rival before Pedrarias could move to eliminate Balboa. The engagement also separates the hero from his lover, whom Balboa carelessly fails to consult in making his decisions, as "his eyes remain fixed on the glorious and transcendental undertaking which he considered to be his destiny." Stoically, Anayansi agrees to leave Balboa's house, requesting only that she be allowed to stay in the community. "You taught me how to live as a European," she observes, "and I could not again become accustomed to being a savage."[117] As night falls on this tragic scene, the moon illuminates a peaceful beach, where Leoncico alone whimpers for the princess's fortunes. This departure enhances Anayansi's nobility. It raises her stature in the mind of the audience and heightens its longing for her reunion with Balboa, who underestimates the importance of their relationship and its centrality to the formation of a country. Anayansi subsequently faces a series of unwanted advances by a Spaniard deemed unworthy of her attention. Andrés de Garabito actually attacks the princess, and he decides to betray Balboa when these attempts prove unsuccessful. Garabito feeds the governor misinformation and suggests that his rival is planning a rebellion. In response, Pedrarias disrupts the foundational romance and consequently the consolidation of the Spanish colony. In a broader sense, he impedes the birth of the Panamanian people.

Paralleling this history of frustration and growing desire is the relation of Pedrarias's incompetence as a leader and his negative impact on the community. The author presents Pedrarias as an embittered old man who arrives full of "malice, treason, and jealousy." Méndez Pereira alludes to the leader's Jewish ancestry, and he describes his ghoulish custom of traveling with a coffin to celebrate each year an earlier incident in which he was mistakenly thought to have died. The newcomer's primary concerns are "gold and the exercise of power," and he neglects the more basic needs of the settlement while recklessly squandering and hoarding its resources.[118] After a fire engulfs the Spaniards'

supply house, Méndez Pereira suggests that the conflagration was nothing more than a cover for Pedrarias to steal provisions. Pedrarias's rule encourages hunger, disease, and flight, as he and his lieutenants commit atrocities against the Indians and ruin the earlier pattern of indigenous-European collaboration. Méndez Pereira focuses particularly on the expedition of Juan de Ayora, who is alleged to have murdered and tortured Indians and to have sold their wives and children into slavery. Balboa's indigenous allies now turn against the Spanish, as Pedrarias interrupts the movement toward integration. The governor's most alarming crime, however, is his arrest of Balboa, whose skill and popularity provoke the envy of his rival. At the end of the novel, Pedrarias orders Balboa's execution before refusing him an opportunity to visit with Anayansi. These tragedies, however, only heighten the sense of tension and the longing for a romantic reunion. The obstructions fuel a desire for an imagined meeting, and in the final chapter, the author provides his readers with a solution.

On a blustery evening in the mountains, Balboa and Leoncico appear as apparitions. The conqueror points one arm toward the Pacific and extends the other toward the Atlantic as his body becomes "transfigured into a cross."[119] Anayansi then emerges from the darkness and positions herself alongside her lover. Their spirits presumably materialize years into the future as a lesson or evocation for the now independent country. Their relationship survives even the characters' deaths and implies the inevitability of aristocratic leadership and the unity of Panama through a shared ethnic heritage based on the Europeanization of the indigenous population. The novel suggests that Panama can progress as long as this patriarchy and racial paradigm remain in place. They offer stability to the republic and keep it divorced from the African diasporic cultures, which had been and remained so central to the country. In many ways, the novel reflects the broader problems of the republic—its isolation from the isthmus's class and ethnic realities and its dependence on what might be described as an "exclusionary type of nationalism."[120] Nationalism, however, would not remain exclusionary, as modernity was also creating new opportunities for blacks and others to express their conceptions of the country and to validate its African cultural legacies. This dissent took on political, literary, and musical forms and became particularly visible in popular artistic expressions. Black proletariat art bloomed in the 1940s, just as the mestizo, Hispanophile project was entering a critical period.

3. RUMBA AND THE RISE OF BLACK PROLETARIAT ART, 1941–1990

For the isthmus's intellectuals, World War II marked a setback in their efforts to counter the effects of North American imperialism and to create a homogeneous national culture capable of quelling the republic's turmoil and reinforcing patriarchy and their own social position. A series of literary works expose their frustrations and chronicle the period in an overwhelmingly negative manner. These books typically depict Panama's black urban areas, and they portray them as falling under increased U.S. influence and threatening the supposed customs and virtues of the interior. The interior with its imagined mestizo population was considered the true source of Panamanian nationalism. It represented the country's pure colonial traditions, while the cities were decadent and overflowing with aliens, many of whom were Chinese, Afro-Antilleans, and South Asians and who had come to the isthmus during the construction of the canal. Joaquín Beleño's *Luna verde* (1950) offers a classic example of these geographic-ethnic perspectives and the feeling that the global conflict was further corrupting society by increasing the foreign presence in Colón and Panama City and now even extending it into the countryside.[1] Beleño (1922–88) was a native of Santa Ana, the traditional working-class barrio of the capital.[2] Much of his novel chronicled his early experiences in the city; nevertheless, he begins the book in the interior, portraying the life of an honorable rural youngster who migrates to the capital to pursue his studies. Despite his graduation from the prestigious Instituto Nacional, he postpones his enrollment at the university and instead takes a menial job in the Canal Zone. There, he endures the gringos' brutal work schedule, the racist structures of their labor system, and even the humiliations of his fellow Panamanians, who begrudge his mannerisms and educational background and sarcastically refer to him as "the lawyer." He quickly becomes a pawn of his bitterness, and he prostitutes his female cousins to acquire a better position. "God-damn money," recalls the character, "Everything is a lie in this green river of dollars."[3]

In Panama, the global conflict had created an economic bonanza as thousands of North American soldiers arrived to protect the interoceanic waterway

and the United States erected antiaircraft weaponry across the isthmus. In addition, construction began on a wider set of locks to make the route less vulnerable to an attack and suitable for the largest U.S. Navy vessels. Although this last effort was suspended in May 1942, Beleño and others remained critical of the projects and their effects on the country.[4] They viewed the wartime activities as an infringement on their sovereignty and as degrading to their sense of integrity. The conflict encouraged Panamanians to exchange their idealism for money and to endure the abuses of the U.S. colony, with its rigid system of racial segregation, its long hours, and its often dangerous working conditions. Beleño's character falls into this "tomb of waste and misery," and to escape, he spends his earnings in Panama City, in the seedy new establishments along the Avenida Central and springing up in many other parts of the capital.[5] For nationalists, rural Panama had always been more wholesome than the cities, which were again receiving thousands of immigrants, who were attracted by the renewed economic opportunities. Although policies had been implemented to limit arrivals from the West Indies, there was a sense of a growing Caribbean presence that was frustrating efforts to lighten the republic and to maintain Panama's image as a part of Spanish America.

"Blacks, blacks, blacks," ranted Demetrio Korsi in his wartime poem "Vision of Panama" in which he complains of the drunkenness and sex trade on the Avenida Central, the most important commercial thoroughfare in the capital.[6] Panama City and Colón were, in fact, developing a lively nightlife, as dozens of cabarets and bars catered to the U.S. servicemen and contracted musicians and dancers to entertain them. Rumba was the dominant music of the period, and Cuban orchestras often performed in these venues, strengthening Panama's ties to the Afro-Caribbean diaspora.[7] Korsi and others saw these influences as harmful and maintained the old paradigm dividing the country. Rural areas were the cradle of Panamanian nationalism, while the cities were debasing its morality and culture. "The war is fatal," concluded Korsi, who described Panama City as "easy" and "open," like the black and "cholita" prostitutes he condemned in his writing.[8] Rogelio Sinán's *Plenilunio* (1947) offered another good example of this perception of the global conflict. *Plenilunio* is the period's most celebrated novel and essentially portrays the capital as a gigantic brothel, teeming with pimps, drug dealers, and gringos and with miserable migrants from the interior whose hopes for a better life are lost in the metropolis's stupor of alcohol, sex, and primitive rhythms. An Afro-Antillean barman appears in one scene, and he slavishly joins a group of drunken U.S. sailors in a rendition of "God Bless America."[9] These novels portrayed Afro-Antilleans as North American lackeys, a theme which was echoed constantly in the press. A 1940 editorial on the "Antillean Threat" asserted that this population was "content to accept whatever

salary, given the fatalism of the black race . . . and to consider insults . . . as something honorable, if they come from the white man."[10] Nevertheless, there was another side to these developments, which Sinan and others were unwilling to acknowledge or which they vilified with their writings.

The war served to validate Panama's Caribbean identity, as it strengthened and confirmed ties to the African diaspora and provided an opportunity for local black painters, excluded from the official networks, to project a vision of their society. In fact, just as President Arias was disenfranchising Afro-Antilleans with his constitutional reforms of 1941, representatives of this community were creating a rival program, whose emergence and evolution are the subjects of this chapter. Critical to its rise was the same process of modernization that democratized cultural norms in Panama and elsewhere and so frightened members of the intelligentsia.[11] Popular art emerged as a consequence of economic changes and exploited the opportunities of the isthmus's transformation, particularly its rapid commercial development. Especially important were the new music and entertainment industries and the boomtown environments of Colón and Panama City. The canal and then the war encouraged the arrival of immigrants, and among this predominantly Afro-Antillean population arose a number of talented painters, many of whom were born in the Canal Zone and who began their careers in the U.S. sector, fashioning its signs, its office letterings, and its billboards. Panama's popular artists have largely been self-educated; however, many of them have gained experience in related businesses, while others have apprenticed under more established figures or have even taken courses at the Escuela Nacional de Artes Plásticas. Indeed, one of the most remarkable aspects of the tradition is how it has gradually infiltrated the educational system and other institutions of the lettered city.

During the war, these men found an outlet for their talents. There had long been a custom on the isthmus of plastering bars, brothels, and similar establishments with what a 1913 guide described as "atrocious landscapes and figures" and making their entrances "as gaudy as a barber's pole."[12] A 1931 article also referred to these "strange pictures" in its description of a sailors' bar in the capital.[13] The creators of these images now found a host of new opportunities. They decorated the expanding nightclubs of the terminal cities, and given the popularity of rumba in the mid-twentieth century, they were encouraged to depict Afro-Caribbean subjects. Rumba and other types of commercialized black music altered the country's aesthetic balance and fortified Afro-Panamanian culture, much as jazz and "other forms of working-class expression" had encouraged similar transitions in Cuba and the Dominican Republic.[14] Leading the way in this important shift was a creative artist named Luis Evans, who became more commonly known as The Wolf.

The Wolf was the son of Haitian immigrants and a charismatic street figure in the 1940s. Shaped by racism, poverty, and social marginalization, his theatrical life inspired a host of followers who spread his style across the republic and beyond its initial Afro-Antillean circles. Indeed, the painters soon represented a variety of ethnicities and mixed easily with one another in their endeavors, suggesting less of a divide between Afro-colonials and Afro-Antilleans and more unity at the working-class level. Driving this expansion was the fierce competition among the entrepreneurs who hired the artists. Painting became a means of advertising businesses as well as the artists' talents and the tastes of their patrons. Paintings quickly materialized in Panama's shops, beauty parlors, markets, hotels, and restaurants. Most significantly, the decorations appeared on Colón and Panama City's buses which eventually came to be known as the "red devils" and which rivaled Haiti's *tap-taps* in their imagery and colors. Caribbean music was one of the central features, and in effect they became roving shows, disrupting the lettered city. Over the next decades, these mobile spectacles continued to evolve and became one of the most defining elements of Panama's urban environment. As my title suggests, bus art and other forms of African diasporic expression have left an important mark on the country and to some degree have even supplanted the official identity promoted by Beleño and described in my earlier chapters. This tradition was urban and working-class in nature, and unlike the project of Panama's state intellectuals, it did not flee into nostalgia, but rather it embraced many aspects of modernization, especially those resulting from World War II and from the rumba craze that the conflict helped to generate.[15]

SOLDIERS, WAR, AND RUMBA

The World War II's impact on Panama was "phenomenal" according to British historian John Major, who emphasizes in his book on U.S.-Panamanian relations the tremendous growth of the isthmus's economy. Major claims that "by 1943 the country's gross receipts" from the Canal Zone had reached "four times the pre-war average." Per capita income roughly tripled in the same period, while government spending increased fourfold during the hostilities. "Panama had never had its so good," insists Major, who notes that this boom was the result of U.S. efforts to protect the canal from a potential Axis attack.[16] Even before the Japanese strike on Pearl Harbor, military officials had begun to open new bases, including an enormous airfield at Río Hato, some seventy miles southwest of the Canal Zone and the place where Beleño actually begins his novel. His hero departs for the Panamanian capital due to the foreign

occupation of these territories and its effect of expelling campesinos from the area. "The gringos are everywhere," wrote Beleño who especially lamented their new presence in the interior and what he saw as their damaging moral impact: their trail of bars, rumba, and prostitutes.[17] The North Americans eventually took over 134 sites and stationed some sixty-eight thousand troops in the country.[18] The Zone's total population hovered around one hundred thousand, or roughly double its prewar average.[19] Many more servicemen and -women traveled through the canal and often spent time on the isthmus.

A 1939 *Life* article chronicled one of these stopovers, when the U.S. fleet arrived in Colón and "gave 40,000 sailors a chance to taste shore life in the . . . largest mass debarkation of the year." A photographer captured their forays about town, their purchases at local shops, and their meals outside the commissary. Several images were taken inside the Atlantic Nite Club, a spacious cabaret that had functioned for at least a decade and where the guests danced or kicked back and drank beer. Another soldier is shown playing a trumpet in front of a local jazz band.[20] The thousands of transient servicemen also demanded services, and many more auxiliaries were needed to accommodate their presence. They maintained the facilities for the visitors and constructed new barracks in the Canal Zone, along with the burgeoning defensive infrastructure, a road from the Río Hato airbase to the capital and another that connected the terminal cities. Workers were also required for the massive lock project, which was initiated in July 1940 and which would have provided the United States with some insurance against an attack on the waterway and have allowed the passage of its largest naval vessels. The Zone, as Beleño describes it, was in "constant movement," with a steady rumble of trucks, men, and dynamite and a voracious demand for more and more laborers.[21]

In response, a steady flow of rural migrants settled in Panama City and into its surrounding territories, which were also undergoing a process of light industrialization and receiving large-scale U.S. investment in the banking and utilities sectors.[22] The population of the capital district mushroomed from 84,000 in 1930 to more than 133,000 by 1940, increasing another 31 percent over the next decade. By the mid-twentieth century, approximately a quarter of the republic's inhabitants lived in the metropolitan area.[23] The city's perimeters also expanded, generally eastward along the Vía España, since the north and west sides had been contained by the Canal Zone and the south was blocked by the Pacific Ocean. Álvaro Uribe notes in his study that many of the capital's basic residential areas were initiated or solidified themselves in this period.[24] Meanwhile the United States also recruited outsiders, much as it had done during the construction of the waterway to meet the needs of this gigantic project. Eventually over 22,000 people came to Panama, mainly from

El Salvador, Costa Rica, and Colombia. Officially, only 5,000 Jamaicans traveled to the country, as local leaders opposed the recruitment of Afro-Antillean laborers. Those who arrived were not allowed to leave the Canal Zone, and they faced repatriation after completing their contracts.[25] Panama's government, however, could not control culture, and in this regard, the isthmus became more linked to the Caribbean. This was especially due to the influence of Afro-Cuban music. *Son, guaracha, guaguancó,* and *bolero* and other forms of African diasporic expression, including jazz, calypso, *cumbias,* and tango, had been avidly commercialized during the previous decades and were spreading as part of the ongoing "vogue of primitivism" and as a result of the burgeoning radio and the recording industry.[26] Panama long ago had begun to welcome foreign musicians, zarzuelas, opera stars, circus acts, and prostitutes.[27] By 1940, it had developed what a tourist ad called a "gay" and "cosmopolitan night life."[28] The war clearly helped to accelerate this phenomenon, as it expanded the market for amusements in the terminal cities and produced a veritable rumba boom on the isthmus. Panama became a major stop for Caribbean entertainers, and their presence undermined the lettered city's efforts to forge an official mestizo identity while reinvigorating the Afro-Panamanian community and its ability to project a sense of blackness.

As a consequence of the conflict and the flood of workers and soldiers, Colón and Panama City developed a raucous and lively atmosphere that *National Geographic* compared to that of a "frontier town" and that Beleño chronicled in great detail in his novel.[29] "Here in the Zone, we do not suffer from the war. We take pleasure in it," reflected one of his characters, and indeed, even in 1942, with the official suspension of Carnival following the Japanese attack on Pearl Harbor, *El Tiempo* reported that "people are enjoying their four days of holiday . . . as if nothing of importance were happening."[30] There was insufficient concern about the war, reported the editors of the *Mundo Gráfico,* who urged their readers to be more "measured in their rejoicing" before the following year's celebrations.[31] *El Tiempo* and other newspapers chronicled the events of the conflict with their bold and sometimes ominous headlines, but they also took note of the isthmus's social scene and its numerous sporting events, concerts, and parties and the impressive influx of foreign celebrities who came to perform in the terminal cities.[32] The protagonists of Beleño's novel spend their off hours in bars, merrily drinking and trying to forget their idealism and the humiliation of having to serve the gringos. The Sloppy Joe, the Ancon Inn, the Good Neighbor, and Cantina Pete are just a few of these establishments, which tended to be concentrated around the Plaza 5 de Mayo and which were conveniently positioned next to the U.S. sector, with its restrictive orders, its rigidity, and its prohibitions. The war inevitably increased the size and number

of these businesses, whose advertisements flooded the local papers. Cantina Miami was located in this area and assured its customers of "superior attention, comfort, and a welcoming atmosphere," along with the "finest foreign and national liquors."[33] Beleño's heroes also frequented the brothels which were spreading along the nearby J and K Streets and which catered to the U.S. servicemen. "Prostitution frees us," reflected Beleño, "from the need to encourage tourism," suggesting that it was the "most powerful filter" funneling money from the Zone.[34] Thousands of women were trafficked into this sector, many of whom came from Cuba and Argentina and whose sundry accents are documented in the text along with the music that characterized these venues. The cantinas' jukeboxes blared North American dance tunes, jazz, calypso, tangos, and Colombian *cumbias*, but Cuban genres were the true soundtrack of the period, given their broad international popularity, their presence in U.S. and Latin American movies, and especially their vigorous promotion over the radio.

Panamanian radio had begun clandestinely in the early 1930s. It arose in the face of U.S. opposition and a 1914 decree by the Panamanian government, which had provided the North Americans with control of all wireless communication. A 1934 law had annulled this concession, and radio businesses grew over the next decade, along with the ability to access foreign broadcasts, which had been arriving from Cuba for roughly a decade and spreading the popularity of the island's commercial music.[35] By the early 1940s, there were nine stations transmitting from Colón and Panama City and many with their own short-wave frequencies. Their numbers would increase quickly over the next several years and even expand into the interior.[36] Their schedules appeared in national newspapers, along with those of the international stations and the occasional advertisements for Cuban music recordings, which Victor and Columbia Records were marketing across the region.[37] These classifieds and articles, written about the industry, reveal the popularity of tropical music programming, the recorded and live performances by Cuban orchestras, and the numerous actors and announcers from the country, who made appearances on local shows. Cuban and Argentine disc jockeys were common in the 1940s, while artists from the island regularly visited the terminal cities and greatly influenced Panamanian popular culture. The Cubans diffused the period's broader fascination with blackness, and they helped to validate Afro-Panamanian culture.

From their initial emergence in the 1910s and 1920s, Cuba's successful commercial performers had often been "musicians in motion." The economics of the business made it difficult to stay on the island, and many groups toured and even established themselves in other countries to increase their marketability and their earnings. Europe and the United States became popular

destinations, especially as the Cuban genres penetrated the movie industry, but another circuit developed in Latin America, with Veracruz and Mexico City becoming two of the most prominent venues for these propagators of Afro-Caribbean culture.[38] Minor Cuban acts began to perform on the isthmus as early as the mid-1920s, and they became more common by the early 1930s.[39] The Bozas had settled in Panama at the beginning of the republic, and several members of this talented, Cuban family would also help to spread the island's music traditions.[40] The Cubans joined a multitude of itinerant tango singers, Oriental dancers, flamenco and ranchera artists, *cumbia* bands, magicians, hypnotists, and opera stars whose travels frequently took them to Panama. Indeed, for much of the twentieth century, the isthmus boasted a lively entertainment scene that depended heavily on the foreigners whose trips often coincided with the Carnival season.

One of the early important Cuban visitors was the vocalist Miguelito Valdés. Valdés had spent a good part of the 1930s sharpening his talents in Colón and Panama City. He returned triumphantly in February 1937 with the famous Casino de la Playa Orchestra to entertain revelers at the capital's Century Club. The Lecuona Cuban Boys and the female orchestra Ensueño also staged shows during this period and were followed in the 1940s and 1950s by such luminaries as Dámaso Pérez Prado, Gustavo Más, José "Chombo" Silva, and Pedro "Peruchín" Justiz.[41] Among the 1947 Carnival attractions were appearances by Orlando "Cascarita" Guerra and his colleague, Miguelito Cuni. Radio Centroamericana broadcast Cascarita's programs and contracted him to sing in its studio after the conclusion of the annual festivities. Similarly, a Cuban group known as the Conjunto Habana spent all of 1946 on the isthmus, with the Cadena Panameña transmitting its music.[42] Myrta Silva came in 1945, with Daniel Santos arriving two years later, presaging the popularity of salsa in the republic and the subsequent influence of Puerto Rican singers, who would fill the space left by the absent Cubans after the rise of Fidel Castro.[43]

The Cubans and others who passed through the isthmus typically entertained audiences in the so-called *toldos*. These were large, open-air platforms that could accommodate up to several hundred people. They were fenced-in and elaborately painted for Carnival and, in many cases, displayed the Caribbean tropical imagery then so in vogue in Panama and elsewhere. In 1910, Carnival had become an official holiday, and the subsequent private and state support of the celebration provided opportunities for popular artists to produce thrones and elaborate street decorations, which often became the focus of newspaper reporting. The Canal Zone enthusiastically participated in the traditions, electing its own queen and producing its own floats.[44] A photo taken of a 1960s-era *toldo* reveals its extravagant lighting and murals which include

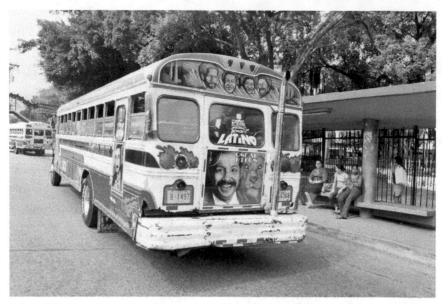

In the 1970s, many Panamanians became devoted fans of salsa, with the stars of the genre often appearing in popular art. A depiction of Venezuelan-born singer Oscar D'León by Óscar Melgar (2002).

a giant head portrait of singer Xiomara Alfaro, an enormous Balboa beer sign, and a depiction of Los Gay Crooners. Bright lettering covers the wall of the exterior, and below the beverage advertisement, dances a curvy *rumbera*.[45] There were thirteen *toldos* in the capital in 1945, several with names suggestive of Cuban *boleros* and other aspects of the island's culture. That same year, the *Estrella de Panamá* praised the Patio Panameño for its ventilation and natural decorations as well as for its opening program of Cuban rhythms.[46] Usually, the foreign guests also offered engagements in the terminal cities' variety and movie theaters. The capital and Colón had eighteen cinemas in the mid-1940s and another fourteen by the end of the decade.[47] They often screened Hollywood and Latin American productions, reflective of the era's pervasive fascination with the tropics. A glance at the offerings in this period reveals such selections as *White Savage* (1943), featuring the "Caribbean Cyclone," María Montez, and *Rosa del Caribe* (1946), with María Elena Marqués.[48] In many instances, the theaters combined a *rumbera* movie with a dance routine, music, and even a raffle. Myrta Silva participated in many such events when she came for Carnival at the end of the war. Coinciding with her shows was a visit by María Antonieta Pons, the seductive Cuban star of the Mexican film industry, who danced and sang for her enthusiastic audiences.[49] Two years later, Yadira

Jiménez, who had played the lead in *Amor de Mi Bohío* (1946), offered similar performances in Panama City.[50] These shows and their recordings inspired local imitators, who would promote rumba over the next several decades, well after the reduction of the U.S. military presence.

Cuban-style *comparsa* groups were organized as early as the 1920s to enliven the capital's Carnival festivities, with the Millonarios Cubanos becoming one of the most popular. Its dozens of members paraded through the streets, and they often participated in the "baptisms" of *toldos*.[51] Smaller *conjuntos* appeared at the end of the decade and offered interpretations of Cuban *son* recordings. In the 1930s, paralleling developments on the island, larger orchestras emerged on the isthmus, with the war later helping to spur on this tendency. The conflict gave life to a host of new venues, such as the spacious beer gardens off the Avenida 4 de Julio, where the Cubans and their soul mates entertained soldiers, Zonians, immigrants, and enthusiastic Panamanians who were plainly ignoring the directives of their leaders and who were adopting the imported rhythms with their "hip weaving" moves.[52] The Spanish intellectual Agustín del Saz immediately took notice of the rumba upon returning to the isthmus after a six-year absence. Writing in the early 1940s, he described what he called the "broadening" of the capital—its packed streets, stores, and visual intensity and the proliferation of a new entertainment industry. "The city," he wrote, "has become full of musicians . . . and dance lovers can enjoy themselves without rest in the night-clubs."[53]

The beer gardens included such places as El Rancho, Jardín Balboa, and Jardín Atlas. The Bavarian-style establishments had open-air seating and heavy stone clubhouses for accommodating dinners as well as dances and other events. During the 1945 Carnival season, Avelino Muñoz entertained patrons at the Balboa with his popular local orchestra [54] Muñoz, Pablo Acosta, and Armando and Carlos Boza were several of the period's most active band leaders, organizing Panamanians to perform tropical music. Simultaneously, Panama had developed a thriving jazz scene, many of whose performers were Afro-Antilleans. The musicians played in the capital's cabarets and often backed up the visiting artists. Armando Boza became especially prominent and incorporated Cubans into his La Perfecta Orchestra. The Happyland, the Kelly, the Rialto, and the Palm Terrace were several of these more ornate venues, which mimicked the ambiance of the island's casinos and which opened their doors during daylight hours to accommodate the schedules of the transiting U.S. Navy vessels.[55] Photos of these clubs reveal their vibrant wall paintings of sultry beaches, flowers, piano keys, and other instruments along with an assortment of exotic landscapes, such as one finds on a red devil.[56] A 1949 image of the Tropical Rhythm Makers shows the orchestra seated in front of a

large mural depicting what seems to be an alpine valley, with temperate trees, bushes, and even a church in the distance (plate 4). Foreigners and nationals gathered in these exuberant surroundings to watch entertainers as varied as jazz orchestras, comedians, accordionists, and swing bands.[57] The exiled Juan Perón later met his second wife after her appearance with a dance group at the Happyland. Celebrities and smaller acts were constantly passing through Panama, which was visited by Mario Moreno "Cantinflas" in May 1942 and by the bullfighter Fermín Espinosa the following October. In September 1943, poet Pablo Neruda offered a reading at the Teatro Dorado, and the New York Yankees and Dwight D. Eisenhower arrived in 1946. World champion Joe Louis came in February 1947, and for several days, he delighted boxing-crazed Panamanians with exhibitions at the national stadium.[58]

Colón, of course, had its own entertainment scene which was centered around the bustling Avenida Bolívar and which included such places as the Cabaret Florida, the Copacabana, and the Cabaret La Conga.[59] Like their counterparts in the capital, these venues mimicked the grand casinos of Cuba and were characterized by their lush Afro-Caribbean decorations, their elaborate stage shows, and their eroticized, tropical acts. During the war, Jade Rhodora was one of the city's exotic performers and executed her "savage dance" with a cohort in a gorilla suit. A 1943 advertisement announced an appearance at the Club Monte Carlo and showed her and her hairy partner in a passionate embrace.[60] When the Monte Carlo had opened its doors a year earlier, it had boasted a lineup that was entirely Cuban and featured a "pair of *rumberos*," vocalists, ballerinas, and various *conjuntos*.[61] Club Chanteclair was another wartime hot spot, and on the evening of 13 February 1945, it offered a mix of eleven presentations, advertised boastfully as a "big parade of stars." Among the supposedly well-known personalities was a group touting itself as the Afro-Cuban Ambassadors, along with an assortment of other entertainers whose stage names conjured up images of the Caribbean.[62] In many ways, the environment of the terminal cities was modeled on the example of swinging Havana. It imitated its shows, its prostitution, and cabarets and elevated, above all, the importance of rumba, which even penetrated upper-class social venues. A 1942 photo shows the president of the republic watching a provocative Cuban dancer in the exclusive Club Unión. The performer was quoted as nonchalantly observing, "But of course, the presidents also like these things."[63]

Beleño naturally complained bitterly about the music. He described it as "half-black and half-bewitched" and related it to the degeneration of the country and to its subservience to U.S. interests. The masses, he suggested, had lost their way and, in the words of one of his characters, would now "have to

be directed." Even the "men from the countryside," he observed angrily, "were dancing like monkeys . . . by the light of the jukebox."[64] Afro-Panamanian band leader and percussionist Francisco Buckley (1940–) recalls the rumba age very differently. He remembers his adolescence in the 1950s and how this grandson of Afro-Antillean immigrants, who lived his first years in the Canal Zone, began to learn Spanish while he explored the city and visited the *toldos* during the Carnival celebrations. Radio was one of his great passions, and he eagerly listened to the broadcasts of such celebrities as Celia Cruz and Beny Moré and other Cuban stars who continued to perform in Panama. For him, there was no contradiction between their songs and morality and his country's cultural and political autonomy. Instead, they became part of his own identity and spurred him to become one of the leading exponents of Afro-Panamanian music in the second half of the twentieth century.[65] Simultaneously, a group of painters was emerging who would also emphasize blackness in their creations and who would challenge the traditional conceptions of Panamanian nationalism and its disappearance of the country's African legacies.

If the intelligentsia was elitist and fled to the countryside, this movement was working-class and urban in nature and fashioned a more cosmopolitan perspective of the country. Many of its early promoters were actually Afro-Antilleans or they were immigrants from other regions but who maintained close ties to the Canal Zone and its black, English-speaking workforce. As a result, they tended to live in Colón and Panama City and drew strength from the area's economic development and the startling rise of Afro-Caribbean music. The wartime entertainment industry was one of their early opportunities, inspiring them and providing them with opportunities to decorate the bars and cabarets of the period and to take their creations to other sectors. Popular art became an important method for marketing the isthmus's hotels, barbershops, theaters, buses, and restaurants. The buses probably became the most visible manifestation of this form of commercial advertisement. Their owners used music as well as the paintings to vie with one another in attracting passengers, especially after the breakup of the large transportation companies by the Torrijos regime in the early 1970s. By this point, popular art had become a dominant aspect of Colón and the capital, and even state institutions had adopted the imagery, demonstrating the malleability of national identity. Eventually elements of the lettered city acknowledged the importance of the paintings, which had arisen as a consequence of the expanding U.S. presence and which, from the beginning, were rooted in Afro-Caribbean culture. Indeed, a striking aspect of the tradition is precisely the number of early artists with ties to the Canal Zone and to its Afro-Antillean population.

THE WOLF AND HIS PACK

Foremost among these painters was Luis Evans, who was more commonly known as "The Wolf" and whom some people have credited with founding the bus art tradition in the first decades of the twentieth century. A 1941 *National Geographic* article displays one of his creations: a spotted cat walking stealthily through the jungle with the words "The Panther," inscribed prominently below the image. The painting appeared on the front door of a truck, whose owner possibly thought of himself as a skillful driver and who broadcast his abilities to navigate the city's congested streets.[66] Research today has disproved the idea that the Wolf was the only person decorating motorized vehicles following their introduction during the construction of the canal. Interviews and other sources suggest that Héctor Agustín Falcón, a self-taught artist and poet from David, probably painted buses in the mid-twentieth century. Other materials have indicated that Víctor Lewis (1918–93), who would become a celebrated canvas painter, might have been one of the Wolf's early rivals. Undoubtedly, there were a number of people, who helped to foment the practice and who competed with one another on the roads of the capital.[67] Nevertheless, Evans seems to have been the most important of these contenders, as the testimonials of his life are especially memorable and provide a glimpse of a theatrical man whose antics were designed to attract attention and which inevitably gave rise to a group of imitators. Cuban anthropologist Fernando Ortiz might have described him as a "negro curro," the "black show-off" type he associated with nineteenth-century Havana and who dressed him or herself in fashionable clothing and paraded about the streets in a defiant manner to confront and weaken the surrounding racist structures.[68] Across America and in many different periods, scholars have documented this familiar pattern of Africans and their descendants challenging their subordination through self-assertion and a pronounced tendency for spectacle. Raul Fernandez speaks precisely of this "braggadocio" when he describes the Cuban *rumberos*, who strutted onto stages and sang their own praises and whose flamboyance, at this moment, was such an important example.[69]

The Wolf was a kind of Panamanian *curro*. He and his followers arose as a consequence of modernization and of the resulting close ties between the isthmus and Caribbean. He especially projected the region's sense of showmanship and what David Brown calls the "assertive occupation of public space."[70] The Wolf, according to his stepsons, was of Haitian descent.[71] His parents had probably immigrated in the early twentieth century to find work in the

construction of the canal or in the hundreds of auxiliary activities that arose as a result of the infrastructure project. They may have formed part of the mass of Afro-Antilleans who after the opening of the interoceanic waterway lost their housing privileges in the Canal Zone and were forced to reside in Colón and Panama City. By 1930, they numbered between fifty and sixty thousand, or roughly 12 percent of the total population.[72] In Panama, these newcomers erected their own community, which increasingly became integrated into the local society. They created what Michael Conniff describes as a "Afro-Antillean subculture" with its own religious, social, and business institutions and with growing if ambivalent ties to the broader community.[73] The isthmus's modernization was transforming the country by increasing the size of its black population, by expanding the reach and impact of Afro-Caribbean culture, and by weakening its claims as a Hispanic republic. In its more honest passages, *Luna verde* reflects this transition. The book affirms the capital's links to the African diaspora and the relative marginalization of what was traditionally considered to be national, particularly in the eyes of the intelligentsia. "I feel obligated to accept the *antillanidad* of this city," wrote the author Joaquin Beleño. "When we talk about history, we see ourselves as linked to South America; but it's as though the canal construction were not part of our history, or the thousands of people who came from the Antilles. . . . Perhaps we are closer to the Antilles than to Colombia and hence the confusion of our souls and our decisions. The aristocracy lives a colorless mix of *colombianismo* and *yanquismo*, while average people find themselves in a stage of *antillanidad* imposed by this black sediment from the Caribbean."[74]

The Wolf's life was reflective of this situation. He was the product of this "sediment from the Caribbean," which was interacting and affecting the local population and was becoming less Antillean and in effect more Afro-Panamanian. The Wolf was a black man who mixed easily in Panama City and who spoke English and Spanish as well as Haitian Creole. His Spanish-speaking stepsons confirmed that he was raised in Calidonia, the traditional stronghold of the Afro-Antillean population, and that he later moved to Santa Ana, the capital's more established and varied working-class barrio. There, the Wolf cared for his adopted family and cultivated his image as a colorful bohemian. In many ways, the Wolf seems to have been a Caribbean showman. He used his abilities, like the Cuban *curros*, to dazzle and defy the notions of a racist society that depicted blackness as something alien and associated it with ignorance, submission, and poverty.

Many remember the Wolf as an affable dandy who dressed in stylish white suits on days he was not painting and who ambled about the city with great dignity, much like a statesman, a sports hero, or celebrity. He often wore a

fashionable hat and a golden necklace, and his broad smile revealed a shiny front denture that added further to his sense of spectacle.[75] A 1942 photo taken for the *Mundo Gráfico* conveys his confidence and panache. The wiry Wolf stands, smiling and facing the camera with hands outstretched in a theatrical manner. In a quote, he compares himself to Roberto Lewis and insists that he and Panama's leading academic painter were the country's only two artists.[76] During the work week, the Wolf trolled the streets. He carried his brushes in a conspicuous manner, tucked behind his ears to announce his services. Younger men recall seeing him in their neighborhoods, laughing and projecting his arrival with his persona.[77] The Wolf's demeanor was boisterous and charismatic and was seemingly designed to broadcast his presence, much like the stage behavior of the Cuban *rumberos*, whom Fernandez describes as "musicians with attitude" and who "enveloped" their audiences with their "witty" references, "street *pregones*," chorus lines, and "jousting stances."[78] To self-advertise and contest his marginalization, the Wolf also made sketches on the seawall along the Avenida Balbao. There he painted palm trees, hearts, and other images, while entertaining bystanders with his singing. His preferred songs were the tangos of Carlos Gardel, as the Argentine star had been born in France, and the Wolf took pride in their shared cultural heritage. On Sundays, the Wolf often visited Panama's horse track which was and remains a popular sporting venue. During the races, he placed himself beside the rail, and he leaped and yelled loudly as the jockeys bolted past him. His stepson, José Ángel "Chico" Ruiloba (1927–2004), noted in an interview that the Wolf rarely had money to place on bets. Nevertheless, he used the scene cleverly to promote his reputation, depicting himself as a daring gambler.[79] Public drunkenness was another part of the show and a means of enhancing the painter's standing as a fascinating character.

Alcohol has surfaced in the lives of some men whom I have included in this study and whose work has often placed them in cantinas and in many similar establishments. It is unlikely that the Wolf was an abstemious type, given his own entry into these venues and his seemingly bohemian character. Nevertheless, Chico and his brother both claimed that their stepfather never abused drugs or drank excessively. They spoke of the Wolf with great respect and underlined his supportive role in their family. At the same time, they acknowledged that his public image was different. In the outside world, the Wolf adopted a persona quite different from his function in the household. In his professional environment, he often appeared as a drunkard who was self-deprecating, loud, clownish, and entertaining. The tales of his drinking are legend among older painters who witnessed his antics when they were teenagers.[80] One such observer recalls an incident in which the Wolf was decorating a *chiva*

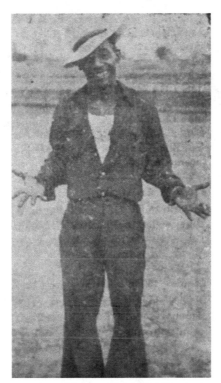

Luis "The Wolf" Evans, 1942. Photo taken by the author at the Biblioteca Nacional. *Mundo Grá-fico*, 11 April 1942.

(a smaller public transportation vehicle that preceded the red devil and that was common in the mid-twentieth century). At one point, the artist mistook his paint thinner for rum and spit and swore loudly to the delight of his on-lookers.[81] The Wolf's behavior always seemed calculated to provoke a reaction, to bring attention to himself, and to elevate his status. It was designed to stir and engage an audience and helped to create an important group of followers, who would spread the popular art tradition over the next decades and who were strikingly similar in a number of ways. Most notable were the prevalence of Afro-Antilleans among their ranks and their close ties to the U.S. sector. The Canal Zone depended heavily on black, English-speaking workers, and it served as the training ground for many of the painters who were beguiled by the Wolf and his antics and followed his tracks into the republic.

A number of these artists were born in the U.S. sector and were raised in its segregated Afro-Antillean communities. Víctor (1930–) and Oliver Bruce (1928–2004) were two of these early painters whose parents had immigrated

from Jamaica and St. Lucia during the construction of the Panama Canal. The couple reared their three children in Frijoles, an Afro-Antillean town within the U.S.-controlled territory, and they sent them to the local English-language schools.[82] Similarly, Chico Ruiloba grew up in the U.S. area and spent his childhood in the village of Red Tank. Many of Red Tank's inhabitants were from the Caribbean, and from this point forward, Ruiloba became partially Afro-Antillean, although his family was Latino and had come from Colombia, presumably about the same time as the Bruces' arrival. In his interview, Ruiloba occasionally conversed with me in English, employing an accent developed in his years among Afro-Antilleans (plate 5).[83] Tomás Sosa (1904–), Medín Mon (1918–), and Virgilio "Billy" Madriñán seem to represent similar cases. All of them were native Spanish-speakers; however, they worked for so long in the Canal Zone that they reportedly acquired a good command of English.[84] Other artists such as Víctor Lewis, Franklin Gaskin (Franco the Great) (1927–), and Héctor Sinclair (1926–) spent their early years in the terminal cities. Nevertheless, their families lived within the Afro-Antillean neighborhoods that had developed as a consequence of the interoceanic waterway and its reliance on Caribbean workers.[85] Colón, in many ways, was an Afro-Antillean community, with its large black and English-language population. Nearly all of these painters became dependent on the U.S. Canal Company and its system of third-party labor. The Zone offered opportunities for men with artistic skills and with the ability to navigate its linguistic differences. It offered training and apprenticeships to the Wolf's disciples and in some cases the prospect for steady, long-term employment as they spread their discipline gradually into Panama.

As the Biesanzes noted in their 1955 publication, the Canal Zone was a kind of "huge plantation" or a "company town" in which there were few democratic institutions and in which power was concentrated in the hands of U.S. officials. The governor and his staff administered the waterway and oversaw affairs as wide-ranging as health care, education, housing, recreation, and garbage collection. The company/government ran the community's bowling allies, bakeries, hotels, swimming pools, and libraries, and it even produced light consumer products, such as toothpaste, cosmetics, and salad dressing. There was little room for private initiative in this "benevolent dictatorship," and consequently, the Zone became intensely bureaucratic and dependent on a proliferation of billboards and other markers that were generally handcrafted through the mid-twentieth century.[86] In a second novel, Beleño commented on this "disciplinary order," which he saw "manifest in the placards hung everywhere."[87] A 1940 photo helps to illustrate this atmosphere. The image shows a quiet Zonian street with numbers carefully painted onto neat buildings and an arrow on the corner pointing to the Balboa Quarantine Station. The station

The enumerated rigidity of the old Canal Zone is still apparent at the Corozal American Cemetery. A sign inside the U.S.-controlled burial ground notes that "witchcraft and animal sacrifices are not permitted" (2011).

itself is surrounded by a fence with a sign prohibiting "unauthorized entry."[88] It was Afro-Antilleans and their associates who generally created these notices, and their reputations rose and fell on their capacity to fashion lettering. Chico Ruiloba was exceptionally gifted in this sense, and he worked in the Canal Zone for over four decades. A family photo album reveals a young Chico seated at his desk, with his art supplies all around him and a foreign supervisor to his right.[89] Similarly, Héctor Sinclair did commercial art for the U.S. Army and was employed by the North Americans for twenty-five years. Sinclair was the son of Jamaican immigrants and had taken drawing classes at Panama City's Escuela de Artes y Oficios. His connections to the interoceanic sector provided other educational opportunities and eventually led him to the United States, where he performed similar functions on several military bases. Such experiences among the artists were not unusual, as a number of them became associated with U.S. entities and traveled and lived extensively outside Panama.[90] Others' ties to the Canal Zone were of a more informal nature yet also influential in their development.

Eugenio/Eugene Dunn (1917–99) worked for many years at Fort Clayton; however, his brother, Jorge/George (1924–2007), never secured such a position

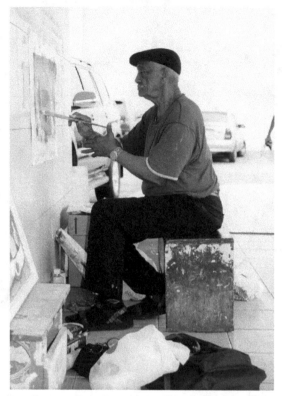

Jorge Dunn outside the Farmacia Arrocha in Punta Paitilla (2004).

but did ad hoc jobs for the North Americans in their clubhouses, cinemas, offices, and commissaries. Both siblings were among a handful of popular artists who fashioned smaller pieces for display in private residences. The Dunns, whose father had been a Jamaican shoe designer, operated a studio/gallery in Panama City, conveniently close to the U.S. area, where they advertised their services to local businesses and made oil, acrylic, and pastel canvases, which became common in foreigners' homes. Many U.S. military officials utilized the Dunns' services to acquire inexpensive portraits of themselves. The Dunns offered the newcomers an economical means to decorate their walls while living in Panama and a memory to take with them when they departed the country. Sometimes the brothers sold these creations directly to U.S. visitors on Stevens Circle, near the Canal Administration Building, and on the Avenida 4 de Julio, across from the Zone. The Dunns were among the first Panamanians to sell their art in the street, and their activities encouraged the organization of craft fairs in the 1960s and 1970s. Painting in public eventually became Jorge's

routine and a means of drawing in spectator/customers. For the last two decades before his death, he labored outside an upscale Panama City pharmacy and continued to direct himself primarily to foreigners, whose tastes and interests affected his compositions, many of which had an Afro-Panamanian quality.[91] The Zone and its inhabitants fostered these painters' training and sometimes their choice of African diasporic material, as evidenced by Dunn's depictions of Colón's old neighborhoods and his representations of the black Caribbean coast (plate 6). The Bruce brothers are another example of the U.S. connection and its role in encouraging artistic expression.

Víctor and Oliver Bruce, who had been raised in Frijoles, were hired by the Canal Company in the mid-1940s. The teenagers were employed as painters in the Zone, and their responsibilities, according to Víctor, were never very demanding and left time to pursue their own endeavors, which included a correspondence course with the Washington School of Art. Among this second generation of the Wolf Pack, the school was apparently a well-known institution, as a number of its members enrolled in classes and sent their assignments to the United States for review.[92] The Wolf's disciples were not self-taught in the strictest sense, but rather, they combined their personal efforts with apprenticeships, on-the-job training, and other forms of instruction. The Zone itself created programs for sharpening the skills of its artists.[93] Many also took classes at the Escuela Nacional de Artes Plásticas, and in an exceptional case, Chico Ruiloba and José Manuel Zabala traveled to Argentina and studied at the Escuela Superior de Bellas Artes Ernesto de la Cárcova.[94] More typically, the foundational experiences of these artists arose from their jobs in the Canal Zone or from similar positions in Panama's government and the country's expanding beer and soda companies, which were plastering advertisements across the isthmus. The Bruces' work in the Zone was of great importance in their early development as painters. The Zone and its billboards provided their artistic tutelage, and eventually they moved to Panama City, where they launched their careers in the business sector, decorating hotels, bars, restaurants, and private residences. There, Oliver adopted the moniker Bruzolli, and both brothers came to be known for their eccentricities, which served to publicize their activities and which marked them, like the Wolf, as colorful street performers. Bruzolli sipped Panamanian *seco*, while undertaking his projects, and sometimes he interrupted them to play blues and jazz tunes on his guitar.[95] One of the Bruces' first assistants was Franklin Gaskin (Franco the Great), who also occasionally painted in the U.S. community and who illustrates, as well, the significance of this connection in the rise of Afro-Panamanian art.

Franco was the son of Jamaican immigrants who had settled in Colón during the construction of the canal. As a young boy, he suffered a terrible

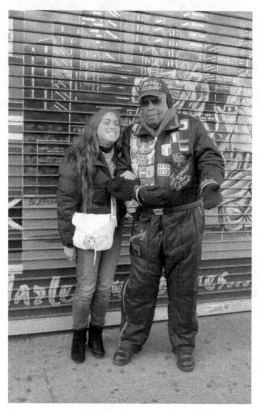

"I'm a showman." Franklin "Franco the Great" Gaskin with
a fan on 125th Street in Harlem (2011).

accident, falling out of a window of his grandmother's apartment. The three-
story plunge left him physically and emotionally scarred, and he was unable
to speak until his teen years. With the encouragement of a Catholic priest, he
turned to magic as a way to overcome his isolation. Franco provided entertain-
ment at weddings and church events, and about this same time, he also began
to paint, as another way to encourage his development. Eventually, he too be-
came a kind of "black show-off," a charismatic performer who did tricks for an
audience while exhibiting his artistic skills in well-trafficked spaces. His adopt-
ed name "The Great" became part of the routine and a means of furthering en-
ticing his spectators, defying obscurity, and elevating his position. On Sundays,
Franco still stages these presentations, designed to attract crowds and to sell
his pieces. He does canvas works on a sidewalk near the Apollo Theater in New
York City, where he emigrated in the late 1950s and where he has decorated
hundreds of metal security gates along 125th Street (plate 7). Young painters

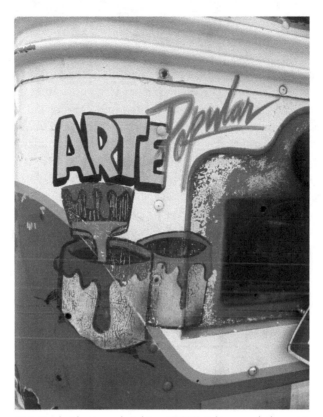

"Arte Popular" by Armando Robinson (2008). Robinson and other paint-
ers recognize their work as a separate genre.

typically apprentice under more experienced mentors as another means of be-
coming familiar with their craft. In the 1940s, Franco collaborated with the
Bruce brothers in Colón before going independent and preceding them to the
capital. There, he found the city full of North American servicemen and en-
countered many opportunities to pursue his profession.[96] After completing a
nude in a Panama City brothel, Franco was approached by a U.S. official and
was asked to help embellish the Canal Zone's Officers Club. There had always
been strong ties between such businesses and the soldiers, who were some of
the most frequent visitors to the red-light district. Franco agreed to a short-
term contract and completed a series of decorations in the building.[97]

Such incidents help illustrate another aspect of popular art and its develop-
ment since the mid-twentieth century. The Canal Zone was the primary train-
ing ground for these painters, as many of them had grown up within its bor-
ders or in the nearby Afro-Antillean neighborhoods. However, these same men

became deeply involved in the republic and became associated with people from many different backgrounds. They had never been isolated in their communities, but instead they transferred easily from one locale to another and ultimately affected Panama's sense of nationalism. This was especially the case during World War II, when the isthmus's economy grew in response to U.S. expenditures, and Panama experienced the rapid commercial development which would continue to shape the capital over the next decades. During the conflict, the country's booming nightclubs utilized and stimulated the rise of black visual expression. The art spread to many other sectors and became especially conspicuous in the expanding transportation industry. The competition among buses, their owners, and painters fueled the extension of this aesthetic practice, making it a central characteristic of the country's urban life. Eventually, even state institutions adopted the showy paintings, incorporating them into the official conception of the country and demonstrating the malleability of national identity. The war and its rumba boom provided the crucial opening. They connected self-taught artists to commercial African diasporic culture and encouraged them to become contributors to the nation-building process.

THE RISE OF POPULAR ART

During the conflict and for several decades afterward, many of the artists in the Canal Zone found regular employment in Colón and Panama City. The Bruce brothers abandoned the Zone altogether, while Jorge and Eugenio Dunn divided their energies between the capital and the more familiar U.S. sector. Similarly, Chico Ruiloba, Billy Madriñán, and Héctor Sinclair pursued freelance jobs in the local economy, while maintaining their positions with the North Americans.[98] Other painters emerged in the mid-twentieth century, who devoted themselves more exclusively to the terminal cities which were expanding and bustling with commercial activities. Alberto Alie was a native of Chiriquí who had grown up in China with his grandparents and who had returned to the isthmus to start his own family. In the early 1950s, he formed TAZ, a decoration company, with Tiberio Álvarez and José Manuel Zabala.[99] The three partners collaborated on many contracts before pursuing their own fortunes at the end of the decade. One of their chief competitors was Sabino Jaureguizar (1912–81). Sabino was a dynamic newcomer from the Basque Country who had entered the business in the late 1930s and who would introduce dozens of younger men to the discipline. Equally influential was Eduardo "Malanga" Meneses Núñez (–1995), a former fisherman who later studied in Cuba, Mexico, and the Soviet Union and who became a specialist in the construction of

carnival floats.[100] Italo Brugiati (1917–2002) also made floats and participated in the 1946 Victory Carnival along with an interesting combination of academic and more informally trained artists. Academic artists occasionally crossed the divide and created decorations for parades and other festivities. For many years, Brugiati fashioned beer and soda signs in David and elsewhere in the interior.[101] For him and others, one of the initial attractions of the republic was its growing entertainment business which expanded in response to the increased U.S. presence and which provided the painters with steady opportunities to embellish cabarets and bars with the trendy Afro-Caribbean imagery. In interviews, the older artists recalled these years with nostalgia. In contrast to Beleño and his depiction of degeneration, they fondly remembered the music of the period and the creative opportunities which it allowed them to pursue, in spite of their isolation from mainstream intellectual circles.[102]

The cabarets where the Cubans and other musicians performed varied in their size and adornments, but most utilized the services of the painters, who plastered the environs with exotic dancers and with the beach scenes, flora, and vibrant colors then so in vogue on the album covers and in the *rumbera* films of these years. The Wolf and his immediate progeny were responsible for these paintings, and they fashioned them in a host of similar places. A March 1946 photo of Manolete taken during the Spanish torero's visit to the capital shows him seated inside the Hotel Central with an equestrian scene displayed on the back wall.[103] A month later, the Lions Club of Panama City hosted a party for the carnival queen, and a newspaper article on this event reveals several hand-painted murals around the dining area.[104] In an interview, Ruiloba related how as an apprentice, he participated in the decoration of Happyland, the capital's leading music club, near the Plaza Cinco de Mayo. The Happyland became a Hawaiian paradise in early 1944. He and others also helped with the *toldos* and the variety theaters during the Carnival season, when they played host to the visiting tropical bands and embellished their structures with similar ornaments.[105] The cinemas also employed the self-taught artists to make the posters for their constantly changing functions. The businesses received small photos of the productions which they presented to their audiences, and the painters reproduced and infused these representations with a sense of popular aesthetics. On his visit in the 1940s, Agustín del Saz was struck by the *tableros*, which sometimes could stretch across the entire front of a theater and which grabbed the viewer's attention with their spectacular colors.[106] Jorge Dunn carried out these duties for many years at the Canal Zone's Balboa Theater. Víctor Lewis became a fixture at Colón's Cine Rex, while Alberto Alie began his long career producing advertisements for Calidonia's Teatro Presidente.[107] It is important to emphasize the painters' attachment to these places

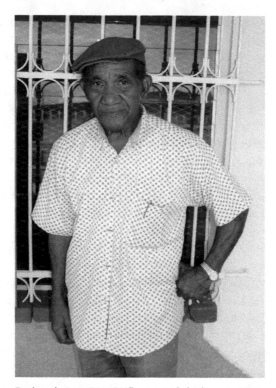

Teodoro de Jesús "Yoyo" Villarué outside his home in 2002.
Yoyo is an early disciple of the Wolf, a former musician, and
Panama's most prolific bus painter. He began decorating the
red devils in the 1940s and continued to paint them into the
early twenty-first century.

and how their shows and Caribbean melodies became closely tied to their personalities.

Not surprisingly, many painters were also musicians who performed the cadenced pieces which so inspired their art. As he advanced into his eighties, Jorge Dunn remained a gifted singer, and often interrupted interviews to croon *boleros* or Perry Como hits from the mid-twentieth century. During the 1940s and 1950s, he and his siblings formed a vocal group, and they occasionally offered shows in the red-light district, sometimes in bars where Dunn had also painted. His brother, Eugenio, joined Payne and His Ambassadors and participated in several other English-language orchestras that primarily played covers of U.S. standards.[108] The Bruce brothers and their sister were also attracted to music, and as youngsters, they presented themselves on Colón's variety radio programs.[109] Oliver Bruce later became an enthusiastic guitarist

whose assistants recall beating on buckets while their mentor led them in improvised renditions of jazz, blues, and tropical pieces.[110] Malanga Meneses was even more involved with music. He created a combo with his brother and played the guitar as well as the Cuban *tres*.[111] Teodoro de Jesús "Yoyo" Villarué (1926–) was also a painter and committed musician and still displays his trumpet proudly in his studio. For fifteen years, he participated in the Cuban-style ensembles, which were so trendy in the mid-twentieth century. The connections to his painting were especially obvious. Sometimes he slept in bars after gigs and woke in the morning to decorate their stages.[112]

Caribbean and black rhythms were a critical part of the emergence of popular art. The rumba craze provided many of the discipline's initial venues and informed its aesthetic principles. Today, artists remain connected to these legacies, as is evident in their use of syncopated patterns, crisscrossed coloring, and frequent depictions of salsa, *bachata*, and reggae stars. Not surprisingly, there have also been an abundance of vocalists, DJs, and general music enthusiasts among the Wolf's younger descendants (plate 8). Marcos Cáceres (1938–) provides an excellent example. Cáceres did commercial art in the 1960s and 1970s, while simultaneously emerging as an important national singer and even becoming known as the "Singing Painter."[113] Rumba and other forms of Caribbean music encouraged the rise of black diasporic imagery, which also became tied to broader economic developments. Indeed, the same paintings which adorned the cabarets and *toldos* also became effective advertisements for Panama City's hotels, shops, street vendors, and buses. Similar drawings appeared in Panama's newspapers.[114] The artists became immersed in this environment and the capital's steady capitalist development. Unlike Beleño and his fellow *letrados*, who saw this moneymaking as morally damaging and who idealized the vision of a "purer" and rural Panama, the popular artists embraced the changes of their era and utilized them to spread their ideas.

Among the most dynamic in this regard was the Basque immigrant Sabino Jaureguizar. Sabino had left Spain in the early 1930s, anticipating the outbreak of civil war in his country and in search of opportunities for his still young and undefined life. In Panama, he taught himself outdoor advertising by studying the translations of U.S. publications and by a trial and error process which occasionally ended badly. Héctor Sinclair recalls a time when a powerful group of investors threatened to ruin the Spaniard's business, after billboards he had made for them, just six months earlier, began to peel badly in the isthmus's humid air. Just as the global conflict broke out in Europe and Asia and ignited an economic bonanza in the republic, Sabino had opened his shop on Calle Estudiante, across from the Canal Zone in the capital's center. A large sign placed above his building trumpeted his services and engaged viewers with its

inverted and amusing lettering. Sabino was a confident and theatrical street character, who blazoned "Sabino sabe pintar" (Sabino knows how to paint) in many different locations. Inevitably, he was influenced by the local environment and absorbed much of Panama's Caribbean culture, especially as he regularly employed five to six assistants, many of whom were Afro-Antilleans.[115]

These men included Héctor Sinclair, Franco the Great, and Chico Ruiloba. Marcos Cáceres later apprenticed under the Spanish master. Their contracts included the decoration of bars and nightclubs, as well as hotels, billboards, and restaurants. For many years, Sabino and his employees fashioned the lettering for the Gago grocery store chain. Usually, the artists labored late into the night, when they rushed about the aisles and adjusted prices and created eye-catching signs to attract customers. Before Christmas, they worked along the Avenida Central, where they began a decades-long tradition of adorning store fronts with manger scenes and angels and with other festive imagery.[116] Fueling this advance was, of course, the competition among the city's spreading businesses which were responding to its physical and demographic growth and which utilized the painters to promote their products. Nothing better serves to illustrate these factors than the nascent transportation industry which was left in the hands of the private sector and which historically was poorly regulated by government authorities. The buses multiplied in number from World War II forward, and they adopted Caribbean music and Afro-Panamanian imagery to beat out their rivals and to attract more passengers in their high-speed races about the capital.

In the mid-1930s, there were just 290 motorized vehicles providing public transportation in Panama City. Wartime rationing briefly slowed their expansion; nevertheless, their ranks continued to increase even during the conflict, ascending to over 800 by 1943.[117] Two decades later, there were roughly 1,100 buses covering the city's twenty-two routes. Many of these began at different parts of the capital but then converged on the Vía España, contributing to a tendency for intense rivalry and traffic jams, documented by the government and numerous student theses at the Universidad de Panamá.[118] The fleet initially depended on so-called *chivas*. The *chivas* or goats were flat-bottomed trucks with wooden or metal cargo covers and side benches, allowing eight to twelve people to sit across from one another. Squeezing on board could be uncomfortable, although the arrangements provided for an unusual amount of interaction between those rubbing elbows inside the cabins. The *busitos* began to arrive in the 1930s and accommodated another eighteen to twenty-two passengers. They and larger models gradually took over the system, and by the late 1960s, the American-style school bus was the predominant way for most commuters to make their way around Panama City.[119] Today, residents still rely

largely on these vehicles, which are usually at least ten years old when they are imported from the United States.

The changes, of course, came along with steady investments and the establishment of transportation companies beginning in the early twentieth-century. While large businesses were able to monopolize parts of the city, they never controlled the entire metropolitan area, and in fact, what is remarkable about the sector is the long-term survival of small proprietors. Their presence assured that transportation remained competitive and encouraged a tendency for risky driving and a propensity to use music and Afro-Caribbean art to entice the entry of sufficient customers. Statistics help to reveal this situation and the function of the paintings as a form of advertisement.

In the mid-1950s, Panama's governmental authorities reported that "independent" owners controlled 73 percent of the capital's commercial passenger vehicles. Moreover, well over half of these modest entrepreneurs did not belong to the cooperatives, which were loosely organized associations responsible for the exploitation of certain routes.[120] Over the next years, the larger entities gained some ground; however, even as late as 1971, businessmen and -women who had less than nine vehicles, still possessed about half of the capital's buses.[121] The result was a highly diffused industry in which responsibilities and routes were often overlapping and in which aggression and speed were considered necessary to help assure one's economic survival. Newspaper and government reports from the 1940s and 1950s reveal the profusion of traffic violations and accidents often involving the harried drivers, who were equally motivated by their contracts. Generally, these did not provide them with stable salaries, but instead they offered them a percentage of the profits or a fee for each route completed.[122] The consequence was a propensity to step on the accelerator and to rush from stop to stop as quickly as possible. The same sources suggest another tactic, designed to assure that passenger use was adequate. This was the employment of designs and music which would entertain people as they rode on the vehicles and which sometimes even drew them in from the sidewalks. In Panama, it was not enough that buses be efficient; it was also important that they be "prity" in order to battle their rivals on the street.

A newspaper photo from the early 1940s shows a pair of boys staring intently at a *chiva*. On its wooden or zinc sides, there is a rural landscape with a road and an unintelligible name sketched around the painting. To the right, is a second vehicle adorned with a palm tree and a "restless bird" flying above a distant island. Names such as the "Bengal Tiger" and "Help Me to Live" came from songs, radio programs, and movies.[123] The buses, like other aspects of proletariat, black culture, appropriated the prestige of these well-known elements and used it to capture and draw in their public. The interiors of the *chivas*

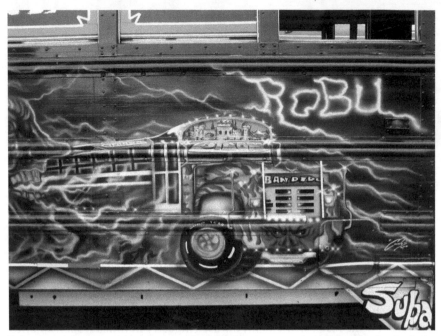

Today the red devils are severely criticized for their often dangerous driving. Speeding bus by Carlos Benjamín Álvarez Espinosa (2008).

tended to be more decorated and were plastered with photos and newspaper clippings of sports heroes, actors, singers, and beauty queens. These offered a rundown of the entertainment scene, and they changed periodically to keep abreast of events. In addition, the inside areas had small handcrafted paintings portraying the interior and Panama's beaches, along with imagined and exotic scenery. One of the classic works was a depiction of mountains capped by snow and said to cool down passengers. The *chivas'* cabins swirled with imagery, and their entrances were festooned with flags, dolls, and other trinkets, all designed to attract and ensnare customers, who were further captivated by the use of music.[124]

The author of a mid-1950s essay whose photos record the *chivas'* "charm" and visual intensity, noted how the drivers "tune in, at the most appropriate times, to the programs of mambos and guarachas." On other occasions, they broadcast riveting sporting competitions, or they offered passengers a chance to catch up with their favorite soap operas. The vehicles, which transported students were usually the most flamboyant and sometimes had upwards to twelve to fifteen whistles, bells, horns, and other noisemakers to further their sense of public spectacle.[125] Modernity, which had driven the elite into

nostalgia, fomented a more creative response among the artists responsible for crafting these roving galleries. Rather than fleeing from the rising commercialism, they absorbed many of its most visible icons, and they fused them with a sense of black, proletariat aesthetics to shore up their position against their competition. This rivalry became even more intense in the early 1970s, when the Torrijos government dissolved the capital's three large transportation businesses and opened the market further to the small entrepreneurs. These operators organized into the Sindicato de Conductores de Transporte Colectivo (SICOTRAC) and acquired nearly all of the capital's vehicles.[126] Ramón Enrique "Monchi" Hormi (1947–), one of the most important contemporary painters, has described the next decade as his "golden age," when lines of buses parked outside his home and when hundreds of red devils circulated throughout the capital.[127] Within a short period, they were the "owners of the street" and the most visually dominant aspect of the urban environment.[128] Not surprisingly, they also came to affect the state and the Panamanian official identity.

This "alternative modernity," which had arisen out of capitalism and out of Panama's links to African diasporic culture, eventually was recognized as something national and as part of the country's cultural heritage.[129] Culture was no longer exclusively rural and associated with mestizaje and the Azuero Peninsula. Now the black cities won recognition for what some described as the urban area's "folklore."[130] The buses, in particular, became an iconographic image that businesses and the tourist industry exploited to market their products. For their part, the artists penetrated the state and used their positions to reformulate its symbols. The state had formerly dressed itself in neoclassical architecture and in features reminiscent of the Spanish period. It had fashioned the Panamanian identity out of cornices and Moorish columns, but now some of its edifices took on a red devil quality, with bright paintings projecting rhythm, hybridity, and panache.

RED DEVILS AND THE STATE

From the 1960s onward, a number of the painters found positions connecting them to civil and religious authorities, and they plastered logos onto their buildings and vehicles and infused them with their sense of aesthetics. For years, Yoyo worked as a humble sign maker for Panama City's municipality, and while many of his responsibilities did not engage his creativity, he was occasionally charged with more imaginative projects. In the early 1970s, he crafted a dazzling puma onto the side of General Omar Torrijos's helicopter, and he

often decorated jeeps, trucks, and other military equipment with humorous, whimsical, and flamboyant figures. In 1983, he did a striking depiction of John Paul II on the side of the aircraft used by the pontiff during a brief visit. For this event, Yoyo also made a board picture of the Pope that was suspended outside the Municipal Palace and today hangs luminously in the Metropolitan Cathedral. The Pope smiles benevolently at the viewer, with his countenance and upper body sketched in brilliant colors. For the two hundredth anniversary of Simón Bolívar's birth, local officials also turned to the bus painter, who fashioned another portrait for display outside their offices.[131]

Equally vibrant and bigger images have appeared in parks, alongside roads, and at the entrance to communities. Such manifestations grew in the 1970s, as Torrijos's government established new artistic institutions, hosted shows that were open to broad participation, and hired both academic and popular painters to make patriotic murals around Colón and Panama City.[132] Popular art subsequently became common in educational institutions, in hospitals, and in many other public locations (plate 9). Monchi, who apprenticed briefly under Yoyo and who spent a decade employed by the National Maritime Authority, has produced several school murals in his hometown, La Chorrera.[133] His colleague, Héctor Aníbal "Lytho" Gómez Rodríguez (1955–), who once dominated Colón's bus decoration, has done a plethora of similar jobs in that city. Lytho's work includes a series of beautiful paintings that grace the walls ringing the Colón free trade area and that display the attractions of the surrounding region.[134] Today, the Instituto Nacional is full of similar imagery, as are the Escuela de Artes y Oficios and the Don Bosco Basílica in central Panama City. Santa Ana's cavernous God Is Love Temple boasts several sizable works by self-taught artists, as do the grounds of Parque Summit, whose intermittent buildings and multihued benches feature depictions of the isthmus's natural life. In David, the managers of the community's most prestigious hospital recently commissioned painters to make landscapes similar to those appearing on the red devils around the facility's MRI equipment.[135] Salazar provides another example of the connections between popular art and such spaces. In 2006, this leading bus painter completed a piece for the Tocumen International Airport. The project which he undertook with a group of Panamanian school children relates various episodes from the country's history.[136] Earlier Captain Nelson Cisneros (1956–), who had studied under Bruzolli, finished two large murals at the capital's Fire Department Headquarters. The more impressive of these murals is entitled "The Fireman of the Future" and could have appeared on a hood of a red devil. It depicts a fireman battling a brilliant conflagration and a cascade of water gushing from a tangled hose.[137]

Bruzolli himself had long been connected to the Fire Department and had created many of its emblems and statues as well as the paintings of nearly all of its commanders, stretching back into the late nineteenth century and today hung proudly at the Darío Vallarino Barracks.[138] Meanwhile, Bruzolli's brother, Víctor, won a number of similar contracts and is responsible for most of the portraits of the comptroller-generals of the Republic.[139] The Dunns' canvases adorn multiple government buildings. Eugenio's depiction of the Instituto Nacional, with its multicolored and pulsating lighting, is displayed in the school's administrative office, while several of Jorge's famous *tinajas* line the vestibule of the National Assembly. There is probably no better example, however, of these connections between the public sphere and the Wolf's descendants than their colleague Malanga Meneses. Malanga had a thriving decorative business in the second half of the twentieth century and specialized in the bright, eye-catching portraits that for a long time were used in political campaigns. Several of these stylized and intense head pieces still lie about his old studio on the Vía España. Malanga was also a prolific designer of floats for Panama's annual Carnival. He and others such as Héctor Sinclair, Billy Madriñán, and Chico Ruiloba established the aesthetic standards of this industry, including its obvious red-devil-like tendency to utilize castles, pagodas, and other foreign icons and to cannibalize them in swirling patterns and colors. In the early 1970s, Malanga's career entered a new phase when he became what his son describes as the "official painter of the state" and made the majority of the monumental adornments for General Torrijos's public rallies.[140] Among such pieces were gigantic billboards, which were sometimes hung from the exteriors of buildings and which relied on popular art's sense of bravado to reinforce the position of the leader. In 1983, for the arrival of the pope, Malanga erected a twenty-five-foot portrait of the pontiff in the middle of Parque Urracá.[141]

As Malanga and others infiltrated the government and embellished it with their tendency for spectacle, their bright hues, cadences, and iconographic imagery, their own creations came to be seen as a manifestation of the Panamanian identity. Elements within the business community were particularly willing to identify the art as one of the country's characteristic features, as they readily could see its appeal and commercial value. The red devils, in this sense, were especially important, and from the early 1970s forward, they evolved into a national symbol. Today, Panama's national rugby team proudly bears their showy name, and radio stations constantly imitate their horn blasts to grab the attention of their listeners. Frequent competitions have been organized by private interests to award the capital's most extravagant bus, and schoolchildren have occasionally participated in contests, presenting paintings imitative

of the tradition.[142] The vehicles have also appeared regularly in pamphlets and other materials directed at the country's visitors. "Popular art thrives in every nook and cranny," insisted one of these glossy publications with photos of murals outside businesses in Colón.[143] "We are very Caribbean," observed another of these works; "in short, we have a tropical happiness that can be seen in the designs on our buses."[144] Even as recent as 2008, a detail from a red devil was included in a travel ad listing "things to do in Panama."[145] An earlier guide produced by local officials, highlighted the red devils in a "folklore" section and connected them to the capital's "cheerful and colorful" nature.[146] Today, dozens of blogs and other web pages offer information about the vehicles, usually presenting them to their readers as a fascinating if somewhat dangerous aspect of Panama City.[147]

The buses' iconographic status is also apparent in the multiple instances in which they have made appearances on television, with the artists occasionally participating in these endeavors. Yoyo collaborated in a recent commercial for the November independence celebrations and was filmed along with the flag, uniformed schoolchildren, the monument to Balboa, and other symbols of Panamanian nationalism.[148] In 2008, a widely seen Telemetro advertisement relied on the red devils in its efforts to introduce a new program called *Buscando a Pepito*. That same year, Taima used the buses to market its cell phones in the republic. Foreign and Panamanian newscasts and variety shows have also offered regular segments on the red devils and have introduced them to thousands of viewers across the continent. Likewise, movies have sometimes relied on the buses to situate their plots in the country's urban areas. Multiple red devils appeared in *The Tailor of Panama* (2001), a fictionalized portrayal of the post-Noriega period that most critics blasted as of mediocre quality.[149] Shortly before the Hollywood production, a well-known clothing store in Panama City sought the services of painter Héctor "Totín" Judiño (1965–). The "My Name is Panama" business, which caters to tourists, asked Totín to design a showy bus to place on the roof of its Vía España building. For several years, Totín's work remained at this location, where thousands of people could admire its creativity and its most memorable feature which was a stylishly dressed demon who stood leering, just left of the side entry, and who called out to passengers, "Welcome aboard, Mommy!" Such displays are now part of the "patriotic kitsch."[150] They have appeared on coffee mugs, postcards, and T-shirts and on numerous other articles sold to visitors. Many stores now hawk miniature replicas with similarly extravagant sayings sketched across their exteriors.

Presently, the capital also boasts two "Red Devil" taverns. One is located near the Tocumen airport and serves a middle-aged and working-class clientele, while the other locale sits on the Vía España and has a younger and more

upscale atmosphere. It specialties include desserts such as "Traffic Jam" choco-late and an appetizer called "Get off the Bus Ceviche."[151] Both places feature popular art decorations and exploit their flamboyance to draw in customers. The Vía España establishment even has a bar crafted amazingly from the body of a red devil. The Chivas Parranderas have also used the vehicles in their ef-forts to attract clients. The Chivas or party buses are painted like the red devils and imitate their loudness and their sense of showmanship. In the evenings, they take visitors and others around the city, with carnival bands blasting bois-terously from their cabins. Passengers contribute to the spectacle with their dancing, applause, and rowdy laughter. Like the red devils, they self-advertise their presence and force the attention of those around them. Such perfor-mances of Panamanian identity have not gone unnoticed and have fostered a reevaluation of the official conception of nationalism. In Panama, official forms of nationalism have not remained hierarchical and solely the product of middle- and upper-class intellectuals. Rather, they have incorporated many other influences, including those of the Wolf and his descendants.

In this regard, the self-taught painters have gained a measure of recogni-tion from the traditional intelligentsia. It has been impossible for this group to ignore the artists, who have been grudgingly accepted as part of the national culture and who have even been imitated on some occasions. A 2005 program by the municipality of Panama invited the country's leading academic painters to participate in a program, decorating the carts which circulate around the capital and sell snow cones to pedestrians.[152] More and more of Panama's art-ists have also turned to the city in search of their subject matter, and they have accepted the hybrid and postmodern perspectives long ago adopted by the Wolf and his followers. Notably, most of them have not received traditional training but rather are architects, graphic designers, and other professionals. Slowly urban areas have gained some legitimacy in the eyes of the intellectual class, which had long regarded the countryside as its source of inspiration and which had been preoccupied with notions of purity and origins.[153] Individual popular painters have also achieved some stature among the country's cultural elite. Víctor Lewis and Eugenio Dunn were the most successful, as they con-centrated on canvas paintings and on penetrating galleries and other main-stream spaces. By the time of their deaths, they had become "national paint-ers," with their works displayed regularly in domestic and foreign exhibitions and canonized in glossy commemorative publications.[154] Interestingly, their rise coincided with the development of a school of indigenous painting that was also closely linked to commercial ventures.[155] They were not, however, the only ones to earn some respect from the intellectual establishment. There was significant, if reluctant, admission that art can appear in many contexts and

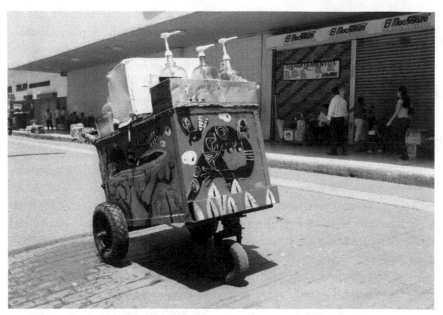

The academy imitates the street. A snow cone cart decorated by artist Braulio Matos as part of the 2005 municipal program.

that even restaurants, bars, and passenger buses can be legitimate venues of expression.

Silvano Lora was a resident Dominican artist whose research helped to mark this transition with an important essay in 1973. In his article, Lora marveled at popular art's dominance of the commercial sectors of Colón and Panama City. He lamented the lack of previous studies, insisting that the genre deserved much greater attention, as it was "representative of the national culture."[156] Lora and others were beginning to realize, as Julio Arosemena would assert just a year later, that the "urban environment is full of folkloric elements" and that Panamanian traditions were not purely rural, as Beleño and others had so often asserted. Arosemena, who taught at the national university, led his students in a study of the buses' copious lettering. They noted the "intentional deformation" of words and phrases and the frequent use of English expressions. They suggested that these were not regrettable appropriations but instead that they constituted a "popular philosophy" and in many cases a "critique of social ills."[157] Other articles and theses followed these investigations and broadened the appreciation of the red devils.[158]

In 1984, academic Stanley Heckadon Moreno published another influential essay in which he argued that the buses reflected the capital's Afro-Caribbean

culture and its residents' appreciation for bright colors, designs, and lively music. He warned against those who were then attempting to implement an overhaul of the transportation system by importing wholesale the examples of other countries. He compared these efforts to the previous decisions to level the capital's colonial fortifications and to "disfigure" its parks and other patrimony in the name of modernization. For Heckadon, the buses had become another part of the city's historical infrastructure and were therefore entitled to measures of protection.[159] Sandra Eleta echoed many of these themes in an award-winning 1985 documentary. Eleta argued that the red devils were a manifestation of black urban identity and that they deserved all Panamanians' approval.[160] More recently, U.S. and European filmmakers have made illuminating videos about the buses, highlighting their forceful and postmodern qualities.[161] Foreigners have always been fascinated by the red devils and have been some of their strongest backers. In 1988, writer Moira Harris included them in her broader study of the "painted vehicles of the Americas."[162]

Domestic appreciation culminated in August 1983, when the Museo de Arte Contemporáneo opened a two-month show about the red devils. Panama's most prestigious public gallery invited contributors to submit paintings, such as appear on the emergency doors of the buses and which many consider to be their aesthetic centerpieces. Thirty decorators took part in the competition, including such prominent figures as Monchi and Yoyo.[163] Salazar unfortunately declined to participate, citing his disinterest and the "red tape" of the contest.[164] A panel of judges reviewed the compositions and determined the presentation of three cash prizes, as well as a commendation from the German ambassador for the best depiction of a "protector saint." Tomás Antonio Fong was the recipient of this last honor, and in an interview, he emphasized how he had developed as an essentially self-taught artist.[165] In general, the jury favored conservative themes and those closely tied to traditional national images. The guidelines for the show also allowed officials to withdraw any works they considered "offensive."[166]

The top award went to Lytho, who presented a reproduction of Raphael's *Madonna in a Chair*. Pedro Pablo Ortega took second place with a copy of the seal of the republic, while the final winner was José Antonio Henríquez, who reproduced Titian's portrait of *Charles V on Horseback*. Some people were disappointed with the failure to recognize more imaginative pieces; however, overall the event was a success, vaulting bus painting into the national consciousness and providing the genre with a sense of validity. A spokesman for the Caja de Ahorros, which has an important art collection and which had helped to sponsor the exhibition, described the works as "authentically Panamanian," insisting that "our people's sentiments and ideas . . . are what inspire these

creations."[167] Equally effusive assessments appeared in the press and linked the red devils to Panamanian identity. One article, published several weeks before the opening, depicted it as the "cultural event of the year." Another portrayed the paintings as "our most authentic folklore," while third praised them in similar terms and suggested that they reflected "what we are as a nation."[168]

No one, of course, should overestimate these reactions. The attitude of the intelligentsia continues to be hesitant toward the red devils and other forms of popular expression. During the 2003 centennial celebrations, several books were published on Panamanian painting but with no references to the creative street tradition.[169] These and other errors demonstrate the ambivalence that cultural elites continue to feel toward the Wolf's progeny and toward their ubiquitous and eye-grabbing creations. On the one hand, they identify them as typically Panamanian and associate them closely with their culture. The red devils in particular have become a "folkloric fact" and have been "projected in commercials, documentaries, and written works," but at the same time, they are still widely misunderstood and frequently dismissed as something frivolous and unworthy of any true appreciation.[170] Chapter 6 examines the current wave of hostility which threatens to eliminate the vehicles in the near future. Panama's national identity remains a battleground for these proletariat painters. Nevertheless, they are winning some obvious victories, as evidenced by other groups adopting their colors, their thematic fluidity, and infectious cadences and becoming like them, "100% prity." In my next chapter, I will explore the aesthetics of bus painting and how it is precisely designed to break down hierarchies, to challenge the status quo and to engage audiences. So often in my interviews, the painters referred to boxers when they attempted to explain their profession. They emphasized how the athletes try to knock out their opponents, while winning over the crowd with their charisma and theatrics. Similarly, the bus artists have exploited intense rhythms, hybrid themes, and sense of panache to fight their way into the national conscience.

Plate 1. Given its appearance in conventionally masculine locations (garages, barbershops, roadsides, and cantinas), women generally do not participate in popular art. However, its aesthetic principles manifest themselves in nail painting, jewelry, hair styles, and clothing. One of the many street nail salons along the Avenida Central (2008).

Plate 2. Restaurants are another site of popular art and often feature landscapes or depictions of food. Still lifes by Villo in La Refre restaurant, Avenida Central (2007).

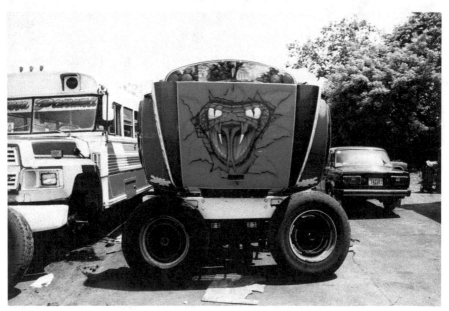

Plate 3. Aggression and panache characterize popular art. Snake hood painting by Rolando González Baruco (2001).

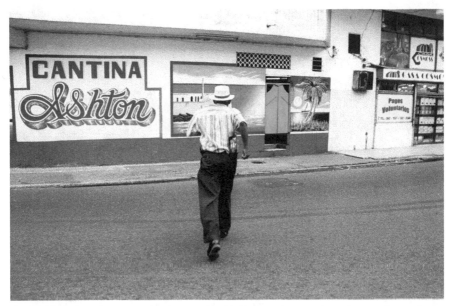

Plate 4. While the cabaret scene has long vanished in Panama, bars remain an important space for the Wolf's progeny. Often they are bedecked with tropical imagery. Artist Luis Camargo walking toward Cantina Ashton. Like the Wolf, he carries his brushes in eye-catching manner (2007).

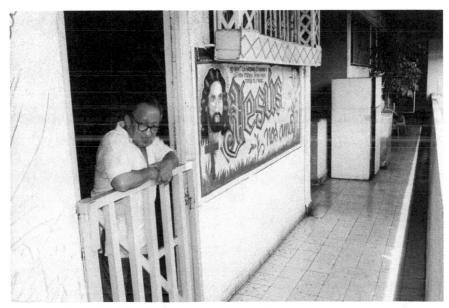

Plate 5. José Ángel "Chico" Ruiloba Crespo was a stepson of the Wolf and spent years living and working in the U.S. Canal Zone. His connection to the Afro-Antillean community was a point of pride, and he spoke English with a Caribbean accent. Chico was also a specialist in ephemeral Carnival decorations, and he regularly recomposed the mural outside his Patio Roche apartment to suit his mood and the passing holidays (2002).

Plate 6. In the 1940s and 1950s, Jorge Dunn sang Cuban and American popular music in the bars and cabarets where he often was employed as a painter. His works frequently have a musical quality, conveying the rhythms of the old nightclubs. Dancing Bottles (2002).

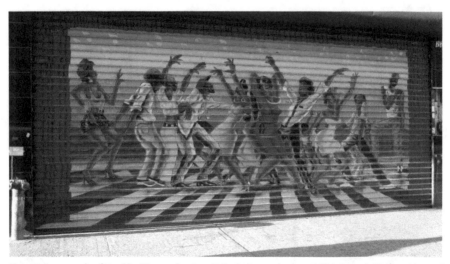

Plate 7. An example of Franklin "Franco the Great" Gaskin's murals along 125th Street in Harlem. Many of these security gates have been removed as the neighborhood undergoes gentrification (2011).

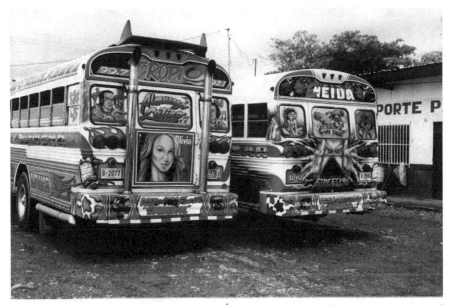

Plate 8. Popular artists remain closely tied to music. Óscar Melgar is presently the leading bus painter and also works part-time as a DJ. Often he fashions references to his radio station. Buses by Óscar (left) and Cristóbal Adolfo "Piri" Merszthal Villaverde (right) (2007).

Plate 9. Popular art can be seen on many public buildings. This mural by Víctor Manuel "Chicho" Hernández decorates a wall in the Panama City Fish Market. The Virgen del Carmen is the patron saint of fishermen (2008).

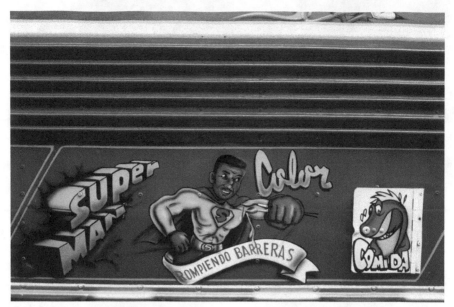

Plate 10. "Superman of Color, breaking down barriers" (2007). This flashy self-portrait by Andrés Salazar appears on the side of a red devil. Many artists depict themselves on the vehicles with a similar sense of theatrics.

Plate 11. "Still the King," (2001). Statements of hyperbole and self-advertisement are sometimes derived from international popular culture. This expression comes from "El Rey," a well-known mariachi song.

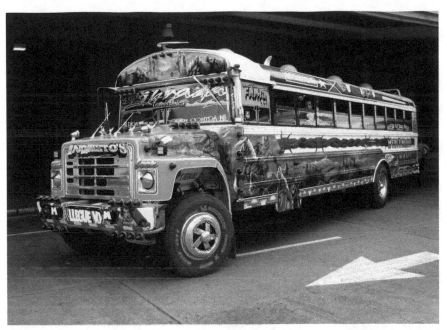

Plate 12. The red devils dispute social marginalization with their loud horns, music, screeching breaks, and extravagant imagery. "I've arrived," bus by Óscar Melgar and Jesús Javier Jaime (2008).

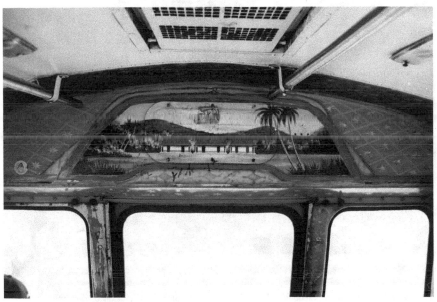

Plate 13. "For the painters, Panama is above all the ocean," wrote Silvano Lora in his 1973 article. A coastal scene by Teodoro de Jesús "Yoyo" Villarué, who is especially known for such depictions (2001). In contrast, studio artists have traditionally demonstrated little interest in this topic.

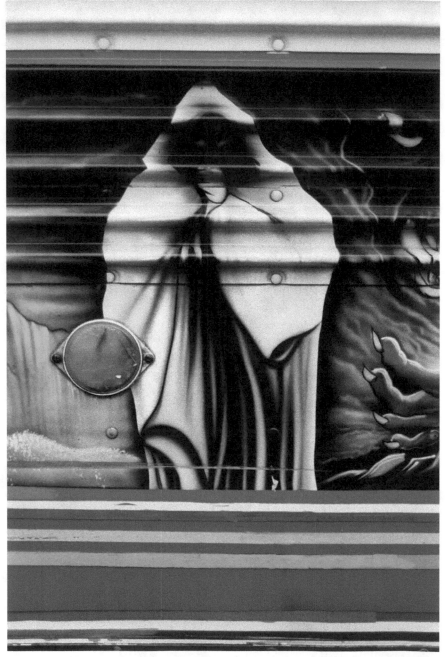

Plate 14. Wizard by Rubén "Chinoman" Lince (2001). Chinoman is known for his bizarre creatures, often derived from fantasy and science fiction movies.

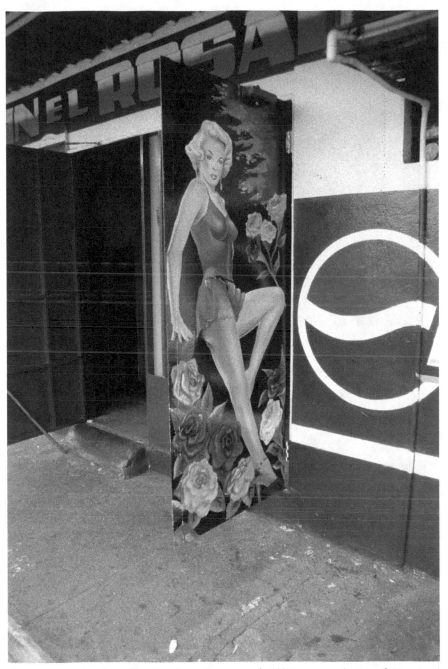

Plate 15. In contrast to the traditional intelligentsia, artists comfortably incorporate the icons of international popular culture to call attention to themselves and the interests they serve. Marilyn Monroe by César Bellido at the entrance to Jardín El Rosal (2008).

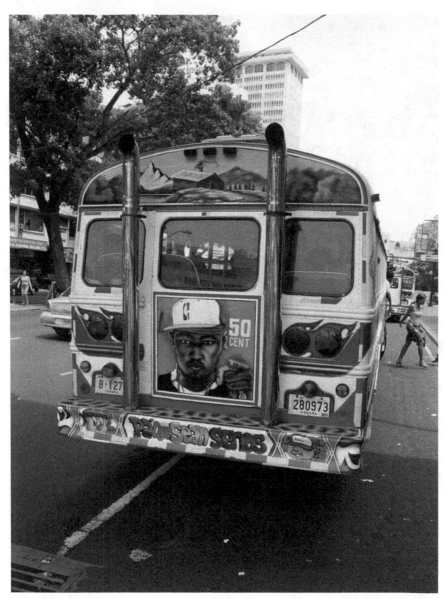

Plate 16. Much like rumba, soul music, and earlier Afro-American genres, hip-hop has contributed to the growth of Afro-Panamanian identity. Rapper 50 Cent (2004) below a temperate-climate landscape by David C. García B. (1977–).

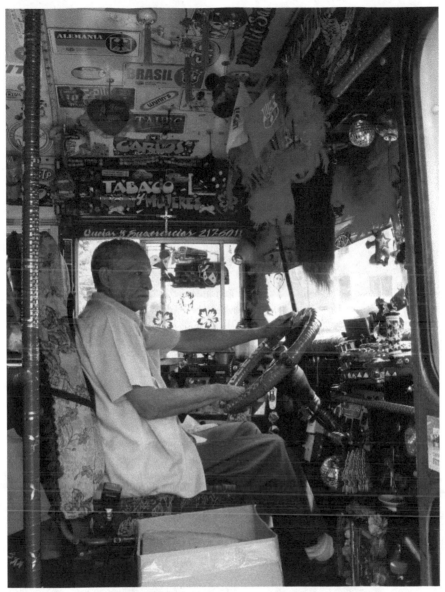

Plate 17. The interiors of the red devils are also frequently decorated. Here an especially exuberant example (2011).

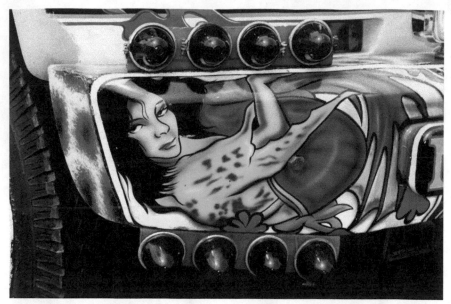

Plate 18. If better known for their projection of forcefulness, the red devils also exhibit scenes of gracefulness, as in this mermaid bumper by Andrés Salazar (2001).

Plate 19. Ancelmo "Chemo" Chávez Castro is a master of the sinuous bands that stretch along the sides of the red devils (2001). Chemo also makes lines for the road commission.

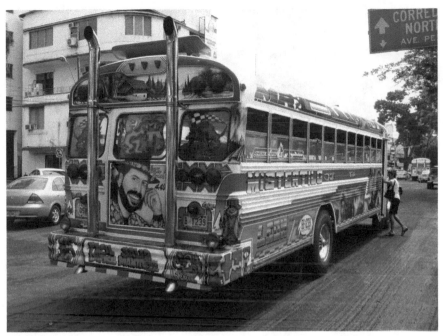

Plate 20. The red devils brim with rhythm and color and often depict famous musicians. Juan Luis Guerra is a popular merengue artist. "Mistertilo" by Andrés Salazar and César Córdoba (2011).

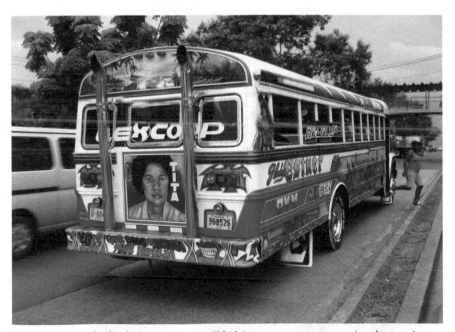

Plate 21. Gladys Esther bus by Jesús Javier Jaime (1968–). Jaime was among a number of artists who rose to prominence in the early 2000s, just as the red devil tradition was falling into decline (2008).

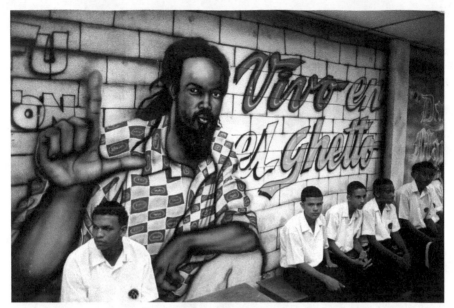

Plate 22. The interior of Barbería Cash Money with a portrait of Panamanian *reggaesero* Kafu Banton (2001) by David C. García B. Barbershops are another point of "black nucleation" and serve as important galleries of popular art. While the red devils have entered into decline, the painting of the *barberías* has become more conspicuous.

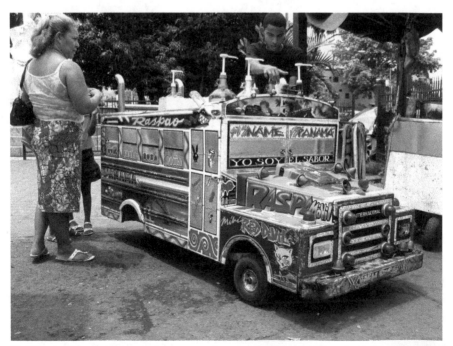

Plate 23. Popular art remains an important part of street vending. Snow cone cart by Héctor "Totín" Judiño (2008).

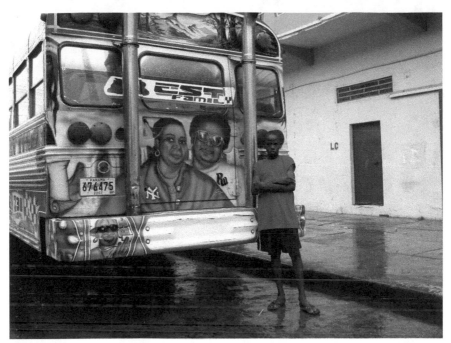

Plate 24. Afro-Panamanian "double consciousness." Popular art and other manifestations of Afro-Panamanian culture are filled with references to the broader diaspora. Colón family portrait by Carlos Benjamín Álvarez Espinosa (2008).

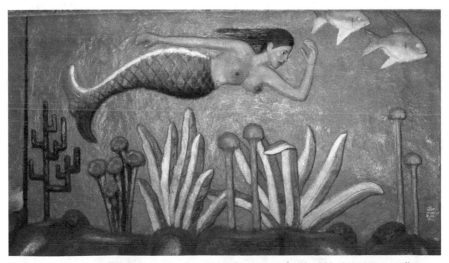

Plate 25. Detail of a wall decoration by Oliver "Bruzolli" Bruce at the Hotel Ideal (2008). Bruzolli was a prolific popular artist who specialized in the decoration of commercial establishments. His works include the famous La Cascada restaurant. His former assistant, Leonardo Ávila, recently retouched Bruzolli's sculptures at the hotel.

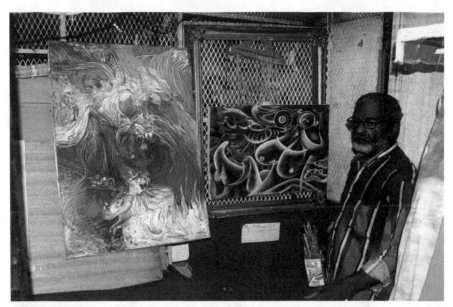

Plate 26. Víctor Bruce in 2006 at the Plaza 5 de Mayo Craft Market. Bruce is a pioneer of popular art. He learned to paint making signs in the U.S. Canal Zone.

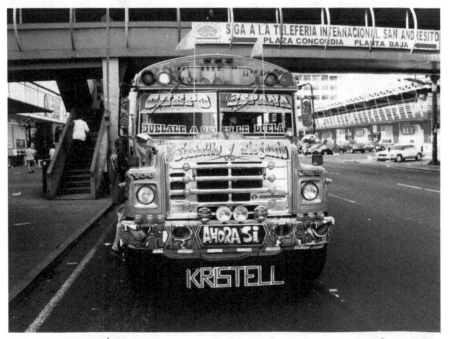

Plate 27. The buses of Óscar Melgar are among the most visually intense and often boast flags, swinging signs, and fancy grillework. "Simple and Elegant" (2005).

4. "100% *PRITY*"

The Aesthetics of Panamanian Popular Art

Streamers from the mirrors, flashing lights across the grill work, salsa from the
tapedeck, elaborate lettering for signs and slogans, and painted decorations
everywhere . . . transform the humble school bus into a Panamanian work of art!
MOIRA F. HARRIS, *Art on the Road*

Visitors to Panama City often take note of the red devils, the old but elabo-
rately decorated school buses that investors import from the United States
and that serve as the community's basic form of public transportation. Most
observers have emphasized their unruly qualities and their capacity to provoke
and draw attention to themselves and even to take possession of the areas
which surround them. A recent article commented on their "thunderous" muf-
flers, their "visual overload," and booming "stereo systems" which, according
to this essay, were able to "wake the dead."[1] Another writer suggested that the
capital's upscale neighborhoods seemed so similar to Miami until these "school
buses . . . barrel down the streets."[2] The red devils are loud, vibrant, and ag-
gressive, and they rarely go unnoticed in the districts through which they pass.
Their deafening horns alone are enough to scatter pedestrians and to send oth-
er motorists scrambling to get out of their way. This powerful presence is not
an accident but rather is the consequence of a deliberate effort to project an
image and to compete for customers. The bus system in Panama is a private in-
dustry and has traditionally been dominated by dozens of small businessmen
who usually own a handful of vehicles and must literally race against one an-
other for their profits. These owners hire artists to help improve their chances
in the full-throttle dashes from stop to stop. The eye-catching paintings pro-
vide a sense of bravado. They hide the vehicles' age and humiliate opponents
while disguising their former function of transporting schoolchildren.[3] The
result is what another observer described as "mobile works of art," imagina-
tive and vivid creations by local painters who are largely self-trained in their
discipline and yet who must be considered professionals in this area.[4] Versions

111

of these roving galleries have existed for over half a century, becoming "one of the most characteristic aspects" of Panama City, according to an article published in 1954.[5] Three decades later, a U.S. academic studied the tradition and confirmed that "Panama, perhaps more than any other Latin American country, lays claim to the most decorated buses."[6] This chapter will analyze the aesthetics of this custom with the aim of providing insights into Panamanian identity and the breaches and struggles which have beleaguered its definition.

I will argue that the red devils have a wider function and that their flamboyance is more than a simple marketing effort to grab passengers visually and entice them to pass through their doors. In fact, the commercialism of buses has also served as an avenue to contest social marginalization and the official notions of Panama's ethnicity. Popular art is a creation of the country's modernization. It arose in the Canal Zone and benefited from the U.S. economic presence, and like other such outgrowths of colonial and neocolonial development, it has provided a means of launching alternative visions and contesting the values of the lettered city.[7] The bus paintings in particular represent an Afro-Caribbean genre that defies long-standing assertions by Panama's leaders that their country is a purely mestizo society whose roots are Spanish and indigenous in origin and that is becoming more "civilized" through this process of ethnic blending. If Méndez Pereira and others envisioned a light-skinned republic, especially as Anayansi succumbed to the charms of Balboa, the effect of the red devils has been to assert blackness, independent and apart from this depicted racial mixing. In addition, they have undermined the patriarchal values, described in chapters 2 and 3 of this publication, and associated with the elite conceptions of nationalism.

To do this, the bus painters have drawn on traditions of "plebeian culture" long associated with Latin America's African population and its migration to cities during and after slavery.[8] In these communities, music, dance, and the plastic arts had often served important collective functions. They had long been associated with rituals and spiritual practices, but they took on particularly public forms in urban areas, where people of color generally benefited from greater freedom and where they staged loud performances to defend and expand their autonomy. The "black show-offs" of Cuba are a classic example, as described by David Brown in his study of nineteenth-century Havana. Dressed in hybrid and fancy clothing, they paraded through the streets in a forceful manner, defying easy social classification and creating "alternative structures of authority."[9] Similarly, the red devils attempt to "kill the others in beauty," according to Andrés Salazar, one of the most influential painters. Salazar defined the bus style as "100% *prity*," creolizing an English word from a popular television program and demonstrating the genre's theatrical qualities as well

as another aspect of its Afro-Caribbean character.[10] This trait is what some have depicted as its tendency for "supersyncretism."[11]

Like the black show-offs of Havana with their flashy outfits and jewelry, the red devils rely heavily on eclectic appropriations and less on what scholars have called African "survivals."[12] They regularly incorporate new and varied objects, and unlike Méndez Pereira and other members of the lettered city, they do not envision themselves as defenders of traditions that are too sacred for the inevitability of change. Instead, their works have a "newspaper quality" and are constantly integrating aspects of popular culture with more conventional Panamanian elements.[13] Bus art, according to Salazar, is a "lot like fashion," relentlessly scrutinizing the world of politics, sports, and entertainment and incorporating succeeding fads into its constructions.[14] If the resulting works seem copied or highly derivative, they are also often imaginative, subversive, and original. Much like Derek Walcott's discussion of European Carnival and its transfer into the Caribbean, "these forms originated in imitation . . . and ended," as he insists, "in invention."[15] Indeed, their objective is to destroy rather than to defend the old structures. In Panama, the compositions create a sense of extravagance and add to the red devils' projection of nonconformity. Laden with imagery, the vehicles are impossible to ignore, especially given their frequent use of public figures and the "prestige" that these portraits lend to the paintings.[16] This visual lavishness is connected to rhythm, a final critical aspect of the genre's Caribbean nature. While Méndez Pereira and his colleagues had valued order and predictability, the orientation of these artists seems more improvisational. They situate their paintings within complex rhythms that scholars have also defined as characteristic of the broader region and more generally of "Africanized cultural space."[17]

Robert Farris Thompson calls this trait a "propensity for multiple meter," an inclination to create and mix competing cadences in dance, music, and the visual arts. In this regard, Thompson especially emphasizes the function of motion and its centrality to African diasporic aesthetics.[18] On the buses, the most obvious motion is the literal movement of the vehicles which often navigate the streets in a daring manner. Indeed, observers have tended to highlight this recklessness and have described it as a kind of dramatic performance, which vibrant colors and patterns only embolden. The splendid syncretism of the red devils takes on rhythmic forms, their cadences complemented by the vernacular expressions painted on the front and back ends of the buses and in other prominent locations. Adding to what might be called these "metarhythmic" structures is the loud salsa or reggae booming from powerful sound systems and muffling the shouts of the driver's assistant, who directs passengers and calls out the vehicle's destination.[19] More recently, Panamanian *típico*

and Dominican *bachata* often assail the ears of those on board and add to the variety of the selections. The result is a compelling "multisensorial" experience closely associated with African musical expression and capable of astonishing and delighting its viewers and drawing them steadily into the spectacle.[20] The Caribbean artist is often a dazzling showman who "desacralizes the cannons of classical beauty" and who blurs the distinction between the stage and the audience.[21] The Panamanian bus artists fit into this tradition. They have created an aesthetic form that weakens established norms and that asserts and propagates the isthmus's Afro-Caribbean culture. This capacity is rooted in a collective conception of art and in a willingness to use it to attack the existing social hierarchies.

COMMUNITY AND PANACHE

Scholars have emphasized the diversity of African artistic manifestations and the difficulty of treating them as a single entity; however, they have also offered some generalizations concerning their development and their philosophical principles. Among other things, they have highlighted art's "functional" role in the religious, governmental, and economic life of the region.[22] "Art and ritual are integral to each other," wrote the authors of a well-known study on Yoruba aesthetics, and while this position has recently received strong criticism from those who insist that precolonial Africans also created art for personal pleasure, much of the evidence still suggests that artists were less concerned with producing for individuals and more with supporting the broad structures of their societies.[23] Generally they fashioned pieces for their religious and political leadership as well as for everyday life and the wider organization of their communities. Especially important was their role in preparing materials to mark the process of female and male initiation, the ascension of a ruler, or other important events. Thompson and others have emphasized these performances and the close connections between dance, music, body decorations, textiles, and sculptures. The traditional African festival mixed and blended art forms, all of which acted in the service of the whole.[24] Art, by its nature, is a communal phenomenon and generates a relationship between its author and audience; however, in precolonial Africa, this link was particularly strong, as few aesthetic creations seem to have emerged in isolation but were connected to other functions and consequently adopted a collective or public quality. Peter Manuel notes how African music often involved all members of a community, who clapped, played instruments, or sang responses or solos,

and how this tended to foster the notion that "musical talent" was "something innate . . . in everyone, rather than being the property only of specialists."[25]

Africans transferred their artistic notions to America, where slavery inhibited their complete articulation and where Europeans controlled educational and cultural institutions. Educational and cultural institutions were minimal in the Caribbean, where, as Franklin Knight has emphasized in his publications, the planter class did not in many cases create true "settler colonies" but rather founded outposts for the cultivation of sugar and brutally exploited their labor populations.[26] African aesthetics nevertheless persevered even in these environments and emerged across the larger region as "folk and utilitarian art."[27] Africans imprinted their sensibilities on popular culture, an area less controlled by the institution of slavery and one in which their influences consequently flourished, particularly in drama, dance, speechmaking, and music.[28] In these fields, whose practice is also inherently collective and closely tied to religious and communal conceptions, African art took on a theatrical and forceful quality, especially where people were more autonomous and less subject to the restrictions of bondage. Life for slaves in San Juan, Cartagena, and Havana was generally less oppressive than in rural environments, and cities became important centers for "black nucleation," especially following abolition in the nineteenth century.[29] In urban areas, artistic activities often seemed intended to engage an audience and to integrate it directly into the creative process while overwhelming opponents with its loud and potent nature.

David Brown describes this "assertive occupation of public space" and associates it with Cuba's religious festivals and with the black *cabildos* that organized parades on these days. Recounting the Epiphany celebrations of nineteenth-century Havana, he notes how the *cabildos* literally took over the streets and forced the city's bourgeois families into their residences.[30] Carnival and other masquerade traditions became especially important in this sense and best reflect this idea of aggressive performance forged from the Africans' communal conception of art and from their experiences of challenging slavery. African diasporic art questioned the status quo and served, as another scholar has observed, as a "form of mental resistance," a means of contesting the shackles of servitude and the legacies of marginalization that it left in its wake.[31] On the fringes, black performers lampooned and insulted authorities while attempting to create a rival order--what Brown describes aptly as an "alternative structure of authority."[32] This order was often prosperous and lavish, "valuing parties, festivities, and collective celebrations" as well as "unlimited consumption of food, liquor, and stylish clothing." In effect, it was a "reversal" of the slave system and of the hardships and injustice it had imposed on the

Religion and elegance. A scene from the annual fancy hat contest, after Easter services at the Museo Afroantillano (2008).

population.[33] In its construction, the artist became a kind of showman whose own character was spectacular and dramatic in nature, and whose personal stature rose, as a consequence within the community. Brown notes how the ostentatious *cabildo* processions confirmed the position of a "black royalty" who ruled over subjects "throughout the year."[34]

Academics have traced these ideas in a range of periods and areas related to African diasporic culture. They have seen them in the extravagance of the noisy dances that slave populations organized across America on saints' days, Christmas, and other "European-derived days of leisure."[35] These principles are apparent in the posturing of Haiti's *rara* bands, which during Holy Week, march continually through the country and which confront and challenge each other with their performances.[36] Similarly, Peter Wade in his investigations of twentieth-century Colombia notes how black migrants gathered in Medellín on Sundays and filled the city center with their music and physical presence.[37] Hillary Beckles and Brian Stoddart examine Afro-Antillean cricket. They highlight the theatrical play of the athletes and their intense relationship with their boisterous fans.[38] Playwright Gus Edwards offers another example in his discussion of Caribbean calypso and the singers, who are called chantwells. Recalling his childhood days in St. Thomas, Edwards describes the chantwells as larger-than-life characters whose brassy names served to win over an audience

and whose lyrics and call-response patterns further captivated the public. The chantwells joked about sex, their neighbors, and the government and generally attracted attention with their subversive language. Edwards remembers the vibrancy of the calypso artists and how he left "mesmerized" by their shows.[39] In many ways, Panama's bus art has operated in a similar manner. The painters have conceived of their work as a performance that stirs people and earns them prestige and recognition while disputing the traditional organization of Panamanian society. The lettered city erected monuments to instruct the population, but the black painters have created a rival set of symbols with their own priorities, hierarchies, and sense of values.

The power of these markers rests on their "public character," a characteristic that Silvano Lora pointed to as the paintings' "defining attribute." To underline this point, Lora made some comparisons, likening Panama's popular artists to the muralists of Mexico, who adorned the interiors of the government's schools and ministries with scenes of the country's history. The Panamanians have never achieved such a lofty status. They have never been confused with the likes of Orozco and Rivera, and their compositions have generally hung in much humbler quarters. However, Lora is correct in the sense that they have also constructed their works mostly in common areas, such as barbershops, bars, in restaurants, and on buses.[40] In my interviews, I have rarely encountered painters who have dedicated much time to producing for individuals. Few popular artists have taken an interest in canvas panting, as they tend to favor walls in visible locations, a preference that is evident in their contract jobs but sometimes apparent even in their own homes. Chico Ruiloba's apartment in Patio Rochet is covered in eye-catching religious and natural imagery and boasts a large self-portrait on its exterior. In it, Ruiloba adopts a Wolf-like persona. He looks out at the viewer with a knowing expression and sports an elegant hat and a paintbrush tucked behind his ear. The painter's eyes are peculiarly absorbing, and one cannot walk by without staring at the artist.

Monchi's house in La Chorrera likewise grabs one's attention with a vibrant mural across much of its front side. It depicts a cabin in a temperate climate, next to a shimmering stream and surrounded by mountains. Similarly, César Bellido's dwelling in Panama City features a tiger prowling through the jungle, alongside lettering which advertises his services. For the same purposes, Marco Antonio Martínez (1948–) fashioned a seductive dancer in the area immediately surrounding his doorway. The figure, who sways and is dressed in flowing clothing, succeeded in alluring this investigator to the porch to inquire about who had made the image. Panama's popular artists occasionally paint for their own pleasure, and they do not, as Lora suggests, work strictly "in the street."[41] In fact, many of these same buildings have elaborate interior decorations that

Announcing his services. César Bellido's tiger outside his Vía España home (2007).

are intended purely for personal enjoyment. Ruiloba's apartment is especially impressive in this sense, with most of the walls covered with representations of nature, religious themes, masks, and other aspects of Carnival, which for years was his area of specialization. Yoyo even has a studio in his house, where he crafts the acrylic pieces hanging throughout his residence. These portraits and landscapes, however, are an exception and represent a small minority of Yoyo's production, which is primarily aimed at mass consumption. Popular art, as Lora insists, is a communal genre and functions much like African diasporic music, with its call-and-response patterns and encouragement of "collective participation" and its sense that the songs belong to everyone.[42] Similarly, the painters pursue projects in well-trafficked places where the public can witness and comment on their progress and presumably become invested in these experiences. One result has been a continual fostering of talent as youngsters witness and study the example of their elders, eventually deciding to enter the profession. In fact, Yoyo and his colleagues insist on this dynamic. They often underline their role as educators and do not see their creations as purely commercial, but instead, like the drumbeats or dances of precolonial Africa, they represent the patrimony of their community.[43]

"The red devils are our national canvas," noted Harry Paredes (1969–), a now largely inactive painter who was employed through most of the 1990s and who first observed and then trained under Andrés Salazar. In a country where few

people can regularly visit galleries, "the buses promote art and serve to educate the population."[44] In essence, the red devils have supplanted Panama's museums, functioning as an important means of collection expression. "Through the paintings we come to understand ourselves," insisted David Ernesto Rodríguez (1967–), who works primarily in Panamá Oeste, the area sprawling westward of the interoceanic waterway and linked to the capital by a series of highways. "We learn about our lives and sentiments through this medium," Rodríguez affirmed in an interview.[45] Popular art, as Lora indicates, has a "clear social function."[46] It does not serve only private or individual ends, but rather, its practitioners see it as playing a broader role and envision it as the capital's most important artistic resource. And who could dispute the painters' claim with literally hundreds of their galleries circling constantly through the capital as well as Colón and the surrounding communities? Their creations speak to a wide audience, placing themselves solidly within the traditions of Afro-Caribbean aesthetics, especially as they relate to dance and music. Moreover, like calypso and other types of black expression, they do this by exuding a sense of panache, as suggested in the term "100% *prity*."

In using this expression, Salazar revealed that at its core, popular art constitutes a kind of spectacle, designed to amaze and draw attention to the artist, who battles with others for the public's favor.[47] "There exists," as one young apprentice observed, "a war among the decorators," not unlike the rivalries among rappers and *soneros*, bluesman, *rumberos*, and calypso performers, who tend to mock and attack each other while trying to display their superior abilities.[48] Similar "battles of aesthetic virtuosity" pervade Caribbean speechmaking, dominoes, stick fighting, beauty pageants, and card games.[49] Many painters compare their profession to boxing, another activity that is theatrical in nature and a favorite sport in Panama and in the wider Caribbean. The idea is to impress and to beguile fans while subduing opponents with your brushstrokes.[50] The best artists attempt to carve out "territories," where they can control the industry and where their clients and admirers regard them as "idols."[51] Today Cristóbal Adolfo "Piri" Merszthal Villaverde (1979–) is the most active decorator in Pacora, and he has assumed this role in the small village just a few miles east of the capital. Óscar Melgar (1968–) dominates the Tocumen and San Miguelito areas, and "Tino" Fernández Jr. (1961–) is the undisputed leader on the west side of the canal, where he is considered a local hero. Rivals identify their works with fancy signatures, and occasionally they provoke each other with bold pronouncements, asserting that no one can match their *stilo*. Some have also adopted catchy nicknames, while others have even taken to fashioning self-portraits that enhance their prestige among their viewers. Salazar recently depicted himself as "Superman of Color" on the side of a lavish red devil

(plate 10). He holds several paintbrushes in a closed fist, and the lettering below him reads, "Knocking down barriers." Piri painted himself next to the Incredible Hulk and pronounced "how green with envy others become" when he decides to "go into action." Rubén "Chinoman" Lince (1969–), whose imagery is often violent, presented himself as a threatening gangster, around lettering announcing his tattoo services. The owners themselves also enjoy this posturing and vie with one another for the most decorated vehicles. As one businessman emphasized outside the La Chorrera terminal, "Everyone wants to have the flashiest bus." Lavish buses not only can help to increase one's earnings but also instill a sense of pride.[52]

Popular art, as Salazar said, is a "way to express oneself" and to assert what he described as the "ego" against the typical condition of human anonymity. To illustrate this point, Salazar described how he became a painter. Salazar's connection to the red devils began when he was seventeen years old, and a cousin asked him to touch up a fading bus that he operated in Panama City. For some time, Salazar had hoped for this opportunity. He had long been a fan of the showy vehicles and was especially inspired by the talents of Yoyo, Virgilio "Billy" Madriñán, and Rubén "El Precolombino" Darío Coya, whose genius he had witnessed on his jaunts around the capital and whom he had often watched while they labored on projects. Nevertheless, from the beginning, he saw these men as his competitors and had always thought of painting "better than they did." In a sense, he sought to "kill the others in beauty," sentiments repeated by many other artists, who, while recognizing the contributions of their mentors and even rivals, also never hesitated to express their independence.[53] The Wolf Pack is like an enormous family. It is unified by admiration, advice and frequent tutelages, but it is also wracked by conflicts and jealousies. "I made myself," insisted Monchi, the most bombastic of all the people whom I interviewed for this study. Monchi, one of the leading painters in the 1980s and 1990s, gave up his art for three years to drive a taxi and has recently taken it up again, to the delight of his admirers. In an interview, he insisted that while he repeatedly comes up with new ideas to vary the entertainment and capture viewers, the younger generations are "essentially imitators" and tend to "copy" him and other older painters. "I am the first and above all the rest," he insisted with a laugh and his characteristic flair.[54]

The buses of Monchi, Salazar, and other artists brim with similar affirmations of pride and hyperbole. Like calypso or rap singers, they are their own promoters and engage in what a Caribbean musical scholar labels "self-advertisement."[55] In bold statements in both Spanish and English, they assert their "power," their "*tremendo filin*," and "black elegance." In many cases, these assertions take the form of pronouncements, such as "I move into the future, more

brilliant than ever" or "My *stilo* is something you can never buy." Moira Harris has compared these *pregones* to bumper stickers, since they usually appear on the front and rear ends of the vehicles and occasionally command others to "respect" the bus, to "shut up," to "stand back," or to "close your mouth."[56] In other instances, they issue menacing challenges ("I dare you") or warn competitors that "It's gonna hurt." The buses "burst out with expression and attitude," writes another visitor to Panama City (plate 11).[57] The same belligerence is sometimes conveyed in images of gangsters flashing gold teeth and giving the finger. Like performers of rap and early salsa, occasionally they portray the "violence" and "alienation" of marginalized sectors.[58] Hip-hop characters are common on the vehicles, and they strike theatrical poses in their wide shirts and pants, their eye-catching jewelry, and their off-center caps. The buses are full of "obscene decals" and "satanic verses," complained a journalist who applauded the recent efforts to regulate public transportation and to "clean up" the red devils.[59] Anger is a traditional part of the bus decoration and offers an effective means of questioning authority, challenging social norms, and attracting attention.[60] As painter José "Piolo" Ortega (1970–) noted in an interview for this study, the "decorations are essentially designed to attract attention."[61] To this end, many artists have also flirted with vulgarity and with sexual subjects, which have periodically invited the censure of authorities.

In fact, research demonstrates that as early as the 1920s, drivers were baptizing their buses with suggestive names and prompting the mayor of Panama City to issue an order against this practice.[62] In 1954, the variety magazine *Siete* reported that photos of "seminude dancers" often could be found inside the *chivas*, presumably to entertain the young, male passengers who used public transportation to go to school.[63] In 1983, the Museo de Arte Contemporáneo sponsored a competition by the bus artists and carefully reserved the right to refuse those paintings that its judges "considered to be offensive."[64] Today artists such Chinoman Lince often depict women in pornographic postures with grossly exaggerated physical features and erotic expressions. Such images, notes another painter, typically face criticism and are often destroyed by the bus inspectors.[65] Armando Robinson's (1971–) work, as well, seems designed to shock his viewers, although he often presents his material in a more humorous manner. In a scene positioned strategically on a gas tank cover, a bearded and scruffy figure farts while urinating into a toilet. As he misses the intended target, he ponders thoughtfully to himself that "While size doesn't matter, it certainly can help."

In the broadest sense, the buses take on a forceful and even arrogant quality. They boast, disparage, and intimidate others, while they appropriate flashy names and even noble titles. Indeed, the buses are not unlike the Caribbean

singers who declare themselves boldly to be El Malo (The Bad One), the Gentleman, the Queen, or the Prince of Salsa.[66] Julio Arosemena noted in his 1974 study that a number of vehicles had adopted aristocratic pretensions, including the King of Kings and the Count of Montecristo. Mr. Estilo was another flamboyant designation that conveyed well the theatrical quality of these galleries.[67] The aesthetics of Mr. Estilo and other bus creations are fundamentally that of a brazen outsider who engages the public in a vigorous manner to win its approval and dispute his marginalization (plate 12). In this regard, the bus artists fit into a much larger pattern. They reflect the history of African slavery and the Caribbean's propensity for dazzling performers who defy the "canons of classical beauty" and in the process contest their social subjugation.[68] Caribbean art constitutes a challenge to the established order, or what Wilfredo Lamb (1902–82), a leading Cuban painter, once described as an "act of decolonization."[69] Like singers of rap, reggae, and calypso, the buses swagger, strut, and demand recognition, declaring themselves "100% *prity*."

HYBRIDITY

If the expression "100% *prity*" connotes bus art's theatrical and rebellious qualities, it also reflects the genre's use of languages and cultures traditionally considered non-Panamanian. "All the Panamanian cultures are displayed on the buses," observed Óscar Melgar, today the most important and active painter and a onetime assistant to Andrés Salazar who considers Panama to be a "bilingual country."[70] In contrast to the country's official intellectuals, who have presented themselves as the defenders of Hispanic traditions, the bus artists have been far more inclusive in their subjects. Their genre, in Salazar's words, "is a lot like fashion," constantly incorporating the latest fads, themes, and personages and moving, as he says, "to the rhythm of new trends."[71] The art itself is thought to be transient, and its creators regularly paint over older images to assimilate new styles and to remain relevant.[72] Chico Ruiloba periodically recomposed the mural outside his apartment to mark newsworthy events and passing holidays. Monchi, as well, has insisted on this variation, noting that if "one becomes stagnant, the public becomes bored."[73] Such ideas reflect well the "syncretic" nature of Caribbean art, which, as Veerle Poupeye has insisted in his discussions, is characterized by its "hybridity, plurality and open-endedness."[74] Musical scholar Kenneth Bilby has called this the Caribbean's "mingling ethic . . . a conviction that to absorb new, external influences . . . is in itself normal and good."[75] Other observers have emphasized similar trends and have demonstrated the capacity of the appropriated subjects to lend

"prestige" to black artistic expression.[76] They help to increase its visibility and ability to overcome aesthetic and philosophical enemies. In Panama, the bus painters have obviously understood this dynamic. In some ways, they have remained tied to Panama's "traditional" culture. However, they have constantly altered it with eye-catching foreign elements and have submitted these to a process of creolization. The result is a compelling conception of Panamanian society that is powerful and impossible to ignore and that depicts more accurately the isthmus's reality than do the petrified visions of the lettered city. "Panama City," as Stanley Heckadon Moreno writes, "sits on the banks of the Pacific, but its cultural antennas point toward the Antilles."[77]

Some of the most important red devil paintings are located in the area directly above the driver's window and in the corresponding arch at the opposite end of the bus. The front and back ends are the most visible, and consequently they tend to be the most elaborated sections. In fact, even red devils with very little painting often have these parts decorated. What is notable is how frequently these critical sections illustrate aspects of rural life. In most cases, the countryside emerges as an idealized region, as seen in depictions of quaint villages and cabins, sugar mills, farms, and tranquil ranches. Distant mountains and rivers often complete the imagery, suggestive of places now relegated to memory. Harris even refers to them as "landscapes of memory," while Lora describes them as "lost paradises." "They are anchored," he says, "in the yearnings and recollections" of artists who attempt to naturalize the urban environment.[78] Peter S. Briggs is less generous in his assessment. He compares these vistas to the "velvet paintings" for sale on many U.S. street corners and emphasizes what he sees as their derivative qualities.[79]

Apparent in these works is the obvious influence of tourism, which, as Poupeye notes, has had a tremendous impact on the Caribbean and which has often exploited "vernacular culture" to live up to the visitors' "expectations."[80] Faced with the pressure of foreigners and their desires, Caribbean artists have tended to romanticize their surroundings and have often used conventional notions when determining their subjects. The results are these landscapes devoid of danger and bountiful in their fruits and benefits for human settlement and with none of the environmental degradation so typical of the region. They lack what Lora calls the "pitfalls of the tropics."[81] A recent bus by Monchi helps to illustrate this perspective. On the upper section, above the front window, Monchi fashioned a hamlet in the Panamanian countryside, with three red-tiled houses lined up next to each other and with the green and exuberant jungle surrounding the settlement. Monchi depicts a pristine village and offers no suggestion of modernity or of the billboards and strip malls that have cluttered the interior. This portrayal resembles that of *ruralista* literature, with its

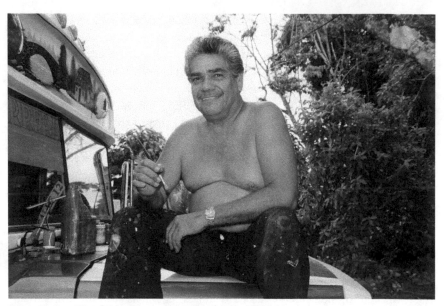

Ramón Enrique "Monchi" Hormi at work on a rural scene in 2004.

emphasis on the colony and its harmonious, paternalistic order, as outlined by Méndez Pereira in his depiction of Balboa. Indeed, morality seems to lie in these visions of nostalgia, occasionally manifesting themselves on other parts of the buses: in paintings of women dressed in *polleras*, Spanish ruins, virgins, religious symbols, and saints. Don Bosco, Saint Francis, and the Virgen de Guadaloupe are often depicted on the emergency doors, as are the Nazareno de Atalaya and Las Tablas's patroness Santa Librada, two of the most important devotional images in the country.

All of these paintings are to some degree suggestive of the traditional Hispanophile identity and its concern for Panama's past and rural culture. Monchi and his protégé, Tino Fernández Jr., are especially inclined toward this imagery, perhaps given their base in outlying La Chorrera, which is less tied to the zone of transit and more attached to the western parts of Panama. Eulogio Herrera Fuller (1965–), who also works in this area, expresses a similar preference for what he calls "national subjects," including "Spanish ruins," the "countryside," and the "Bridge of the Americas," which crosses the canal and connects the interior to the capital.[82] In his view, these topics are most reflective of the nation, a position expressed as well by Héctor Betancourt (1963–), who proudly recalls winning second place in the 1983 Museo competition. Betancourt fashioned a tri-partitioned shield, with separate illustrations of the Bridge of the Americas, a scene of the countryside, and a woman in a

pollera. Betancourt, who entitled his work *Something of Ours*, does not reject the themes of official nationalism.[83] He and others have regularly incorporated the *ruralista* perspective even as they have combined it with other ideas to expand their conception of Panamanian society. *Ruralismo* is apparent on many parts of the buses; however, it is remarkable how frequently the painters alter its assumptions by moving its scenes to unfamiliar territories or by combining its visions with newly appropriated elements. Afro–Latin American art is characterized by its "antidogmatic" nature, insisted Gerardo Mosquera in an important publication, and it is notable that the popular artists are not rigid in their presentations, but rather they alternatively ignore and utilize *ruralismo* and frequently tie it to novel contexts.[84]

Yoyo Villarué is the country's oldest bus artist and has been decorating the vehicles since the early 1940s. Villarué spent part of his childhood in Colón province, where his parents directed the public school in Nombre de Dios. This experience seems to have had a great effect on Yoyo, and as a consequence, he often paints scenes from the Caribbean rather than from the Azuero Peninsula, the traditional focus of Panamanian nationalists.[85] This shift in geographic location is of great significance, as Yoyo assigns ideals long associated with the interior and its imagined mestizo population to the Atlantic coast and its black inhabitants. In fact, his work so frequently focuses on this area that one might justifiably describe him as a painter of the Caribbean, which he depicts in dazzling colors serving to stun and to draw in his audience. Similarly, Yoyo's son, Danilo (1952–), focuses on the ocean, and his cartoonish representations of bathers, fish, and boats also suggest strong ties to the Caribbean. It is revealing that Silvano Lora, in his seminal article on popular art, insisted that "for the painters, Panama is above all the ocean" (plate 13).[86] This value is unusual in Panama's artistic production and has not been similarly emphasized by the country's official intellectuals, who have always preferred the isthmus's villages, particularly those of the Azuero Peninsula. Other bus painters present bucolic scenes that are entirely foreign in their content or landscapes that are more the product of the imagination. Harris fittingly describes these as "dream destinations abroad," and in many cases, they represent mountainous areas that seem more like the Alps than the modest Cordillera Central.[87] Monchi, for example, often portrays quaint alpine cabins in fall forests next to shimmering streams. Imposing medieval fortresses sometimes replace these cozy lodges, again suggesting an effort to defy the isthmus's climate and to transport the viewer to a more temperate environment, perhaps to Germany, to France, or to Switzerland.[88]

Other painters focus on well-known urban landmarks, presenting the skyline of New York City, Paris's Eiffel Tower or the Arc de Triomphe. The

Taj Mahal and the Roman Coliseum have also appeared above many window shields, as have Mount Rushmore and the Great Wall of China, the Golden Gate Bridge, and the Leaning Tower of Pisa. Rolando González (1973–) and Chinoman Lince, along with many other younger painters, have specialized in more surreal visions, often of a masculine or even hypermasculine quality and apparently inspired by fantasy and science fiction movies. *Lord of the Rings* (2001–3) and *Harry Potter* (2001–9) seem to have especially influenced them.[89] They fill the front and back ends of their red devils with paintings of warriors with fantastic weaponry, wizards, kings, and fire-belching monsters. Chinoman's compositions are particularly powerful, provoking one of his colleagues to describe them as "nightmares" (plate 14).[90] The bus artists then have not limited themselves to Panamanian territory. Instead they have combined domestic with exotic locales, and even when asserting the nationalist idea that the countryside is somehow more virtuous than urban areas, they have often shifted the focus to different parts of the country, such as Yoyo's Caribbean coast. Nothing seems fixed in these striking landscapes, other than the continual disposition to seek change. It is what Paul Gilroy describes as the "changing same," evident in many forms of African diasporic music.[91] In the art world, Poupeye and others have referred to this phenomenon as "creolization," a Caribbean tendency to mix old with new elements that "maintain their identity to varying degrees."[92] Closely related to this syncretism is a reliance on what one artist referred to as the "bombardment of the media."[93] The bus artists, in contrast to the nationalist intellectuals, are incessantly adjusting their subject matter to reflect the ongoing events, personages, and media of their periods. The idea, as many have suggested, is to draw in the public and to make the vehicles exciting and visually dominant. The images are well known and easily recognizable and lend their strength and prestige to the buses (plate 15). "Even if you manage to track down the Contemporary Art Museum," wrote a recent visitor to the capital, "the exhibitions pale in comparison with what's . . . on parade through the streets." Over the years, others have expressed a similar sense of astonishment with the capacity of the red devils to incorporate "cultural icons" and to integrate them skillfully into their works much like the masks and sculptures of a traditional West African festival or symbolic representations of southern folk art.[94]

During World War II, an author from the United States was surprised to happen upon the photos of Winston Churchill and Franklin Delano Roosevelt hanging inside a captivating *chiva*.[95] A decade later, a local journalist commented with a similar sense of amazement at the buses' use of the radio and film industry to make their presence felt in Panama City. Most *chivas* boasted catchy nicknames, which were taken from the movies, from popular songs, or from

the compelling sitcom of the moment. "False Kisses" and "Sinner" were two such designations suggestive of the close ties to the entertainment industry. Print media was also important at this time, so the *chivas* were full of "magazine and newspaper clippings . . . of the most famous actors, boxers, and national and international baseball stars." Beny Moré and other Cuban musicians made their appearances on the vehicles, just as Fidel Castro would do in the early 1960s. All of these things contributed to the *chivas'* magnetism, which was their central characteristic and which made them a "true institution" of the capital.[96] In the early 1970s, another investigation reaffirmed the allure of these same elements, commenting specifically on a bus named "Marshal Dilo," "which although orthographically incorrect . . . honored the TV series 'Gunsmoke.'"[97] By this time, television had become another source of inspiration, and its heroes and villains frequently found their way onto the red devils, particularly onto one of their most conspicuous locations.

Since the early 1960s, Panamanians had been importing U.S. school buses to replace the dwindling number of dilapidated *chivas* and the *busitos* that had become popular in the mid-1940s. The emergency doors of the new models, which are still seen throughout Panama City, provide what Briggs describes as a "flat space large enough for detailed and highly visible paintings." Indeed, the dimensions are similar to those of a large canvas, while the borders afford a natural frame.[98] In many cases, a pair of vertical exhaust pipes outline the picture and increase the roars from the engine. When the Museo de Arte Contemporáneo organized its 1983 exhibition, artists decorated these doors for the competition, indicating their stature in the aesthetic scheme of the buses.[99] The back entrance had become the genre's signature work, and as Briggs carefully documented, the majority of these pieces emanate from themes in popular culture. Briggs, who conducted a large survey of the subjects, reported that nearly 33 percent were derived from U.S. sources--typically from music, movies, and television programs. Another 43 percent depicted "Panamanian or Latin themes," again largely taken from the media.[100] Today sport heroes, political leaders, singers, and actors are still some of the most preferred subjects, whether these be foreigners or natives of the country. Usually they appear in the frontal and symmetrical positions, often associated with traditional African sculpture or with the works of southern vernacular artists.[101] In my own wanderings, I have seen people as varied as Victorio Vergara, a celebrated Panamanian accordionist; Jennifer Lopez; John Paul II; and legendary salsa singer Héctor Lavoe, starring out from the ends of buses. Rapper 50 Cent has recently appeared on an emergency door, as have Shakira and Mexican star Belinda, Panamanian reggae artist Japanese, Matt Lauer, and Brazilian soccer star Ronaldinho (plate 16). Sometimes their countenances appear smiling,

While celebrities grace the backs of the red devils, so do the spouses and children of owners. Bus owner Sergio Escobar and his son pose before a portrait by Óscar Melgar (2008).

but they usually bear the "cool" or "pursed-lipped dignity" that Robert Farris Thompson associates with West African statuary. Heads are the traditional focus of the region's carvers, and the buses are filled with many comparable portraits, usually of domestic and international celebrities.[102] In other instances, it is the owner's wife, son, or daughter, whose face is plastered on the back of a vehicle and who, for several years, circulates about the capital, disputing the official iconography of the republic.

The red devils are improvised and ultimately open-ended. Like many other elements of Afro-Caribbean culture, they spurn the rigid nostalgia of the state-supported intelligentsia, and instead they exhibit what one musical study has described as a kind of "newspaper" quality. Similar to calypso and to Haitian rara, they often relate "things which happen from day to day," and they exploit the prestige of these adopted elements to entertain and command the public's attention.[103] Indeed, who could ignore a portrait of Xena the Warrior Princess, the fierce and striking character of a long-running television series, as she brandishes her sword in her silver-studded skirt? And who would not similarly glance at a depiction of Rocky Balboa as he positions himself to knock

down one of his opponents? Such portrayals have led some to suggest that the tradition is overly imitative and lacking in taste and artistic merit. This is essentially the position of Peter Briggs who, in his rambles about Panama City, saw little of worth in the bus paintings and emphasized what he felt were their kitschy and plagiaristic qualities. "There were no experiments," he wrote, "in visual expression," but rather most images simply "mimic other arenas of . . . mass culture." Briggs was especially disdainful of a Willie Colón portrait which, according to him, was "copied directly from a record album . . . commonly displayed in the stores."[104] Undoubtedly, Briggs could have identified many other "reproductions," just as today one can find numerous things taken from magazines, movies, and the Internet. Proletariat art often has an iconographic and derivative quality and has traditionally suffered from these accusations of its "unauthentic" character.[105] However, what such assessments fail to address are the vehicles' many imaginative aspects, their not infrequent use of inventive subjects and their creative adaptation of appropriated figures. "The artist," as Gerardo Mosquera writes in an article on Afro–Latin American aesthetics, "will slightly 'de-westernize' western culture . . . by molding it according to non-western views."[106] Celine Dion, for example, stares out from the back of a Salazar bus, her fair countenance framed by vibrant geometric shapes, bold lines, caricatures, and catchy phrases, all of which make the subject different from the original. Likewise Salazar's portrayal of a U.S. professional wrestler renders him virtually a Panamanian. "The Rock" appears on the back of a bus, framed in waves of motion and color that maintain his image and its visual power but that contextualize him brilliantly in local society. The painters stage their work amid elaborate and vivid cadences which, like talented bands covering the songs of other musicians, subvert the source to offer something original.[107]

RHYTHM

Critical to this subversion is a "propensity for multiple meter"--what Thompson sees as a broader tendency for African diasporic artists to foment complex beats and to weave them ingeniously through their constructions. In this regard, Thompson is especially adamant about motion, and he insists that African art is often designed to move, in contrast to the bronze monuments of the lettered city. Traditional masks and sculptures are worn by dancers participating in community festivals.[108] Other scholars have noted the centrality of rhythm and have insisted on its ability to creolize foreign forms and to generate "Africanized cultural spaces."[108] Richard Powell describes what he calls the "blues aesthetic" in modern African American visual culture and its strong ties

to black popular music.[110] Peter Wade's investigations are also illustrative. In his initial book on race in Colombia, he demonstrates how many of the country's black dances are actually rooted in European forms, and how slaves and their descendants dramatically altered these genres with their syncopation, drums, and call-and-response patterns.[111] The same commentators, who have described the buses as a public spectacle, underlining their forcefulness and syncretic qualities, have also highlighted the red devils' use of rhythm.[112] The red devils project a multitude of pulses, layered over one another in a "kind of collage sensibility."[113] They launch and entwine these through their booming stereos systems, their rapid shifts, paintings, and linguistic expressions, enveloping the viewer and drawing him or her into the show. Ultimately, the spectator participates in the creative act, much like the tourists on New Orleans's Jackson Square, who clap and sway to the music of the brass bands and who ignore the nearby war hero's statue. In a similar manner, the red devils propagate Panama's black culture. With their powerful and "multisensorial" rhythms, they render impotent the monument to Balboa and other urban fixtures of mestizaje as they metrically trumpet their own sense of Panama.[114]

The most palpable rhythm, of course, is the actual operation of the buses, which tend to zoom about in a reckless manner and whose frantic movements are complimented by roaring mufflers, screeching brakes, horns, and deafeningly loud whistles. Multihued streamers whip violently from the hubcaps, and often a klaxon, more appropriate for a sea vessel, warns others to get out of the way. The red devils compete forcefully with one another for passengers. Ticket sales traditionally have been the basis for salaries, and the result is what another writer observed on a busy corner: "When the traffic light changes," she wrote in 1987, "the buses rush forward as if on a race track."[115] Sudden lane changes and intimidation are also part of this behavior, sometimes resulting in fatal collisions. A May 1997 issue of the national daily *La Prensa* reported that more than forty people had already died that year as a result of bus accidents.[116] The same source recorded that in 2001 the red devils were implicated in 3153 crashes, while incidents involving trucks and other large vehicles totaled just 755 for the entire country.[117] "Like our national politicians," complained a bitter critic of public transportation, "those red devils act as though they are immune from the law."[118] In fact, they seem to have created an alternative legal system, becoming, as the earlier observer noted, the "owners of the streets."[119]

When they arrive at a stop, the red devils come to an abrupt halt, and the *pavo* or turkey springs from the entrance to hold back those waiting to get on board and to allow those exiting to leave rapidly. Quickness at these points is seen as critical in allowing for a profitable journey through the city, and sometimes the red devils refuse to halt and force their customers to jump

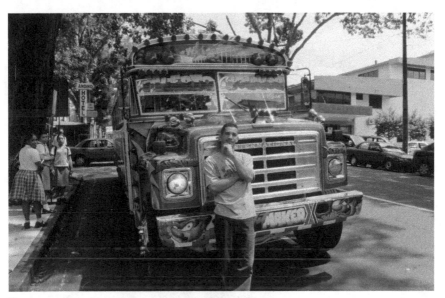

The *pavo*, another part of the red devil show (2008).

dangerously from the doors or to leap up the steps, while the vehicle is still rolling. In rhymes, the assistant announces the destination, and he calls out to those entering, "Pa'trás, pa'trás, pa'trás" (To the back, to the back, to the back). The objective is to load the cabin to its capacity, prompting one journalist to compare the buses to the trucks used to ship cattle to market.[120] During peak hours, passengers sit three to a row, and the aisles are often full of people who lurch and sway with the jerks of the bus. Vivid and multilayered designs serve to embolden these patterns and add to the vehicles' "collage sensibility," so characteristic of Caribbean and Afro-American cultures and closely related to their musical and religious traditions.[121]

In the interiors, small paintings decorate the front and back ends, mimicking the visual scheme on the outside of the vehicles. They appear in the arches, next to the ceiling, and normally portray landscapes or celebrities. Other times, they present witty adages that are designed to provoke and engage the customers. Salazar has traditionally employed these spaces to depict the faces of famous salsa singers, while Yoyo has used them for his representations of the coast. The area around the driver is especially ornamental and swirls in a clutter of trinkets and decals and usually some form of religious imagery. Here is the legacy of the older *chivas*, which, according to the author of a 1954 article, were crammed with clippings and with other adornments. In a photograph taken for the essay, several men sit near a jumbled dashboard whose complexity

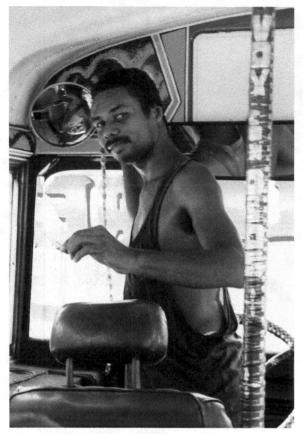

Eulogio Herrera Fuller decorating the interior of a bus. Fuller works primarily in the communities to the west of the Panama Canal (2001).

resembles that of a Santería altar and whose baroque style is typical of Afro–Latin American religious expression, with its use of eclectic and often improvised materials. The recycled or "found object" is a well-known element of Afro-American art.[122] Agustín del Saz witnessed the same decorative tendencies inside Colón's working-class homes in the early 1940s.[123] Today small statues of Jesus and the Virgin Mary are often displayed below the windshield. They can stand next to things as incongruous as a sticker of Garfield the Cat, Che Guevara, or the Peace Corps logo.[124] Commercial symbols also make their way into the buses, although they generally do not advertise products, but instead they are intended to increase the prestige of their bearer. I have regularly seen trademarks for clothing and tennis shoes, radio stations, sports teams, and automobile companies. Adding to the interior's sense of convolution are the

steering wheel and the pole near the passengers' entrance. Each of these are covered with combinations of colored tape, giving them the "rhythmized" or "checkerboard" appearance that Thompson associates with Mande textiles and that he views as a centerpiece of Afro-American visual expression.[125] The gear stick is also similarly decorated and is sometimes topped with a shiny pool ball (plate 17). Outside, other undulating or geometric designs are painted on the vehicle's bumpers. They encircle the hood, the door, and the emergency exit, and artists wrap them cleverly around the lights, effectively stretching their spherical forms. Longer strips extend along the curved rooftop and normally encase the red devil's name, which is itself fashioned with flashy lettering and is often derived from a movie or song. "Afrocentric zig-zags" cover most of the spaces not used for the larger portraits, and usually they are interspersed with smaller lively creatures or gangster-like cartoons who grimace and pose and who occasionally make obscene gestures at the public.[126] Images are stacked upon images in the buses, contributing to the overall sense of motion.

The best painters sometimes place these personages on the edges and other rounded parts of the vehicles, further creating a sense of plasticity. Forcefulness is clearly a part of the red devils, and sometimes flames even burst up from the wheels, suggesting that the buses are literally burning with energy. Nevertheless, gracefulness and subtlety can also appear in these works, particularly in these more marginal places. Óscar and Salazar are especially talented at fashioning willowy women and fleshy creatures along the outside sections of the bumpers or in the arch which runs to the left of the doorway (plate 18). The buses' long sides, by and large, receive less attention. Major compositions occasionally appear in these sections, but they usually are reserved for simple sinuous bands that combine several lines of luminous colors and that stretch from one end to the other (plate 19). Windows are also frequently painted, and lacy, curtain patterns were once common on the back ends. Capira's Ancelmo "Chemo" Chávez Castro (1962–) is a master of these combinations, which add to the red devils' syncopated quality. The colors themselves are dazzlingly intense and gleam like the "finishing in much tropical African and Afro-American sculpture."[127] They play off the isthmus's shadows and intense light, and while red, yellow, and blue are the most popular choices, other tones appear and add themselves to the mixture, contributing further to the sense of fluidity (plate 20). "All the colors of the rainbow . . . blow like vapors through the streets of Panama," wrote another observer given more to poetic expression.[128] The effect of this brilliance is, of course, to draw the attention of the viewer who is further engaged by the use of music. Bus art, in general, is intended to "move the public," and stereo systems are probably the most important element that utilizes rhythm and incorporates the audience.[129] In many ways, these songs

complement the paintings, with their equally rich and layered cadences: their piano grooves, claves, congas, and timbales.

Peter Briggs commented that on his 1978 rides, he usually listened to and felt the "static vibrations of maximum salsa . . . played through an inexpensive, undersized and overextended cartridge."[130] Caribbean music has been the traditional fare on the buses, ranging from the mambos and *guarachas* of the 1940s and 1950s to the merengue and reggae of more recent decades.[131] Today, salsa is still frequently heard on the red devils, as are Panama's home-grown *típico*, Dominican *bachata*, and Colombian *vallenato* along with hip-hop and other popular tunes in English. Once I even heard Michael Bolton crooning "When a Man Loves a Woman" through the speakers. The red devils offer a variety of musical genres; nevertheless, all these songs typically are played at high volume and tend to envelop the passengers in their cadences. Disco balls and blinking lamps are also common and visually track the show with their pulses. They light up the grillwork in the evenings and sometimes illuminate rounded skylights on the rooftops. As one observer wrote in the mid-1980s, the passenger finds him or herself so immersed in these varied rhythms, such that "when exiting, he or she leaves marking the beat."[132] Even critics acknowledge feeling "dizzy" after taking a ride on the buses.[133] On other occasions, these roving discotheques affect the entire city, as they literally shake from their sound systems and hurl their noises into the street. In my own observations, it has not been unusual to see couples dancing or rocking tentatively as they wait to get on board. In effect, the red devils produce a powerfully convincing aesthetic and integrate their customers into the nomadic spectacle. In the 1970s and 1980s, smell was even part of the show, as red devils were commonly perfumed by their owners and enveloped their passengers in sweet aromas.[134] The same sensorial experience is achieved by vernacular expressions that add their accents to the visual-acoustic jangle. "No soy moneda de oro pa'caerle a cualquiera" (A gold coin doesn't fall into just anyone's hands), boasted a bus recently cruising the Vía España. Such statements appear both inside and outside the red devils and in Caribbean fashion transform the "onlooker" into a "participant."[135]

In 1973–74, Julio Arosemena and his Universidad de Panamá students conducted a study of these phrases, which are so common in African diasporic expression and which are plastered on bumpers, rearview mirrors, and interior spaces and which exploit grammatical and orthographic innovations, *panameñismos*, and even words in English. Frequently, they speak in double entendre and employ symbols and acronyms to convey their meanings. This art, much like southern vernacular painting, occasionally "wears the mask" to disguise its most "biting commentary."[136] Arosemena and his class recorded more than

"¿Que lo que es?" means "What's up?" in Panamanian vernacular. However, in this context, it might be interpreted as "You wanna piece of this?" (2008).

seventeen hundred idioms, insisting that they be regarded as a form of "urban folklore."[137] For too long, Arosemena argued, Panamanians had ignored their principal cities, viewing them as devoid of national customs while considering the countryside the only source of isthmian culture. "The urban environment is actually bursting with folklore elements," asserted Arosemena, who described the phrases as a form of "popular philosophy." The writings, he observed, cover a variety of topics, ranging from idealism, humor, religion, satire, and love. In many cases, they praise the competence of the driver, the artist's skills, and even the bus itself. They brag about their talents, their style, charisma, and money, and often make boasts about their sexual prowess. An old convention, which is still seen on some red devils, is to paint the names of former lovers in the spaces above the passengers' windows. Not all of the lettering, however, is so macho, especially that which appears below the emergency exit on the exterior of the red devils. Here, the messages often assume the role of a counselor and, in effect, dispel advice to other travelers.[138] "Only remember the past to avoid its numerous errors," recommended one of these more thoughtful phrases. Another insisted that "triumph is only for those who take

risks," while a third suggested that the "wealthiest are not those who own the most but instead are those with the fewest needs." The back ends of the buses sometimes cite biblical passages or quotes from people such as Mother Teresa. Others offer "criticism of social maladies," provoking the reader to think and contemplate their veracity. The result is that the viewer/customer becomes engaged on another level and is drawn further into this rhythmic and appealing spectacle.[139] As Arosemena emphasizes, some expressions are so powerful that they become "recorded in our minds."[140]

The red devils represent a mobile, Afro-Caribbean spectacle. They challenge the conception of Panamanians as a people whose background is purely European and indigenous and who are becoming more "civilized" through racial mixing. Instead, the buses project a forceful sense of blackness that stands apart and defies this official conception of nationalism and its connotations of patriarchy and a benevolent social order. With their loud horns, music, slogans, and vibrant paintings, the red devils blast and defeat their intellectual enemies as they magnify and exalt their presence in society. They exploit the communal traditions of black plebeian culture and its capacity to take over the urban environment. Moreover, they do this while constantly appropriating aspects of television, radio, movies, the Internet, and the print media, which they mix with older nationalist themes. The film stars, athletes, entertainers, and political figures who regularly appear on the sides of the vehicles offer them a sense of prestige and recognition while becoming entangled in the buses' powerful rhythms.

The Panamanian artists display a remarkable capability to weave cadences through their designs and explosive imagery and to wrap these beats around their captivated audiences. The outcome is what Richard Powell defines as a "multisensorial" experience that grabs and draws the viewers into the exhibition and that encourages people to tap their feet to the music and to repeat the metrical verses in the interior of the red devils.[141] In the Caribbean, as Benítez Rojo notes, "something obscure . . . takes away the space that separates the onlooker from the participant."[142] The bus painters fit into this broader tradition, so evident in a well-known salsa ballad by Rubén Blades, the country's most internationally prominent musician and recently Panama's minister of tourism and culture. In "Juan Pachanga," the central character suffers a "betrayal" and loses the woman he loves. He responds to his pain much like the popular artists attack their marginalization within society: He dons two-toned shoes, cologne, and fashionable clothing and spends his time at nightclubs and parties, presenting himself as a carefree dandy. To borrow Salazar's description, he attempts to "kill the others in beauty."[143] As Blades notes, this strategy is, in some ways, successful. Pachanga cannot fully escape his sorrow;

nevertheless, when he walks the streets of his barrio, onlookers are stunned by his elegance, and they instinctively stop and call out to him, "Hey man!"[144] Juan Pachanga, like the buses, seizes and incorporates his audience, displaying the remarkable capabilities of Panama's Afro-Caribbean aesthetics to seduce and to defeat some of its most avowed enemies. This style, as we shall now see, has spread to many other sectors, as the red devils themselves have recently fallen into the decline.

5. CHOMBALÍZATE

Re-Africanization of Sports, Music, and Politics, 1990–2010

Chombalízate was the phrase written on a showy red devil recently working the Panamanian capital and commanding onlookers to turn themselves into *chombos*. The term is a derogatory word for blacks in Panama and is associated particularly with Afro-Antillean culture and with connotations of stupidity, laziness, and licentiousness. In this case, however, the painter had turned it into something positive, much as African Americans in the United States have occasionally converted the n-word into an expression of empowerment by throwing it "right back in their oppressors' faces."[1] The implication of *chombalízate* was that it had now become acceptable or even hip to be considered of African descent. As a consequence, no one should deny or hide one's blackness, but instead should embrace it, celebrate and even flaunt it. The *chombalízate* red devil was clearly doing the former, as it sped down the street with its bright, eye-popping lettering, its vivid imagery, horns, and hard-driving reggae. In the last years, such turnarounds have not been uncommon, as many Panamanians have accepted their African heritage, whether it be of Antillean or colonial extraction, and they have questioned the ideas of people such as Méndez Pereira who ignored the legacies of slavery and the canal and who portrayed the isthmus as a mestizo nation, the progeny of the union between Anayansi and Balboa. Sociologist Gerardo Maloney has helped to document this phenomenon, noting the "serious debates" within Panamanian society regarding the nature of national identity. While some place the isthmus in Central America and insist that its roots are essentially indigenous and European, others are less convinced by this location and point to other factors when they attempt to describe the republic. Sometimes the latter argue that Panama is a "Caribbean country, based on its ethnic and cultural composition."[2] Indeed in many ways, it seems to be severed from its immediate neighbors and to be drifting toward Puerto Rico, Cuba, Haiti, and the Dominican Republic.

Panamanians in the last years have become increasingly divided about their self-image and their racial/ethnic composition. The rifts have not appeared

exclusively among mestizos, whites, and Afro-Panamanians but also involve an ever more assertive indigenous population. There are seven Native American groups in the republic, and since the late 1990s, they have won significant victories in assuring their governmental autonomy. Although their social and economic situation remains precarious, today they boast three provincial *comarcas* and two more at the municipal level. These are areas, similar to U.S. reservations, where in theory, indigenous leaders exercise considerable independence from the republic's central authorities. While the oldest, Kuna Yala, was founded in 1938, the majority were established during the last decade and now cover over twenty percent of the country. Ngöbe-Buglé (created in 1997) alone encompasses nearly seven thousand square kilometers and is surpassed only in size by the Darien, Veraguas, and Panama provinces.[3] Here I will not explore the gains of these ethnicities and their contributions to the growing sense of pluralism, but rather I would like to make some concluding remarks about the rise of Afro-Panamanian identity and its expansion during the last two decades, even as popular art has fallen into decline.

As political and economic factors have weakened the red devil tradition, a black sensibility has arisen in many other sectors and has continued its assault on the lettered city. The depth of these changes is quite remarkable, as the lettered city has itself undergone transformations and has periodically even incorporated certain black cultural elements, including those defined as Afro-colonial, Afro-Antillean, or more broadly as Afro-Panamanian. Maloney notes that writers in recent decades have developed a "new Afro-Panamanian literature" that attacks the racial stereotypes of earlier novels and attempts to represent accurately the lives of black Panamanians.[4] Similarly, Maloney and others have produced a plethora of films and scholarly works on the Afro-Panamanian community. Historical and contemporary inquiries have blossomed in the last years, solidifying the Afro-Panamanian experience within the academy.[5] This interest in African legacies has not been confined to the intelligentsia but has also manifested itself in broader segments of society. Panama, Colombia, Brazil, and other parts of the region are experiencing what George Reed Andrews has described as cultural "blackening," a weakening of the old ethnic paradigms that elevated the conception of a homogenous mestizo population and a strengthening of separate, Afro–Latin American identities. Andrews cautions that these developments are still tentative and are not a simple reproduction of traditional U.S. racial conceptions, as Latin American viewpoints remain much more nuanced and continue to be affected by things such as geography, social class, and the darkness of one's skin. Nevertheless, blackness has become a part of many people's perspectives, even if it has not convinced the majority of inhabitants.[6]

In Panama, this change has exhibited itself in multiple ways, from the growing visibility of a black beauty contest to the expansion of the capital's Antillean Carnival and other celebrations such as Portobelo's Diablos and Congos Festival.[7] The congos and other regional black rhythms now rival the Azuero Peninsula's traditionally dominant dances in terms of popularity and the frequency of their performances, and in general, the history and traditions of the interior are presented in a more complex manner, with greater acknowledgments of their African elements and less insistence on their whitening or transculturation.[8] However, it is in the area of commercial culture where notions of blackness have become especially prominent and are eroding the myth of a unified, mestizo population. In the past decade, professional soccer and reggae music have become hugely popular and have emerged as markers of the Afro-Panamanian community while providing a way for blacks to integrate into the mainstream.[9] Their rise has followed a familiar pattern, expanding from marginal sectors of society through a series of transnational factors typical of the process Andrews calls "re-Africanization."[10]

Much like the self-taught painters of earlier decades, both reggaeton and soccer have gained strength in a broader international context favorable to the advance of African diasporic identity. Each has benefited from the advance of globalization which increased Panamanians' access to the outside media and their ability to travel and experience the racial dynamics of other countries. Hip-hop and foreign athletics have also been crucial in convincing Panamanians of the validity of black-identified expressions and their multiple uses of spectacle, hybridity, and rhythm.[11] Reggaeton and soccer have both utilized these elements and have helped to foment a sense of cultural plurality. The effect on the isthmus's identity is quite remarkable and even has had important political repercussions. Black civic organizations have increased in number and are exercising greater influence on government policy. Consequently, so-called minority cultures are winning key victories and are forcing the expansion of what is considered Panamanian beyond the Hispanophile notions of the lettered city. While self-taught artists cannot be credited exclusively for this phenomenon, they should receive some acknowledgment for their efforts to reintroduce blackness into the nation and to break the monopoly of Anayansi and Balboa. Nationalism, as Florencia Mallon suggests, is a kind of battleground on which people such as the Wolf continue to play a key role even as his particular legacy has weakened.[12]

RED DEVILS TO HELL?

"Panama sends the Red Devils to Hell" was the title of a May 2001 article that appeared in Miami's *El Nuevo Herald* and which celebrated what its Panamanian author described as an urgent overhaul of the capital's bus system. Winston Spadafora, the then minister of Government and Justice, had recently negotiated an agreement with the country's transportation associations. In exchange for an eventual increase in the passenger fares, the bus owners had consented to improve their services. They would submit to a more rigorous system of inspection and would require workers to "shave, tidy up, and wear a uniform." Employees would now attend "human relations classes," and they would eliminate what the essay described as their vehicles' "obscene decals, their satanic phrases, double meanings and references to death." Also prohibited would be the "portraits of naked women," the "flashing red, violet and yellow lights," and the "salsa and reggae capable of breaking one's eardrums." The article voiced the traditional opposition to the red devils and the elite and middle-class determination to impose order on the city, especially after the collapse of the military government, with its strong ties to groups such as SICOTRAC. The red devils, in the author's mind, were a danger to public safety. They were reckless, as evidenced by their numerous collisions, and their art was distasteful and unworthy of preserving.[13] There were numerous other newspaper reports, published around this period, most of which expressed a similar sense of anger and expectation that "those mechanical dinosaurs that have terrorized the capital for decades" were now facing "their final days."[14] While such hopes have not been entirely fulfilled in the last decade, they have been assuaged to some degree, and the expectation is that they will continue to make inroads in the near future.

In the early 1990s, well before the Spadafora agreement, national and local officials had begun these attempts to implement changes and discourage the red devils as part of a broader effort to reform the capital and to endow it with an infrastructure more suitable for its population. There was a sense that the city had grown chaotic and had fallen into disrepair during the military period. Officials particularly hoped to develop a modern transit network by encouraging new investors to enter the market and by weakening SICOTRAC and comparable organizations. The perspective was revealed in a 1993 seminar attended by representatives of the business community, government, and various professional organizations. Participants bemoaned the explosive growth of Panama City and argued for a dramatic restructuring to deal with

the situation. They especially criticized the transportation sector and the small businessmen who had benefited from reforms during the Torrijos period. The owners, according to this viewpoint, lacked entrepreneurial sense, while their equipment was inappropriate and often in disrepair. The eventual hope was to relieve Panama's crowded streets and to decrease the need for vehicular traffic.[15] The Arnulfistas, who have governed twice since 1990, have made the most efforts to implement this vision, as they tend to regard SICOTRAC and other bus associations as unfortunate remnants of the military period and an obstacle to rational urban development. The opposition Democratic Revolutionary Party, however, has also contributed to the changes, undoubtedly spurred on by a series of horrific accidents and the growing public outcry over the buses' safety records and the overall inefficiency of the system.[16] A sensationalist press has helped to fuel the uproar with an endless stream of reports and articles on the irresponsible behavior of some drivers and the challenges faced by average people who must depend on the vehicles to make their way around the city.[17]

Initially, the campaign took the form of new policies that dictated matters such as routes and color coding and what decorations and equipment could be added to buses. As early as May 1991, municipal officials prohibited the use of stereos and other noisemakers in an effort to reduce sound pollution.[18] These measures, by most accounts, were ineffective and were followed by legislation from the national government. In May 1993, President Guillermo Endara signed a law that affected many aspects of passenger transportation, including safety, concessions, terminals, and fees. In general, Law 14 strengthened the Ministry of Government and Justice and its ability to control the bus industry and to provide customers with a more uniform service. The law, which was followed by a series of decrees, took specific aim at the red devils, prohibiting such things as loud engines and exhaust pipes, rims with long accessories, and flashing emergency lights.[19] The creation of the Autoridad de Tránsito y Transporte (1999) helped to implement these regulations, and in 2001, the Spadafora's directives conditioned approval for a fare hike on further changes to the red devils.

These provisions required employees to take mandatory etiquette classes, wear uniforms, and follow stricter operating guidelines. Authorities also insisted on the elimination of images considered to be violent, vulgar, or sexual.[20] In response to a bus fire in 2006, which took the lives of eighteen passengers, the Martín Torrijos government moved to tighten these restrictions with a more stringent transportation law in October 2007.[21] This measure increased the state's ability to extend and rescind concessions to businesses and to reshape the entire network in the city. Less than a year later, the president announced

The domesticated devil? As the decoration of buses entered into decline, Óscar Melgar began to devote himself to studio art, attempting to take the aesthetics of the red devils into this more conventional setting. Óscar collaborated with Mariá Raquel Cochéz on this piece, which is possibly the only red devil ever painted by a woman. The gallery where it appeared, Galería Diablo Rosso, takes its name from the buses (2011).

his intention to remove the red devils definitively from the capital with the creation of a new structure of articulated buses to be operated by two major companies.[22] Torrijos's successor, Ricardo Martinelli, immediately moved to discard this option in favor of a metro system to be combined with a network of corporate managed vehicles.[23] While planning for the reforms remains in preliminary stages, it is likely that some action will be taken in the near future. The probability of change casts a shadow over the industry and discourages investors from spending their money to pay for ornamentations and elaborate paint jobs. Over the last decade and a half, the red devils have come under increasing pressure, and as a result, fewer and fewer buses are adorned with imagery, and artists have begun to dedicate themselves to other activities.

Interviews with numerous painters have confirmed the crisis, while casual observations on the street reveal the dearth of opportunity for people such as Tino Fernández, Monchi Hormi, and Óscar Melgar, who today supplements his income hosting a radio salsa program. Likewise, Tino balances his bus work with less creative projects in shops and other businesses. Monchi, for some time, abandoned art altogether and instead earned his living as a taxi driver.[24] "The decoration is dying," affirmed their colleague David Rodríguez, who, like many other people interviewed for this study, bemoaned the weakening of the genre and what he regards as one of Panama's major artistic traditions.[25] The red devils, in Paredes's words, are Panama's "national canvas," and their waning presence signifies a restriction on the ability of average people to project their conceptions of the country.[26] Even elements of the press have voiced their agreement and have lamented the "demise of a . . . part of Panamanian culture." *The Panama News,* the isthmus's English-language paper, has even called on the government to provide subsidies and to sponsor competitions to revive the practice.[27] Similarly, Estudio1Panamá, a popular website, has asserted that "Panama without the red devils is not Panama" and has insisted that regardless of the changes to public transportation, the new vehicles must boast the same decorations.[28]

Today, at least half of Panama City's buses are minimally painted, and some have so few embellishments that they reveal their old school districts' lettering. Logos from Florida, Georgia, and other U.S. states are now a common sight on the isthmus's roadways. Another frequent sight are the "white elephants" or the "refrigerators," as some people disparagingly call them. These are the modern, air-conditioned buses that over the last decade have replaced many of the red devils. In addition to imposing stricter rules on the industry, Panama's officials promoted the upgrading of the transportation fleet by extending low-interest loans to qualified investors. As these groups acquired new buses through government-backed financing, they did not change them in any significant manner.[29] "You don't decorate a Mercedes," noted Tino, whose business has also fallen among the older owners.[30] Many of these businessmen cite the economic slowdown which plagued the economy immediately after the departure of the North Americans (1999) and which came at a time of increasing gas prices.[31] These changes and hikes in operating costs have been another factor discouraging the painting of the vehicles. The used Blue Bird buses are now fewer in number, and they tend to be less adorned than previous red devils. Nevertheless, popular art in Panama is far from dead.

Indeed, even as demand in the transportation business has declined, many new painters have emerged on the scene and are demonstrating their talents in a range of venues. Chinoman Lince, for example, has taught his younger

brothers how to paint, and the three siblings currently operate a studio/tattoo parlor on the eastern outskirts of Panama City, in the 24 de Diciembre area. The signature of the "Extreme Boys" has appeared on many buses as well as on arms, legs, motorcycles, and bikes.[32] As the red devils decline, their style spreads to other sectors and even has materialized on Panama's ubiquitous cell phones. Piri Merszthal is another of Chinoman's disciples and a resident of the nearby village of Pacora. When Piri is not involved in a bus project, he earns money decorating taxis in his hometown.[33] Similar taxis have appeared in La Chorrera and in other parts of the country. In addition, many painters continue to work in commercial establishments, especially in the lower-income parts of the capital where businesses depend on traditional sign makers. As Yap Sanchez noted in an interview in Santa Ana, he has no problem finding jobs in this barrio, where paintings embellish the walls of many establishments.[34] In San Felipe as well, there is demand for these services, as evidenced by the hand-painted announcements outside a billiard parlor and a dentist office on the Avenida Central. Nearby is a wonderfully adorned *santería botanica* that boasts murals of the religion's principal *orishas*. Even El Rey and other middle-class supermarkets still rely heavily on the artists to create the posters used for indicating prices. Pizzeria Leonardo, a popular chain in the capital, is decorated with Ángel Quintana's cartoons of soccer stars, singers, politicians, and actors. My favorite drawing features a sour-faced Al Bundy, the star of the long-running comedy *Married with Children*) slumped on his couch, with a soda and slice of pizza in hand.[35]

In poorer areas, popular artists have also developed a specialization of decorating hair salons serving the black population. These *barberías* are often bedecked with portraits of movie stars, singers, athletes, and eye-catching designs. The figures usually include Panamanian and Puerto Rican musicians such as El Chombo, Daddy Yankee, and Ivy Queen or U.S. stars such as 50 Cent. One startling example can be found on the Avenida Central where the Barbería Cash Money boasts a mural depicting the reggae singer Kafu Banton and a large portrait of rapper Tupac Shakur (plate 22). On the outside wall, there is a representation of the Statue of Liberty, mixed with other landmarks of New York City. Dozens of ghetto-style salons have appeared in the terminal cities as well as in many other parts of the republic. Today Barbería Black Community offers haircuts just blocks away from David's Parque de Cervantes. Nearby is the colorful Tiburón (shark) Carwash, with attention-grabbing paintings in its interior including one with a spaceship hovering above a vehicle and shooting down rays to make it spotless. Panama's burgeoning tourist industry has also relied on the painters to help reel in potential customers. Hotel Don Tavo in El Volcán has several Jorge Dunn pieces in its lobby, and its exterior is covered

with gigantic scenes of the surrounding forests and mountains. While popular art persists in many such places, it is unlikely that the genre will disappear entirely from the buses, as Armando Robinson predicted in 2001 (plate 23).

The red devils, he insisted, will probably continue into the future, as the older Blue Bird models are sturdier than the white elephants and are better suited for the isthmus's driving conditions.[36] Ironically, potholes seem to be another factor assuring the preservation of the red devils. Today, the bus terminals are filled with the remains of models unable to withstand the republic's punishing roads. Panama, in the past, has attempted to modernize its bus fleet, most conspicuously in the early 1970s, and it is likely that the present efforts will face similar obstacles and will not be fully implemented. As it is designed, the new system will not reach many of the sprawling suburban areas and presumably leave neighborhoods open to smaller operators. Thus in no way is popular art condemned to elimination, as some politicians and journalists have predicted. In fact, some evidence suggests that it may be strengthening. Its aesthetics have appeared in other areas and continue to do battle with the lettered city and its conception of a mestizo republic. Several of these areas include music, sports, and politics.

A RED TIDE RISING

Since the late 1980s, one of the isthmus's most striking developments has been the rise of reggaeton and soccer as expressions of Afro-Panamanian culture. Both have legitimate roots in the black, working-class neighborhoods of Colón and Panama City, but like popular art, they have also benefited from a number of international circumstances that reinforced their value in these communities and eventually their influence among the general population. The globalization of athletics and spread of reggae and hip-hop have been especially important in fostering these traditions and their growth during the last two decades as markers and promoters of Panama's black identity. These factors helped transform what were essentially limited phenomena into practices with a much broader appeal and acceptance. They effectively became symbols of national identity and ones closely associated with Afro-Panamanians.

English football entered Panama in the early twentieth century, about the same time it was spreading through the rest of Latin America as a consequence of expanding foreign investment and increasing contacts with the outside world.[37] The country's first leagues were established in the 1920s, and while they attracted a growing number of Panamanians, they continued to rely heavily on immigrants, especially Spaniards, Central Americans, and

Afro-Antilleans. For most of the twentieth century, soccer remained an urban-based activity and was overshadowed by other types of recreation, as is apparent in John and Mavis Biesanz's 1955 study, which outlines and ranks various forms of entertainment.[38] Cockfighting and rodeo events were most important in the interior, while baseball had also made significant inroads. Baseball had arrived in the late nineteenth century, when the North American employees of the Panama Railroad Company competed against one another in the terminal cities. With the construction of the canal and the increased U.S. presence, locals transformed the game into their national pastime.[39] By the time of Biesanz and Biesanz's writing, baseball was the preferred sport in the capital, where crowds additionally flocked to the hippodrome on weekends and packed into gymnasiums to watch boxing competitions.[40] Soccer had yet to emerge as a prominent spectator sport, as it would become in the 1990s. By this point, the country's preferences had evolved as a result of new international influences, particularly the globalization of the athletic industry and the prominence of soccer in this more general phenomenon.

During the final decades of the twentieth century, soccer entered into its "postmodern" era, a period that sports historians associate with its massive commercialization and its rise in many areas where it had not been as popular. Soccer now took on a truly global character, as coaches and players became connected to a vast recruiting network and the media created an international fan base for the most prestigious European clubs.[41] Panama, as one journalist wrote, "did not escape" the frenzy.[42] Foreign cable channels arrived in the 1980s, and consequently, Panamanians saw the traditional reports about U.S. baseball but also updates on the UEFA tournament in Europe and other prominent soccer events such as South America's Copa Libertadores. The national radio and television stations followed this example and began to broadcast Spanish League competitions, whose players included a growing number of Brazilians, Africans, and other brown-skinned players.[43] These matches became of great interest to Panamanians, much as the World Series had intrigued them for decades. The game's globalization acted to shift Panamanian interests and focused attention on an activity that had long been associated with the black urban population and that was increasingly connected to players of African descent. As a consequence, the sport offered another avenue for the assertion of Afro-Panamanian identity, particularly through the rise of a new semiprofessional league.

The Asociación Nacional Pro Fútbol (ANAPROF) was founded in 1988 and initially, it suffered from numerous legal and financial difficulties as well as internal divisions among its members. The league even endured a brief schism and split into two confederations between 1994 and 1996. The departure of

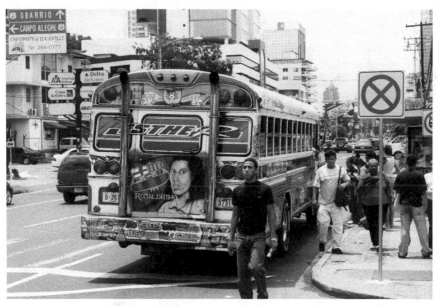

Brazilian soccer stars and the logos of their European teams often appear in places of "black nucleation." Anonymous portrait of Ronaldinho (2007).

several teams, however, was ultimately resolved, and subsequently ANAPROF experienced considerable progress, especially in its most lucrative markets in Colón and the capital.[44] In fact, what is most striking about the rise of professional soccer is its foundation in the terminal cities among their working-class and black populations. It is here that soccer's roots were most extensive and where the globalization of the sport has had its biggest impact, as evidenced by the league's most successful clubs, which include the capital-based Tauro and Plaza Amador and Árabe Unido in Colón.[45] Soccer has less appeal in the more mestizo interior, where baseball continues to be the dominant game and where today there are just two top-level competitors in the professional ranks. The Colón–Panama City corridor houses the majority of ANAPROF clubs in addition to a myriad of youth and recreational leagues, women's teams, and a burgeoning number of soccer academies. It has also produced most of the players who have gone on to careers in Europe and South America and provided the national squad with the majority of its members, many of whom are "descendants of the Caribbean diaspora."[46]

The supporters of the national team are known as the Red Tide, and since the turn of the twenty-first century, their fortunes have clearly been rising, along with the corporate support for their passion. The under-twenty group

qualified for the last three world championships, while the senior players reached the finals of the 2005 Gold Cup before suffering a loss to the United States on penalties. In 2009, they won the Copa de Naciones, which serves as a Central American championship. Each of these achievements has attracted more aficionados as well as investors who understand the sport's marketing potential and whose resources have strengthened the country's "soccer fever" and the visibility of its particularly black style.[47] Indeed, what is most striking about the sport's rise in Panama is not simply the preponderance of dark-skinned players or the large percentage of urban, working-class teams, but rather it is their noticeable use of blackness.

Soccer interests utilize the perceived qualities of Afro-Panamanian culture to gain visibility and sell themselves to their audiences. In this regard, they are very similar to the red devils in that they adopt a sense of rhythm, syncreticism, and spectacle to disrupt the status quo and call attention to themselves. Many players assume brassy nicknames—Roberto "Bombardero" Brown and "El Pistolero" Garcés—and effect the bravado and the showmanship of the buses. The same sentiments of *triunfalismo* (triumphalism) sometimes influence the media and the growing number of fans who crowd into stadiums and occasionally beat on drums to root for their teams.[48] *Murga* or carnival bands are the traditional form of cheering, and they typically play at the more sedate baseball games. *Comparsa* or drumming groups, however, are more customary at the soccer matches and add to their subversive and boisterous atmosphere. The Red Tide is an especially lively rabble, and it invades the capital center to mark its victories. Some observers have commented on the sport's sense of spectacle and compared it to the affectations of popular musicians, particularly the young singers of the new genre, reggaeton, or reggae en español, as Panamanians prefer to call it.[49]

Reggae en español is a type of dance music that emerged in the 1980s in the hardscrabble neighborhoods of Panama and Puerto Rico and which more recently has become a global phenomenon, evolving into a major aspect of U.S. Latino identity.[50] The music is a complex mix of Afro-diasporic rhythms, combining elements of *soca* and reggae with Spanish Caribbean styles such as *bomba* and *plena*. The Panamanian version has relied heavily on dancehall and hence the insistence by many analysts to see it as a separate genre.[51] More recent productions sometimes mix in merengue or cuts of salsa, *bachata*, and even *típico*. Reggaeton is also influenced by hip-hop and is similarly performed by flamboyant showmen who often speak rather than sing their lyrics. In many cases, they have pronounced Afro-Antillean accents and throw English words into the mix. While female artists have recently become prominent, the majority of musicians traditionally have been male.[52] Like soccer players, they tend

to adopt flashy names to self-advertise and demonstrate their sense of impor-
tance. Songs are characterized by their distinctive "dem bow" beat, hypermas-
culine posturing, and depictions of ghetto life. Panama has a prominent strain
of "protest reggae," focusing precisely on the injustices of this existence and
practiced by such talents as Kafu Banton.[53] Eddy Lover and the controversially
named Nigga interpret the genre in a more romantic fashion also typical of
Panamanian reggae.[54] In many instances, the singers treat sexual topics, ad-
dressing these in an explicit manner and provoking the predictable calls for
their censor.[55] Reggae's fans have also contributed to this scandal with their
pelvic swinging move known as the *perreo*. The *perreo* or doggy-style is a pro-
vocative dance in which the female partner faces away from her companion
and rhythmically grinds her buttocks into his groin.

While the *perreo* is more of a Puerto Rican phenomenon, it is not uncom-
mon to see people performing it enthusiastically in Panamanian bars or at soc-
cer games when speakers launch the latest recordings into the audience and
the crowds react to the catchy cadences, especially at halftime or before the
start of the contests. Recreational matches are often more festive, as DJs play
recordings continually during the action, under pavilions next to the fields.
These shelters protect spectators from the blazing sun but also act as infor-
mal dance halls, where young people party, chat, and sway to the beats. Soc-
cer matches in Panama are loud and celebratory events which readily exploit
aspects of African diasporic culture. It is notable that several ANAPROF clubs
and even the national team have adopted reggae-style songs as their anthems
and have supported the use of drumming at their competitions.[56] Drums and
reggae have since spread to other sporting venues and have occasionally creat-
ed tensions among older fans accustomed to the more traditional *murga* bands.
In the meantime, reggae dominates many radio stations and has challenged
the still-ubiquitous salsa, heard on Panama's buses and in its discotheques.
Reggae is another example of a growing black identity and its connection to
various transnational factors. Indeed, the same issues that have given rise to
black sport and art have encouraged this important musical phenomenon.

The roots of reggaeton can be traced back to the 1970s, when DJs in Pan-
ama's Afro-Antillean community, particularly in Colón and the capital's Río
Abajo neighborhood, began to entertain listeners with the songs of Bob Mar-
ley, Jimmy Cliff, and other Jamaican artists. The entry of these rhythms was
the consequence of the connections between the Caribbean and Panama's
population and the broad popularity of black commercial culture.[57] Reggae,
soul, and others aspects of Afro-American expression often took on a politi-
cal significance, similar to their roles in North America's Black Power move-
ments. Early *reggaeseros* often sported dreadlocks and faced harassment from

The Sporting San Miguelito Comparsa at Bernando "Candela" Gil Soccer Stadium (2008).

police authorities, who arrested them and forcibly cut their hair.[58] Such styles were a means to affirm an Afro-Panamanian identity in a society in which the state had discouraged the notion of blackness and had appropriated many of its manifestations into its project of mestizaje. Reggae and dancehall asserted dissent. Like popular art and other elements of black plebeian culture, they affirmed the existence of a separate Afro-Panamanian ethnicity and loudly disputed black marginalization. In the early 1980s, the Panamanians began to create Spanish-language versions and to mix their beats with local and foreign rhythms. *Discotecas móviles* (mobile sound systems) helped spread the genre, blasting the music at a wide variety of events, ranging from *quinceañeras*, weddings, and tame school dances to Río Abajo's more edgy and rebellious parties.[59] Another important market were the capital's passenger buses. Red devil drivers commissioned cassettes that boasted of their style, power, and sexual prowess and attracted customers with reggae's startling hybridity.[60]

A similar process had occurred with the *combos nacionales*, the downsized tropical bands of the 1960s and 1970s that had dominated the isthmus's live music scene and that had combined Afro-Cuban styles with other genres, such as funk, soul, calypso, and rock.[61] Like the combos, reggae en español is

Portraits of Bob Marley abound in urban Panama: in barbershops, in cantinas, and on the backs of buses. This depiction, by Héctor "Totín" Judiño, adorns the exterior of the Bar Paraiso (2008).

a transnational creation inspired by the broader Afro-American culture, especially by the subsequent spread of hip-hop and its astounding global presence. Reggae's early innovators, such as El General (Edgardo Franco) and Nando Boom (Fernando Brown), were the products of Panama's Afro-Antillean community, with its strong ties to the broader Afro-American diaspora. In the mid-1980s, Franco resettled in New York where he would later record his first international hits. Similarly, Renato (Leonardo Renato Aulder) grew up in the U.S. Canal Zone and draws comfortably on soul, R & B, and many other inspirations in the fashioning of his music. Puerto Ricans also figured prominently in these developments and have been widely credited for absorbing new influences and incorporating them into Spanish-language reggae.[62]

Puerto Ricans now dominate reggaeton. However, the music's Panamanian roots are broadly acknowledged, and the isthmus continues to produce a cadre of creative performers, some of whom, such as Mach & Daddy, El Roockie, La Factoría, and Comando Tiburón, have achieved considerable international success. Reggae en español has become wildly popular, and whether performed by locals or their Puerto Rican competitors, concerts regularly draw thousands of spectators. Others play recordings on their iPods and stereo systems and sway to their rhythms in discotheques and bars. Reggae has become another soundtrack of the country, and it projects a "defiant embrace of blackness,"

Reggae en español, the soundtrack of Afro-Panama. *Reggae-sero* Japanese performs a halftime show at Bernando "Candela" Gil Soccer Stadium during a match between Sporting San Miguelito and Atlético Veragüense (2008).

challenging the conception of a culturally homogenous society rooted in the process of European-indigenous mestizaje.[63] Not surprisingly, this identity has not confined itself to dance halls, buses, stadiums, and the isthmus's playing fields, but it has also become manifest in the republic's public affairs. Coinciding with the emergence of reggae and soccer has been the proliferation of Afro-Panamanian community organizations and their increasing influence on the government. These groups, which tend to be more middle-class in nature, have grown enormously during the last three decades, just as elements of the country's music and sports scene have evolved to become more identifiably black. "Re-Africanization" is occurring on many levels--in the country's cultural and political life, and among its working-class and more professional sectors.[64] In an article for the *Historia general de Panamá*, Gerardo Maloney points to a number of factors which are similar to those encouraging the rise of reggae and soccer and which have contributed to this process of civic re-Africanization.[65]

CIVIC RE-AFRICANIZATION

Maloney emphasizes the importance of Antillean-Panamanian leaders and their contacts with societies facing similar ethnic struggles. George Reed Andrews, Michael Conniff, and George Priestley underline many of the same issues, noting the effect of the South African freedom movement and other anticolonial struggles on this middle-class sector, with its strong ties to the broader diaspora. In many ways, Panama's Afro-Antilleans are a transnational population. They are closely tied to other black communities, and especially crucial have been their experiences in North America, particularly upon the negotiation of the 1977 Torrijos-Carter Treaty (plate 24). This agreement, which led to the U.S. submission of the Panama Canal, politicized Afro-Antillean professionals, both on the isthmus and in the United States, and increased their interest in ethnic-based politics.[66] The domestic situation was undoubtedly most critical. Panama's profound economic and social disparities and its entrenched racist structures were the most fundamental issues spurring civic re-Africanization. However, factors outside the immediate national reality again helped to galvanize Afro-Panamanians and encouraged their program of asserting blackness.

Afro-Antilleans and their descendants had always been a major component of the Canal Zone's labor force, and logically, they took a keen interest in the negotiations between the U.S. and Panamanian diplomats in the mid-1970s to determine the future of the interoceanic route. Union officials connected to this sector were generally skeptical of the discussions and feared, with good reason, that any improvements in bilateral relations would likely result in a major sacrifice for their members. There was no uniformity, however, among Afro-Antilleans, and those who were more integrated into local society tended to favor the government's campaign to end the decades-long U.S. presence in Panama. The regime itself was populist in nature, and while its conception of culture remained rooted in the vision of a white/mestizo country, the state opened its offices to black middle-class participation and supported the creation of new civic organizations. Others emerged under more independent leadership, partly inspired by the U.S. civil rights victories, by the struggles in South Africa, and by soul and funk music and other elements of commercial black culture. The groups included the Acción Revindicadora del Negro Panameño (ARENEP), the Unión Nacional de Panameños, Los Doce, and the Asociación de Profesionales, Obreros y Dirigentes de Ascendencia Negra (APODAN). None of them were able to attract mass memberships and to advance in

a significant way their agendas. Nevertheless, they represented what Priestley describes as a major step forward in the isthmus's ethnic relations, as "they all questioned the traditional concept of the monocultural and monolingual nation-state" and proposed a "more inclusive" model.[67]

Simultaneously, Torrijos cultivated ties to Antillean-Panamanian residents in the United States, who had begun to emigrate there in the mid-1950s, especially in the wake of the Remón-Eisenhower Treaty (1955). This accord had dramatically cut Afro-Antillean employment in the Canal Zone and had coincided with efforts, on the part of North Americans, to move non-U.S. workers out of this area and to force them to live in the republic. There, they had faced the prospect of increased taxes, a shortage of housing, and mounting hostility from the country's Spanish-speaking population. Many had decided to leave for the United States, where they had settled primarily in Brooklyn, New York, with smaller numbers in Queens, Manhattan, and the Bronx. By the 1970s, they had reached some twenty thousand. These expatriates feared for their relatives' fate in Panama with the implementation of any new agreement. As a result, they pushed for special concessions, while they generally backed Torrijos and his efforts to secure the waterway for the Panamanians. Indeed, elements of the New York colony became fervently nationalistic, as families insisted on celebrating Panamanian holidays, traveling to the isthmus, and renewing their contacts in the homeland. Several groups were founded to support the canal negotiations while simultaneously insisting on a black identity. Such was the beginning of an ethnic political agenda, which Afro-Antilleans had largely avoided during previous decades in favor of "clientelistic" relations with leading figures and in support of labor, student, and other broad-based organizations.[68]

In the U.S. legislative process following the signing of the treaty, unions and their allies won a series of significant victories for the Canal Zone's Afro-Antillean workers. The Panama Canal Act (1979) provided them with the right to early retirements and to guaranteed residence in the United States. Many subsequently followed their predecessors to Brooklyn where they linked themselves to its large African American population and to New York's multiple Caribbean enclaves. These immigrants also came to witness firsthand the ethnic dynamics of United States. The fight to end white supremacy had long inspired Afro-Antilleans, who had faced U.S.-style segregation in the Canal Zone and whose perceptions were affected by black North Americans whose careers or military service had brought them to the isthmus along with their familiarity with the struggle for racial justice. In New York, Panamanians became more acquainted with these perspectives, and they explored further the merits of ethnic-based politics. At the same time, they took advantage of their

new professional opportunities to obtain influence and affect events in their country.[69] Some of Panama's most talented minds left the country with this exodus, yet a remarkable aspect of their departure has been their ability to stay engaged in Panamanian life even as its Afro-Antillean subculture has deteriorated.

Michael Conniff insists that the signing of the Torrijos-Carter Treaty signaled the dispersal of Panama's Afro-Antillean community and its migration abroad or further integration into the republic. He notes the decline of Afro-Antillean fraternal societies, the closing of the *Panama Tribune* and other English-language publications, and the continued adoption of the Catholic faith by families that had formerly worshipped in Protestant churches. Pondering many of the same circumstances, Carlos Russell, a leading Afro-Antillean activist, later questioned whether his community had become like the "last buffalo."[70] By the time of Omar Torrijos's death in 1981, ARENEP and APODAN had also become inactive as a consequence of internal divisions, and yet a new phase had begun for middle-class, black organizers, who increasingly asserted a broader Afro-Panamanian identity and who reached out to other sectors beyond the Antillean community.[71] At this point, professional activists crossed the same Antillean-colonial divide that the Wolf and his colleagues had previously traversed.[72] This stage was equally tied to transnational factors and drew strength from these outside associations. Maloney points to the impact of U.S. foreign policy and the antipathy many Afro-Antilleans felt toward the North American government's decision to topple the regime of General Manuel Noriega. Especially critical were the heavy-handed economic measures that imposed considerable hardship on average citizens without effecting a political transition. These failures led to the December 1989 invasion, which helped to rouse further the U.S.-based Panamanians, who attempted to inform the North American public about the situation and who lent their support to organizations on the isthmus. Among the most prominent of the leaders were a group of academics and businesspeople based in New York City.[73] They and others supported Afro-Panamanian mobilization, which also benefited now from the backing of foreign foundations and from institutions such as the Inter-American Development Bank and the United Nations Commission on Human Rights. These bodies became ascendant in the 1980s, and they offered their intellectual and financial capital to groups across Latin America committed to racial and social equality.[74]

The importance of such connections became evident in 1980, when Panama hosted the Second Congress of Black Culture in the Americas and welcomed representatives from nearly every country in the region. This gathering, first held in 1977 in Cali, examined many issues affecting blacks in America and

served to validate their presence in Panama. The meeting was followed by a succession of national conferences that further explored the lives of Afro-Panamanians and their particular struggles within a racist society.[75] This growing consciousness of blackness coincided with the rise of new organizations such as the Centro de Estudios Afro-Panamaneños and the Sociedad de Amigos del Museo Afro-Antillano. In the 1980s, these groups tended to focus on cultural issues and avoided confrontations with Panama's military regime. Nevertheless, their exhibitions, activities, performances, and lectures provided an additional impetus to the Afro-Panamanian community, which the Catholic Church was also beginning to recognize.[76]

In the mid-1980s, the church created the Pastoral Afro, an attempt to assess and engage more directly the spiritual sensitivities of black Panamanians. This regionwide campaign, which originated in Ecuador and Colombia, incorporated diasporic culture into religious services and took into consideration the concerns of Afro–Latin Americans as part of a new social agenda. In 1986, Panama hosted the movement's third continental conference in the colonial port of Portobelo, and the effort subsequently became prominent in the Colón and Darien provinces, where the Episcopal and Methodist Churches developed very similar agendas of ministering in a fashion more appealing to Afro-Panamanians.[77] Meanwhile, Rastafarianism bloomed in the terminal cities, with a visible number of young adherents sporting the faith's characteristic beards, cornrows, and dreadlocks. In the 1990s, Panama's Alianza Rastafari became a vocal defender of the black community while deepening its ties to the broader diaspora.[78] At the same time, educational institutions, such as the Universidad de Panamá, strengthened the country's links to the Caribbean. Regional studies associations began to hold meetings in the capital, while the central campus's English department became particularly active and sponsored regular events on Afro-Panamanian and Caribbean literature.[79] In 2001, the rector of the University of the West Indies met with officials at the Universidad de Panamá and signed an agreement to provide for scientific and cultural exchanges.[80] In more recent years, these connections have only increased as Afro-Panamanian leaders continue to organize their community and to pressure the government and private sector for concessions.

Since the U.S. invasion and the return to democracy, the number of Afro-Panamanian interest groups has proliferated, in part as a reaction to neoliberal policies and the hardships these have imposed on Panama's black population.[81] In addition, the support of NGOs and international organizations seems to be critical to their formation.[82] New entities include the Comité Panameño Contra El Racismo, Rescate Juvenil, the Fundación Bayano, and the Respuesta Afropanameña as well as the Red de Mujeres Afropanameñas, the Congos de

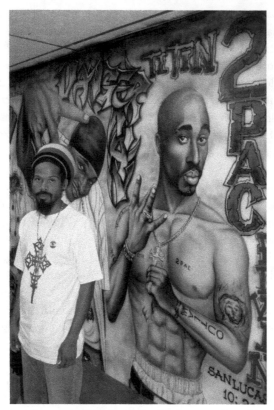

Rastafarian artist Víctor Hugo "Pirri" Rodríguez in front of his
Tupac Shakur mural in Barbería Cash Money (2008).

Panamá, and the short-lived Fundación George Westerman. Abroad, Afro-Pan-
amanians have also continued to form bodies such as New York's Afro-Pana-
manian Chamber of Commerce and the Asociación Afro-Panameña in Atlanta.
The diaspora community has played a pivotal role, as many of its members
have reached retirement age and are now devoting their time and resources
to Panama. Indeed, there is a growing community of returnees who now live
seasonally in the country.[83] In 2001, the Comisión Coordinadora de la Etnia
Negra was created to encourage collaboration between the now numerous
black organizations and to foster a common agenda among their members. In
2003, these groups again came together and organized an Afro-Panamanian
Forum in anticipation of the upcoming presidential elections.[84] Afro-Panama-
nians have never had a separate political party, and many of their civic groups
have revolved around personalities. However, they have also been capable of

considerable cooperation and of exerting pressure to secure a string of recent victories. Many advances have taken place over the past decade, although much remains to be done to incorporate blackness into the nation.

A key victory has been the 2000 designation of 30 May as the Day of Black Ethnicity.[85] The event is enthusiastically observed throughout the country and is marked in Colón and Panama City with a monthlong string of art exhibitions, parades, lectures, food fairs, and concerts.[86] A subsequent executive decree by President Martín Torrijos stipulated that schools participate in the activities and created a commission to encourage their cooperation.[87] The celebration of black ethnicity is a remarkable achievement and has contributed significantly to a growing sense of pluralism, evident in the erection of a 2003 monument which was constructed as part of the republic's centennial celebrations and which honors Panama's diverse immigrant groups. The Plaza de la Cultura y las Etnias was built at the entrance to the Amador Causeway, and it recognizes not only the Chinese, Afro-Antillean, and Hindu minorities but also Panama's Greek, Jewish, and Spanish populations as well as its French, Italian, and U.S. communities. Most importantly, it does not resort to the old mestizaje discourse, but instead it acknowledges the autonomy of Panama's cultural groups.[88] The Afro-Antillean component was further highlighted with the 1998 opening of El Pueblito Afroantillano in a park below Ancon Hill, a place historically tied to Panamanian national identity. El Pueblito was constructed with funds from the municipal government and offers several examples of Afro-Antillean architecture, alongside similar representations of the interior and indigenous areas.[89] Blackness appears here as an exclusively Antillean phenomenon and seems unduly separate from the rest of the country, whose population during the colonial period was dominated by slaves and free people of color.[90] Nevertheless, the site's appearance alone is a remarkable achievement, and it has been accompanied by a string of legal advancements for the cause of ethnic tolerance.[91]

The national and Panama City governments have recently passed the first legislation since the mid-twentieth century to deal with the issue of racial discrimination.[92] Law 11 of April 2005 attempts to address the work environment. The law prohibits employers from making decisions on the basis of "race, birth, disability, sex, religion, or political ideas."[93] The Torrijos administration subsequently established a commission to provide recommendations on the "full inclusion of the Panamanian black ethnicity."[94] Roughly a year later, this body concluded its reports and called for, among other things, the establishment of a "state entity" to focus on issues affecting the black population. President Torrijos acceded to the demands with the creation of a relatively powerless council, and in 2005, he appointed a second Afro-Panamanian to the country's

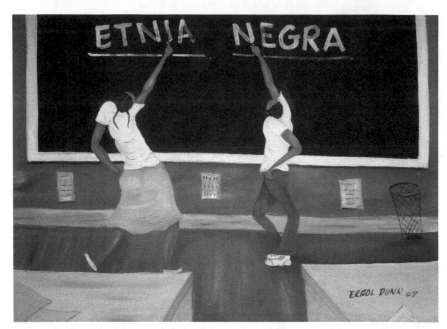

Errol Dunn's depiction of the Day of Black Ethnicity and its celebration in Panamanian schools (2007). Errol is the son of Eugenio Dunn and the nephew of Jorge Dunn.

Supreme Court.[95] In addition, the government agreed to allow absentee balloting, a reform clearly directed at the diaspora community.[96] Nevertheless, Panama still lacks what Maloney calls a concerted effort on the part of the government to reevaluate and emphasize the isthmus's African heritage.[97] The media perpetuates negative stereotypes, while the school system remains under the lettered city's influence and its conception of mestizaje.[98] More troubling is the issue of social exclusion, which continues to be widely evident in Panamanian society.

If Afro-Panamanians have gained a legal and symbolic portal into the nation, this doorway has not yet fostered a meaningful presence. As Priestley emphasized in a recent article, blacks in Panama suffer from persistent discrimination that has been formalized in the business community by a requirement that people generally provide photos when they apply for employment. In 2001, the municipality of Panama City banned the practice for city jobs. Still blacks, as Priestley notes, are "largely absent from . . . the commercial, banking, and financial sectors," and while many have gained access to higher education, "their numbers . . . do not translate into decent jobs."[99] Poverty remains the lot of many Afro-Panamanians, who additionally face the burden of de

facto segregation. It is difficult to tabulate these and other disparities, as ethnic categories were eliminated from the national census beginning in the mid-twentieth century and were only reinstated in 2010 in what some observers describe as a problematic and ineffective manner. Nevertheless, residential areas in many parts of the country seem to resemble those in North America in that they are noticeably divided along ethnic and socioeconomic lines. In the capital, Afro-Antillean descendants tend to live in "high crime, high unemployment areas" such as El Chorillo, Río Abajo, and San Miguelito.[100] Most obvious is the city of Colón, with its largely black and impoverished population. In addition, Priestley notes that the "right to reserve admission" has often served as a means to exclude people of color from certain nightclubs and restaurants. A campaign by the Comité Panameño Contra el Racismo, working with Universidad de Panamá law students, documented many of these abuses and secured the passage of Law 17 of 2002, prohibiting such practices in public places.[101] Stories of police harassment also are common among Afro-Panamanians and represent another area in need of attention.[102] Clearly much more remains to be done to incorporate Afro-Panamanians and to create a true sense of ethnic pluralism. Nevertheless, popular and middle-class intellectuals have made an important start in insisting that blackness be a part of the national identity. Their campaign arose in the mid-twentieth century and exploited many aspects of the imperialist-modernization process. In particular, it benefited from the World War II and from Panama's growing ties to Caribbean culture. As the republic remains tied to similar international influences and to the domestic dynamics fomenting African diasporic expression, it is likely that these conversions will continue into the future and re-Africanization will proceed forward, reshaping the Panamanian sense of nationalism.

APPENDIX
The Wolf Pack

This appendix offers biographical information on Panamanian popular artists. It focuses on those who have adorned the country's buses but also includes a number of people who have not concentrated on the red devils but whose work is closely related. The list is by no means complete. I am undoubtedly leaving out many individuals, as there are literally hundreds of self-taught painters who have been employed in commercial venues. Nevertheless, I have attempted to included the most important of them as well as some of the least-known figures in order to display the genre's basic tendencies. The lives of these creative men are the basis of my study and illustrative of its central arguments. In the listings, I include their artistic names, as these monikers identify them in Panamanian society. The taxi driver who took me to interview Teodoro de Jesús Villarué had never heard of the tradition's "old master," until I referred to him as "Yoyo." Subsequently my cabbie enthusiastically described Yoyo's talents, as he transported me rapidly to his home. Yoyo and his companions are the sons of the Wolf. They are linked together by a lineage of apprenticeships and a sense of aesthetics which they extend even today. Yoyo once told me that popular art will never die, and hopefully this catalog will help prove his statement, demonstrating the practice's transfer from one generation to the next.[1]

ALBERTO ALIE. Alie ran an important commercial art studio from the 1940s into the 1980s and was Sabino Jaureguizar's chief rival in Panama City. He was born in Chiriquí but was raised in China and only returned to the isthmus in the mid-twentieth century, after he had married and established his own family. Like Sabino, he took advantage of Panama's economic development and concentrated on billboards and other street advertisements for the country's growing new businesses. Carnival floats were another of his specialties, and he constructed stands and other decorations for the country's numerous fairs. According to his son, Alie was an autodidact painter whose formal education was limited to the sixth grade but who possessed an extraordinary talent for drawing, honed through his voracious reading of books and manuals

and through a love of copying Walt Disney characters. Alie began his career in Calidonia, where he fashioned posters for the Presidente movie theater from photographs sent with the cinematographic productions. In the 1950s, he formed a successful company, TAZ, with Tiberio Álvarez and José Manuel Zabala. After disagreements lend to the dissolution of this entity, Alie devoted himself increasingly to serigraphy, making limited-edition prints for foreign and domestic artists. Numerous young men apprenticed under his guidance, including the prominent bus painter Billy Madriñán. Jorge Dunn described Alie as a man of great talent and as the "best silk screen artist in all of Central America." Héctor Sinclair notes that he could "place his colors," and that "they looked messy up close but perfect from far away." Alie's son and daughter still run their father's company, which continues to concentrate on serigraphy.[2]

CARLOS BENJAMÍN ÁIVAREZ ESPINOSA (1971–). Similar to Tino in La Chorrera or to Óscar Melgar in the capital, Carlos is the dominant bus decorator in Colón. Indeed, the majority of the vehicles in the city and in much of its surrounding area are the product of this disciplined artist. Carlos grew up in Panama City but now lives in Limón with his wife and family. Artistic endeavors are part of his background. Villarué is one of his relatives, and his older and now deceased brother, Raúl adorned red devils for many years. Carlos' sister also dabbles in canvas works. As a youngster, Carlos first apprenticed under Raúl and later studied with Salazar alongside several other painters. Óscar Melgar is a close friend and generational colleague, and their production is comparable in many regards. Both have adopted Salazar's explosive style and tend to smother surfaces in complex imagery, zigzag patterns, and flamboyant *pregones*. Colón's population is primarily Afro-Panamanian, and as a consequence, Carlos' buses often portray people of color, whether they are the children or relatives of the owners or highly admired figures in the community. According to his wife, Carlos is passionate about his profession and is determined to defend it in the face of the changes now affecting the transportation industry. Carlos is also a martial arts athlete and does decorative jobs in businesses and private residences.[3]

IAN CARLOS ANGUIZOLA (1981–). Ian Carlos operates slightly outside Panama's popular visual traditions and is more inspired by the international graffiti movement. However, there are important ties between him and other painters, including their employment in many of the same venues: *barberías*, stores, video clubs, and restaurants. In addition, they depict some of the same things, including urban scenes, singers, and elements of hip-hop culture. Ian Carlos grew up on the western side of the canal, in Arraiján, where he often

saw Tino Fernández and Monchi Hormi at work. Their red devils helped to inspire his interest in art, and he speaks enthusiastically about the painted buses and their "daily parade" through Santa Ana. Ian Carlos manages an Internet café in this neighborhood, but his real passion is graffiti art. Like other Panamanian graffiti artists, he focuses less on indiscriminate bombings but instead uses his talents for commercial purposes. Ian Carlos earned a photography degree at the Universidad del Arte Ganexa and later lived for extended periods in Costa Rica and Barcelona. At the time of this interview, he was planning to study in New York and to return to Panama to open a decoration business.[4]

SIMÓN "SAT" ATENCIO GUERRA (1961–). Sat turned to the red devils "out of necessity." In 1979, he was studying graphic design at the Universidad de Panamá, and he needed a way to support himself. He began to decorate buses and continued for the next fifteen years before gaining employment at a publicity agency. He eventually became a well-known painter and participated in the 1983 show sponsored by the Museo de Arte Contemporáneo. Sat misses his life as a popular artist, noting its relative freedom and creativity and its impact on his future career: "Half of my education came from those years," he insists, "helping me to enter into the field of advertising." In fact, the red devils' style is a form of self-promotion. The flashy designs and slogans serve to attract customers and bring renown to the painter and the owner. Sat emphasizes that while many people paint for financial reasons, the artists' work has taken on a much broader significance. For him, the red devils have become a symbol of the country and a reflection of Panama's national identity.[29]

LEONARDO "LEO" ÁVILA (1958–). Leo is a Panama City artist who began painting in the mid-1970s. One of his regular clients is a street vendor nicknamed Velita who sells *velas* (candles) and other items outside a bakery on Calle I, near Hotel Ideal, in the commercial center of the capital. Every several weeks, Leo changes the scenery painted on the stand where Velita displays his goods. Velita feels that the images attract customers, often people who have just purchased birthday cakes. "Popular art," as Salazar once said, "is a lot like fashion," and it must change with the times to be effective. Leo is a graduate of the Escuela Nacional de Artes Plásticas and is a former assistant of Oliver "Bruzolli" Bruce. He recently restored Bruzolli's sculptures at the extravagant Hotel Ideal, a longtime hangout for sailors and U.S. servicemen. The soldiers are gone, but the mariners remain, laughing and drinking around the grimy pool and surrounded by mermaids, dolphins, and other ceramic creations. Over the last three decades, Leo has also decorated buses and dozens of restaurants,

cantinas, and grocery stores. He speaks of his mentor Bruzolli with great affection, describing him as "one of the great ones." Today Leo works out of a small studio in the hotel.[5]

FÉLIX ERNESTO "CHOLOPURUCA" BARRIOS BÓSQUEZ (1968-). Cholopuruca is a lesser-known artist who currently works in the town of Chepo. Chepo is a village about twenty miles east of the capital, and it offers a smaller market for painting buses. Also contributing to his obscurity is Cholopuruca's refusal to provide a signature on most of his pieces. The decoration of the red devils is a fiercely competitive business in which individuals pit their abilities against those of their opponents. Their creativity and skills are hotly debated, and a sense of hierarchy clearly divides the painters. For some people, this rivalry can be intimidating, and they only sign pieces when they are certain of their quality. Cholopuruca turned to art after abandoning his studies following his second year of high school. Initially, he apprenticed under Salazar and Roy, the latter of whom he considers to be his most important teacher. Besides buses, Choloporuca also decorates signs, cars, and varied commercial establishments. One of his most conspicuous murals can be found on the exterior of Chepo's Chocky's seafood restaurant. Cholopuruca covered the building with a maritime scene and with lettering similar to the graffiti on New York subway cars.[6] Hip-hop clearly informs Cholopuruca's perspective, much as rumba and salsa influenced many of his predecessors.

CÉSAR BELLIDO. César's house on the Vía España has a large painting of a tiger moving stealthily through the jungle. The image is placed on the building's front exterior and next to lettering which announces his services: "foam works, acrylic paintings, and scenery murals." Scholars have insisted that popular art is a public genre and that it is primarily designed to sell goods and services. While there is undoubtedly much truth to this generalization, the interior of César's home also features wall paintings. One of these is a depiction of an Alpine village, very similar to those seen on the front end of red devils. In fact, many popular artists have embellished their residences, belying the notion that their work cannot serve for private enjoyment. For years, César painted signs for Coca-Cola in Panama. Today, he is employed by the MultiArte company, a small but well-known art shop owned by Sixto Castro de Burunga. MultiArte's contracts have included the outfitting of the Chivas Parranderas. The "party buses" are identical to the red devils, but are used for taking visitors for tours around the city. Usually, they exude a festive atmosphere and entertain passengers with music and dancing. *Murga* or carnival bands play on the

back end of the vehicles and blast their festive tunes into the street. César is proud of his participation in this project.[7]

HÉCTOR J. BETANCOURT C. (1963–). Héctor was a well-known bus painter in the 1980s. Born in Panama City, he spent his early years in Coclé and often returned there to visit his relatives. Perhaps as a consequence, Héctor has always admired Monchi and his tendency to depict rural images. The countryside and its inhabitants were also an inspiration for Héctor who accepts the traditional nationalist conceptions and criticizes artists who concentrate on foreign subjects. In 1983, he participated in the Museo de Arte Contemporáneo show with an entry entitled *Something of Ours*. Héctor's piece was a depiction of the interior, alongside a *pollera* and the Bridge of the Americas. A second submission was called *My Panama of Yesterday* and was a reproduction of a famous Marañón house. Like others interviewed for this study, Héctor feels that Panamanian society does not support creativity, and he even insists that there are many talented people locked away in the country's prisons. Héctor himself eventually quit the profession and opened a small repair shop along the Panama-Colón highway. Artists often have mechanical abilities, as they do much of their work in terminals and garages. Sabino's family offers another good example. His son and grandson are no longer involved in painting but instead fix cars and trucks in the Juan Díaz neighborhood.[8]

OLIVER DELROY "BRUZOLLI" BRUCE (1928–2004). Bruzolli was the brother of painter Víctor Bruce and one of Panama's most important popular artists in the second half of the twentieth century. He began to work in the mid-1940s and continued until his death in 2004. His warm personality tended to attract disciples, such as Leo Ávila and Nelson Cisneros. According to them, Bruzolli was an unconventional man whose antics were similar to those of the Wolf and which functioned, in a way, to project and market his business. Héctor Sinclair recalls that Bruzolli could also be a demanding person, and he would repeatedly return to touch up jobs if he thought that they were inadequate. "He always wanted to be number 1," recalls another of his collaborators. The reputation of a painter rested on his capacity, as Salazar once said, to "kill the others with beauty." Bruzolli often worked while sipping a bottle of seco, the sugar-based alcohol produced in the Panamanian interior. Frequently, he pursued his undertakings late into the night and sometimes interrupted their progress with impromptu jam sessions. Bruzolli played jazz and blues tunes on his guitar, while his assistants banged on buckets and sang along with their teacher. Music had always been a central part of Bruzolli's life, and as a

young man, he and his siblings formed a small vocal group and occasionally performed on Colón's radio station. Bruzolli was primarily a commercial artist who specialized in the decoration of restaurants, stores, and bars. Often he bedecked these locales with plaster figures, usually of a tropical nature. Hotel Ideal and the now demolished La Cascada restaurant in Panama City provide two of the best examples. Bruzolli filled the courtyards of each venue with impressive statues of dolphins, mermaids, tigers, and other creatures inspired by Walt Disney movies (plate 25). At each of these sites, he also created large waterfalls cascading down from bulky rock constructions. Another of Bruzolli's masterpieces is the facade of Bar Manchego, a once-popular nightclub in the Santa Ana neighborhood. Its exterior boasts an enormous relief of Don Quixote seated on Rozinante and with Sancho Panza at his side. Bruzolli was the son of Afro-Antillean immigrants. He grew up in the Canal Zone, in the silver-roll town of Frijoles. There he attended U.S. schools and enrolled in an art correspondence course while working for the North Americans. As teenagers, both he and his brother, Víctor, fashioned signs in the U.S. community. For years, Bruzolli also did projects for the Panama City Fire Department and was commissioned to make the portraits of its commanders. Today, these pictures hang in the Cuartel Darío Vallarino, in the building's upstairs meeting hall. The firefighters paid tribute to Bruzolli at his funeral, providing his coffin with an honor guard.[9]

VÍCTOR OSWALD BRUCE (1930–). Víctor Bruce is the son of Afro-Antillean immigrants. His father came from Jamaica, and his mother was from St. Lucia. They arrived on the isthmus in the early twentieth century and raised their three children in Frijoles, a silver-roll town in the Canal Zone. There, Víctor attended North American schools and as a teenager was employed by the U.S. government. Víctor's background is typical in this sense, as many of the early painters were connected to the Canal Zone and gained their initial artistic experiences in the foreign-controlled area. Among other things, Víctor fashioned signs for the Canal Company. His formal training was limited to a correspondence course which he completed when he was not occupied by his duties. Later, he left for Colón and then Panama City, where he decorated the growing restaurants, bars, stores, and movie theaters. He also did commissions in private residences. Víctor recalls fondly the years after World War II when Panama had a lively entertainment scene, and there was great demand for his services. During this time, Victor also sang in a small musical group with the other members of his family. Víctor is the brother of artist Oliver Bruce, and like his sibling, he has received only modest recognition, a fact he

occasionally protests by publicly burning his works. In the early 1970s, he was hired by Panama's national comptroller's office to make portraits of the heads of this institution. The paintings, which hang in the ministry's executive board room, include all but the six most recent occupants of this position. Today, Víctor spends his time in the capital's crafts market, and he is teaching his son Robert how to paint (plate 26). One of Víctor's earlier students was Franco the Great who warmly recalls his mentor's generosity.[10]

RICARDO BUSTAMANTE. According to Ricardo Lay Ruíz, Bustamante was a long-term employee of the Cervecería Nacional and painted cantinas through the 1960s and 1970s. Bustamante was self-taught in the discipline and was one of the most able decorators of these venues as well as other businesses featuring beer advertisements. In his 1973 article on street art, Silvano Lora included photos of Bustamante's murals. These images date from 1970 and were made at the famous capital night club, *La Cosita Buena*. *La Cosita Buena* has traditionally catered to Panama City's rural migrants and has been one of the leading venues for *música típica*, the accordion-based music that dominates the provinces. Bustamante provided depictions of the countryside and of Carnival in the interior. In one scene, an elaborately adorned oxcart carries the Carnival queen through a village, with a large crowd dancing in front of a *toldo*. The *toldos* are beer gardens, which function during this season and which are another important setting for popular art. Bustamante was probably familiar with these places and perhaps had been employed as a float maker.[11]

MARCOS CÁCERES (1938–). Marcos was widely known as El Pintor Cantante (The Singing Painter). He was a successful national singer in the 1960s and 1970s, who devoted himself to performing romantic music but who also earned a living as a commercial artist. Héctor Sinclair recalls his outstanding abilities and how he often made television appearances or left work to tour through Central America. Cáceres was also interested in academic painting. A 1975 group exhibition, sponsored by the military government, lists him among the show's participants. His biography notes that the painter had been born in Panama City and that besides an apprenticeship under Sabino Jaureguizar, he had never received any artistic training. The Basque immigrant had one of the most active decorative businesses and frequently took on talented assistants, many of whom went on to become independent painters. According to Chicho, Marcos still does commercial art.[12]

LUIS CAMARGO (1943–). I met Camargo in the heart of Santa Ana, where he was painting one of Calle J's many bars. The cantina is a traditional setting

of popular art and a place where Camargo is often employed. On most after-noons, he can be found on this street, tending to its businesses' decorative needs. Much like the Wolf, Camargo is a charismatic figure whose dress and behavior call attention to himself. In a city where the baseball cap has become the standard male headgear, Camargo sports an elegant straw hat. Similarly, he forgoes the convenience of a toolbox and instead tucks his paintbrushes conspicuously in his back pocket. While painting, he sometimes entertains those around him with renditions of popular songs. His demeanor, moreover, is friendly and gregarious, and during our interview, he periodically interrupt-ed the discussion to call out to acquaintances and address them as "family." "We're all basically family," explained the artist. Camargo studied electronics at the Escuela de Artes y Oficios but was unable to complete the program due to his parents' deaths. To support his siblings, he turned to the red devils and worked on the buses in the early 1960s. The Cervecería Nacional later hired him as a painter, and he made signs for the company for over three decades. Now retired from this business, he remains very active and content with his jobs on Calle J. "Life is sweet," concludes Camargo.[13]

SIXTO CASTRO DE BURUNGA (1957–). Castro de Burunga is the owner of MultiArte, a sign and decoration studio in Panama City, located in the Pueb-lo Nuevo neighborhood. His activities are comparable to those of Sabino and Alberto Alie, who decades earlier had established very similar businesses. Cas-tro opened his shop several years ago, after the sale and reorganization of the Cervecería Nacional and his unexpected dismissal from the company. Since he was eighteen, he had been employed by the brewery, and he had spent most of his time fashioning its advertisements on the walls of stores, restaurants, and cantinas. Beverage manufacturers plaster these announcements everywhere, and in some cases, the images are skillfully hand-painted. Just as the Canal Zone had served to educate older artists, the Cervecería Nacional trained the younger Castro, who had always loved to draw but who had received no formal instruction. Most of his seven employees have similar backgrounds and have painted red devils and commercial establishments. Castro's murals cover the walls of the Jardín El Rosal, a beer garden next to MultiArte, whose front door is adorned with a colorful rosebush. In the last years, he has also helped to decorate a number of churches. Today, Castro admits that he has little time for such projects and that most of his clients now ask for less artistic pieces, usu-ally just lettering with simple designs. The more creative art, he says, is unfor-tunately dying. Nevertheless, he insists that Panama still has "a lot of talent" and that even if poorly paid, "people will use any opportunity to paint from the heart and externalize their feelings." One of MultiArte's busiest periods is the

Christmas season, when Castro and his colleagues make giant nativity scenes. They also are very active in the weeks before Carnival, as they construct floats for the parades in Panama City.[14]

ANCELMO "CHEMO" CHÁVEZ CASTRO (1962-). Chemo is an employee of Panama's highway commission, and like many of the bus artists of earlier generations, he learned his craft through related occupations. Chemo fashions traffic signs and lines along the republic's roads. He was born in Panama City and raised in La Chorrera. Today, he resides with his wife and children in Capira, the westernmost outpost of the red devil tradition. The buses of Capira are the least decorated. Their base color is turquoise, and their roofs are solid white, while Chemo adds names and subtly combined patterns, often willowy streaks of red, blue, and yellow. Rhythm is a prominent aspect of Panamanian popular art, and Chemo's brush strokes offer some of the most graceful cadences.[15]

NELSON CISNEROS (1956-). Nelson Cisneros is an officer in the Panama City Fire Department and is one of a number of firefighters and policemen who have also devoted themselves to painting. Their lives and activities reflect the influence of popular art and its ability to penetrate even the offices of the government and affect the symbols of Panamanian nationalism. Cisneros became a commercial artist in the 1980s under the guidance of Bruzolli who was occasionally contracted to decorate the capital's fire stations. Another of Bruce's responsibilities was to make portraits of all the fire chiefs since the late nineteenth century. Cisneros had always enjoyed music and literature, and as a youngster, he had become obsessed with drawing. He jumped at the chance to collaborate with Bruzolli whose talents were well-known in Panama's working-class neighborhoods. Cisneros' own paintings include murals in the Fire Department Headquarters. Among these are a piece called "The Crossing of the Races" and another entitled "The Fireman of the Future." Cisneros also completed the portrait of fire chief Mujica, when before his death, Bruzolli was unable to finish the work and asked his pupil to take responsibility. "He told me that my hand was his," Cisneros recalled with great emotion. Despite the intense competition among the painters, they readily recognize each others' abilities and their debts to one another. The popular artists are like an enormous family with both tensions and fraternal bonds linking its members.[16]

CÉSAR CÓRDOBA (1966-). One of the most salient aspects of the red devils is their sense of competition, whether the rivalry is among competing drivers, artists, regions, or different age groups. César sees himself as

representative of the decorators who first appeared in the mid-1980s and became dominant over the next decade. This group of men is still active and has yet to be surpassed by their younger competitors. "Today's painters," César insists, "paint better than those before," citing Rolando González and Óscar Melgar as some of his generation's leading figures. Like many of the talented men who emerged during this period, Cesar worked for two years with Andrés Salazar, whose wife is an aunt of the younger painter. At the same time, César undertook more formal studies at the Escuela Nacional de Artes Plásticas. Under Salazar's influence, César learned the importance of popular culture and of tracking its evolution in one's compositions. César's buses usually reflect whatever is fashionable: the "actor, the singer, or the athlete of the moment." His landscapes often depict temperate or Alpine villages, but they also sometimes incorporate the Panamanian interior. The red devils are not rigidly nationalistic, but rather, they constantly mix traditional symbols of Panamanian identity with more modern and even foreign elements. Today, César is employed primarily in the Tocumen area. He recently has begun, like many other artists, to depict himself in flattering self-portraits, usually placed to the right or left of the taillights. In one image, he stands and thrusts his index figure over his head, indicating that he is Number 1.[17]

RUBÉN "EL PRECOLOMBINO" DARÍO COYA. El Precolombino was a well-known bus artist in the 1960s and 1970s whose red devils inspired many other people, including such important figures as Andrés Salazar. A tradition of instruction connects the various generations of painters, and as a teenager, Salazar often watched El Precolombino working and learned a great deal from these observations. He explains that Darío's nickname came from his tendency to depict pre-Colombian elements in his compositions. El Precolombino no longer decorates vehicles but instead devotes himself to constructing Carnival floats. As a bus painter, he worked the Juan Díaz, Pedregal, and Tocumen lines.[18]

EUGENIO/EUGENE DUNN (1917–1999). Eugenio Dunn was a long-time painter in the Canal Zone, a musician, and one of Panama's leading twentieth-century artists. His more academically trained colleagues referred to him as "El Maestro," in recognition of his considerable achievements, realized without the benefit of any formal training. Dunn's works are regularly part of prestigious retrospectives and are included in the country's most important collections. The Afro-Antillean Museum in Panama City also displays two of his pieces, and his portraits line the walls of many government offices. Dunn was the son of a Jamaican shoemaker who immigrated to Panama during

the construction of the canal and who married a woman from St. Lucia. The Dunns raised their family in Calidonia, close to many of the music clubs which sprung up during the mid-twentieth century. This environment undoubtedly influenced the Dunn children, all of whom became talented singers. For years, Eugenio performed with Payne and His Ambassadors and with other jazz-style orchestras in Colón and the capital. Earlier Eugenio had attended the Instituto Nacional, the once-esteemed public high school that bordered the U.S. sector and that had long been a hotbed of Panamanian nationalism. Presently, Dunn's abstract depiction of the academy graces a wall of the rector's office. World War II created a great demand for labor, and after his completion of the secondary program, Dunn found a job with the U.S. Army, painting signs at Fort Clayton. He kept this position until his retirement, offering him a measure of economic stability but without sufficient resources to support his large family. As a consequence, he and his brother Jorge opened a studio on the Avenida Justo Arosemena, which they later moved to the Avenidas Peru and Cuba. There, they displayed and sold their paintings and made arrangements for commercial projects. Jorge and Eugenio were also among the first painters to take their creations directly to the street. They exhibited them in places such as the Canal Zone's Stevens Circle, Avenida 4 de Julio, and the Casco Viejo. During vacations, Eugenio traveled with his sons, crafting and touching up billboards across the republic. In the evenings, the boys earned extra money adjusting the lettering in supermarkets. Errol Dunn recalls that his father was also an enthusiastic teacher, and for years, he gave classes at the Escuela Nacional de Artes Plásticas. In addition, during the 1960s, he appeared briefly on a weekly television program and explained his methods to its viewers. Eugenio's style tends to be more realistic than that of Jorge. However, both men's compositions manipulate color; they play with light and display a rhythmic quality reminiscent of the old music clubs. Their subject matter is often similar and includes rural and urban landscapes, still-lifes, and the Afro-Antillean community. Some of Eugenio's most interesting pieces are more abstract in nature and incorporate African diasporic themes. Eugenio's sons, Errol and Eugene Jr., are continuing the Dunn tradition of painting and are focusing even more on Afro-Panamanian subjects.[19]

JORGE/GEORGE DUNN (1924–2007). Dunn was an autodidact painter, born in Panama City, and one of the republic's most well-known popular artists. His biography often appeared in national newspapers, and he presented his pieces at shows in Panama and the United States. His notoriety rested in part on his visible presence. For over twenty years, he worked in a conspicuous location, composing and selling his paintings on a Paitilla neighborhood

sidewalk, just outside the Farmacia Arrocha. The pharmacy's owner, who was Dunn's friend, encouraged him to relocate to this place where foot traffic was heavy and foreigners were numerous. Dunn had previously painted in Stevens Circle, the small plaza honoring John Stevens in the Canal Zone and another place often frequented by tourists. Tourism has deeply affected art in the Caribbean basin and has encouraged the prominence of folkloric topics, which visitors perceive as representative of the region. Many of Dunn's compositions were scenes of the interior or vivid renderings of the isthmus's beaches. Another favorite subject was Panama's working-class barrios, which he depicted in a nostalgic manner, with their street vendors, pedestrians, and meandering dogs. Dunn portrayed these areas as he recalled them, during his youth in the mid-twentieth century. His intention, as he said, to "provide a memory" for those who had spent some time in the country. North Americans were always among his most loyal customers, but many of the isthmus's leading collectors also purchased Dunn's still-lifes and landscapes. In the Canal Zone, Dunn often did commercial jobs and made signs and ornamentations for the clubhouse, the commissary, and the Balboa movie theater. Even today, his images can still be found in locales as varied as banks and hospitals, bus stations, hotels, stores, and pawn shops. As a younger man, Dunn was also employed as a musician. In the late 1940s through the 1950s, he sang with his brother and sister in the republic's booming nightclubs, some of which were decorated with his art. In his interview, he recalled this era with great fondness and even provided a small rendition of "Prisoner of Love," the Perry Como hit from 1946. Music was an evident part of Dunn's aesthetical sense, as many of his pieces have a rhythmic quality, particularly his depictions of fish, ships, and bottles. Their swirling lines, lights, and rich colors convey the feeling of the old cabarets. Dunn was the son of a Jamaican shoemaker who came to Panama during the construction of the canal. Jorge studied at the Escuela de Artes y Oficios and took drawing classes with the Chilean professor Coto Conde. Dunn, however, regarded himself as primarily self-taught and credited art books for his education. Before devoting himself entirely to his chosen profession, Dunn practiced his father's craft for twenty years. His brother Eugenio was also a prominent artist, and today, several nephews are continuing the family tradition and focusing, as well, on Afro-Panamanian subjects.[20]

RAFAEL "RAFY" ERAZO (1968–). Rafy spent his childhood in Panama City, and as a youngster came to admire the buses of Andrés Salazar. Eventually, he enrolled in the Escuela Nacional de Artes Plásticas and apprenticed under Óscar Melgar for approximately twelve months. In recent years, Rafy has emerged as a prominent independent painter and today dominates the Mano

de Piedra–Panama City route. His buses are very similar to those of his mentors and are packed with designs, portraits, cartoons, and landscapes. In an interview, Rafy noted that the red devils have an important function in projecting an image of Panama to the outside world.[21]

JUSTINO "TINO" FERNÁNDEZ (FATHER) (1933–). Tino has been a bus driver for most of his adult life. However, from the 1950s to the mid-1960s, he also made paintings for the *chivas* of Panama City. These works were small canvases and were hung in the vehicles' interior and most often were illustrations of the Panamanian countryside. While Tino never became a well-known artist and eventually dedicated himself solely to driving, he did have a major impact on his son, who subsequently became one of the tradition's leaders. The younger Tino recalls the influence of his father, emphasizing his ability to manipulate situations in which his capacities did not match his clients' expectations. In fact, many self-taught painters face similar limitations which they must overcome with ingenuity and with the strength of their expression. The appeal of popular art is partly its idiosyncrasies arising from a long and deeply personal process of learning. Once, the elder Tino was asked to paint a female bather lying next to the water on a tropical beach. Tino proceeded to outline an elaborate seascape; however, when the client returned, he was dismayed to find that there was no woman in the picture. In response, Tino pointed to a shark's fin slicing through the ocean and suggested that the unfortunate vacationer had gone for a swim. On another occasion, he was hired to depict a ranch with horses grazing calmly in a nearby corral. Tino completed the corral, but he left the gate open and explained that the animals had escaped to the mountains. Humor is another characteristic of the bus artists, and it emerges in their personalities and their images.[22]

JUSTINO "TINO" FERNÁNDEZ JR. (1961–). Tino was born in Panama City and was raised in La Chorrera, where he continues to reside. The son of a bus driver and part-time painter, Tino was inspired to take up art by his father, who bought him supplies and encouraged him to develop his skills. On weekends, the young Tino road with his father, and they commented on the decorations of passing vehicles. On occasions, they also visited the homes of prominent painters. Museums are not artistic reference points for many Panamanians, but rather restaurants, bars, and the red devils serve this function. Tino later enrolled in the Escuela Nacional de Artes Plásticas, studying for three years and earning a degree. At the school, his instructors depicted the bus artists as imitators who crudely appropriated the creations of more educated people. Tino, however, had come to admire men such as Monchi, King,

Yoyo, and Salazar, and he soon began to work on the red devils. He is now one of the most important popular artists and is especially visible in Panamá Oeste, the area on the western side of the canal, including the city of La Chorrera. His location, he notes, has had a big impact on his style which is comparable, in many respects, to that of Monchi. His clients in La Chorrera prefer more traditional themes and discourage the fluorescent colors so evident in the terminal cities. As a consequence, Tino has become a specialist in rural landscapes and also demonstrates a predilection for idealized female figures, including princesses, saints, and even fantastic warriors dressed in animal skins and brandishing swords. Even in La Chorrera, the red devils are flamboyant and are designed to capture the public's attention.[23]

YAYO FLORES (1977–). Standing next to a red devil bursting with imagery, Yayo described bus art as a kind of combat, a "war among the decorators" to see who is most creative. Similarly, Hector J. Betancourt compared the tradition to boxing and suggested that picking up one's brush is like stepping into the ring. The owners, they both noted, also compete amongst each other and pride themselves on having the flashiest vehicles. Afro-Caribbean artistic expression is often theatrical and sometimes contains within it a sense of spectacle. Yayo at the time of his interview was working for Rolando González and had been employed as his assistant for over six years. Assistants often become independent painters, and Yayo expressed his desire to become one as well. Unfortunately, Yayo's buses have not yet appeared in Panama City, perhaps as a consequence of the red devils' decline.[24]

TOMÁS ANTONIO FONG. Fong was a leading popular artist from the late 1970s into the 1990s and worked closely with King in the Veranillo bus terminal. Both painters were among the first to use the airbrush and also were active periodically in Colón. In 2001, one of Fong's red devils still circulated through the streets of Panama City, although in a plainly deteriorated state. Above its front window, the vehicle boasted an enormous tidal wave crashing onto a beach with tropical vegetation. This seascape was an apparent reproduction of Katsushika Hokusai's (1760–1849) *The Great Wave off the Coast of Kanagawa*. Self-taught artists often appropriate other pieces, transforming and placing them into unusual settings. Who would expect to find a copy of the Japanese masterpiece framed on the front end of a Panamanian bus? Fong was well-known for these reproductions as well as for his exceptionally beautiful nudes, which he crafted in the interior of the vehicles. In 1983, Fong participated in "Homage to a Popular Art," the exhibition organized by the Museo de Arte Contemporáneo. Fong's entry received a special commendation from

the German ambassador for the best work depicting a "protector saint." In an interview for the event, Fong emphasized his unconventional training, commenting that "painters like him had been born with this art and had never studied painting in any formal way." While such statements are to some extent valid, it is important to note that many popular artists have taken classes and have even graduated from the Escuela Nacional de Artes Plásticas. Others have studied at Universidad del Arte Ganexa, the capital's private art academy. In addition, an informal system of apprenticeships exists among the painters. Totín Judiño, for example, worked briefly under King and Fong before collaborating with Yoyo for five years. Some sources suggest that Fong is still active at the Arco Iris terminal in Colón; however, a long-term drug addiction has apparently affected his career, and he is said to live in a destitute state. Efforts to locate Fong were not successful.[25]

FRANKLIN "FRANCO THE GREAT" GASKIN (1927–). Franco the Great is the self-declared Picasso of Harlem, who grew up in Colón and later was employed in Panama City before moving to the United States in 1958. Franco is best known for his decoration of the metal security gates along New York's 125th Street. Franco's motto is "The world is my workshop," and he has traveled to Mexico, Senegal, France, and Japan to paint stores, hotels, street murals, and nightclubs. He has also done similar jobs in many parts of the Caribbean. In Harlem, on Sundays, he works on the sidewalk directly across from the Apollo Theater. Here in the tradition of Panama's popular artists, he paints for the public and performs as a showman. When he first arrived, he often painted for free, and he used these opportunities, like the Wolf along the seawall, to gain people's attention and broadcast his abilities. Magic is another of his passions, and he entertains his many onlookers with his charisma and tricks. Franco was born in 1927 in Colón, where his family had settled after immigrating from Jamaica. At age three, Franco suffered a terrible accident, falling from the third-floor window of his grandmother's apartment. The mishap left him traumatized and unable to speak until he was well into his teen years. Franco turned to drawing as a means of expression and as a way to overcome his isolation. Magic later became another of his interests, and he regained his confidence by performing at church potlucks, weddings, and other social functions. In the 1940s, Franco began to apprentice under Víctor and Oliver Bruce, whom he considers his artistic mentors and who were quickly becoming well-known popular painters. The trio did commercial art in Colón before Franco became independent and moved to the capital. In Panama City, Franco continued to make billboards and to decorate bars, hotels, and music venues. He was occasionally employed by Sabino Jaureguizar, who owned the most active

decoration business in the capital. Like many of the early artists, Franco also constructed *toldos*, the open-air dance halls erected especially for Carnival. In addition, he did sporadic jobs in the U.S. Canal Zone, sometimes after military officials saw his compositions in brothels. Most of Franco's imagery today is African in nature, a fact he credits to his residence in Harlem. Preferred topics include children and pensive nude figures, typically set in African contexts. Toward Panama, Franco expresses ambivalent feelings. He recognizes its importance in his artistic formation, but he also emphasizes its traditional racist attitudes, especially in regard to the Afro-Antillean population. Today when people ask where he is from, Franco insists that his home is Africa.[26]

HÉCTOR ANÍBAL "LYTHO" GÓMEZ RODRÍGUEZ (1955–). Lytho is a self-taught artist from Panama City, who now lives in El Jiral and who works principally in Colón. He is responsible for many of the brightly colored paintings on the walls outside Colón's free trade zone. These include portrayals of the province's fauna, Colón's famous Church by the Sea, and its 5th of November Park. Over the years, his projects have also included buses, cantinas, signs, Carnival floats, and party decorations. He has done innumerable jobs at the Manzanillo International Terminal. For a period, he was employed by the Cervecería Nacional. In addition, he has painted murals in many educational institutions, including the elementary school next to his house, whose halls and classrooms are lined with his creations. According to the records of the Museo de Arte Contemporáneo, Lytho participated in the museum's 1983 competition, taking first prize with his entry *The Madonna in a Chair*. This was a depiction of a virgin holding a baby with an angelic child at her side. The image, which was derived from a Raphael portrait, reflected what some felt was the exhibition's conservative nature. Panama's elite has never been comfortable with the country's Afro-Caribbean culture, and even in events, such as this exhibition, it has expressed its preference for works with European content.[27]

ROLANDO RICARDO GONZÁLEZ BARUCO (1973–). Rolando owes his career, to some extent, to the U.S. invasion of December 1989. At the time, he was studying at the Tomás Herrera Military Academy with the hope of becoming an infantry officer. The North American occupation ended this ambition, as Panama's army was defeated and then dismantled. To earn money, Rolando turned to his natural talents and began to touch up the faded works of other bus artists, including red devils by Yoyo, Salazar, and Monchi. Rolando became a well-known figure, rushing from job to job with his brushes and materials in hand. He soon earned a reputation as a competent painter and was commissioned to decorate entire vehicles by himself. Rolando is now one of the

capital's most prolific artists, and he is unique among the *decoradores* in that he is also a bus owner. The artist has his own garage and studio in Tocumen, an outlying area near the Panama City airport. Rolando was born in the province of Chiriquí, the western agricultural region bordering Costa Rica. He moved to the metropolitan area in 1983.[28]

VÍCTOR MANUEL "CHICHO" HERNÁNDEZ (1946–). One of the most impressive images today along the Avenida Central adorns the vending stand of Ismael Mussa Kellman. Mussa's stand, which is located in Calidonia, contains a representation of the ethnic "roots of Panama." The mural is a depiction of several women of indigenous, African, and European origin. The figures are simple and stand motionless next to one another. They stare out at the viewer with minimal expression and hold his or her attention with their boldness and expressive color. Chicho is the author of this and other vibrant works lining the kiosks of the Calidonia neighborhood, as well as the San Felipe, Santa Ana, and Marañón areas. He recently completed an amazing series of paintings at the Fish Market in honor of the Virgin of Carmen. These represent the annual celebrations in honor of the patron saint of Panama's sailors. Chicho was born and raised in Panama City and was introduced to commercial art as a teenager. He first made signs as one of Sabino's assistants and later became an adept sculptor. For years, he built Carnival floats with Malanga Meneses and collaborated with Oliver Bruce on some of his most important projects, including the decoration of the extravagant Hotel Ideal and the now demolished La Cascada restaurant. Chicho describes La Cascada as a "fantasy world," inspired by hundreds of Walt Disney characters whom the artists re-created in wire, foam, and plaster and whom they distributed throughout its expansive garden-patio. Today, Chicho makes a wide variety of things, ranging from masks and hats for Carnival to billboards, stone carvings, and portraits of the deceased. Styrofoam birthday figures are another of his specialties. Chicho prefers to work from memory rather than relying on photos or newspaper clippings. He also has painted many of the colorful boats tethered alongside the capital's docks. Interestingly Chicho, who studied welding as a youngster, refuses to sign most of his pieces, as he considers them to be rushed and of inferior quality.[30]

EULOGIO HERRERA FULLER (1965–). Fuller is a native of Panama City, who began to work on buses when he was a teenager and trained for three years under Andrés Salazar. He is employed primarily in Panamá Oeste. This is the increasingly populated area on the western side of the canal and extending to Capira. Like other prominent decorators in the region, particularly the

leading figures Tino and Monchi, Fuller expresses a preference for "national subjects." National in his mind is associated with the countryside and includes subjects such as colonial villages, the ruins of Old Panama, and the Chorrera waterfalls. Fuller, however, is also attracted to modern themes, and his compositions frequently utilize popular cartoons rendered in what he describes as "flashy" colors. The bus tradition is not a stagnant discipline, and even its more conservative practitioners, such as Fuller, continually act to transform its content. On many occasions, they "cannibalize" foreign elements and make them Panamanian by placing them into novel contexts. In the interior of a bus, just above the emergency door, Fuller reproduced an image of Garfield the Cat, lazily napping on a tropical beach. The portrait is framed by the fluorescent, checkered patterns, so often seen on the front and back of his red devils. Despite his time with Salazar, Fuller considers himself to be a self-taught painter and affirmed in his interview that "my art was born in me."[31]

RAMÓN ENRIQUE "MONCHI" HORMI (1947–). After Salazar and Yoyo, Monchi is probably the most significant contemporary painter, and he is also an excellent example of the rivalry which tends to divide the practitioners of this discipline. In an interview, Monchi exhibited his characteristic swagger, his disdain for his competitors, and his sense of humor. He depicted the younger painters essentially as "imitators" while emphasizing his generation's ingenuity and his personal inventiveness in particular. "Many of these *muchachos* have tried to copy me," he recalled in a teasing manner, "but I am the first and above all the rest." The son of a Colombian welder who came to Panama during World War II, Monchi was born in the capital in 1947. His family moved to La Chorrera when he was six, and he still lives there today in a modest residence. The house stands out, however, among the surrounding buildings, as its front wall boasts a mural of an alpine village. Similar villages adorn the exteriors of many of Monchi's buses. In La Chorrera, Monchi met Yoyo who worked there for a period and inspired the youngster to take up painting. To pay for his materials, Monchi delivered water to poor neighborhoods, and he taught himself how to draw by doodling in schoolbooks. In the 1960s, he began decorating red devils, first in Panama City and then in La Chorrera, where he was determined to dominate the public transportation system and become the leading artist in Panamá Oeste. "The buses there once said, 'Yoyo, Yoyo, Yoyo,'" he recalls. "I wanted them all to read 'Monchi, Monchi, Monchi!" From the 1970s to the early 90s, Monchi came to realize this ambition. Tino notes that on many occasions, the vehicles were lined up in Monchi's driveway, waiting to be attended by the now recognized master. Through most of the 1990s, Monchi also worked as a painter for the National Maritime Authority. In his choice

of imagery, Monchi has always preferred "realistic drawings": landscapes, human figures, and increasingly religious subjects. Rural scenes have also been one of his specialties, and to a great extent, he is responsible for the more conservative style to the west of Panama City. His red devils are similar to those of Yoyo, in that they tend to be less crowded and more balanced than those of his younger competitors who generally cram the front and back ends with figures. Once a Catholic, Monchi now practices evangelical Christianity, and some of his red devils have overtly Christian themes, such as passages from the Bible and urgings to accept Jesus. Finally, it is important to note Monchi's role as a mentor. Both Tino and Ventura worked as his assistants, and many others consulted with him as they launched their careers. Monchi is a kindhearted person, notwithstanding his proclivities for bluster.[32]

SABINO JAUREGUIZAR (1912–81). Sabino was one of Panama's most productive commercial painters in the second half of the twentieth century and a key figure in the spread of popular art traditions. Like many of his contemporaries, he was also of immigrant stock, although his ties were to Europe and not to the Caribbean. Sabino was born in Barakaldo, Basque Country. He traveled to Panama City in the early-1930s, as he foresaw the outbreak of the Spanish Civil War and sought a better life for himself in America. At the close of the decade, he opened a shop on Calle Estudiantes, across from the Canal Zone and close to the capital's commercial district. The large lettering above the building caught the viewers' attention, as it announced Sabino's services but in an inverted fashion. "Sabino sabe pintar" (Sabino knows how to paint) was his slogan, and he blazoned it across the city to attract customers. Like the Wolf, Sabino understood the value of self-advertisement and the role of humor in creating business. His location, moreover, was ideally suited to take advantage of the expanded U.S. presence with the outbreak of World War II. The resulting economic boom benefited entrepreneurs such as Sabino, who initially knew little about commercial painting but who gained knowledge by trial and error and by reading translated foreign publications. Sabino eventually ran Panama City's most successful studio and won contracts from many of the capital's new businesses, including the Gago grocery store chain. Sabino's most important function, however, was probably that of a teacher in terms of the expansion of popular art. He commonly employed five to six assistants, many of whom were of Afro-Panamanian descent, and he provided them with the experience to launch independent careers. These men included Héctor Sinclair, Franco the Great, Marcos Cáceres, and Chico Ruiloba. Jorge Dunn recalls that Sabino was himself an excellent painter and was especially skillful at making letters. He was also apparently good at shooting guns. Sabino, according to

his son, was an expert marksman and represented Panama in several international competitions. During his free time, he loved to go hunting or to take his launch, the *Euskal Herria*, on fishing trips. Pool was another of Sabino's passions, and for a brief time, he owned a cantina near the Avenida Central.[33]

HÉCTOR "TOTÍN" JUDIÑO (1965-). Judiño is a well-known popular artist who rose to prominence in the 1990s and who first became fascinated with the red devils after a schoolteacher scolded him for drawing in his notebooks and warned that he was destined to become a bus painter. His mother also discouraged him from following this route and urged him to consider a more professional career: "Everyone's mom wants him to be a doctor or lawyer, not someone who runs around decorating buses," he explained in an interview at the Pedregal terminal, where today he does most of his jobs. Nevertheless, Totín eventually dropped out of high school and enrolled at the Escuela Nacional de Artes Plásticas. He also took classes at the private academy Ganexa and apprenticed under Fong and King for a brief period, before collaborating with Yoyo for five years. Totín considers himself to be a disciple of Yoyo, although he was also inspired by other painters of the 1980s, including Monchi and Roy. Totín's own fame, arose, in part, from his work for a clothing retailer which caters primarily to tourists. In 1997, he was hired by My Name Is Panama to decorate an elaborate red devil for publicity. Totín's choice of imagery was typical of the genre and included scenes of the countryside, the canal, and pop culture. The vehicles' paintings normally are of an open-ended nature and combine traditional elements of Panamanian identity with things drawn from the mass media. In addition, they often project signs of aggression to self-advertise and demonstrate social inconformity. At the entrance to the vehicle, Totín painted a devil, ominously urging female passengers to step through the door. "Welcome aboard, Mommy," exclaimed the smiling demon, who sported a fancy hat and was decked out with diamonds. The bus was placed over the company's Via España store, in the center of Panama City. This prominent display of a red devil confirmed for many painters what they had long thought about their art: It had become a means of expressing Panamanian nationalism, not unlike the bronze statues placed around the capital. Coincidentally, after Totín completed this job, the *Tailor of Panama* was filmed in Panama City, and three of his buses figured prominently in the movie. The private sector has readily recognized the marketability of popular art and has appropriated it periodically for its own purposes. Today, miniature red devils appear in gift shops, while their images are plastered on t-shirts and coffee mugs. Comparing his production to that of more academic artists, Totín notes that he "opted for the more famous style of painting."[34]

KING. King was a well-known bus artist in the 1970s and 1980s who was primarily employed in the eastern half of the capital and who also did occasional jobs in Colón. He apparently became interested in decorating red devils while washing the vehicles in a Panama City terminal. Tino spoke especially glowingly of King's talents, emphasizing his abilities to make detailed landscapes and to decorate bumpers and other rounded areas with eye-catching cartoons, figures, and patterns. Today, he is also widely regarded as one of Panama's early airbrush masters. His career seems to have taken a rapid turn downward, when he fell victim to a long-term drug addiction and, according to some, was even sent to jail. King is roughly the age of Andrés Salazar, and although he is no longer a prominent painter, he seems to have undergone a recovery. He apparently does sporadic work in the Veranillo terminal, and his commercial signs also appear in the surrounding areas. These billboards are identifiable by his distinctive signature, which includes an exclamation point at the end of his name, shaped in the form of a paintbrush. Both Rafy and Totín were inspired by King's images, and the latter was employed briefly as his apprentice.[35]

RICARDO LAY RUÍZ (1952–). Lay learned to paint from books and correspondence classes before obtaining a position at the Cervecería Nacional. Through the first half of the 1970s, he fashioned murals and beer advertisements in cantinas, restaurants, and similar venues, working closely with his mentor, Bustamante. In this period, Lay also decorated buses and collaborated with his cousin Monchi, as well as with Yoyo. Lay subsequently worked in a publicity agency, and in 1994, he founded his own business, which manufactures billboards in La Chorrera. In the appendix to his 1973 article, Silvano Lora includes photographs of the Cantina León in Calidonia. The exterior of the bar exhibited two works by Lay: a landscape of the interior and a reproduction of the Bridge of the Americas. Inside there was also a painting of a lion.[36]

VÍCTOR LEWIS FERRER (1918–1993). In the 1940s and 1950s, Lewis worked as a Colón sign painter and for years made posters for the Rex movie theater. Later he moved to the capital where he opened a shop in El Chorrillo and became a well-known commercial artist. Lewis decorated businesses as well as buses, and in addition, he did oil paintings on traditional canvases, selling these to individuals and to galleries. In 1968, he had his first exposition in the cultural center of the U.S. Information Service. He eventually came to be known as a primitive artist and participated in numerous shows in Panama and abroad. Through the 1970s, he regularly presented his works in the prestigious International Xerox competition, then one of Central America's most significant art events. In 1977, he won the top prize for his rendition of

El Viejo Hotel Imperial. The following year, the Museum of Modern Art of Latin America honored Lewis with a solo exhibition in Washington, D.C. Lewis is regarded as the isthmus's most important "primitive" painter, and he is regularly included in retrospectives on Panamanian art. In 2003, the Banco Nacional and Caja de Ahorros featured him in a commemorative publication as part of Panama's centennial celebrations. Lewis's paintings normally depict Colón's working-class barrios, whose aged wooden houses he represented in great detail and with a sense of their intense communal life. His perspective on these areas, however, was always modern, as Lewis portrayed these places as he saw them and without a sense of nostalgia. Residents walk down the sidewalks in contemporary dress. They chat and hold hands or look down from their balconies, while others wait at the corner for public transportation. Television antennas sprout from rooftops, and Coca-Cola signs hang outside the stores. In general, Panamanian popular art is concerned with the present and refuses to be limited by the old nationalist convention of portraying the isthmus in an imagined, older age.[37]

RUBÉN "CHINOMAN" LINCE (1969–). When middle-class Panamanians complain about the indecency of diablos rojos, they are often referring to Chinoman's buses. His vehicles are among the capital's most numerous and are designed to shock and call the attention of the viewer. In one rival's words, they are "always a kind of nightmare" and often feature gangsters, threatening machines, and ominous creatures. His depictions of women frequently border on misogynous. In one painting, an exotic warrior-princess gazes intently at the viewer with a glowing orb placed conspicuously between her legs. It is important to note, however, his less controversial subjects, such as movie stars, singers, natural scenes, and even children. The former gang member began to paint in 1988 and also earns his living as a tattoo artist. Recently, he has begun to collaborate with his brothers, David (1989–) and Fernando (1981–), who act as his assistants. The "Extreme Boys" are spreading the red devil style, especially in Tocumen, San Miguelito, and other outlying areas. In the last years, as the demand for the painted buses has diminished, they have plastered their art on things as varied as motorcycles, taxis, bikes, and even cell phones. Currently, Chinoman works out of a barbershop in the 24 de Diciembre commercial district, which also boasts many of his paintings. For years, popular artists have decorated the capital's hair salons, and Chinoman's murals can be found in many such businesses stretching from Colón to Panama City. Most of these images are inspired by hip-hop culture and include sport heroes, entertainers, and graffiti-style designs. Referring to his talent, Chinoman insists that "it was born in me" and emphasizes that he learned how to paint by himself.

Chinoman's nickname refers to his Asian features. He is the proud father of a five-year old son who, according to Chinoman, has also started to paint.[38]

VIRGILIO TEODORO "BILLY" MADRIÑÁN. Billy formed part of a group of young men who in the 1940s and 1950s, eagerly followed the Wolf's example and began to decorate the cantinas, restaurants, and theaters of the capital. The war boom was of great benefit to this generation and provided new venues for artistic expression. Billy is often described as a bohemian who also understood the value of spectacle in building a reputation and attracting customers. His contemporaries include Chico Ruiloba, Teodoro de Jesús Villarué, Héctor Sinclair, and Víctor and Oliver Bruce. Like many of them, he also was connected to the Canal Zone whose operations utilized the services of self-taught painters. A 1991 article published in the *Crítica Libre* describes Billy as an ex-employee of the dredging division, and Jorge Dunn confirmed in an interview that Billy had a longtime job with the North Americans. Héctor Sinclair also emphasized this background and noted that although he was "Latin," Billy lived for years in the Zone area and consequently spoke excellent English. During his early years, he collaborated with important sign makers, including Alberto Alie and Sabino Jaureguizar. He later became an independent artist and painted buses until the early 1990s. His red devils helped to inspire many other people, including such important figures as Totín and Salazar. Salazar recalls seeing Billy as a child and how this experience served to inspire his own career. Popular art is often done in open places, and as such, it attracts and educates younger people who take it upon themselves to continue the tradition.[39]

MARCO ANTONIO MARTÍNEZ ORTEGA (1948–). Marco is a self-taught artist who lives in La Chorrera. He earns a living by decorating businesses and by fashioning Carnival floats and crafts for tourists. His curriculum includes participation in numerous art fairs, in both Panama and the United States. He is especially adept at making the devil masks that are a prominent part of the Corpus Christi celebrations, selling them to stores in Panama City. Marco was born in the capital's Marañón neighborhood. He began to paint buses in the early 1970s, and over the next decade, he became one of the capital's most prolific decorators. He entered the field as an apprentice under Yoyo and was also employed by Bruzolli at Hotel Ideal. In addition, his training benefited from the informal meetings of artists at Malanga Meneses's studio in Bella Vista. There, colleagues and elders gathered through much of this period, and Marco became familiar with various media, including papier-mâché, painting, carving, and sculpture. In 1983, Marco participated in the Museo de Arte Contemporáneo show with a piece depicting the execution of Victoriano

Lorenzo and a portrait of the indigenous hero, Urracá. Marco, who describes his skills as "inheritance from God" has also held jobs in the fishing industry.[40]

ÓSCAR MELGAR (1968–). With the red devils' decline in the late 1990s, Óscar Melgar emerged as the tradition's most conspicuous defender, with the most buses today in Panama City. He became especially important after Andrés Salazar became ill which opened the market up to younger artists. Óscar was born in Panama City in 1968 and is one of the few bus decorators to have attended the Universidad del Arte Ganexa, a private art academy in the capital. More characteristically, he apprenticed under Andrés Salazar, assisting him for three years while completing his training. Óscar began to work professionally in the early 1980s, and like others of his generation and those a bit younger, he expresses a clear preference for vibrant scenes, often derived from movies, television, and magazines. The Rock, Julia Roberts, Willie Colón, and Héctor Lavoe have been some of his recent subjects. Frequently, Óscar also depicts infants and young children, presumably the sons and daughters of the bus owners. In contrast to the statues of the national government, average people become the heroes in these alternative monuments. Like Salazar, Óscar also jams his surfaces with imagery. Designs, expressions, and grimacing faces fill even the most peripheral spaces, and as a consequence, his buses are especially flamboyant. Their visual complexity is intense and projects the rhythm that is characteristic of the genre (plate 27). In the last years, Óscar has also taken to employing iron, and many of his vehicles now sport impressive front grills adorned with horse statues and elaborate lighting. Truly it is a spectacle to see one of Óscar's red devils rolling down the street and demanding attention. Like many previous artists, Óscar is also interested in music. As a teenager, he was involved in the mobile discos that dominated Panama's entertainment scene in the 1980s. More recently, he deejayed at Radio Tropi Q, a popular salsa station in the capital. Oscar is one of the few painters to receive a measure of recognition from the broader intellectual community. In 2007, his canvas works were the feature of an individual exposition, and in 2006, he traveled to Liverpool, England, where he and an assistant decorated six buses as part of the city's international art festival.[41]

EDUARDO "MALANGA" MENESES NÚÑEZ (–CA. 1995). Malanga was an important Panama City artist in the second half of the twentieth century. He was born in San Francisco de la Caleta, a small seaside community on the edges of Panama City, where he first earned his living as a fisherman. Malanga turned to painting after his sister asked him to make a seascape for her ceviche business. Early in his career, he relied on his natural abilities as

well as the advice of other people, but he eventually undertook formal studies in Mexico, Cuba, and the Soviet Union. In Cuba, he became fascinated with the island's music and later formed a combo with his brother, Juan Antonio. Malanga was a gifted singer and played the guitar and Cuban *tres*. For many years, he also managed a successful studio, first in Calidonia, near the Teatro Presidente, and subsequently on Avenida Peru, next to the Teatro Bella Vista. Marco Antonio Martínez recalls that in the 1970s, Malanga's Arte Centro was a popular hangout for the city's commercial painters. Among his many other activities, Malanga decorated buses, stores, bars, dance halls, and restaurants. His son emphasizes that one of his specialties was fashioning elaborate Styrofoam wall coverings for Panama City's bar mitzvahs. Malanga also made signs for the country's political campaigns, such as a portrait of Tomás Gabriel Altamirano Duque that today hangs inside the Meneses garage. An unusual aspect of Malanga's career was his close connection to General Omar Torrijos. Torrijos became aware of Malanga's talents and in effect designated him as the state artist, insisting that he construct many of the government's ornamentations, including the billboards that depicted the military leader and that were frequently erected at his rallies. One of these images measured some seven stories and covered the side of the Hotel Internacional. When the Pope visited Panama in 1983, Malanga was commissioned to make a twenty-five-foot sign welcoming the religious leader to the capital. The artist occasionally made more permanent works, including a statue of Christ off Isla Grande in thanksgiving for his son's medical recovery. The Carnival season was always Malanga's busiest period, as he often designed up to five floats for the parades in the capital and the interior. Jorge Dunn emphasized in an interview that for many years, Malanga was the most active creator of these vehicles and that he usually hired others to help complete his projects. Héctor Sinclair sometimes collaborated with Malanga, and in an interview, he showed a photograph of one of their products: an elaborate float in honor of Dr. Martin Luther King with an enormous bust of the civil rights leader. Víctor Bruce described Malanga as a "Hispanic black, someone who looked like me but who didn't speak English." Malanga died around 1995. His nickname came from his time in Cuba and refers to a popular vegetable on the island.[42]

CRISTÓBAL ADOLFO "PIRI" MERSZTHAL VILLAVERDE (1979–). Piri is a self-taught artist who paints buses outside his house in Pacora, along the village's principal avenue. Pacora is situated just east of Panama City, and its red devils, which link the community to the capital, are some of the country's most extravagant. Like many of his colleagues, Piri does not have an extensive formal education. He abandoned school after completing sixth grade; however, he

subsequently began a series of enriching apprenticeships with César Córdoba and later Chinoman. Chinoman considers Piri to be his disciple, noting that he instructed him for a period of three years. Piri separated from his mentors in 2000 and has become one of the most active decorators, probably only second to Óscar in his production. His buses are similar to those of other young painters in that they tend to be plastered with complex imagery, lettering, and intense designs. One of Piri's particular touches is to make paintings that cross the entire front and back ends, rather than confining themselves to traditional spaces such as the bumpers and the emergency doors. Several years ago, he depicted the Incredible Hulk in this manner. Another bus boasts a giant F.C. Barcelona seal, and on a third, he created an enormous lion staring out from the tangled brush of a jungle. Below and on the corners, he sometimes makes scrolls, which have become common on many buses. Usually, these contain boastful sayings or insights intended to edify the viewer: "In the heart of the prudent lies true wisdom." In addition to the red devils, Piri also paints taxis and bicycles, many of which can be seen in his hometown. Remarkably, the red devil style seems to be spreading, even as bus art itself has become less evident.[43]

DAVID NAVARRO (1937-). David is a La Chorrera–based artist, who began decorating buses when he was fifteen years old as a means of supplementing his income as a *llantero*. David fixed tires (*llantas*) in his hometown bus station and earned about 20 cents for each one he repaired. His pictures would fetch him an extra 3 dollars, and at this point, they appeared exclusively inside the cabins and usually represented elements of the Panamanian interior: beach scenes, villages, and mountainous landscapes. He recalls that he could complete about ten to fifteen per day. He occasionally painted names derived from the movies, from the music scene, from sports, and from radio soap operas. After Yoyo's arrival in La Chorrera, David became the older painter's assistant and learned how to extend the imagery onto the exterior and to rely more heavily on elements of popular culture. Soon David expanded the scope of his activities and began to decorate cantinas and other businesses. He has painted the majority of the bars in La Chorrera and has had many projects in other parts of the interior. As an adult, he took classes at the Escuela Nacional de Artes Plásticas. David now works exclusively in La Chorrera and makes signs and smaller canvas pieces in his home.[44]

JOSÉ "PIOLO" ORTEGA (1970-). Piolo is a self-taught painter from La Chorrera, who began to work professionally in 1987 and who in the past has often collaborated with Tino and Monchi. As a boy, Piolo developed a great

admiration for Monchi, who was then one of Panama's most active artists. Piolo often visited Monchi's nearby residence to learn from his efforts and occasionally to lend a hand. Piolo paints red devils and restaurants in La Chorrera and has also embellished many of the city's taxis. The popular art tradition continues to expand, even as the decoration of buses has entered into decline. Piolo's specialty is what he calls "fantasy drawings"—landscapes and scenes of futuristic worlds. The bus artists often appropriate existing images, but they also use their imaginations to create more original works.[45]

PEDRO PABLO ORTEGA OLIVARDÍA. According to a 1978 newspaper article, Pedro was an important young artist during this period, who had by this time decorated over two hundred buses. In an interview, he credited Yoyo and Monchi for his training and complained that popular art still had not received sufficient recognition. This is still a common grievance among the painters who note their low pay and the dwindling market for their services. In 1983, Pedro was the second-place winner in the Museo de Arte Contemporáneo competition, receiving three hundred dollars for his painting *Mi País Panamá* The work was a copy of the government's official insignia, along with scenes of Panamá Viejo, the canal, and the Bridge of the Americas. The judges favored such traditional national images, frustrating those who had submitted more creative pieces.[46]

HARRY PAREDES (1969–). Harry painted buses through much of the 1990s. He received his education at the Escuela Nacional de Artes Plásticas and benefited from an apprenticeship with Andrés Salazar. In recent years, as the demand for bus art has declined, Harry has spent more time decorating businesses. For Harry, this is a regrettable situation. He notes that Panama's popular art tradition has been extraordinarily creative and has helped to project a positive image of the isthmus. Tourists, he insists, are fascinated by the red devils which also have an important domestic function. According to Harry, the vehicles serve to educate the population and to foment its knowledge and interest in art. In a country where few people have opportunities to visit museums, they have become Panama's "national canvas." Harry's views are reflective of a broader belief among the artists that their paintings have become a symbol of national identity, much like the *polleras* and folk dances of the interior.[47]

JOSÉ MANUEL QUINTERO (1979–). José is an autodidact painter who in June 2001, claimed to have decorated more than one hundred buses. His production over the last years has increased significantly, with dozens of his

red devils now circulating around Panama City. He first worked on the vehicles as Salazar's assistant and was employed by the Panamanian master for a year and a half. Similar to his mentor and other Panama City artists, José tends to emphasize contemporary subjects. He selects his materials primarily from television programs, movies, comic strips, and popular music. His buses, as a consequence, have a newspaper quality and constantly incorporate new and trendy elements. Panama's self-taught artists often use the mass media and frequently depict foreign singers, actors, sports heroes, and politicians. They see nothing anti-national in these appropriations, an attitude which contrasts sharply with that of mainstream intellectuals who have often insisted on a "purer" vision of the isthmus, divorced from modernity and from such "outside" influences. José now paints primarily in Ciudad Bolívar, an outlying area of the capital.[48]

OSVALDO "MOZAMBIQUE" QUINTERO (1955–). Mozambique is one of the seven painters currently employed by MultiArte, an important art studio in the capital, which crafts signs and other decorations for Panamanian businesses. The weeks before Carnival are the firm's most active period, when workers construct floats for Panama City's parades. Before Christmas, they fashion Styrofoam nativity scenes for display in shops and residences. Prior to joining the company, which is owned by Castro de Burunga, Mozambique had earned a living as a commercial painter. For over twenty years, he made advertisements for several beverage manufacturers in the country' bars, restaurants, and supermarkets. Mozambique's entry into this field was unexpected, and he has never taken any formal classes. "The street was my teacher," noted Mozambique who as a teenager, studied plumbing at the Escuela de Artes y Oficios. After graduation, he decided to change professions and decorated red devils through the late 1970s. The Panama-Colón route was his main area of operation. Today, Mozambique still does occasional freelance work. One of his most recent projects was a series of impressive murals at the entrance to the Colón free trade zone. Mozambique's nickname comes from a Panamanian band, popular in the 1970s. As a teenager, the artist was fond of the group's music and often sang its songs while he was working. Friends, as a consequence, began calling him Mozambique.[49]

VÍCTOR "CHOLÍN" REYES (1968–). Cholín began decorating passenger vehicles when he was sixteen years old; however, demand for his talents only grew in the late 1990s, when he initiated his eventual domination of the Torrijos-Carter route. Today, he is one of the capital's most active artists, although he also works as a driver to earn a living. In the last years, many of his colleagues

have taken up other occupations, as fewer bus owners employ their services. Like most of his predecessors and contemporaries, Cholín draws on international popular culture to adorn the red devils. Singers, actors, and athletes appear in his compositions, which, like those of Salazar, are packed with this imagery. Despite his use of such changing subjects, Cholín considers buses to be "something traditional." The red devils' style has existed for over half a century and has become a "folkloric" aspect of Panamanian society. Many other artists agree with this position, as do some members of the business community, who occasionally draw on the practice in presenting the country. As a teenager, Cholín admired the creativity of Salazar with whom he worked briefly before beginning his own career.[50]

ARMANDO ROBINSON (1971–). Armando is a popular self-taught painter who works in Colón and the capital and whose art touches on themes of vulgarity and aggression. Self-assertion is a critical part of the red devils' spectacle, and Armando contributes to the display with images of scowling men, menacing creatures, and aggressive adages, often projected on the front or rear bumpers. "Soy la ley" (I'm the law), asserts one of Armando's bearded figures as he flashes his pointy teeth and brandishes a club. Armando began to decorate buses when he was twenty-one, initially employed as an assistant by Andrés Salazar. More recently, he was hired by the producers of *The Tailor of Panama* as an adviser for the Hollywood movie. Elite and foreign interests have regularly utilized popular art, as they see its appeal and commercial significance. Unfortunately, new transportation companies have not recognized this value and so far have neglected to hire the artists. As a consequence, there are fewer and fewer painted buses on the capital's streets. In an interview, Armando bemoaned the transit system's renovation and the subsequent decay of the red devils: "Torrijos," he claims, "gave public transportation to the people, and now a few rich people want to retake it in the name of modernization." Robinson predicts, however, that the red devils will never be entirely replaced, as their competitors are too fragile for the republic's roads. Potholes are ironically another factor encouraging artistic expression among Panama's working class. "The expensive buses," he avows, "will be unable to service many areas and will leave these places to the smaller proprietors." Armando's observations appear to be correct as many of the newer vehicles have already fallen apart and are rusting away in the capital's junkyards.[51]

DAVID ERNESTO RODRÍGUEZ (1967–). David is employed primarily in Panamá Oeste, the area to the west of the interoceanic waterway and stretching to the town of Capira. He began working on buses in 1994 and is closely

connected to the painter Tino, today the region's most active decorator. In fact, David first worked as Tino's assistant, and occasionally still collaborates with him in La Chorrera. David was born in Chitré, and as a young boy, moved with his family to the capital. The city's bustling streets immediately caught his attention and sparked an interest in the red devils. While he and his parents lived in El Chorrillo, in the heart of Panama City, his aunt resided in a more outlying neighborhood. On weekend trips to his relative's house, he often road on Salazar's buses and gradually came to appreciate his skills. While David never apprenticed under the older artist, he spent considerable time studying Salazar's images, and he considers him to be another of his teachers. Like many of his contemporaries, David has also benefited from formal studies and earned a degree at the Escuela Nacional de Artes Plásticas. The red devils' decline and recent health concerns have forced David to look for other employment opportunities. He now works full time for a transportation company, but remains a great devotee of the vehicles. Indeed, the artist spends much of his free time constructing large and amazingly detailed models. Several of these replicas measure at least three feet long and feature hand-painted designs, chrome tailpipes, and rotating wheels. The *busitos* have appeared in numerous radio events and have been received with great enthusiasm in local parades. David is now pondering whether to construct smaller versions to market to tourists and aficionados of popular culture.[52]

VÍCTOR HUGO "PIRRI" RODRÍGUEZ MALDONADO (1971–). As a teenager coming to age in the black city of Colón, Pirri was often perplexed by his school history lessons. His teachers and texts underlined Panama's indigenous background and the arrival of the Spanish conquerors in the sixteenth century; however, they often neglected the country's long experience with slavery and the immigration of thousands of Afro-Antillean workers during the construction of the Panama Railroad and the interoceanic canal. These ironies were not lost on the young Afro-Panamanian, who subsequently converted to the Rastafarian faith and who adopted an openly black identity, just as reggae and hip-hop became popular on the isthmus. The transformation of Pirri's self-awareness is plainly evident in his work. Pirri specializes in the decoration of black barbershops, which he tends to plaster with African American singers, NBA stars, and *fútbol* players as well as with the images of Panamanian *reggaeseros*, Bob Marley portraits, and other Rastafarian icons. Pirri studied construction at the Instituto Profesional y Técnico de Colón. He learned to paint as an apprentice under Armando Robinson and through a job with a billboard company. Consequently, he has a broad range of experience and has worked on things as wide ranging as restaurants, signs, automobiles, buses,

and T-shirts. Most of his contracts have been in Colón or along the highway connecting the city to the capital, especially near his home outside Chilibre. Pirri prefers not to sign his creations, but instead he marks them with passages from the Bible.[53]

ROY (CA. 1965–1999). Roy grew up in the small town of Chepo, approximately twenty miles east of Panama City. He studied mechanics at the Instituto Tomás Alva Edison before turning to the red devils and becoming Salazar's assistant. Roy was employed as an independent painter from the mid-1980s to the late 1990s and primarily served the Pacora and Tocumen terminals. By all accounts, he was a generous person whose mentoring and teaching helped to spread the tradition and whose talent for painting with an airbrush was exceptional. His red devils are described as some of the most creative of this period. He marked them with a flashy, distinctive signature, which has become a standard practice for most of the decorators. Choloporuca was among his many apprentices who later went on to their own careers. Piri was also influenced by the painter and insists that Roy helped to foment his artistic interests. Roy was roughly the same age as Totín and died of a cerebral hemorrhage in 1999. In addition to his many buses, Roy painted a landscape in the hospital of his hometown. Unfortunately, this mural seems to have been lost in the facility's many renovations.[54]

JOSÉ ÁNGEL "CHICO" RUILOBA CRESPO (1927–2004). Chico described Panamanian popular art as a "Caribbean imitation," emphasizing that "Afro-Antilleans were the ones who initiated it" and that they were replicating, in many ways, the customs of their own countries. Chico's observations have a certain authority as he grew up in Red Tank, a silver-roll town in the Canal Zone, and thereafter remained closely tied to the isthmus's Afro-Antillean population. For forty years, he was employed by the U.S. Canal Company, and in his work fashioning street signs and other announcements, he frequently mixed with the colony's Afro-Antillean workforce. More importantly in this regard, his mother married the Wolf, and Chico lived with the Haitian-Panamanian artist during much of the 1940s. The Wolf's showy example had an impact, as evidenced by photos of Chico in elegant hats, sporting fine clothing and wearing dark glasses. Chico matured under the Wolf's influence, and from the time he was ten through the 1950s, he decorated Panama City's bars, buses, and theaters. In his early years, he was hired by the Spanish entrepreneur Sabino and collaborated on such projects as the renovation of Happyland, the trendy wartime cabaret on the Plaza Cinco de Mayo. Chico became a central figure in the preparations for Panama's Carnival; for twenty-two years,

he made the floats used in the celebrations in Las Tablas. In 1946, after the triumph of the Allies, he helped build allegorical figures for Panama's City's victory Carnival. Chico is exceptional in many respects, particularly in terms of his education and his ties to some of Panama's most well-known academic painters. As a teenager, Chico studied with Humberto Ivaldi at the Escuela Nacional de Pintura. Later, as a young man he went to Argentina, where he continued his training at the Escuela Superior de Bellas Artes Ernesto de la Cárcova. His traveling companions included Alfredo Sinclair and Juan Bautista Jeanine. Contrasting his life with that of his more famous friends, Chico suggested that financial concerns led him to veer from their path and to embark on a more commercial career. "Many great artists," he emphasized, "have suffered hunger, and their works only became valuable after their deaths. That," he said, "didn't interest me a bit." A group of Puerto Rican soldiers gave Ruiloba his nickname "Chico" (boy) when he was fourteen and employed as a stevedore in the Canal Zone.[55]

ANDRÉS SALAZAR (1955–). Salazar is the most influential popular artist in the latter part of the twentieth century. His red devils dominated Panama's roads during the 1980s and 1990s, and he is important not only for his tremendous creative production but also for the critical role he has played as a mentor. Innumerable younger men have apprenticed under his direction, and even those such as David Ernesto Rodríguez who have not worked with him directly describe him as the "teacher of us all. "From him," David affirms, "we have essentially all emerged." Such declarations are understandable upon seeing Salazar's buses, which best project the style of "100% *prity*," particularly its emphasis on syncretism, rhythm, and spectacle. Salazar's red devils often have musical themes. They are packed with images of national and foreign singers, and their visual intricacy fosters a sense of movement. They also typically benefit from excellent stereo systems, flashing lights, whistles, and powerful horns. Salazar's vehicles teem with cadences that entice the public and incorporate it into the show. Salazar was raised in Panama City. He attended school through the sixth grade and later studied at the Escuela Nacional de Artes Plásticas. Inspired by Yoyo, Billy, and El Precolombino, he began to decorate buses when he was seventeen. His cousins first hired him to help with their red devils, and gradually he won contracts from other owners, steadily building his reputation as the most innovative painter. Even rivals such as Monchi readily acknowledge his abilities. Commenting on the artists whom Salazar has trained, Monchi notes they "have always hoped to decapitate their teacher, but none have been able to take Salazar's head." Sadly in recent years, illness has slowed the master who is now on dialysis and awaiting a kidney transplant.

Despite his weakened state, he continues to paint buses as well as cars, motorcycles, bicycles, and portraits. In his demeanor, Salazar remains a youthful man who exudes a sense of optimism, ingenuity, and tolerance.[56]

HÉCTOR ALFONSO SINCLAIR (1926–). Popular art is, in many ways, an outgrowth of Panama's modernization and the changes imposed on the country by U.S. imperialism. There are few better examples of this phenomenon than Héctor Sinclair whose family immigrated from Jamaica during the construction of the interoceanic waterway and whose career path has paralleled the shifts in U.S. foreign policy. Sinclair was born and raised in Colón. He moved to the capital as a teenager to study at the Escuela de Artes y Oficios. There he developed an interest in commercial painting, and he found numerous opportunities in the expanding city. In the mid-1940s, the republic's economy was booming, as a consequence of the flood of U.S. troops who had come to protect the canal during World War II. Sinclair found a job with Sabino, the self-taught artist and dynamic Spanish immigrant who had opened a studio in the late 1930s. His commissions included agreements to decorate hotels, restaurants, bars, and movie theaters. Sabino and his assistants also made billboards, carnival floats, and posters for political campaigns. During the Christmas season, they painted the storefronts along the Avenida Central with religious and festive imagery. Sinclair eventually established his own shop and earned the enmity of his former boss. Popular art is a competitive business, as rivals vie for limited contracts and try to outduel each other with their creativity. Sinclair later found a position with the North Americans and was employed as a Canal Zone artist for twenty-five years. He periodically traveled to military bases in the United States and continued his freelance activities in the republic. His training includes a correspondence course with the Washington School of Art and a graphic design class at the national university. In an interview, Sinclair emphasized popular art's role in fostering a sense of self-worth among Panamanians: "We are a small country and nobody knows us. We are 'sub-developed and second-world,' as they call us, and so we like to see a good piece of art. . . . It gives us a sense that we too have capacity, that we have abilities and also are modern." Sinclair remains active in the field. He works on canvas pieces nearly every afternoon alongside Eugene Jr. and Errol Dunn in their Parque Lefevre studio.[57]

SINESTRA. In the 1950s and 1960s, the big cabarets in Colón and Panama City gradually ceded their position to more intimate *boîtes*. The shift reflected changes in Panamanian music, specifically the decline of the large, Cuban-style orchestras and the rise of smaller groups known as *combos*. In his 1973 article

on popular art, Silvano Lora provides photographs of the Boîte Jazz Pop. The walls of the club were decorated by Sinestra, who painted female nudes, ballerinas, and references to drama. Unfortunately, Lora provides no information about Sinestra, and I was unable to find any other sources about him beyond a brief reference to him in Revilla Agüero's *Cultura hispanoamericana en el Istmo*.[58]

BUENAVENTURA "VENTURA" TORDESILLA (1964–). Ventura is another of the talented painters who began to decorate buses in the late 1970s and who has since become one of the tradition's prominent figures. Ventura spent his childhood in La Chorrera, where he became fascinated with the work of Monchi and served as his assistant for a year and a half. His studies also include a diploma from the Escuela Nacional de Artes Plásticas, and he has recently returned to the academy to pursue a degree in graphic design. Ventura has also produced advertisements for Panama's beverage companies, and in the late 1980s, he made signs on U.S. military bases. On my various trips to Panama, I have seen a number of his red devils, which are similar to those of Yoyo and Monchi and are more simple and balanced than those of contemporaries. Instead of plastering the vehicles with multiple images, Ventura tends to concentrate on the front and back ends and creates scenes of exceptional quality. Often his perspective is that of a close-up which he presents in a highly stylized manner. On the emergency door of a recent bus, he fashioned such a depiction of a ship passing through the Miraflores locks. Immediately to the right was a red devil dancer, whose upper body and headdress were the centerpiece of the painting and who looked directly at the viewer. On another bus, he made a remarkable portrait of the Black Christ of Portobelo, an important devotional image in the country. Today, Ventura admits that he is gradually leaving the profession as there are fewer and fewer opportunities for the painters. "For me," he laments, "the red devils have died." His dream now is to become a teacher and to offer classes on art and publicity.[59]

FÉLIX UREÑA (1983–). In May 2001, Félix was employed as Rolando's assistant and explained how he had come to occupy this position. In school, the red devils were a frequent topic of conversation, as his classmates compared and contrasted the merits of artists. Students have always been one of the principal groups using Panama's public transportation, and consequently, painters often design buses to attract their attention and secure them as customers. Félix lived close to Rolando's Tocumen garage, and he sometimes visited and observed the decorator's work. Rolando eventually asked him to help complete projects, assigning him minor tasks and instructing him along the way. Félix expressed his admiration for his mentor's talents as well as his desire to

become an independent artist. Young men in general spend several months to several years collaborating with a mentor before launching their own careers. Félix's red devils have yet to appear in Panama City. Perhaps with the decline of the red devil tradition, he has chosen another path in life.[60]

DANILO "DANNY" VILLARRUÉ (1952–). Villarrué graduated from the Instituto José Dolores Moscote in Panama City and is the son of the famous bus painter Yoyo Villarué. In school, Danny received no formal artistic training but instead learned the craft by collaborating with his father beginning in the 1970s. Danny's initial function was essentially that of an assistant; however, the relationship has long since become that of equals, and both men sign their completed works. Their red devils often can seem quaintly old-fashioned in comparison to the creations of younger artists. Yoyo and Danny's imagery is normally less dense. They avoid the tendency to fill their surfaces with figures and instead insist on open spaces. Elegant yellow, orange, blue, and red lines run along either side of the roofs and the bumpers and provide a sense of pro-portion. Everything seems balanced in their paintings. In larger areas, they fashion portraits of celebrities or eye-catching scenes of the interior, coastal villages, ruins, or the Bridge of the Americas. Yoyo and Danny's buses also lack the vulgarity which other *decoradores* have used to assert their position. Self-advertisement is an important aspect of the popular art tradition and a means of establishing one's reputation. Yoyo and Danny, however, project themselves differently from the typical hypermasculine assertions on many of the buses. For example, "White Magic" was the name of one of their red devils seen sev-eral years ago on the Vía España.[61]

TEODORO DE JESÚS "YOYO" VILLARUÉ (1926–). Yoyo is the "old master" of Panama's street art tradition and a person for whom almost all the painters expressed admiration. Yoyo's first *chivas* date from the early 1940s, and in the initial years of the twenty-first century, several of his red devils were still visible on the streets. The resilient painter grew up in Panama City. His father was a lawyer and taught at the Instituto Nacional, while his mother was also employed as a teacher. In the mid-1930s, the family lived in Nom-bre de Dios, a small colonial town on the Atlantic side of the isthmus, where Yoyo's parents directed the local school. The experience seems to have had a great impact on the artist, as some of his most accomplished works are de-pictions of the Caribbean, its coastal villages, beaches, palm trees, and boats. Indeed, one of the most satisfying experiences for this author was to identify these brilliant seascapes on Yoyo's buses. Another of his traditional themes has been music, as Yoyo was once an accomplished trumpeter and performed

in the Cuban and jazz orchestras of the 1940s and 1950s. Rhythmic patterns and singers have always appeared in his imagery. Popular art is closely tied to World War II and to the cantinas, cabarets, and dance halls of that period. In his early years, Yoyo also decorated these venues, sometimes after playing all night on their stages. In addition, he painted posters, storefronts, and restaurants, forming part of a cadre of young artists who were drawn into the discipline by the Wolf and who often visited him while he was working. Contemporaries include Virgilio "Billy" Madriñán, Malanga Meneses, Héctor Sinclair, and Chico Ruiloba. Yoyo's training also involved a period at the Escuela Nacional de Artes Plásticas, where he studied under its longtime director Adriano Herrerabarría. His most important education, however, probably came from practical experiences. For years, Yoyo made signs for the capital's municipal government, and he was often hired by Panama's military officers to embellish their vehicles with numbers and lettering and sometimes with showy imagery. One important assignment was to outline a puma on General Omar Torrijos's helicopter. The Catholic Church also gave Yoyo an important commission, to make a portrait of John Paul II in honor of his 1983 visit. The picture now hangs in the Panama City Cathedral. Another of Yoyo's paintings, a depiction of Simón Bolívar, graced the offices of the municipal government. Yoyo's career reflects the trajectory of popular art, its emergence on the margins of Panamanian society and its evolution into a symbol of national identity. Yoyo's son, Danny, is also a painter and has collaborated with his father on many projects.[62]

PASTOR ISIDRO "CHINO" SING YAP SÁNCHEZ (1949–). Chino has fashioned signs and decorated businesses since 1981. He is especially known for his work in Santa Ana, the capital's traditional working-class barrio. He is particularly active in its Chinese quarter, where his grandparents settled in the early twentieth century. Chino learned how to paint in secondary school and later took classes at the Universidad Tecnológica de Panamá while pursuing a degree in civil engineering. Financial troubles prevented him from completing this program, and today Chino works in a furniture store, close to the Plaza Santa Ana. Its location is ideal in the sense that it is near the many shops that still employ painters. In lower-income areas, popular art is abundant on the exteriors and interiors of commercial establishments. When asked about the apparent decline of the tradition, Chino responded that he "never has any problem in finding jobs." In his spare time, Chino enjoys making portraits and landscapes.[63]

NOTES

ACKNOWLEDGMENTS

1. Fukuyama, *End of History.*
2. Wade, *Blackness and Race Mixture*, 46.

INTRODUCTION

1. García Canclini, *Transforming Modernity*, 11.
2. Lora, "Pintura popular," 109.
3. Salazar, interview.
4. Wyoming20, "Preparing for a New Continent!"
5. Salazar, interview.
6. Gilroy, *Black Atlantic*, 1; Rowe and Schelling, *Memory and Modernity*, 105. For an interesting discussion of modernization and vernacular art, see Paul Arnett's introduction to *Souls Grown Deep*, ed. Arnett and Arnett. Arnett notes that in the 1970s and 1980s, many scholars believed that television and other elements of the mass media would shortly overrun untutored and previously isolated black "folk" artists. Instead, production boomed in the next decades, and what died was the "idea of cultural or creative purity" ("An Introduction to Other Rivers," in *Souls Grown Deep*, ed. Arnett and Arnett, 1:xvi).
7. García Canclini, *Transforming Modernity*, 11.
8. Kevo, "Devilish Escapades"; Wilkinson, "Arte rodante," 46, 47.
9. Gilroy, *Black Atlantic*; Vélez, *Drumming*, 92–93; Andrews, *Afro–Latin America*, 171–90; Simmons, *Reconstructing Racial Identity*; Feldman, *Black Rhythms*; Darién J. Davis, "Postscript," in *No Longer Invisible*, ed. Minority Rights Group, 359–70; Sansone, *Blackness*, 95–163; Andrews, *Blacks and Whites*, 191–93; Hanchard, *Orpheus and Power*, 95–141; Crook, "Black Consciousness"; Frigerio, "Re-Africanization"; Pinho, "Etnografias do brau"; Tina Gudrun Jensen, "Discourses on Afro-Brazilian Religion: From De-Africanization to Re-Africanization," in *Latin American Religion*, ed. Smith and Prokopy, 275–94. Scholars have used the term *re-Africanization* to describe the reassertion of Afro–Latin American identities from the mid-twentieth century forward and especially apparent in the Dominican Republic, Cuba, Brazil, Colombia, and Panama. While underlying the domestic roots of these movements, most studies also point to the influence of transnational factors and the region's integration into the "global Pan-Africanist discourse" to explain their emergence and impact on both political and cultural life.
10. A short list would include people such as Leoncio Ambulo, Isaac Benítez, Earl Livingston (1942–), and Lloyd Bartley (1913–97). Alfredo Sinclair (1915–) is probably Panama's most recognized painter, and he is an Afro-Panamanian. Interestingly, as he began his career in the 1940s and 1950s, Sinclair worked in a neon light shop in Panama City and was closely connected to a

number of popular artists, including Gilberto Ruiloba and José Ángel "Chico" Ruiloba. Sinclair credits Gilberto for helping him move from Colón and establish himself in the capital. See Alfredo Sinclair, interview; Monica E. Kupfer, "Los cincuenta años de pintura de Alfredo Sinclair," in *Alfredo Sinclair: El camino de un maestro*, 11, 22; José Morales Vásquez, "Rescate del olvido: Earl Denis Livingston," *El Siglo*, 31 August 2008; José Morales Vásquez, "Segunda Parte: Rescate del olvido, Earl Denis Livingston," *El Siglo*, 9 September 2008; José Morales Vásquez, "Rescate del olvido: Lloyd Bartley," *El Siglo*, 6 April 2008.

11. Héctor Sinclair, interview; Chico Ruiloba Crespo, interview; Alemán and Picardi, *Cien años*, 132–33; *Colección pintórica*, 106; Renato Ozores, "La pintura en Panamá," in *Panamá: 50 años*, 266–67.

12. In *The Revolt of the Masses*, Ortega y Gasset offered a pessimistic vision of this transition. He argued that the political and technological advances of the nineteenth century had created a society in which the masses dominated and were "concerned only with their own well-being." He predicted an almost apocalyptic future for Europe: "If that human type continues to be master . . . , thirty years will suffice to send our continent back to barbarism" (60, 52). For a more positive discussion of the "democratization" of culture, see Hobsbawm, *Age of Empire*, 236–42.

13. See, for example, Víctor F. Goytía, "Introducción," in Arrocha Graell, *Historia*, x. Arrocha Graell's book was one of the earliest comprehensive attempts to explain Panama's independence and to defend the country from its detractors.

14. Rama, *Ciudad letrada*.

15. McGuinness, *Path of Empire*, 94.

16. Liberals in the mid- to late nineteenth century became less attached to their classic political principles, and under the influence of positivism and social Darwinism, they became more concerned about the material manifestations of "progress." For explanations of these changes, see Hale, *Transformation of Liberalism*; Molina, *Ideas liberales*, 175–93.

17. This conception of nationalism as a modernizing project was not unique to the Panamanian oligarchy but reflected broader regional trends. Elites across Latin America identified modernization with nationalism and regarded foreigners as their allies in the fight against "barbarism." In the second half of the nineteenth century, as they fell under the influence of social Darwinism, they would undertake what Andrews calls a "war on blackness." See Burns, *Poverty of Progress*; Andrews, *Afro-Latin America*, 118; Graham, *Idea of Race*; Skidmore, *Black into White*; Moore, *Nationalizing Blackness*, 26–40; Butler, *Freedoms Given*, 16 46; Wright, *Café con Leche*, 13–96; Andrews, *Afro-Argentines*, 101–6.

18. Soler, *Formas ideológicas*, 33–62; Figueroa Navarro, *Dominio y sociedad*; Szok, *Última gaviota*, 13–34.

19. This disillusionment with modernization was not exclusively Panamanian but was part of a wider tendency. Latin American intellectuals became unsettled by immigration; by the period's rapid economic, political, and technological changes; and by the frequent interventions of the United States. Often, they postulated that Latin Americans were more spiritual than their materialistic neighbors and should find their own path to modernity. For an example of this thinking, see Ramos's discussion of Cuban writer José Martí in *Divergent Modernities*, 151–279.

20. Nairn, *Break-Up of Britain*, 328.

21. This elevation of mestizaje and lightening or disappearance of blackness occurred in many parts of Latin America. José Luis González (*Puerto Rico*, 1–30) has outlined a similar phenomenon in early-twentieth-century Puerto Rico. In reaction to the economic and social disruptions of U.S. imperialism, intellectuals began to exalt the Spanish colony and the *jíbaros*, the island's mestizo peasantry. These same writers ignored Puerto Rico's blacks, who exercised greater influence after

separation from Spain. For similar discussions, see Lillian Guerra, *Popular Expression*, 19–121; Skidmore, *Black into White*; Moore, *Nationalizing Blackness*; Wright, *Café con Leche*, 97–124; Kutzinski, *Sugar's Secrets*; Vianna, *Mystery of Samba*; Hanchard, *Orpheus and Power*, 43–74; Juan E. de Castro, *Mestizo Nations*, 55–92; Wade, *Blackness and Race Mixture*, 8–19.

22. Sommer, *Foundational Fictions*.

23. Méndez Pereira first published the novel as *El tesoro de Dabaibe*. In 1936, he changed the title to *Núñez de Balboa, el tesoro de Dabaibe*. The book has subsequently gone through numerous editions.

24. Castillero Calvo, *Negros y mulatos libres*, 3.

25. Nairn, *Break-Up of Britain*, 328.

26. Rowe and Schelling, *Memory and Modernity*, 105.

27. For some examples of this perspective on *negros coloniales* and *negros antillanos*, see Diez, *Cimarrones y los negros*; Gerardo Maloney, "Significado de la presencia y contribución del Afro Antillano a la Nación Panameña," in *Historia general*, ed. Castillero Calvo, vol. 3, book 1, 153–54; Marrero, *Nuestros ancestros*, 2–6; Manuel de la Rosa, "El negro en Panamá," in *Presencia Africana*, ed. Martínez Montiel, 217–92.

28. See Watson and Nwankwo's analysis of Afro-Antillean literary figures and Duke's study of the Sociedad de Amigos del Museo Afroantillano de Panama (SAMAAP). Research suggests that Afro-Antillean identity has remained critical even as Panamanians of West Indian descent have become more integrated into Spanish-speaking society. Watson, "Use of Language"; Watson, "Are Panamanians of Caribbean Ancestry an Endangered Species?"; Nwankwo, "Art of Memory"; Duke, "Black Movement Militancy."

29. Studies of music have especially underscored this ability of transnational influences to shape or undermine official identities. See, for example, Zolov, *Refried Elvis*; Austerlitz, *Dominican Music*, 30–51; Moore, *Nationalizing Blackness*, 118–22; Wade, *Music, Race, and Nation*, 25–29, 72–78; Christopher Dunn, *Brutality Garden*.

30. Salazar, interview.

31. Aguirre, *Agentes*, 172.

32. Brown, *Santería Enthroned*, 33; Walker, *No More, No More*, 3–4.

33. Benítez Rojo, *Repeating Island*, 218.

34. This tendency to embrace modernity in a positive fashion is evident in other parts of the postcolonial world. In an essay on African art, "No Condition Is Permanent," Guy Brett notes that while the region's "intelligentsia experiences change as a dilemma, the popular painters . . . take hold of foreign influences . . . with both hands and transform them with incredible inventiveness" (in Brett, *Through Our Own Eyes*, 102).

35. In 1939, Cuban scholar Fernando Ortiz provided a classical description of this process. He compared Cuban society to *ajiaco*, a stew into which numerous ingredients are mixed and blended while retaining a sense of their distinctive flavor. Since the publication of his essay, hybridity has become a common theme for many studies of the Caribbean. It is especially prominent in works on Caribbean music and art. See Ortiz, "Cubanidad"; Poupeye, *Caribbean Art*, 15; Judith Bettelheim, John W. Nunley, and Barbara A. Bridges, "Caribbean Festival Arts: An Introduction," in *Caribbean Festival Arts*, ed. Nunley, Bettelheim, and Bridges, 32; Kenneth M. Bilby, "The Caribbean as a Musical Region," in *Caribbean Contours*, ed. Mintz and Sally Price, 211.

36. Benítez Rojo, *Repeating Island*, 18.

37. Analysis of African and African diasporic art has often revealed its rhythmic quality and its ability to combine several different mediums into a single, unified performance. See Thompson,

African Art in Motion; Richard J. Powell, "Art History and Black Memory: Toward a 'Blues Aesthetic,'" in *History and Memory*, ed. Fabre and O'Meally, 236, 237.

38. This capacity to win over and even envelop the audience is another frequently described element of Caribbean culture. For an excellent example, see Raul A. Fernandez's description of mid-twentieth-century rumba in *From Afro-Cuban Rhythms to Latin Jazz*, 50–51; Benítez Rojo, *Repeating Island*, 22, 123.

39. Mallon, *Peasant and Nation*, 7, 10.

CHAPTER 1

1. Weeks and Gunson, *Panama*.

2. The works of Ricaurte Soler and Alfredo Figueroa Navarro have been especially important in presenting this perspective. See Soler, *Formas ideológicas*; Figueroa Navarro, *Dominio y sociedad*.

3. Rama, *Ciudad letrada*.

4. McGuinness, *Path of Empire*, 94.

5. Panamanians often refer to their country as a "crucible" or "melting pot of races." One of the term's earliest and most important uses came in a 1936 novel by José Isaac Fábrega, *Crisol*.

6. Alfredo Castillero Calvo, "Estructura demográficas y mestizaje," in *Historia general*, ed. Castillero Calvo, vol. 1, book 1, 262. Recent estimates of Panama's population vary between 130,000 and 500,000. Most scholars now place the number at about 225,000. For a general discussion of estimates and pre-Hispanic demographics, see Richard Cooke and Luis Alberto Sánchez Herrera, "Panamá indígena: 1501–1550," in *Historia general*, ed. Castillero Calvo, vol. 1, book, 1, 48–49.

7. Alfredo Castillero Calvo, "La esclavitud negra," in *Historia general*, ed. Castillero Calvo, vol. 1, book 1, 430–34; Jaén Suárez, *Población*, 379; Roberto de la Guardia, *Negros*, 15–31.

8. Araúz and Pizzurno Gelós, *Panamá hispano*, 141–42; Jaén Suárez, *Población*, 374–77, 379–84; Bennett, *Africans in Colonial Mexico*, 14–15.

9. Alfredo Castillero Calvo, "Color y movilidad," in *Historia general*, ed. Castillero Calvo, vol. 1, book 1, 287–89; Castillero Calvo, "Esclavitud negra," 429–30, 439–41, 449; Castillero Calvo, *Negros y mulatos libres*, 8–15.

10. Jaén Suárez, *Población*, 377–79; Araúz and Pizzurno Gelós, *Panamá hispano*, 117–29; Alfredo Castillero Calvo, "La trata de esclavos," in *Historia general*, ed. Castillero Calvo, vol. 1, book 1, 454–90.

11. Castillero Calvo, *Negros y mulatos libres*; Castillero Calvo, "Color y movilidad," 303–11; Jaén Suárez, *Población*, 367–396.

12. Castillero Calvo, "Color y movilidad," 287.

13. Castillero Calvo, "Esclavitud negra," 437–38.

14. Haiti became a major concern of the oligarchy, according to historian Alfredo Figueroa Navarro. Figueroa cites the writings of Mariano Arosemena to illustrate the fear of the revolution and its possible repercussions in Panama. See Figueroa Navarro, *Dominio y sociedad*, 90–97, 215–30, 310–16; Mariano Arosemena, *Apuntamientos históricos*, 15, 20–21.

15. Soler, *Formas ideológicas*, 27–28, 78–79. See also Soler, "Prólogo," in *Pensamiento político*, 10–11; Ricaurte Soler, "El hispanoamericanismo en la independencia panameña de 1821," *Lotería* 190 (September 1971): 1–13; Ricaurte Soler, "La independencia de Panamá de Colombia," *Lotería* 400 (December 1994): 57–59.

16. Araúz and Pizzurno Gelós, *Panamá colombiano*, 24.

17. Soler, *Formas ideológicas*, 78.

18. Ibid., 27–28, 78–79. For similar interpretations, see Mariano Arosemena, *Independencia*; Mariano Arosemena, *Apuntamientos históricos*, 3–138; Castillero Calvo, "Independencia de

Panamá"; Castillero Calvo, "Fundamentos económicos y sociales"; Araúz, *Independencia*; Perez-Venero, *Before the Five Frontiers*, 1–6; Freedman, "Independence of Panama," 58–147.

19. Justo Arosemena, *Estado Federal*, 23.

20. Acta de Independencia de Panamá, in *Pensamiento político*, ed. Soler, 26.

21. Mariano Arosemena, *Apuntamientos históricos*, 170; Acta Hanseática de 13 de septiembre de 1826, in *Pensamiento político*, ed. Soler, 31–33; Araúz and Pizzurno Gelós, *Panamá colombiano*, 56–63; Castillero Calvo, "Movimiento anseatista."

22. Mariano Arosemena, *Apuntamientos históricos*, 153.

23. José Dolores Moscote and Arce, *Vida ejemplar*, 1–9.

24. Mariano Arosemena, "A la memoria de 28 de noviembre," in *Itinerario*, ed. Ricardo Miró, 78.

25. Mariano Arosemena, "Representación del Procurador de Comercio, Mariano Arosemena, sobre el proyecto del General de División Juan D'Evereux," in *Historia y nacionalidad*, 6.

26. Mariano Arosemena to General José Domingo Espinar, 31 October 1929, in ibid., 18.

27. Mariano Arosemena, "Discurso pronunciado por D. Mariano Arosemena en la sesión solemne del Cabildo de Panamá el 28 de noviembre de 1867," in ibid., 241.

28. Argelia Tello Burgos, "Mariano Arosemena y su formación espiritual," in Mariano Arosemena, *Historia y nacionalidad*, ix.

29. José Dolores Moscote and Arce, *Vida ejemplar*; Méndez Pereira, *Justo Arosemena*.

30. Justo Arosemena, "Nuestros intereses materiales," in *Escritos*, 27–33.

31. Justo Arosemena, *Estado Federal*, 18.

32. Justo Arosemena, "Nuestros intereses materiales," 30. For other examples of Arosemena's thinking about the Spanish colony and the need for liberal reform and immigration, see Justo Arosemena, "Estado económico del Istmo," in *Escritos*, 7–10; Justo Arosemena, "Fomentar la industria es el segundo de nuestros objetos cardinales," in *Escritos*, 14–16; Justo Arosemena, *Estado Federal*, 3–63; Justo Arosemena, "Discurso de posesión del jefe superior de Panamá, 1855," in *Fundación*, ed. Soler, 82–87.

33. Figueroa Navarro, *Dominio y sociedad*.

34. McGuinness, *Path of Empire*, 25–29, 95–96.

35. Figueroa Navarro, *Dominio y sociedad*, 265–317, 337–44. McGuinness, *Path of Empire*; Daley, "Watermelon Riot."

36. Figueroa Navarro, *Dominio y sociedad*, 302–17, 337–46; McGuinness, *Path of Empire*, 84–172.

37. McGuinness, *Path of Empire*, 170–83; Bancroft, *History*, 525.

38. Acta de la reunión del Cabildo Abierto congregado en la ciudad de Panamá, 9 July 1831, in *Pensamiento político*, ed. Soler, 34.

39. Tomás Herrera, "Alocución del presidente del Estado del Istmo a sus habitantes," 27 September 1941, in ibid., 122.

40. Acta de Chiriquí, 31 March 1861, in ibid., 51.

41. Justo Arosemena, *Estado Federal*, 18.

42. Ibid., 16, 13.

43. Ibid., 49.

44. See, for example, Justo Arosemena, "¡¡¡Alerta panameños!!! To Be or Not to Be, That Is the question. Shakespeare," in *Escritos*, 74–78; Justo Arosemena, "Paz y justicia," in *Escritos*, 79–85; Justo Arosemena, "La situación," in *Escritos*, 86–91; Justo Arosemena, "El Istmo de Panamá," in *Escritos*, 92–105; Justo Arosemena, "Contribución sobre buques conductores de pasajeros," in *Escritos*, 106–10; Justo Arosemena, "La cuestión americana y su importancia," in *Escritos*, 247–63; Justo Arosemena, "Discurso pronunciado por el Doctor Justo Arosemena, en julio de 1856, contra la expansión colonialista de los EE.UU.," in *Justo Arosemena*, ed. Nils Castro, 299–301.

45. Ricaurte Soler and Nils Castro are most responsible for creating this interpretation of Arosemena as an anti-imperialist leader. See Soler, *Fundación*, ix–xxxii; Nils Castro, *Justo Arosemena: Antiyanqui y latinoamericanista*; Nils Castro, "Prólogo," in Justo Arosemena, *Justo Arosemena: Patria y federación*, 7–67; Justo Arosemena, *Estudio sobre la idea de una liga americana*, in *Fundación*, ed. Soler, 184–243; Justo Arosemena, "Discursos pronunciados en el Congreso Hispanoamericano de Lima, noviembre de 1864," in *Fundación*, ed. Soler, 244–53.

46. Arosemena made this comment in an 1850 speech at Panama City's Municipal Palace in honor of independence from Spain (quoted in Argelia Tello Burgos, "Estudio introductorio," in Justo Arosemena, *Escritos*, xlix).

47. Mariano Arosemena to Justo Arosemena, 4 November 1856, in Mariano Arosemena, *Historia y nacionalidad*, 176.

48. Proyecto de ley sobre la neutralidad de Panamá, in Arrocha Graell, *Historia*, 130–35.

49. Acta del pronunciamiento de 18 de noviembre de 1840, in *Pensamiento político*, ed. Soler, 38–40; Ley fundamental del Estado del Istmo de marzo 20 de 1841, in *Pensamiento político*, ed. Soler, 38–40; Araúz and Pizzurno Gelós, *Panamá colombiano*, 85–87.

50. Acta de Chiriquí, 54–55, 52.

51. Ramón Valdés, *La independencia del Istmo de Panamá: Sus antecedentes, sus causas y su justificación* (1903), in *Documentos históricos*, ed. Castillero Reyes, 210.

52. McGuinness, *Path of Empire*, 22.

53. These two grantees were Harmodio Arias and Augusto S. Boyd. Arias served as president between 1932 and 1936, and Boyd between 1939 and 1940. Other prominent recipients of scholarships included Jeptha Duncan, José Daniel Crespo, Octavio Méndez Pereira, and Catalino Arrocha Graell. See Céspedes, *Educación*, 55, 66–67.

54. Ibid., 46; Castillero Reyes, *Historia de Panamá*, 198–99; Méndez Pereira, *Memoria*, ii.

55. Eusebio Morales, "Discurso, April 25, 1909," in *Historia del Instituto Nacional*, 113.

56. *Historia del Instituto Nacional*; José Dolores Moscote, *Experiencia*; García, "Instituto Nacional"; "El Instituto Nacional"; Susto, "En el cincuentenario"; Rafael Moscote, "En los cincuenta años"; Ernesto de la Guardia Jr., "Del Instituto Nacional."

57. Morales, "Discurso, April 25, 1909," 113

58. José Dolores Moscote and Arce, *Vida ejemplar*, 359; Méndez Pereira, *Justo Arosemena*. Tomás Herrera (1804–54) was another nineteenth-century patriot whose life was elevated to hero status. See Alfaro, *Vida*.

59. In Colombia, the Regeneration continued until 1930 (Arrocha Graell, *Historia*, 222).

60. Rodrigo Miró, "Introducción," in Arrocha Graell, *Semblanzas*, 7.

61. Ibid., 7–8; Gasteazoro, "Presentación."

62. Arrocha Graell, *Historia*, 177. For similar interpretations, see Ramón Valdés, *Independencia*, 181–212; Pablo Arosemena, *La secesión de Panamá y sus causas*, in *Documentos históricos*, ed. Castillero Reyes, 241–62; Escobar, *Legado*; Ortega Brandao, *Independencia*; Ortega Brandao, *Jornada*; Castillero Reyes, *Causa*.

63. Duncan and Crespo, *Democratización*; Duncan, *Educación y civismo*; Duncan, *Maestro*; Duncan, *Función*; Crespo, *Principios*; José Dolores Moscote, *Actividades*.

64. Crespo, *Bancos*; Crespo, *Moneda*; Morales, "Estudio sobre el Banco Nacional," in *Ensayos*, 95–104; Morales, "Nuestras condiciones económicas, fragmento de la *Memoria de Hacienda de 1922*," in *Ensayos*, 147–56; Morales, "Reformas necesarias en el sistema tributario, fragmento de la *Memoria de Hacienda de 1924*," in *Ensayos*, 169–77; Morales, "Impuesto sobre las ventas comerciales, historia, descripción, y justificación," in *Ensayos*, 179–85.

65. José Dolores Moscote, *Orientaciones*, 2; José Dolores Moscote, *Introducción*.

66. Other prominent examples of this architectural style include the Panama City train station (1913), the Palacio de Artes (1915), the Palacio del Gobierno (1915), the Spanish embassy (1915), the Santo Tomás Hospital (1924), and the Gorgas Institute of Tropical Medicine (1926). See Gutiérrez, *Arquitectura*, 198–213; Brenes, "Teatro Nacional, casa de cultura"; Brenes, "Teatro Nacional."

67. Porras, "Discurso pronunciado."

68. Eusebio Morales, "Mis primeros recuerdos de Belisario Porras," in Porras, *Belisario Porras*, 67. For the most complete information about Porras, see Sisnett, *Belisario Porras*.

69. Porras, *Memorias*, 49, 55.

70. Belisario Porras, *Mensaje dirigido por el Presidente de la República a la Asamblea Nacional al inaugurar sus sesiones ordinarias el 1 de septiembre de 1916*, in *Modernización*, ed. Pizzurno de Araúz and Muñoz, 33.

71. For a discussion of the impact of social Darwinism on Porras's policies, see Peter Szok, "'Rey sin corona': Belisario Porras y la formación del Estado Nacional, 1903–1931," in *Historia general*, ed. Castillero Calvo, vol. 3, book 1, 49–70.

72. Belisario Porras, *Panama Morning Journal*, 30 October 1911, in *Records of the Department of State*, roll 4, 819.00/354, 0030.

73. Rodolfo Caicedo, "Paz y progreso," in *Parnaso panameño*, ed. Méndez Pereira, 149–51.

74. For a discussion of this process in Latin America and elsewhere, see John H. Kautsky, "An Essay in Politics," in *Political Change*, ed. Kautsky, 22–29; Gellner, *Nations and Nationalism*, 8–52; Tom Nairn, "The Modern Janus," in *Break-Up of Britain*, 322–29; Rama, *Ciudad letrada*, 71–104; Kedourie, *Nationalism*, 22–28; González, *Puerto Rico*, 1–30.

75. For the best explanations of the zone's racist structures, see Conniff, *Black Labor*; Greene, *Canal Builders*.

76. Morales, "Discurso escrito en 1916 para ser pronunciado al regreso de una misión a la República Argentina," in *Ensayos*, 208, 211, 213.

77. Morales, "Colón: Su pasado y su provenir," in *Ensayos*, 78; Morales, "Nuestras condiciones económicas," 154.

78. Roberts, *Investigación*, 216–17.

79. Erasmo de la Guardia, *Tragedia*, 45.

80. Conniff, *Black Labor*, 29, 66. On labor in the Canal Zone during the construction era, see Greene, *Canal Builders*. On Afro-Antillean immigration, see Newton, *Silver Men*.

81. Jaén Suárez, *Población*, 22; *Censo demográfico 1930*, 17. The 1930 figure includes residents of the U.S. Canal Zone. The republic's population was roughly 467,000.

82. *Censo demográfico 1930*, 17, 21–23, 131, 139–41.

83. Garay, *Tradiciones y cantares*, 6–7.

84. Palacios, "Una verguenza para Panamá," September 1925, in *Nuestra América*, 138.

85. Blanco Fombona, *Letras y letrados*, 168n.

86. McGuinness, *Path of Empire*.

87. Yolanda Marco Serra, "Panamá en el siglo XX: un siglo para las mujeres," in *Historia general*, ed. Castillero Calvo, vol. 3, book 1, 339–40.

88. Morales, "Discurso escrito en 1916," 2:214–17; Morales, "1928," in *Ensayos*, 2:218–23. For similar criticisms of Panamanian politics and its personalistic qualities, see Andreve, *Consideraciones*; José Dolores Moscote, *Orientaciones*.

89. See Howe's masterful account of the uprising and the events leading up to the rebellion in *People Who Would Not Kneel*.

90. Labor disputes abounded in this period, both in the Canal Zone and in the republic. For the best description of the renters' strike, see Cuevas, "Movimiento inquilinario."

91. Erasmo de la Guardia, *Tragedia*, 106.

92. Major, Mellander, and Castillero Pimentel offer some of the most detailed descriptions of U.S.-Panamanian relations in this period. See Major, *Prize Possession*, 116–54; Mellander, *United States in Panamanian Politics*, 59–186; Castillero Pimentel, *Panamá y los Estados Unidos*, 91–275.

93. On the Chiriquí occupation, see Cuestas, *Soldados americanos*.

94. For more on this foreign presence and its impact on Panamanian nationalists, see Pérez and León Lerma, *Movimiento*, 8–13; Szok, "'Rey sin corona,'" 61–65.

95. Goytía, *Partidos políticos*, 30. For a sense of the extent of foreign advisers, see Pizzurno Gelós and Araúz, *Estudios*, 122–24.

96. Nairn, *Break-Up of Britain*, 327.

97. Szok, *Última gaviota*, 93–114.

98. José Isaac Fábrega, *Crisol*.

99. Octavio Méndez Pereira quoted in *Nueva poesía*, ed. Saz, 19.

100. Ricardo Miró quoted in Rodrigo Miró, "'Patria' en su contexto histórico," in *Cuatro ensayos*, 84.

101. Rodrigo Miró, "Introdución a la obra poética de Ricardo Miró," in *Cuatro ensayos*, 19–23; Rodrigo Miró, "'Patria,'" 71–95; Alfaro, "Ricardo Miró," in *Esbozos biográficos*, 105–8; Susto, "Doce panameños ilustres," 12; "Centenario de Miró," 3–4; Saz, *Nueva poesía*, 18–25.

102. Rodrigo Miró, "'Patria,'" 71–95; Saona de Bscheider, "Análisis estilístico"; Chong, "Estudio filosófico."

103. Ricardo Miró, "La última gaviota," in *Obra literaria*, 90.

104. Ricardo Miró, "La última gaviota," in *Preludios*, 85.

105. Ricardo Miró, "La leyenda del Pacífico," in *Obra literaria*, 242.

106. Ricardo Miró, "A Portobelo," in ibid., 250–51.

107. See, for example, Enrique Geenzier, "La torre de Panamá Vieja" and "A España," in *Nueva poesía*, ed. Saz, 125–28; Gaspar Octavio Hernández, "La cabeza de Vasco," in *Antología panameña*, 97–99; Octavio Fábrega, "Canto a Vasco Núñez de Balboa," in *Antología panameña*, 118–23; Guillermo Andreve, "El poema de Pacífico," in *Parnaso panameño*, ed. Méndez Pereira, 229–40.

108. See Watson's analysis of the lives and works of Federico Escobar (1861–1912) and Gaspar Octavio Hernández (1893–1918) in "Nationalist Rhetoric."

109. Julio B. Sosa, *India dormida*.

110. Uribe, *Ciudad fragmentada*, 12–22. See also Rubio, *Ciudad de Panamá*, 82–86. For an excellent literary description of Panama City's transformation, see José Isaac Fábrega, *Crisol*, 20–21.

111. Rogelio Díaz, "Arquitectura y urbanismo," in *Panamá: 50 años*, 293.

112. Gutiérrez, *Arquitectura*, 248.

113. Castillero Reyes, *Palacio de las Garzas*, 7–20.

114. Gutiérrez, *Arquitectura*, 248.

115. José Dolores Moscote and Arce, *Vida ejemplar*; Méndez Pereira, *Justo Arosemena*; Castillero Reyes, "Panamá y sus estatuas"; Susto, "Disposiciones legales."

116. Alfaro, *Vida*, 301.

117. Porras, "Discurso, 29 de septiembre de 1924," 17.

118. Belisario Porras to Alfonso XIII of Spain, 31 January 1913, *Lotería* 106 (September 1964): 4.

119. Porras, "Discurso, 29 de septiembre de 1924," 17; "Contrato sobre el monumento," 21–22; "Notas editoriales," 3–4; Susto, "Orígen del balboa"; Castillero Reyes, "Efigie de Balboa"; Vial, "Personas," 85.

120. *Juegos florales*, 7–8; *Tourist Guide of Panama*, 79–83, 96.

121. Octavio Méndez Pereira, "La conservación del idioma puede influir en el sostenimiento de la independencia nacional," in *Juegos florales*, 117.

122. *Homenaje de Panamá*, Edificio la Colina, Universidad de Panamá; Castillero Reyes, "Panamá y sus estatuas," 53.

123. In the 1910s, Juan B. Sosa (1870–1920) served as a diplomat in Spain, where he conducted some of Panama's first colonial investigations. In 1923, Juan Antonio Susto (1896–1984) was appointed vice consul in Seville. The young archivist spent the next several years producing guides of the Archivo General de Indias. Other early and important investigators of Panama's colonial history include Manuel María Alba, Octavio Méndez Pereira, Enrique J. Arce, and Guillermo Rojas y Arrieta. The San Lorenzo Fort, Natá, Panamá Viejo, and Parita were several of the colonial sites to receive initial state protection. See Juan B. Sosa, *Panamá la Vieja*; Susto, *Panamá*; Alba, *Cronología*; Méndez Pereira, *Historia de la instrucción pública*; Rojas y Arrieta, *Reseña histórica*; Juan B. Sosa and Arce, *Compendio*; Rubio, "Monumentos históricos"; Rubio, "Monumentos históricos . . . documentos"; Susto, "Disposiciones legales."

124. Mariano Arosemena, Louis Lewis, and Damián Remón, "Memoria sobre el comercio, presentada a la Sociedad de Amigos del País en la sesión ordinaria del 1°. de diciembre de 1834," in *Pensamiento político*, ed. Soler, 110–20; Clare Lewis, "Familia Lewis."

125. Lewis, "Panamá la Vieja," in *Apuntes y conversaciones*, 40. For further information about Lewis and examples of his writing, see Lewis, *Retazos*.

126. Jurado, *Itinerario y rumbo*, 39, 44. For further discussion of the Panamanian novel and it rural themes, see Sinán, "Rutas"; Gómez, "Aporte de Mario Augusto Rodríguez."

127. Korsi, introduction to *Antología*, 8.

128. Huerta, *Alma campesina*, 4.

129. For other examples of this literary perspective, see Ignacio de J. Valdés, *Cuentos panameños*; Ignacio de J. Valdés, *Sangre criolla*; Melquíades Tejeira, *Misceláneas*; Rojas Sucre, *Terruñadas*; Temístocles Ruíz, *Cuentos panameños*; Jurado, *San Cristóbal*; Mario Augusto Rodríguez, *Campo adentro*.

130. See Garay's 1921 protest letter regarding U.S. intervention in Panama's border dispute with Costa Rica (Narciso Garay to Charles E. Hughes, 24 August 1921, *Lotería* 48 [November 1959]: 25–29).

131. Garay, *Tradiciones y cantares*, 202.

132. Guerra M. de Rodríguez, "Educación, estudio y análisis"; "Narciso Garay (currículum vitae)"; Susto, "Narciso Garay Díaz," 19; Tapia, "Figuras de proscenio"; Carlos Manuel Gasteazoro, "Presentación de Narciso Garay," *Lotería* 48 (July 1979): 1–45.

133. Gonzalo Brenes, "Música y danzas de Panamá," in *Panamá: 50 años*, 226–30.

134. Manuel Zárate and his future wife organized the first folk festival at the Instituto Nacional in November 1938. Interest in the traditions grew over the following years, and in 1949, Manuel initiated one of the country's enduring celebrations, the Festival Nacional de la Mejorana, held each year in Guararé, a small town in the Azuero Peninsula. Both Manuel and Dora wrote extensively about folk culture. See Zárate and Pérez de Zárate, *Tambor y socavón*, 28–35; Zárate and Pérez de Zárate, *Décima y la copla*; Zárate, "Senderos y cumbres"; Díaz, "Zárate."

135. "Lady Mallet," who had married a British diplomat, distinguished between the colonial and modern *pollera*. The colonial *pollera* was less ornate and was associated in her mind with domestic servants, while the modern *pollera* was much more elaborate and was often worn during Carnival. In her youth, her father forbid Lady Mallet and her sisters to partake in dancing *tamborito*, as he found the African-based rhythm to be "indecent" (Obarrio de Mallet, "Pollera colonial y la moderna").

136. For biographical information on Arnulfo and Harmodio Arias, see Conte-Porras, *Réquiem*; Sepúlveda, *Harmodio Arias Madrid*.

137. Arias served as president between 1949 and 1951 and again in 1968. The military was one of his long-term enemies and participated in his removal from office.

138. For descriptions of Arias's domestic policies, see Benedetti, *Arnulfo Arias*; Escobar, *Arnulfo Arias*, 66–120; Conte-Porras, *Réquiem*, 180–87; Pizzurno de Araúz and Muñoz, *Modernización*, 161–208.

139. On U.S.-Panamanian relations, one of the best accounts is that of Arias's foreign minister. See Roux, *Capítulo*. See also Major, *Prize Possession*, 263–67.

140. Artículo 10, Constitución de 1941, in *Constituciones de Panamá*, ed. Goytía, 611–12; Escobar, *Arnulfo Arias*, 106.

141. Conte-Porras, *Réquiem*, 191.

142. Decreto Ley 6, 30 September 1941, in *Decretos leyes*, ed. Susto, 83–85.

143. Escobar, *Arnulfo Arias*, 103, 108–12; Siu, *Memories*, 115–21; Ley 24, 24 March 1941, in *Leyes expedidas*, ed. Susto, 229–41.

144. Efforts to control immigration and to ban the arrival of certain ethnicities date back to the earliest days of the republic. "Chinese, Turks, and Syrians" were prohibited from entry in 1904. In 1926, non-Spanish-speaking blacks were added to this list, along with Japanese, "*Indico-Orientales*, Indo-Aryans," and "Dravidians." In that same year, all businesses were required to hire at least 75 percent of their employees from the national labor pool. Although these laws were impractical and in some cases were amended, animosity against newcomers continued to grow. In 1928, the National Assembly passed new restrictions on the right to Panamanian citizenship. Previously, anyone born in Panama was a citizen, but now the children of immigrants were required to pass an examination within a year of their twenty-first birthday. Conniff notes that Afro-Antilleans born after 1928 "had no secure nationality." See Ley 6 de 1904, *Gaceta Oficial* 1, no. 7 (18 March 1904): 1; Ley 6 de 1926, *Gaceta Oficial* 23, no. 4968 (16 October 1926): 1; Ley 13 de 1926, *Gaceta Oficial* 23, no. 4977 (28 October 1926): 1–2; Acto legislativo no. 6 de 1928 (de 19 de octubre), in *Constituciones de Panamá*, 62; Conniff, *Black Labor*, 65–66.

145. Artículos 12 and 23, Constitución de 1941, in *Constituciones de Panamá*, 612, 615; Conniff, *Black Labor*, 99; Westerman, *Inmigrantes antillanos*, 73–77. George Westerman, a journalist and an important Afro-Antillean leader, emphasized the impact on public education. Afro-Antilleans frequently faced many obstacles when they attempted to enroll their children in the republic's schools.

146. Arias Madrid, "Discurso de 21 diciembre de 1939," in Escobar, *Arnulfo Arias*, 32.

147. Ibid., 100.

CHAPTER 2

1. Sommer, *Foundational Fictions*, 7.

2. Ibid., 7, 6, 29.

3. Among the many works included in Sommer's study are José Mármol's *Amalia* (1851); Gertrudis Gómez de Avellaneda's *Sab* (1841); José de Alencar's *O Guaraní* (1857) and *Iracema* (1865); Jorge Isaacs's *María* (1867); Alberto Blest Gana's *Martín Rivas* (1862); Ignacio Manuel Altamirano's *El Zarco* (1888); Manuel de Jesús Galván's *Enriquillo* (1882); Juan León Mera's *Cumandá* (1879); and Juan Zorrilla de San Martín's *Tabaré* (1886). Sommer also examines a number of "populist" novels that were written in the first half of the twentieth century and that responded to U.S. imperialism and to the other challenges of the period. Among these are José Eustacio Rivera's *La vorágine* (1924) and Rómulo Gallegos's *Doña Bárbara* (1929). Méndez Pereira lists most of these novels in a 1930 discussion of Latin American romanticism (*Literatura nueva*, 103, 105).

4. Sommer, *Foundational Fictions*, 18.

5. Méndez Pereira, Castillero R., and Susto, *Informe*, 15. Isaacs, a Cali native, was the author of *María* (1867), probably the most widely read foundational fiction.

6. Moreno Davis, "Octavio Méndez Pereira," 70.

7. Nairn, "Modern Janus," 339.

8. Méndez Pereira, *Cervantes*; Méndez Pereira, *Bolívar*; Méndez Pereira, *Breve historia*; Méndez Pereira, *Ejercicios: 3° y 4° grados*; Méndez Pereira, *Ejercicios: 5° y 6° grados*; Méndez Pereira, *Fuerzas*.

9. The original title was simply *El tesoro de Dabaibe*. My notes refer to the 1934 text, although I use the more common name for the book, *Núñez de Balboa*. Panamanians in their fifties and sixties commonly recall reading the novel in high school. Today, the book is no longer listed as part of the school system's official curriculum. Unfortunately, the Dirección Nacional de Currículo y Tecnología Educativa at the Ministerio de Educación could offer no help in determining when the work was removed from the approved reading list. My investigations at the Biblioteca Nacional, however, revealed that the novel was used in the 1950s and at least until the mid-1970s. Ministerio de Educación, *Especial*, 47; Dirección Nacional de Educación Secundaria, *Programa de español*, 31; "Lista de obras aprobadas."

10. Octavio Méndez Pereira, "Panamá, país y nación de tránsito," *Biblioteca Selecta* 1, no. 2 (February 1946): 7–25.

11. See, for example, Méndez Pereira, "Memoria," 22–30; Méndez Pereira, *Universidad americana*; Méndez Pereira, "Responsabilidad"; Méndez Pereira, "Panamá," 22–23; Méndez Pereira, *Juramento académico*, 9–12.

12. The function of literature in building nations is apparent in many of Méndez Pereira's publications. A school manual he coauthored on "civic instruction" includes numerous poems, hymns, and creative essays. See Méndez Pereira and Martínez, *Elementos*, 130–99.

13. Méndez Pereira, *Tesoro de Dabaibe*, 109.

14. Sommer, *Foundational Fictions*, 27, 48.

15. Ibid., 233.

16. Nairn, "Modern Janus," 334, 339.

17. Mary Matossian, "Ideologies of Delayed Industrialization: Some Tensions and Ambiguities" in *Political Change*, ed. Kautsky, 218.

18. Méndez Pereira, "Panamá."

19. Jaén Suárez, *Población*, 379–84.

20. Arosemena Jaén, *Prisma*, 5, 6.

21. Méndez Pereira, "Panamá."

22. Arosemena Jaén, *Prisma*, 12–17.

23. Méndez Pereira, *Memoria*, i.

24. Méndez Pereira, "El hombre europeo," in *Fuerzas*, 12. For a similar declaration, see Méndez Pereira, *Juramento académico*.

25. See also Méndez Pereira's early anthology of Panamanian literature, in which he describes the Colombian period as a time of "backwardness and ignorance." Méndez Pereira, *Justo Arosemena*; Méndez Pereira, *Parnaso panameño*, ii.

26. Méndez Pereira, "Panamá," 17–19; Méndez Pereira, *Bolívar*, 275; Méndez Pereira, "El americanismo del sur y el americanismo del norte," in *Fuerzas*, 32. For similar descriptions of the colony, see Méndez Pereira, *Breve historia*, 72–73, 89–90; Méndez Pereira, *Cuaderno*, 9–10; Méndez Pereira, *Historia y antología*, 23–24.

27. Méndez Pereira, *Literatura nueva*.

28. In this regard, Méndez Pereira's aspirations followed a widely discussed pattern, that of the "marginal men" on the periphery. The marginal men were marginal because they had received foreign educations and no longer fit into the societies from which they had come. Moreover, the imperialist administrations of their homelands blocked their ascension in the few modern institutions in which they might serve. Out of personal interest, they became strong advocates of modernization while challenging the direct foreign presence in their countries. The education and role of the "marginal men" are discussed in Kedourie, *Nationalism*, 27, 72–92; Kautsky, "Essay in Politics," 22–29, 44–49; Matossian, "Ideologies," 252–64; Anderson, *Imagined Communities*, 113–40. For the particular case of Panamá, see Pérez and León Lerma, *Movimiento*, 8–10.

29. Octavio Méndez Pereira, "Debilidad de nuestro organismo nacional," in Arosemena Jaén, *Prisma*, 29–33. For more on his views of economics, imperialism, and plutocracy, see Octavio Méndez Pereira, "Cuba y Panamá ante el imperialismo, conferencia del doctor Octavio Méndez Pereira, leída en la Academia Colombiana de Historia en la tarde del 26 de julio de 1938," in Méndez Pereira, Castillero R., and Susto, *Panamá en la Gran Colombia*, 27–30; Méndez Pereira, "Las satrapías," in *Fuerzas*, 149–50; Méndez Pereira, "El imperialismo económico y el superimperialismo," in *Fuerzas*, 151–56.

30. Méndez Pereira cites Morales's well-known essay, "La población del istmo" ("Panamá," 17 18).

31. Ibid., 16.

32. Méndez Pereira, "Debilidad," 31.

33. Méndez Pereira, "El nacionalismo étnico como base del Estado," "El nomadismo del dinero y del espíritu," and "La ciudadanía activa del futuro," all in *Fuerzas*, 100, 107, 120.

34. Octavio Méndez Pereira, "El Quijote como lazo de unión entre España y la América hispana," in *Juegos florales*, 69.

35. For examples of this thinking, see Méndez Pereira, "Cuba y Panamá," 27–54; Méndez Pereira, *Bolívar*; Octavio Méndez Pereira, "La neutralización del Canal, según varios panameños," in *Antología del Canal*, 132–35.

36. Méndez Pereira, "Conservación del idioma," 117. For similar expressions of angst regarding immigration and insistence on cultural homogeneity, see Octavio Méndez Pereira, "Discurso pronunciado por el Doctor Octavio Méndez P., al descubrir la lápida del Parque de Cervantes," in *Juegos florales*, 41–43; Méndez Pereira and Martínez, *Elementos*, 12–23; Méndez Pereira, "Responsabilidad," 32; Méndez Pereira, *Bolívar*, 328.

37. Méndez Pereira, "Quijote como lazo"; Méndez Pereira, *Cervantes*.

38. Méndez Pereira, *Historia de la literatura española*; Méndez Pereira, *Historia de la literatura española*, 2nd ed.; Méndez Pereira, *Historia de la literatura española*, 3rd ed.

39. Méndez Pereira, *Breve historia*; Méndez Pereira and Torres Rioseco, *Historia y anotología*; Méndez Pereira, *Cuaderno*.

40. Méndez Pereira, *Emociones y evocaciones*, 27–29, 23–26, 33–35, 18–22.

41. Nairn, "Modern Janus," 339.

42. Octavio Méndez Pereira, "Discurso pronunciado por el Doctor Octavio Méndez Pereira en el Aula Máxima del Instituto Nacional (3 de noviembre de 1914)," in *Octavio Méndez Pereira*, 293.

43. Justo Facio, a native of Panama, served as the first rector from 1909 to 1911. George Goetz, a German, briefly held the position in 1911–12. Goetz's successor was North American Edwin Dexter, who headed the school from 1912 to 1918. See *Historia del Instituto Nacional*, 23–33; Céspedes, *Educación*, 62–67; García, "Instituto Nacional," 11–14.

44. Octavio Méndez Pereira to Alfredo L. Palacios, 15 February, 25 May 1926, in Méndez Pereira, *Para la historia*, 1–11.

45. Octavio Méndez Pereira, "Discurso pronunciado en el banquete ofrecido a las delegaciones que asistieron al congreso panamericano, conmemorativo de la augusta asamblea convocada por Bolívar en 1826 (30 de junio de 1926)," in *Octavio Méndez Pereira*, 209. For more sense of these anxieties, see Méndez Pereira, Castillero R., and Susto, *Informe*, 7–15.

46. Méndez Pereira, "Panamericanismo," in *Fuerzas*, 39–44; Méndez Pereira, *Universidad americana*.

47. For examples of this thinking, see Méndez Pereira, "Cuba y Panamá," 27–54; Méndez Pereira, *Bolívar*; Méndez Pereira, "Neutralización del Canal," 132–35.

48. Octavio Méndez Pereira, "Los zapadores del canal," in *Antología del Canal*, 20–24.

49. Méndez Pereira, "Responsabilidad," 32.

50. Méndez Pereira, "Panamá," 16, 22–23.

51. Méndez Pereira, "Memoria," 28, 54. For similar views on the function of education and culture, see Méndez Pereira and Martínez, *Elementos*, v–xii; Méndez Pereira, *Universidad autónoma*; Méndez Pereira, "Responsabilidad"; Méndez Pereira, "Concepto de la ciudadanía," in *En el surco*, 1–5; Méndez Pereira, "La cultura general y la eficiencia" (1924), in *En el surco*, 57–71.

52. Ernest Renan, "Qu'est-ce qu'une nation?" in *Nationalism*, ed. Hutchinson and Smith, 17–18.

53. Méndez Pereira's own sources reveal the violence Balboa used to undertake the conquest and to establish his position in the colony. Oviedo accuses Balboa of enslaving Indians and working many of them to their death, and he is especially critical of Balboa's decision to exile his rival, Diego de Nicuesa. Nicuesa leaves in a leaky ship, and he and his companions are never heard from again. Las Casas is even more critical of Balboa, and when he discusses the conquistador's execution on orders of Pedrarias, he suggests that in some way, it was a fitting end for someone "distinguished in doing harm to the Indians." See Fernández de Oviedo y Valdés, *Historia general*, 28:179–85, 29:253–254; Las Casas, *Historia*, 3:87.

54. Méndez Pereira, *Tesoro de Dabaibe*, iii.

55. Sommer, *Foundational Fictions*, 7.

56. Méndez Pereira, *Tesoro de Dabaibe*, iii.

57. Martire d'Anghiera, *Orbe novo*; Fernández de Oviedo y Valdés, *Historia general . . . Islas*; Las Casas, *Historia*; Pascual de Andagoya, *Relación de los sucesos de Pedrarias Dávila*, in *Colección*, ed. Fernández de Navarrete, vol. 3; Castellanos, *Elegías*; López de Gómara, *Historia general*.

58. Altolaguirre y Duvale, *Vasco Núñez de Balboa*; Anderson, *Old Panama*; Escofet, *Vasco Núñez de Balboa*; Gaffarel, *Núñez de Balboa*; Gutiérrez Urrutia, *Vida y hazañas*; Herrera y Tordesillas, *Historia general*; Irving, *Life and Voyages*; Toribio Medina, *Descubrimiento*; Aguirre Morales, *Pueblo del sol*; Fernández de Navarrete, *Colección*; Pizarro y Orellana, *Varones ilustres*; Quintana, *Vidas*; Ruíz de Obregón, *Vasco Núñez de Balboa*; Strawn, *Golden Adventures*; Wafer, *New Voyage*.

59. See, for example, Vasco Núñez de Balboa to King, 20 January 1513, in *Colección*, ed. Fernández de Navarrete, 215–24; Méndez Pereira, *Tesoro de Dabaibe*, 117–22; Vasco Núñez de Balboa to King, 16 October 1515, in *Colección*, ed. Fernández de Navarrete, 224–29; Méndez Pereira, *Tesoro de Dabaibe*, 249–50; Instrucción dada por el Rey a Pedrarias Dávila para su viaje a la provincia de Castilla de Oro, 2 August 1513, in *Colección*, ed. Fernández de Navarrete, 208–14; Méndez Pereira, *Tesoro de Dabaibe*, 209–10.

60. Real de González, "Octavio Méndez Pereira," 38.

61. Castillero Reyes, "Panameños y los estudios históricos," 25.

62. According to Gasteazoro, Araúz, and Muñoz Pinzón, the name *Anayansi* first appeared in Calderón Ramírez, *Caciques y conquistadores* (1926). The chronicles had suggested that Balboa had entered into a relationship with Careta's daughter after the Spaniard had attacked the cacique's village. Las Casas insists in his narrative that the woman later attracted Andrés de Garabito's

attention and that jealousy was the motive behind his decision to help secure Balboa's execution. See Calderón Ramírez, *Caciques y conquistadores*, 10; Gasteazoro, Araúz, and Muñoz Pinzón, *Historia de Panamá*, 354–55; Las Casas, *Historia*, 2:571, 3:84.

63. Gasteazoro and Vergara M., "Aproximación," 63.

64. Sommer, *Foundational Fictions*, 7, 8.

65. Andrés Bello quoted in ibid., 8.

66. Ibid., 9, 8.

67. Burns, "Ideology," 429.

68. Sommer, *Foundational Fictions*, 9.

69. Escofet, *Vasco Núñez de Balboa*, 7–8.

70. Ibid., 6–7.

71. Méndez Pereira, *Tesoro de Dabaibe*, iii.

72. Cabal, *Balboa*, 5.

73. Méndez Pereira, *Tesoro de Dabaibe*, iii. Blasco Ibáñez was an outspoken republican, a long-time member of the Spanish Cortes, and a prolific author. His most famous work is his World War I novel, *Los cuatro jinetes del apocalipsis* (1916).

74. Méndez Pereira, *Tesoro de Dabaibe*, i–vii.

75. Cabal, *Balboa*, 5.

76. Ruíz de Obregón, *Vasco Núñez de Balboa*, 11–12.

77. Altolaguirre y Duvale, *Vasco Núñez de Balboa*, xcv, xciv.

78. Strawn, *Golden Adventures*, 18, 17.

79. Sommer, *Foundational Fictions*, 18.

80. Tomás Martín Feuillet, "La flor de Espíritu Santo," in *Itinerario*, ed. Ricardo Miró, 120–22.

81. Méndez Pereira, *Tesoro de Dabaibe*, 130.

82. Ibid., 184.

83. Méndez Pereira, *Breve historia*, 41.

84. This scene offers an excellent example of Méndez Pereira's attempts to cross the "lagoons" of history and embark in what Escofet described as the "vessel of conjecture." The chronicles had described Panquiaco's declarations; however, the author embellishes these descriptions to serve his goal of depicting Panama as the beachhead of Spanish culture. See Las Casas, *Historia*, 2:573; Méndez Pereira, *Tesoro de Dabaibe*, 84–85.

85. Díaz del Castillo, *Historia verdadera*.

86. Strawn, *Golden Adventures*, 154–55; Méndez Pereira, *Tesoro de Dabaibe*, 198–200.

87. Méndez Pereira, *Tesoro de Dabaibe*, 18.

88. Ibid., 85. In *Breve historia*, Méndez Pereira depicts Pizarro as Balboa's "friend, subaltern, and later his substitute" (41).

89. Real de González, "Octavio Méndez Pereira," 37.

90. Méndez Pereira, *Tesoro de Dabaibe*, 290; Méndez Pereira, "Panamá," 17–18.

91. Juan B. Sosa, *Panamá la Vieja*.

92. Sommer, *Foundational Fictions*, 48.

93. Ibid., 173–74.

94. Méndez Pereira, *Tesoro de Dabaibe*, 59.

95. Ibid., 62.

96. Sommer, *Foundational Fictions*, 48.

97. Méndez Pereira, *Tesoro de Dabaibe*, 61.

98. Ibid., 63, 185.

99. Ibid., 7.

100. Ibid., 63.

101. Sommer, *Foundational Fictions*, 48.

102. The importance of family is evident in a secondary text that Méndez Pereira coauthored on civic instruction. The book ties family closely to the nation-state and includes essays on "motherly love," the "home," and similar topics. See Méndez Pereira and Martínez, *Elementos*, 1–5, 167–68, 171–77.

103. Méndez Pereira, *Tesoro de Dabaibe*, 83.

104. See, for example, Méndez Pereira, *Breve historia*, 59–61; Méndez Pereira, "La obra del maestro" (1923), in *En el surco*, 49–50; Méndez Pereira, "Ensanche de la cultura" (1924), in *En el surco*, 76.

105. Nairn, "Modern Janus," 327–29.

106. Méndez Pereira, *Tesoro de Dabaibe*, 66, 99, 111.

107. Méndez Pereira, *Breve historia*, 60.

108. Méndez Pereira, *Tesoro de Dabaibe*, 109.

109. Ibid., 230.

110. Spanish chronicler Gonzalo Fernández de Oviedo first provided this figure of 2,000,000 people, which is now considered to be exaggerated. Recent estimates of Panama's precontact population vary between 130,000 and 500,000. Most scholars now place the number at about 225,000. For a general discussion of estimates and pre-Hispanic demographics, see Cooke and Sánchez Herrera, "Panamá indígena," 48–49; Fernández de Oviedo y Valdés, *Historia general*, 29:236.

111. Méndez Pereira, *Tesoro de Dabaibe*, 142.

112. Ibid., 270.

113. Méndez Pereira, *Bolívar*, 325. See his citation of Paul Rivet, who describes the transformation of Rio de Janeiro from a black into an "essentially white city."

114. Méndez Pereira, *Breve historia*, 68.

115. Méndez Pereira, ""Responsabilidad," 32.

116. Sommer, *Foundational Fictions*, 48.

117. Méndez Pereira, *Tesoro de Dabaibe*, 263, 264–65.

118. Ibid., 206.

119. Ibid., 298.

120. Priestley, *Military Government*, 7.

CHAPTER 3

1. Pulido Ritter suggests that Beleño's writings confirm the "profound fragmentation" at this time along class, ethnic, religious, and ideological lines ("Joaquín Beleño," 6). Neocolonial development conflicted sharply with the aspirations of the country's lettered city. For more on Beleño and his novels, see Ana Patricia Rodríguez, *Dividing the Isthmus*, 67–75.

2. Jurado, "Prólogo"; Beleño, "Auto-Biografía."

3. Beleño, *Luna verde*, 49, 80.

4. Major, *Prize Possession*, 306.

5. Beleño, *Luna verde*, 30.

6. Demetrio Korsi, "Visión de Panamá," in *Itinerario*, ed. Ricardo Miró, 318.

7. I use the word *rumba* in its generic sense to mean broadly Afro-Cuban music. More specific genres popular during the war included *son*, *bolero*, *guaracha*, and *danzón*.

8. Korsi, "Visión," 318–19.

9. Sinán, *Plenilunio*, 123.

10. "El peligro antillano," *Mercurio*, 26 January 1940, 2.

11. Hobsbawm, *Age of Empire*, 236–42.

12. Fraser, *Panama*, 57.

13. "Tourists Should Follow Example of U.S. Sailors," *Star and Herald*, 27 February 1931, 12.

14. Moore, *Nationalizing Blackness*, 133; Austerlitz, *Dominican Music*, 46–51.

15. Moore, *Nationalizing Blackness*, 11.

16. Major, *Prize Possession*, 240; Conniff, *Panama and the United States*, 93–94; LaFeber, *Panama Canal*, 99.

17. Beleño, *Luna verde*, 219, 233.

18. Major, *Prize Possession*, 240; Lindsay-Poland, *Emperors*, 45; "History of the U.S. Southern Command."

19. Uribe, *Ciudad fragmentada*, 55.

20. "Life Goes on Shore Leave with 40,000 Sailors of the U.S. Fleet in Panama," *Life*, 6 February 1939, 62–65.

21. Beleño, *Luna verde*, 36.

22. LaFeber, *Panama Canal*, 99–100.

23. *Censos nacionales de 1950: quinto censo de la población*, cuadro 1.

24. Uribe, *Ciudad fragmentada*, 63–72.

25. Major, *Prize Possession*, 212, 240, 284–85; Conniff, *Panama and the United States*, 93–94, Conniff, *Black Labor*, 101, 106. Such measures seem to have been largely successful, at least according to the 1950 census, which recorded a decline in the number of Caribbean-born residents from 22,606 in 1940 to 17,263 in 1950 (*Censos nacionales de 1950*, 1–2).

26. Moore, *Nationalizing Blackness*, 166.

27. Foreign entertainers began to arrive in the mid-nineteenth century, after the completion of the Panama Railroad (1855), which ran between the Pacific and Atlantic coasts and which revived the isthmus's role as a place of transit. Their numbers increased, according to Ingram, when the French attempted to build a canal in the 1880s. See Ingram, "Música," 72–73; Ingram, "Creación musical," 247; Díaz Szmirnov, *Génesis*, 75–113.

28. "Stay a While in Panama--Crossroads of the World," *Para Nosotros*, December 1940, 26.

29. Luis Marden, "Panama, Bridge of the World," *National Geographic* 80, no. 5 (November 1941): 591.

30. Carnival was officially suspended in 1942. Nevertheless, Panamanians and others crowded into beer gardens, bars, and clubs, where they were allowed to celebrate until 11 P.M. See "A pesar de que los bailes son hasta las once de la noche, se advertió mucho entusiasmo ayer," *El Tiempo*, 16 February 1942, 2; "Bailó todo el mundo hasta las 11," *Mundo Gráfico*, 22 February 1942, 10.

31. "El carnival y la guerra," *Mundo Gráfico*, 6 March 1943, 8.

32. Information on wartime daily life in this chapter is taken from, *El Nuevo Diario* (1940); *El Tiempo* (1942); *Mundo Gráfico* (1942–46); *Mercurio* (1940); *El Panamá-América* (1939–40); *Estrella de Panamá* (1939–46); *Star and Herald* (1939–46); *La Nación* (1945); *Para Nosotros* (1940–43).

33. "Bar-Cantina Miami," *La Nación*, 1 June 1943, 3.

34. Beleño, *Luna verde*, 204.

35. "La Voz de la Victor," *El Nuevo Diario*, 4 January 1940, 3; "Daily Radio Programs," *Star and Herald*, 16 February 1941, 4; Staff, *Historia y testimonios*; Vasto, *Historia*, 26–33.

36. *Extracto estadístico*, 3:314; Guillermo R. Valdés, "Radiales," *La Hora*, 1948.

37. Moore, *Nationalizing Blackness*, 101–4; "Le gusta a Ud. la música cubana, Radio Teatro Estrella de Panamá," *Estrella de Panamá*, 5 February 1939, 10; "RCA Victor Antes de Comprar Radio, Radiales o Discos Visite 'La Postal,'" *El Nuevo Diario*, 14 January 1940, 5; "RCA Victor 'La Postal,'" *El Nuevo Diario*, 18 February 1940, 3; "Deleítese oyendo las últimas canciones en Discos Columbia, CIA Cyrnos, SA," *La Hora*, 16 November 1948, 3.

38. Raul A. Fernandez, *From Afro-Cuban Rhythms to Latin Jazz*, 42–46.

39. The *Star and Herald* reported in 1931 that a Havana-based orchestra opened the Carnival celebrations at the capital's Club Unión. Later that year, singer Lydia de Rivera performed in honor of President Ricardo J. Alfaro. By the early 1930s, Cuban women also seem to have become numerous in the terminal cities' cabarets. See Villalobos de Alba, "Bolero," appendix; "Momo Rules in Union Club as Carnival Commences," *Star and Herald*, 15 February 1931, 1, 9; "Metropole Cabaret," *Star and Herald*, 22 February 1931, 10; "Nos visita una genial artista cubana," *Estrella de Panamá*, 15 October 1931, 1, 15; "Cabaret New Happyland, bonitas muchachas, artistas americanas, cubanas, etc.," *Estrella de Panamá*, 3 October 1931, 16; "Tourist Cleaned of $350 in Colon," *Star and Herald*, 15 October 1931, 1, 11.

40. Buckley, *Música salsa*, 157, 175.

41. Ibid., 35–36; "Te dansant, Los días 5, 6, 7, 8, 9 de 5 a 7 pm con la Orquesta Cubana Ensueño en el elegante Salón de las Palmas, Hotel Central," *Estrella de Panamá*, 5 February 1934, 13.

42. "Miguelito Cuni actuará durante los carnavales en el Toldo La Victoria," *La Hora*, 14 February 1947, 7; "Esta triunfando 'Cascarita' en el Palmira," *La Hora*, 18 February 1947, 8; "Un año de actuación ininterrumpida," *La Hora*, 15 February 1947, 8.

43. *Estrella de Panamá*, February 1945; "Daniel Santos en Panamá," *La Hora*, 3 February 1947, 6; Buckley, *Música salsa*, 49.

44. By the 1920s and 1930s, reporting on the decorations became quite common. See a 1931 article on celebrations at the Club Unión and its throne, which is described as a "magnificent work of art" ("Momo' Rules in Union Club as Carnival Commences," *Star and Herald*, 15 February 1931, 1, 9; Díaz Szmirnov, *Génesis*, 107).

45. Foster Steward, *Expresiones musicales*, 69; "Fueron un rotundo éxito los bailes infantiles," *Mundo Gráfico*, 14 February 1948, 20; Schull, Woodruff, and Camarano de Sucre, *Living*, 82.

46. "Carnaval al Día," *Estrella de Panamá*, 3 February 1945, 7, 11.

47. "En los teatros hoy," *Estrella de Panamá*, 12 February 1946, 3; "Hoy en los teatros," *Estrella de Panamá*, 13 February 1949, 3.

48. "White Savage" (Teatro Tropical), *Estrella de Panamá*, 13 July 1943, 5; "Rosa del Caribe" (Teatro Presidente), *Estrella de Panamá*, 3 February 1946, 12.

49. *Estrella de Panamá*, February 1945; *Star and Herald*, February 1945.

50. *La Hora*, February 1947.

51. The Millonarios seem to have been a central part of Carnival in the 1920s and would continue to perform until 1960. In 1925, they even had their own *toldo*. See Buckley, *Música salsa*, 71–72; "Ecos de Carnaval," *Estrella de Panamá*, 13 February 1925, 3; "Los últimos festejos indican que aumenta la alegría carnavalesca," *Estrella de Panamá*, 8 February 1926, 11.

52. Marden, "Panama," 592–93; Schull, Woodruff, and Camarano de Sucre, *Living*, 74–75.

53. Saz, *Panamá*, 55, 49–50.

54. "El Balboa Jardín, lugar romántico para las noches de Carnaval," *Estrella de Panamá*, 12 February 1945, 3; "Un paraíso en las faldas de Ancón," *Para Nosotros*, June 1943, 22; "Panamá cuenta con un pequeño rincón alemán: el Atlas Garden," *Mundo Gráfico*, 25 March 1933, 13; "'El Rancho' Preferred by Those Who Know Good Food," *Star and Herald*, 11 February 1945, 3; Panama Canal Commission Photos, Brady, 27–28.

55. Arquímedes, "Famosos clubes noturnos," www.critica.com.pa/archivo/11132007/vido4.html (accessed 19 March 2008); Buckley, *Música salsa*, 67, 157–59, 168, 180–81, 197.

56. Steward, *Las expresiones musicales*, 71, 149, 150, 156, 201

57. Arquímedes, "Famosos clubes noturnos"; Buckley, *Música salsa*, 67, 157–59, 168, 180–81, 197.

58. "This Is Only a Little Goodbye," *Time*, 29 September 1975; "Cantinflas pasó por Panamá," *Mundo Gráfico*, 20 February 1943, 20; "Los acontecimientos del año que termina," *Mundo Gráfico*, 26 December 1942, 10–11; "Fermín Espinosa (Armillita) en Panamá," *Mundo Gráfico*, 31 October 1942, 14; General Dwight D. Eisenhower at Administration Building, 13 August 1946, Panama Canal Commission Photos, People, No. 63.

59. Panama Canal Commission Photos, Brady, Robert S. Brady obituary; Buckley, *Música salsa*, 67.

60. "'Jade Rhodora' in Her Original Savage Dance, Monte Carlo (Colon)," *Star and Herald*, 25 July 1943, 10. See also Panama Canal Commission Photos, Brady, 30–32.

61. "Festejo Apertura de Club Nocturno Montecarlo," *Estrella de Panamá*, 28 February 1942, 6.

62. "Tonight Big Parade of Stars, Club Chanteclair," *Star and Herald*, 13 February 1945, 5.

63. "No lo hubiera hecho mejor una auténtica mulata!" *Para Nosotros*, March 1942, 5.

64. Beleño, *Luna verde*, 36, 246, 248.

65. Buckley, *Música salsa*, 91–92.

66. Marden, "Panama," 607.

67. Chico Ruiloba Crespo, interview; Bruce, interview; Correa Delgado, interview; Torrijos and Dámaris Barrio, "Complejo educacional y artístico," 10; Héctor A. Falcón, "Del jardín nacional," *El Mundo Revista Mensual* 2, no. 18 (December 1923): 16; Manuel E. Montilla, "Brevario del arte." The details of Falcón's life are unclear. One source suggests that he was born in 1904 and that he died as early as 1946. A bachelor's thesis at the Universidad de Panamá, however, associates the painter with 1970s cantina paintings as well as with a depiction of the Twelve Apostles in the Zone's St. Mary's Church. Unfortunately, I was unable to locate this latter piece on a visit to the church. For biographical information on Lewis, see the appendix.

68. Ortiz, *Negros curros*; Brown, *Santería Enthroned*, 32–34.

69. Raul A. Fernandez, *From Afro-Cuban Rhythms to Latin Jazz*, 51, 46.

70. Brown, *Santería Enthroned*, 33, 36.

71. The two stepsons are Chico and Gilberto Ruiloba. Chico Ruiloba Crespo, interview; Gilberto Ruiloba Crespo, interview.

72. Conniff, *Black Labor*, 66; *Censo demográfico 1930*, 17.

73. Conniff, *Black Labor*, 66.

74. Beleño, *Luna verde*, 206.

75. Chico Ruiloba Crespo, interview; Gilberto Ruiloba Crespo, interview; Yoyo Villarué, interview; Héctor Sinclair, interview.

76. "El decorador de las chivas," *Mundo Gráfico*, 11 April 1942, 10.

77. Chico Ruiloba Crespo, interview; Gilberto Ruiloba Crespo, interview; Yoyo Villarué, interview; Héctor Sinclair, interview.

78. Raul A. Fernandez, *From Afro-Cuban Rhythms to Latin Jazz*, 50–51, 46.

79. Chico Ruiloba Crespo, interview; Gilberto Ruiloba Crespo, interview; Yoyo Villarué, interview; Héctor Sinclair, interview.

80. Chico Ruiloba Crespo, interview; Gilberto Ruiloba Crespo, interview; Yoyo Villarué, interview; Héctor Sinclair, interview.

81. Yoyo Villarué, interview.

82. Bruce, interview.

83. Chico Ruiloba Crespo, interview.

84. Yoyo Villarué, interview; Salazar, interview; Chico Ruiloba Crespo, interview; Jorge Dunn, interview; Reyes, interview; Judiño, interview; Jaureguizar, interview; Erazo, interview; Osvaldo "Mozambique" Quintero, interview; Martínez, interview; Tordesilla, interview; Hormi, interview;

Herrera, interview; Héctor Sinclair, interview; Errol Dunn, interview; *Concurso pictórico*, 18, 21; Vic Canel, "Obras de arte popular urbano," *Crítica Libre*, 18 February 1991, 8.

85. Gaskin, interview; Chico Ruiloba Crespo, interview; Jorge Dunn, interview; Héctor Sinclair, interview; Wolfschoon, *Manifestaciones artísticas*, 375–77; *Colección pictórica*, 117; *Xerox 79*, 84; *Concurso pictórico*, 16; Lora, "Pintura popular," 111; Bruce, interview; Jaureguizar, interview; Franco the Great, website; Errol Dunn, interview.

86. Biesanz and Biesanz, *People of Panama*, 67, 65; Wells, *Panamexico*, 225. On the establishment of the Canal Zone and its authoritarian style of governance, see Greene, *Canal Builders*, 37–74.

87. Beleño, *Curundú*, 16.

88. *Panama Canal Historical Photos*, 85, 13-H-6 (2).

89. Ranfis Ruiloba Photo Collection.

90. Errol Dunn lived and worked in Europe and the United States as a commercial artist for the U.S. Army. His brother, Eugene Jr., pursued a career as a commercial artist in New Jersey. Errol Dunn, interview; Eugene Dunn Jr., interview.

91. Jorge Dunn, interview; Errol Dunn, interview; Eugene Dunn Jr., interview.

92. Bruce, interview; Héctor Sinclair, interview.

93. The résumés of many academic and commercial artists often refer to such programs. See, for example, the biographies of Lloyd Bartley (1913–97) and Alfredo Isaac (1947–), both of whom began their training in the Zone (*Colección pintórica*, 108; *Concurso pictórico*, 14). For further discussion of the Zone's impact on Panamanian art, see Monica E. Kupfer. "Del cincuentenario a la invasión: el arte contemporáneo en Panamá, 1950 a 1990," in *Cien años*, ed. Alemán and Picardi, 47.

94. Chico Ruiloba Crespo, interview; Ozores, "Pintura en Panamá," 275–76; Madrid Villanueva, *Grabado*, 27.

95. *Seco* is a popular and locally produced sugar-based liquor. Bruce, interview; Bush, interview; Yoyo Villarué, interview; Héctor Sinclair, interview; Ávila, interview; Cisneros, interview; Wever, interview; Jorge Dunn, interview; Camargo, interview; Errol Dunn, interview; Hernández, interview.

96. Gaskin, interview; Bruce, interview; Franco the Great, website.

97. Gaskin, interview.

98. Bruce, interview; Jorge Dunn, interview; Errol Dunn, interview; Eugene Dunn Jr., interview; Chico Ruiloba Crespo, interview; Yoyo Villarué, interview; Salazar, interview; Reyes, interview; Judiño, interview; Jaureguizar, interview; Erazo, interview; Osvaldo "Mozambique" Quintero, interview; Marco Antonio Martínez, interview; Tordesilla, interview; Hormi, interview; Herrera Fuller, interview; Héctor Sinclair, interview; *Concurso pictórico*, 18; Vic Canel, "Obras de arte popular urbano," *Crítica Libre*, 18 February 1991, 8.

99. José Manuel Zabala (1920–) was an academically trained artist who studied under Humberto Ivaldi at the Escuela Nacional de Pintura. Zabala later traveled to Argentina with his friend, Alfredo Sinclair, and enrolled at the Escuela Superior de Bellas Artes Ernesto de la Cárcova. The two had previously worked in a shop constructing neon lights in Panama City. After his return to the isthmus in the early 1950s, Zabala abandoned "artistic painting" and devoted himself to commercial endeavors. Madrid Villanueva describes Zabala as one of the "pioneers" of printmaking in Panama. See Ozores, "Pintura en Panamá," 275; Madrid Villanueva, *Grabado*, 27.

100. Gaskin, interview; Bruce, interview; Chico Ruiloba Crespo, interview; Jorge Dunn, interview; Camargo, interview; Errol Dunn, interview; Martínez, interview; Tordesilla, interview; Tino Fernández (father), interview; Hormi, interview; García, interview; Hernández, interview; Héctor Sinclair, interview; Alie, interview; Correa, interview; Jaureguizar, interview; Ozores, "Pintura en Panamá," 275–76; Madrid Villanueva, *Grabado*, 27; *Concurso pictórico*, 17.

101. Listed among the creators of the floats participating in the 1946 Victory Carnival are a number of well-known academic artists. Among them are the painters Humberto Ivaldi and Juan Bautista Jenine, the photographer Francisco Narbona, and the sculptor Leoncio Ambulo. Brugiati, Sabino, Falcón, and José Aranda Klee were several of the event's popular artists. Interesting, Gilberto Lewis, the son of Roberto Lewis, also created a float for the occasion. He would continue to design the vehicles over the next two decades and would become one of Carnival's most celebrated figures. Students from the Escuela de Artes y Oficios were contracted to make street decorations. See "Notas del Carnaval," *Estrella de Panamá*, 19 February 1946, 3; "Los periodistas tendrán su reina en el carnaval," *Estrella de Panamá*, 21 February 1946, 1, 5; "Gráficos del carnival de la Victoria," *Mundo Gráfico*, 9 March 1946, 20; "Gráficas de la coronación de S.M. Gladys II," *Estrella de Panamá*, 21 February 1939, 1; "Italo A. Brugiati," *Expresión: Revista Chiricana de Arte y Cultura*, August–September–October 1984, 16; "Gilberto Lewis," www.critica.com.pa/archivo/05212001/naco3.html (accessed 27 March 2008); Manuel E. Montilla, "Brevario del arte."

102. Chico Ruiloba Crespo, interview; Bruce, interview; Jorge Dunn, interview; Héctor Sinclair, interview.

103. "El famoso torero 'Manolete' en Panamá," *Mundo Gráfico*, 16 March 1946, 20.

104. "La Reina Marcela II, huésped de los Leones," *Mundo Gráfico*, 23 February 1946, 7.

105. Chico Ruiloba Crespo, interview; "Lucho Donaldo, propietario del 'Happyland,' le introduce cambios en su decorado y arquitectura," *El Flas-Lay*, 22 January 1944, 1.

106. Saz, *Panamá*, 44; Jorge Conte-Porras, "La ciudad de Panamá en los inicios de la década del 1930," *Epocas*, 2nd era, 19, no. 3 (February 2004): 9.

107. Jorge Dunn, interview; Gómez-Sicre, *Víctor Lewis*; Alie, interview.

108. Jorge Dunn, interview; Errol Dunn, interview; Eugene Dunn Jr., interview.

109. Bruce, interview. In the early 1940s, Colón's Voz de la Victor (HP5K-HOK) featured a "Kiddies Program" that regularly invited local children to perform on the radio. See "Encourage Kids in Coleman's Radio Concert," *Star and Herald*, 16 February 1941, 15.

110. Wever, interview; Cisneros, interview.

111. Meneses, interview.

112. Yoyo Villarué, interview.

113. *Concurso pictórico*, 6; García Hudson, interview; Héctor Sinclair, interview.

114. The advertisements, head portraits, and cartoons of the period's newspapers resemble typical popular art creations. In the 1940s, J. G. Mora Noli was a young, self-taught artist who seems to have been very involved in these activities. See "El escultor Mora Noli," *Mundo Gráfico*, 2 May 1942, 11; J. G. Mora Noli to *Mundo Gráfico*, *Mundo Gráfico*, 23 May 1942, 2; "Rod Badia, Lo mejor en sabor, Lo primero en calidad," *Mundo Gráfico*, 23 May 1942, 9. For another example of these drawings, see Max Factor Jr., "Secretos de Hollywood," *Epocas* 4, no. 81 (12 January 1950): 28.

115. Jaureguizar, interview; Bruce, interview; Gaskin, interview; Chico Ruiloba Crespo, interview; Héctor Sinclair, interview; Jorge Dunn, interview; Errol Dunn, interview.

116. Jaureguizar, interview; Bruce, interview; Gaskin, interview; Chico Ruiloba Crespo, interview; Héctor Sinclair, interview; Jorge Dunn, interview; Errol Dunn, interview; *Concurso pictórico*, 6

117. Secretaría de Agricultura, *Anuario de Estadística*, 466; *Extracto Estadístico: años 1941–1942–1943*, 2:317, 319.

118. Villegas, *Estudio*, 8–11; López M., "Empresas," 134–35; Belgrave, "Servicio de autobuses," 12–14, 50; Earle and Alvarado, "Estudio," 41–42. See also Rubio, *Ciudad de Panamá*, 221–22.

119. *Solución panameña*, 55.

120. Belgrave, "Servicio de autobuses," 17.

121. *Solución panameña*, 92, 96.

122. According to police records from the capital, there was annual average of 142.2 accidents for every one hundred buses between 1947 and 1949. The statistics for the smaller *chivas* were also alarming. They averaged 51.8 accidents per one hundred units, while the number for passenger cars was just 6.4. The average for all vehicles was 11.1. Similar disparities appear in reports from 1954 to 1957, while the city's newspapers were filled with stories of speeding and other violations by the public transportation drivers. See *Extracto estadístico, 1947–1948–1949*, 17; *Nuestro progreso*, 65. For police reports, see "Noticias Policia" column in *El Nuevo Diario* (1940s). On the drivers' pay, see Belgrave, "Servicio de autobuses," 4–5, 18; Earle and Alvarado, "Estudio," 38; Cáceres Vigil, "Principales características," 31–40; Ríos Mojica and Jiménez M., "Acumulación," 118–19; Cornejo and Flores, "Evaluación y análisis," 26–27.

123. "Que no les quitan los nombres a las chivas," *Mundo Gráfico*, 28 March 1942, 20; "El decorador de las chivas," *Mundo Gráfico*, 11 April 1942, 10.

124. "La pintoresca vida de las chivas y los chiveros," *Siete*, 26 June 1954, 14–15; "Un oficina de coordinación para atender al servicio público de transportes sugiere Luis Barletta," *Mundo Gráfico*, 3 October 1942, 5.

125. "La pintoresca vida de las chivas y los chiveros," *Siete*, 26 June 1954, 15.

126. On Torrijos's reforms and the following period, see Cáceres Vigil, "Principales características"; Ríos Mojica and Jiménez M., "Acumulación"; Cornejo and Flores, "Evaluación y análisis"; Vega Franceschi and Chung Martínez, "Condiciones."

127. Hormi, interview.

128. Wilkinson, "Arte rodante," 46, 47.

129. Rowe and Schelling, *Memory and Modernity*, 105.

130. Arosemena Moreno, "Algunas consideraciones," 13; Bertalicia Peralta, "Temas de hoy, sobre el 'arte popular,'" *La República*, 26 July 1983; Eva E. Montilla, "La pintura popular en los autobuses," *Autopista* (supplement to *La Prensa*), 18 June 1993, 7.

131. Yoyo Villarué, interview; Villarué Photo Collection; "Reseña histórica"; "Donan oleo del Papa a la Catedral," Villarué Photo Collection; "Júbilo nacional por la presencia en nuestra tierra del mensajero de la paz," *Estrella de Panamá*, 5 March 1983, 1, B15; "En tierra hospitalaria," *Estrella de Panamá*, 6 March 1983, 1, C1; "Cuando se disponía a salir," *Estrella de Panamá*, 6 March 1983, 1, C2.

132. Many Panamanians credit the military government for expanding the republic's cultural opportunities even as it placed clear limits on freedom of speech. As part of its populist political project, the state founded entities such as the Instituto Nacional de Cultura (INAC) and the Departamento de Expresiones Artísticas at the Universidad de Panamá. In 1975, it organized the Concurso Pictórico Nacional Soberanía. Artists gained more opportunities to study abroad, while officials extended INAC's activities in the interior. In 1977, they established an annual competition in the Ministerio de Trabajo y Desarrollo to promote artistic production among the country's working class. Today the competition is coordinated by the Instituto de Estudios Laborales (IPEL) and offers prizes in poetry, short stories, painting, and sculpture. Economic changes in the 1970s also tended to fuel this growth. The creation of an international banking sector demanded paintings for new offices and funded the foundation of numerous private galleries. In the 1970s, the banks and the state became important patrons of Panamanian art. See Gálvez Barsallo, "Sinopsis analítico," 9–10; *Primer certamen*, 5–6; *Concurso pictórico*, 13, 32–32; Kupfer, "Del cincuentenario a la invasion," 44–45; Álvarez P., "Desarrollo pictórico," 47, 73–74; *Arte panameño hoy*, 8; Kupfer, *Century of Painting*, 24–25.

133. Hormi, interview.

134. Osvaldo "Mozambique" Quintero, interview; Vergara, interview.

135. David Dell, "A Look into the Chiriqui Hospital," *The Visitor/El Visitante*, 4–10 April 2008, 6.

136. "Primera Dama."

137. Cisneros, interview.

138. Ibid.; Wever, interview.

139. Bruce, interview; López, interview.

140. Meneses, interview; Yoyo Villarué, interview; Salazar, interview; Chico Ruiloba Crespo, interview; Jorge Dunn, interview; Reyes, interview; Judiño, interview; Jaureguizar, interview; Erazo, interview; Osvaldo "Mozambique" Quintero, interview; Martínez, interview; Tordesilla, interview; Hormi, interview; Herrera, interview; Héctor Sinclair, interview; Errol Dunn, interview; Bruce, interview; Camargo, interview; Tino Fernández Jr., interview; García, interview; Hernández, interview; Ranfis Ruiloba Photo Collection.

141. The billboard depicted the pontiff with outstretched arms and read, "Panama's children receive with devotion your sacred blessings." The Casinos Nacionales' employees commissioned this piece. A newspaper article documenting this work referred to Malanga as a "well-known national painter" ("Pintura del Papa fue instalada por Casinos," *Estrella de Panamá*, 5 March 1983, B1).

142. *Guía Ciudad de Panamá*, 57; Villarué and Rodríguez Moreno, *Pintura decorativa*, 61.

143. Victoria H. Figge, "Zona Libre de Colón," in *Así es Panamá*, ed. Mendoza de Riaño, Jaramillo Jiménez, and Aristizábal Álvarez, 202.

144. Sanjur, *Panamá*, 31. For another example, see Murillo, *Panamá*, 6.

145. "Cosas para hacer en Panamá, Travel Panama," *The Visitor/El Visitante*, 4–10 April 2008, 35.

146. *Guía Ciudad de Panamá*, 57. Panama City officials helped write this guide, which was published in Spain as part of the celebrations commemorating the five hundredth anniversary of Columbus's landing.

147. See, for example, Gracey, "Warnings or Dangers"; Barnes, "Using Diablos Rojos."

148. Villarué and Rodríguez Moreno, *Pintura decorativa*, 28, 50.

149. *Tailor of Panama*, chapters 1, 12. Chapter 12 also features scenes from a brothel with a large interior mural.

150. Judiño, interview.

151. Red Devil Bar Menu, Vía España, 2 May 2008.

152. "Ahora los carros de raspao ofrecen cultura en las calles," *La Prensa*, 13 March 2005; Ballesteros, interview.

153. Adrienne Samos, "Hacia el gran cambio: arte de los noventa hasta nuestros días," in *Cien años*, ed. Alemán and Picardi, 74–88.

154. *Conmemoración del Centenario de la República*, 18, 72; *Colección pictórica*, 117; Wolfschoon, *Manifestaciones artísticas*, 375–77; *Víctor Lewis*.

155. Bernal, *Pintor panameño*, 29–30; *Xerox 79*, 74; Kupfer, "Del cincuentenario a la invasión," 46. Luis Méndez was one of the early leaders of this movement, gaining notoriety in the 1970s through the Xerox art competitions. Méndez was born in Kuna Yala and earned a construction degree at the Escuela de Artes y Oficios. Later, he studied medical illustration at Baylor University and worked for years for a prominent Panamanian ophthalmologist. Today, there are multiple Kuna painters, many of whom also began as commercial artists.

156. Lora, "Pintura popular," 110.

157. Arosemena Moreno, "Algunas consideraciones," 13, 16.

158. Students at Panama's private and public universities have written a number of lengthy theses on the topic. See, for example, García de Paredes and Cohen, "Rótulos"; Barahona G., "Evolución histórica"; Villarué and Rodríguez Moreno, *Pintura decorativa*.

159. Heckadon Moreno, "Pintores," 100.

160. Sandra Eleta, *Sirenta en B*, 1985.

161. *Driven*, Archive of the Grupo Experimental de Cine Universitario; *Diablos rojos*.

162. Harris, *Art on the Road*, 30–43.

163. "Homenaje a un arte popular, 23 de agosto al 20 de septiembre de 1983," Archivo del Museo de Arte Contemporáneo, Panama.

164. Salazar, interview.

165. Tomás Antonio Fong quoted in Ramón Oviero, "La pintura en los buses: Un arte popular," *La Prensa*, 26 August 1983.

166. "Homenaje a un arte popular."

167. Carlos I. Arjona, assistant director of the Caja de Ahorros, speech, 23 August 1983, Archivo del Museo de Arte Contemporáneo.

168. Julio Arosemena Moreno, "El evento cultural del año, homenaje a un arte popular: los buses de Panamá," *La Prensa*, 31 July 1983, 9b; Bertalicia Peralta, "Temas de hoy, sobre el 'arte popular,'" *La República*, 26 July 1983; Agustín del Rosario, "De parte interesada," *Matutino*, 4 July 1983, Archivo del Museo de Arte Contemporáneo.

169. See, for example, Alemán and Picardi, *Cien años*; Kupfer, *Century of Painting*.

170. Eva E. Montilla, "La pintura popular en los autobuses," *Autopista* (supplement to *La Prensa*), 18 June 1993, 7.

CHAPTER 4

1. Kevo, "Devilish Escapades."

2. Sky Gilbar, "Riding toward Oblivion," *Miami Herald*, 11 November 2006, 10a.

3. Ariel Omar Rodríguez Domínguez, interview.

4. Vic Canel, "Móviles obras de arte," *Panama Canal Review*, Autumn 1972, 20.

5. "La pintoresca vida de las chivas y los chiveros," *Siete*, 26 June 1954, 14.

6. Briggs, "Panamanian Popular Art," 187.

7. Rowe and Schelling, *Memory and Modernity*, 105.

8. Aguirre, *Agentes*, 172.

9. Brown, *Santería Enthroned*, 32–34, 43.

10. Salazar, interview.

11. Benítez Rojo, *Repeating Island*, 218.

12. The conception of African culture emerging in original forms in America is closely associated with the scholarship of Melville J. Herskovits. Robert Farris Thompson's work has also been critical in demonstrating these transfers in artistic and spiritual traditions. Sidney Mintz and Richard Price are perhaps most responsible for encouraging a different vision of African American culture. In an influential 1976 publication, they recognized the African roots of African American culture; however, they also argued that it was largely a New World creation. Peter Wade has demonstrated the evolving and hybrid quality of Afro-Colombian music, while Brown has conducted similar work on Afro-Cuban religion. See Herskovits, *Myth*; Thompson, *Flash of the Spirit*; Mintz and Richard Price; *Birth of African-American Culture*; Wade, *Blackness and Race Mixture*, 272–78; Brown, *Santería Enthroned*.

13. Gordon Rohlehr, "Calypso and Caribbean Identity," in *Caribbean Cultural Identities*, ed. Griffith, 65.

14. Salazar, interview.

15. Walcott, "Caribbean," 9. See also Daniel Miller and Joan Mandle and Jay Mandle's discussions of Coca-Cola, Christmas celebrations, the NBA, and U.S. soap operas in twentieth-century Trinidad and Tobago. Miller and the Mandles question the opposition between local and global

culture in the country, and they show how imported commercial elements have often become tied to the Trinidadian sense of identity. See Daniel Miller, "Why We Should Not Pair 'Local' with Culture or 'Global' with Capitalism," in *Globalization, Diaspora, and Caribbean Popular Culture*, ed. Ho and Nurse, 24–42; Joan D. Mandle and Jay R. Mandle, "Grassroots Basketball in Trinidad and Tobago: Foreign Domination or Local Creativity?" in *Caribbean Popular Culture*, ed. Lent, 133–44.

16. Brown, *Santería Enthroned*, 39–47; Abrahams and Szwed, *After Africa*, 36–37.

17. Brown, *Santería Enthroned*, 52.

18. Thompson, *Flash of the Spirit*, xiii; Thompson, *African Art in Motion*.

19. Benítez Rojo, *Repeating Island*, 18.

20. Powell, "Art History and Black Memory," 236, 237.

21. Benítez Rojo, *Repeating Island*, 22, 123.

22. Wassing, *African Art*, 6.

23. Drewal and Pemberton, *Yoruba*, 16.

24. Thompson, *African Art in Motion*; Bettelheim, Nunley, and Bridges, "Caribbean Festival Arts," 35. This combination of media into a "single performance" is also apparent in Caribbean festivals. See also Herold, *African Art*, 5–15; Kerchache, Paudrat, and Stéphan, *Art of Africa*, 51–53; Hackett, *Art and Religion*, 1–2; Suzanne Blier, "Africa, Art, and History: An Introduction," in *His tory*, ed. Blier, 18; Regenia A. Perry, "African Art and African-American Folk Art: A Stylistic and Spiritual Kinship," in *Black Art Ancestral Legacy*, 48. For a criticism of this depiction of African art as purely ritualistic, see Schildkrout and Keim, *African Reflections*, 15; Willet, *African Art*, 153–57; Clarke, *African Art*, 15–20.

25. Manuel, Bilby, and Largey, *Caribbean Currents*, 7.

26. Knight, *Caribbean*, 66–87.

27. Edmund Barry Gaither, "Heritage Reclaimed: An Historical Perspective and Chronology," in *Black Art Ancestral Legacy*, 18; Farrington, *Creating Their Own Image*, 26–27; Bernier, *African American Visual Arts*, 18–20; Regenia A. Perry, "Black American Folk Art: Origins and Early Manifestations," in *Black Folk Art*, 25; Babatunde Lawal, "African Roots, American Branches: Tradition and Transformation in African American Self-Taught Art," in *Souls Grown Deep*, ed. Arnett and Arnett, 1:30–36; Vlach, *By the Work of Their Hands*, 19–52.

28. Mosquera, "Africa in the Art," 32–33; Petrine Archer-Straw and Salah M. Hassan, "Alternative Centres: African and Afro-Caribbean Art," in *Oxford History*, ed. Kemp, 483–84.

29. Andrews, *Afro-Latin America*, 101–2, 121–24.

30. Brown, *Santería Enthroned*, 33, 36. For other examples, see Richard Burton's discussion of Jonkonnu in Jamaica and Walker's analysis of Congo Square in New Orleans. Burton, *Afro-Creole*, 65–83; Walker, *No More, No More*, 44–58. For an overview of festivals in the Caribbean, see Nunley, Bettelheim, and Bridges, *Caribbean Festival Arts*.

31. Andrews, *Afro–Latin America*, 29.

32. Brown, *Santería Enthroned*, 32–34, 43.

33. Andrews, *Afro–Latin America*, 101; Aguirre, *Agentes*, 171–72.

34. Brown, *Santería Enthroned*, 43–44.

35. Walker, *No More, No More*, 3–4, provides an excellent listing of these performances in parts of the Caribbean and in North and South America. See also Abrahams and Szwed's discussion of festivals and "play" involving public "noise," "verbal dueling," and "style and code-switching" (*After Africa*, 28–36).

36. McAlister, *Rara*.

37. Wade, *Blackness and Race Mixture*, 212–13.

38. Beckles and Stoddart, *Liberation Cricket*, 89–161.

39. Gus Edwards, "Caribbean Narrative: Carnival Characters--In Life and in the Mind," in *Black Theater*, ed. Harrison, Walker, and Edwards, 110, 111. Scholars have attributed these characteristics and ability to envelop the audience in a sense of performance to many other forms of Afro-American music and oratory. Raul Fernandez sees them in mid-twentieth-century rumba, describing them as the "aesthetics of sabor." Brenda Berrian and Jocelyne Guilbaut outline many of the principles in their discussions of French Caribbean *zouk*. See Raul A. Fernandez, *From Afro-Cuban Rhythms to Latin Jazz*, 50–51; Berrian, *Awakening Spaces*, 149–50; Jocelyne Guilbaut, "On Interpreting Popular Music: Zouk in the West Indies," in *Caribbean Popular Culture*, ed. Lent, 84–86. On Afro-American speechmaking, see Abrahams and Szwed, *After Africa*, 45–46.

40. Lora, "Pintura popular," 109, 112.

41. Ibid., 112.

42. Ibid.; Manuel, Bilby, and Largey, *Caribbean Currents*, 7–9.

43. Yoyo Villarué, interview.

44. Paredes, interview.

45. David Ernesto Rodríguez, interview.

46. Lora, "Pintura popular," 112.

47. Salazar, interview.

48. Ureña, interview; Flores, interview; Rohlehr, "Calypso and Caribbean Identity," 63.

49. Robert Farris Thompson, "Recapturing Heaven's Glamour: Afro-Caribbean Festivalizing Arts," in *Caribbean Festival Arts*, ed. Nunley, Bettelheim, and Bridges, 19; Burton, *Afro-Creole*, 169–73; Abrahams, *Man-of-Words*.

50. Betancourt, interview.

51. Heckadon Moreno, "Pintores," 98.

52. Ramos Pérez, interview.

53. Salazar, interview.

54. Hormi, interview.

55. Rohlehr, "Calypso and Caribbean Identity," 69; Burton, *Afro-Creole*, 187–98; Abrahams and Szwed, *After Africa*, 77–81. "The use of talk to proclaim the presence of self" is a long-identified aspect of Afro-American culture. Abrahams and Szwed discuss this tradition of "dramatizing oneself" in the "elevated speechmaking" and conversations of Caribbean slave populations.

56. Harris, *Art on the Road*, 41.

57. Barnes, "Using Diablos Rojos."

58. Manuel, Bilby, and Largey, *Caribbean Currents*, 76.

59. Franco Rojas, "Panamá manda al infierno a los 'diablos rojos,'" *El Nuevo Heraldo*, 6 May 2001.

60. Here again, bus art reflects a broader Afro-American pattern. "Anger in black art," as Addison Gayle wrote in a 1971 publication, "is as old as the first utterances of black men on American soil." Harry B. Shaw discusses the theme in relation to black popular culture. See Gayle, *Black Aesthetic*, xv; Shaw, *Perspectives*, 2–3.

61. Ortega, interview.

62. Vic Canel, "Obras de arte popular urbano," *Crítica Libre*, 18 February 1991, 8; Vic Canel, "Móviles obras de arte," *Panama Canal Review*, Autumn 1972, 20.

63. "La pintoresca vida de las chivas y los chiveros," *Siete*, 26 June 1954, 14.

64. "Homenaje a un arte popular."

65. Melgar, interview.

66. For many years, Willie Colón (1950–) has marketed himself as El Malo and has regularly utilized gangster themes on his album covers. Cuban star Celia Cruz (1925–2003) was known as

the Queen of Salsa. Today, Luis Enrique (1962–) calls himself the Prince of Salsa, while his rival, Gilberto Santa Rosa (1962–), is the genre's self-proclaimed Gentleman. Aristocratic and similarly flamboyant names are the norm among calypso performers. See Manuel, Bilby, and Largey, *Caribbean Currents*, 76–78; Burton, *Afro-Creole*, 193–94.

67. Arosemena Moreno, "Algunas consideraciones," 24.

68. Benítez Rojo, *Repeating Island*, 22, 123.

69. Wilfredo Lamb quoted in Poupeye, *Caribbean Art*, 9.

70. Melgar, interview.

71. Salazar, interview.

72. Again, this characteristic reflects a broader regional trend. "Festival arts" in the Caribbean are largely "ephemeral," insist Bettelheim, Nunley, and Bridges. Works are discarded after the celebrations, although ideas are "carried forward from year to year" ("Caribbean Festival Arts," 36).

73. Hormi, interview.

74. Poupeye, *Caribbean Art*, 15.

75. Bilby, "Caribbean as a Musical Region," 211. For a contemporary example, see also Stephanie Sadre-Orafi analysis of Trinidad's rapso music. Rapso artists utilize elements of local musical culture, but they also rely on imports such as hip-hop and dub. They situate these in the local experience and strengthen their own sense of identity to challenge the country's official construction of nationalism. The Caribbean is not a "passive receptor" of global commercial influences. Stephanie Sadre-Orafi, "Hypernationalist Discourse in the Rapso Movement of Trinidad and Tobago," in *Globalization, Diaspora, and Caribbean Popular Culture*, ed. Ho and Nurse, 215–51.

76. Brown, *Santería Enthroned*, 39–47; Abrahams and Szwed, *After Africa*, 36–37.

77. Heckadon Moreno, "Pintores," 93.

78. Harris, *Art on the Road*, 33; Lora, "Pintura popular," 111. Lora argues that this nostalgia arises from the fact that Panama's urban dweller is often a "displaced peasant" who feels disoriented within his or her new environment. While Lora's argument may be valid in a general sense, it is notable that few artists interviewed for this study came from the interior.

79. Briggs, "Panamanian Popular Art," 190, 192–94.

80. Poupeye, *Caribbean Art*, 22. For a similar discussion of tourism's impact in Africa, see Clarke, *African Art*, 22–23.

81. Lora, "Pintura popular," 111.

82. Herrera, interview.

83. Betancourt, interview.

84. Mosquera, "Africa in the Art," 34.

85. Yoyo Villarué, interview.

86. Lora, "Pintura popular," 110.

87. Harris, *Art on the Road*, 33.

88. Figueroa Navarro, interview.

89. Villarué and Rodríguez, *Pintura decorativa*, 73.

90. Judiño, interview.

91. Gilroy, *Black Atlantic*, 106. For another perspective on this attitude, see Sally Price's analysis of Suriname's Maroon art in "Always Something New: Changing Fashions in a 'Traditional Culture,'" in *Crafting Gender*, ed. Bartra, 17–34.

92. Poupeye, *Caribbean Art*, 15; Bettelheim, Nunley, and Bridges, "Caribbean Festival Arts," 31–33.

93. Etanislao Arias quoted in Ramón Oviero, "La pintura en los buses: un arte popular," *La Prensa de Panamá*, 26 August 1983.

94. Kevo, "Devilish Escapades"; Jane Livingston, "What It Is," in Livingston and Beardsley, *Black Folk Art*, 16, 23.

95. Ealy, *Republic of Panama*, 113.

96. "La pintoresca vida de las chivas y los chiveros," *Siete*, 26 June 1954, 14.

97. Vic Canel, "Móviles obras de arte," *Panama Canal Review*, Autumn 1972, 72; Villarué and Rodríguez, *Pintura decorativa*, 158, 159.

98. Briggs, "Panamanian Popular Art," 190.

99. "Homenaje a un arte popular."

100. Briggs, "Panamanian Popular Art," 192.

101. Willet, *African Art*, 135, 197; Herold, *African Art*, 17; Ferris, *Afro-American Folk Art*, 4; Robert Farris Thompson, "African Influence on the Art of the United States," in *Afro-American Folk Art*, ed. Ferris, 53.

102. Lawal insists that the "head often dominates a typical African figure sculpture, since it is regarded as the seat of life force and personal destiny." Artists are "more concerned about the conceptual rather than the optical" and employ what Lawal describes as "selective realism" ("African Roots, American Branches," 35). See also Thompson, "African Influence," 53; Herold, *African Art*, 17–19.

103. Rohlehr, "Calypso and Caribbean Identity," 65; McAlister, *Rara*, 40–43; Bettelheim, Nunley, and Bridges, "Caribbean Festival Arts," 32. In an article on Panamanian calypso, Pulido Ritter draws many parallels, emphasizing the genre's diasporic and transnational character ("Lord Cobra").

104. Briggs, "Panamanian Popular Art," 192–94.

105. Mosquera, "Africa in the Art," 34; Ferris, *Afro-American Folk Art and Crafts*, 6.

106. Mosquera, "Africa in the Art," 34, 35, 102; Judith M. McWillie, "African-American Vernacular Art and Contemporary Critical Practice," in *Testimony*, ed. Hoy, 20–21; Edmund Barry Gaither, "Witnessing Layered Meanings in Vernacular Art," in *Testimony*, ed. Hoy, 67.

107. For an explanation of "versioning" in reggae music, see Hebdige, *Cut 'n' Mix*. See also Berrian's discussion of "recontextualization" among contemporary French Caribbean musicians. "They . . . take delight," she writes, "in mixing Creole, English, Spanish, and French languages, rhythms, and harmonies to pioneer a cross-culturalism" (*Awakening Spaces*, 9, 173–205).

108. Thompson, *Flash of the Spirit*, xiii; Thompson, *Art in Motion*.

109. Brown, *Santería Enthroned*, 52.

110. Powell, *Blues Aesthetic*.

111. Wade, *Blackness and Race Mixture*, 272–78.

112. See, for example, Heckadon Moreno, "Pintores," 97.

113. Powell, "Art History and Black Memory," 239.

114. Ibid., 236, 237.

115. Wilkinson, "Arte rodante," 47.

116. Manuel Álvarez Cedeño, "Gobierno ordena medidas contra los 'diablos rojos,'" *La Prensa*, 24 May 1997.

117. Antonia Edith Gutiérrez, "No cumplen con el reglamento," *La Prensa*, 15 July 2002.

118. Ralph Hauke Moran, "Panamá, les miserables," *La Prensa*, 16 February 2000.

119. Wilkinson, "Arte rodante," 47.

120. Hermes Sucre S., "Los últimos transportistas rudos," *La Prensa*, 31 January 2001.

121. Jack Lindsey speaks of this "almost audible rhythm," apparent in the "patterning" of many southern vernacular pieces. Bettelheim, Nunley, and Bridges, "Caribbean Festival Arts," 36; Powell,

"Art History and Black Memory," 239; Brown, *Santería Enthroned*, 31; Jack Lindsey, "Tradition and Continuum in African American Folk Art," in *Souls Grown Deep*, ed. Arnett and Arnett, 1:63.

122. "La pintoresca vida de las chivas y los chiveros," *Siete*, 26 June 1954. Thompson also emphasizes the "mixed media" associated with West African sculpture. He notes how an "image can not only be adorned with nail-head eyes . . . but also brass studs, feathers, tin, or sheet brass in such a way as to sometimes disguise the wood . . . altogether." See Mosquera, "Africa in the Art," 33; Poupeye, *Caribbean Art*, 60, 81, 84; McWillie, "African-American Vernacular Art," 20–21; Thompson, "African Influence," 53; Herold, *African Art*, 33–35.

123. Saz, *Panamá*, 34.

124. Villarué and Rodríguez, *Pintura decorativa*, 122.

125. Thompson, *Flash of the Spirit*, 207–22.

126. Powell, *Black Art*, 15.

127. Thompson, "African Influence," 53.

128. Wilkinson, "Arte rodante," 45.

129. Heckadon Moreno, "Pintores," 95.

130. Briggs, "Panamanian Popular Art," 190.

131. "La pintoresca vida de las chivas y los chiveros," *Siete*, 26 June 1954, 15.

132. Wilkinson, "Arte rodante," 45, 47.

133. Franco Rojas, "Panamá manda al infierno a los 'diablos rojos,'" *El Nuevo Heraldo*, 6 May 2001.

134. García Hudson, interview.

135. Benítez Rojo, *Repeating Island*, 16.

136. For an explanation of "invented" or "improvisational scripts," see McWillie, "African-American Vernacular Art," 16–17; Gaither, "Witnessing Layered Meanings," 79; Livingston, "What It Is," 13. For a related discussion of signifying in African American culture, see Gates, *Signifying Monkey*.

137. Arosemena Moreno, "Algunas consideraciones," 12.

138. Ibid., 13, 16.

139. "Relating an intimate and compelling personal experience in a communal setting" is another widespread trait of black vernacular art. "The assumption," as Gaither writes, is that "others will identify with its contents" and will enter in a kind of "call and response engagement" (Witnessing Layered Meanings," 64–66).

140. Arosemena Moreno, "Algunas consideraciones," 16, 11.

141. Powell, "Art History and Black Memory," 236, 237.

142. Benítez Rojo, *Repeating Island*, 16.

143. Salazar, interview.

144. Rubén Blades and Louie Ramírez, "Juan Pachanga," performed by Blades, *Rhythm Machine*.

CHAPTER 5

1. Kennedy, *Nigger*, 48.

2. Maloney, "Significado," 153.

3. BID-CEPAL, "Pueblos indígenas"; Dirección de Estadística y Censo, "Algunas características."

4. Maloney, "Significado," 165, 166. Carlos Guillermo Wilson is one of this movement's most important figures. His most famous novel, *Chombo*, chronicles the struggles of Panama's Afro-Antillean community during the first decades of the twentieth century. Other authors listed by

Maloney in his article include Alberto Smith, Juanita Mitil, Melva Lowe de Goodin, Carlos Russell, Melvin Brown, and Winston Churchill James.

5. Studies of Afro-Panamanian history and blacks in contemporary Panama have grown considerably in the last several decades. Several of the leading investigators include George Priestley, Alberto Barrow, Armando Fortune, Alfredo Castillero Calvo, Aims McGuinness, and Alfredo Figueroa Navarro. Roman Foster and Maloney have produced a plethora of movies on Afro-Panamanian culture.

6. Andrews, *Afro–Latin America*, 182–90.

7. Priestley, "Antillean-Panamanians or Afro-Panamanians?" 61; Barrow, *No me pidas una foto*, 151–54. The Panameñísima Reina Negra contest was first organized in 1978. It replaced the "Miss Soul" Carnival Queen competition, begun at the beginning of the decade. Organizers came to favor the Spanish-language event as "it was inclusive of all Black Panamanians" and "indicative of the changing reality of Antillean-Panamanians . . . many of whom had begun to embrace the idea of being Afro-Panamanian." The Portobelo Congo Festival began in November 1999, and it now is one of the country's most popular cultural events and is actively promoted by the country's tourism authorities. The festival's growth has coincided with rising interest in Panama's other ostensibly "black dances" such as the *bunde* and *bullerengue* of Darien and the *zaracundé* of the Azuero Peninsula. In 2005, this new focus on black music resulted in the production of a CD of Darien music. See *Centro de Estudio*; Yureth Paredes, "Un canto a la libertad," *Estrella de Panamá*, 5 March 2007, E1; "Darién"; Karla Jiménez Comrie, "El bullerengue llega a la ciudad capital," *La Prensa*, 31 March 2006.

8. For an example, see the Instituto Panameño de Turismo's website and its explanation of Panamanian culture. While insisting that the majority of Panamanians are mestizos, the article underlines the country's extensive African presence, and it explains that the racial mixing which occurred on the isthmus was not exclusively between Europeans and indigenous peoples but also included slaves and their descendants. All groups contributed to the process of mestizaje, and their descendants are now present "throughout Panama" ("Cultura"). See also Octavio Carrasquilla's discussion of the *pollera*, the *tamborito*, and other elements of Azuero's culture in "El valor de la etnia negra," *Crítica*, 3 June 2008, 49.

9. In a recent historiographical essay on sports, Guttman underlined this "common strand" of analysis: their use "as a means . . . to participate in the larger society while simultaneously maintaining . . . a separate ethnic identity" ("Sports, Politics, and the Engaged Historian," 369). For one of the earliest articulations of this idea, see Rader, "Quest."

10. Andrews, *Afro–Latin America*, 171–90. On the impact of transnational factors, see also Vélez, *Drumming*, 92–93; Simmons, *Reconstructing Racial Identity*; Feldman, *Black Rhythms*; Davis, "Postscript," 359–70; Sansone, *Blackness*, 95–163; Andrews, *Blacks and Whites*, 191–93; Hanchard, *Orpheus and Power*, 95–141; Crook, "Black Consciousness"; Frigerio, "Re-Africanization"; Pinho, "Etnografias do brau"; Jensen, "Discourses on Afro-Brazilian Religion," 275–94.

11. Scholars have recently focused a great deal of attention on the diffusion of sports and hip-hop as part of the process of globalization. See, for example, Bottenburg, *Global Games*; Mitchell, *Global Noise*.

12. Mallon, *Peasant and Nation*.

13. Franco Rojas, "Panamá manda al infierno a los 'diablos rojos,'" *El Nuevo Heraldo*, 6 May 2001; 3B. Rojas was actually born in Chile but was a longtime journalist with Panama's *La Prensa*. His article was a virtual copy of Mario A. Muñoz, "A partir de hoy los pasajeros de buses pagan 25 centavos," *La Prensa*, 3 May 2001, 1A. Much of the same language appeared in a later publication by

Spadafora's Ministry of Government and Justice. See "Compromiso para mejorar el Transporte," *Avances, Ministerio de Gobierno y Justicia* 1, no. 1 (September 2001): 7.

14. Hermes Sucre S., "Los últimos transportistas rudos," *La Prensa*, 31 January 2001.

15. See, for example, the comments of Alfredo Arias, minister of Public Works; Jesualda de Sánchez, director of the National Transportation Directorate in the Ministry of Public Works; and Dionisio de Gracia, director of land transport and transit in the Ministry of Government and Justice, in Ministerio de Gobierno y Justicia, *Tránsito vehicular*, 3–6, 6–12, 31–36. For a more recent and similar perspective, see "Caos en el tránsito y el transporte," *ENE* 2, no. 11 (January 2000): 28–29.

16. The safety record of the buses continues to be abysmal. In 2003, the bus drivers represented nearly 13 percent of those involved in the capital's traffic accidents and 20 percent of those implicated in fatalities. In 2004, the statistics were 13 and 16 percent, respectively (*Accidentes de tránsito: año 2003*, 59–63; *Accidentes de tránsito: año 2004*, 56–60).

17. See, for example, "Noche de peripecias en un 'diablo rojo,'" *La Prensa*, 23 April 2008, 6A; Deivis Eliecer Cerrud, "Ruido sigue atormentando a usarios de autobuses," *Panamá América*, 13 June 2007, D3.

18. Decreto no. 312, Alcaldia de Panamá, 6 May 1991, *Gaceta Oficial*, 15 May 1991, 2–3. Similar decrees from this period include Decreto no. 550, Alcaldía de Panamá, 24 July 1991, *Gaceta Oficial*, 2 September 1991, 4–5; and Decreto no. 395, Alcaldía de Panamá, 1 July 1992, *Gaceta Oficial*, 15 July 1992, 5–6.

19. Ley 14 de 26 de mayo de 1993, in *Disposiciones legales y reglamentarias*, ed. Córdoba V. and Córdoba C., 54–78; Decreto Ejecutivo 186 de 28 de junio de 1993, in *Disposiciones legales y reglamentarias*, ed. Córdoba V. and Córdoba C., 79–88; Decreto 160 de 7 de junio de 1993, in *Disposiciones legales y reglamentarias*, ed. Córdoba V. and Córdoba C., 89–138; Resuelto 167 de 29 de junio de 1993, in *Disposiciones legales y reglamentarias*, ed. Córdoba V. and Córdoba C., 139–44; Decreto Ejecutivo 17 de 23 de enero de 1998, *Gaceta Oficial*, 2 February 1998, 3–8.

20. Hermes Sucre Serrano and Sady Tapia, "Gobierno aprueba tarifa única del pasaje a 0.25," *La Prensa*, 27 April 2001; Mario Muñoz, "A partir de hoy los pasajeros de buses pagan 25 centavos," *La Prensa*, 3 May 2001; Jahaira Polo, "Primero aviso, después sanciones a transportistas," *La Prensa*, 9 May 2001; Jahaira Polo and Marta Ferrer, "Logran acuerdo sobre el precio del pasaje," *La Prensa*, 14 May 2001; Mario A. Muñoz, "Si transportistas incumplen, no habrá aumento del pasaje," *La Prensa*, 16 August 2001.

21. Rolando Rodríguez, "F. Icaza y Cía fue la empresa," *La Prensa*, 25 October 2006. Ironically, this case did not involve a red devil bus but one of the newer models. Nevertheless, the tragedy brought negative attention to the industry and raised legitimate concerns among the public, disgusted by the deaths and reckless driving and the difficulties in commuting about the city.

22. Ley 42 de 22 de Octubre de 2007, *Gaceta Oficial*, 24 October 2007; Leonardo Flores and José González Pinilla, "Nace el Transmóvil, se irán los 'diablos rojos,'" *La Prensa*, 15 May 2008, 6A.

23. "Gabinete aprueba Leyes"; "Información."

24. Melgar, interview; Tino Fernández Jr., interview; Hormi, interview.

25. David Ernesto Rodríguez, interview.

26. Paredes, interview.

27. "Subsidize Panamanian Culture: Bring Back Bus Painting," *Panama News*, 2 March 2004.

28. "Panamá sin diablos rojos."

29. José Quintero de León, "Diablos rojos temen a los buses de lujo," *La Prensa*, 20 May 2001; "Compromiso para mejorar el Transporte," *Avances, Ministerio de Gobierno y Justicia* 1, no. 1 (September 2001): 7; José Quintero de León, "Gobierno pone en ejecución acuerdo sobre el transporte,"

La Prensa, 15 May 2001; Gionela Jordan V. and José Quintero de León, "Entrada de nuevos buses provoca controversia," *La Prensa*, 17 May 2001; Santiago Cumbrera, "Otra millonada para buses," *Panamá América*, 9 July 2007; Marcel Chery Jaén, "Transportistas denuncian estafa," *La Prensa*, 16 February 2004.

30. Tino Fernández Jr., interview.

31. Directorate of Analysis and Economic Policies, *Economic Statistics*, 3; "Caos en el tránsito y el transporte," *ENE* 2, no. 11 (January 2000): 28.

32. Lince, interview.

33. Merszthal Villaverde, interview.

34. Yap Sánchez, interview.

35. Pizzeria Leonardo has branches throughout the capital. The Al Bundy drawing is located in the Obarrio neighborhood store.

36. Robinson, interview.

37. On the emergence of football in South America, see Mason, *Passion of the People?* 1–14.

38. Biesanz and Biesanz, *People of Panama*. Soccer did not penetrate into more rural communities until the 1940s and 1950s. Chiriquí was an important exception to this generalization, as European and Central American workers who were connected to the banana and railroad companies participated in matches in the early 1930s. See Ricardo Turner, "Breve historia del deporte en Panamá," in *Historia general de Panamá*, ed. Castillero Calvo, vol. 2, book 2, 240; Carlos Alberto Martínez, "Historia del fútbol"; Carlos Alberto Martínez, "'Lega Eshpañola' I"; Torchía M., "Precedente histórico," 10–13; Lee Escala and Saldaña, "Fútbol," iii; Cruz, "Historia," 3–5; Jaén Vargas and Mendoza, "Interés del fútbol," 2; Luis Antonio Guerra Jr. and Gracia, "Evolución," 6–11.

39. Turner, "Breve historia," 237–38.

40. Biesanz and Biesanz, *People of Panama*, 364.

41. Giulianotti, *Football*; Murray, *World's Game*, 129–75.

42. Carlos Alberto Martínez, "'Lega Eshpañola' II."

43. Villarreal, "Historia de la televisión"; Olmedo Ramos and Concepción S., "Análisis," 27–30; Carlos Alberto Martínez, "Historia del fútbol"; Carlos Alberto Martínez, "'Lega Eshpañola' I."

44. Carlos Alberto Martínez, "Historia del fútbol"; Carlos Alberto Martínez, "Fútbol panameño"; Álvaro Sarmiento Meneses, "ANAPROF, hito histórico," *La Prensa*, 15 June 2003, 10; Campo Elías Estrada, "El fútbol, entre agitación y polémica," *La Prensa de Panamá*, 7 December 1995, 31A; Flores Rugel and Puertas Blades, "Organización y desarrollo," 23–25.

45. "Club Plaza Amador"; "Historia, Tauro FC"; Espinoza, "Historia del DAU."

46. Eric Jackson, "Reggae Buays dem a weep and a wail," *Panama News*, 5–18 September 2004, www.thepanamanews.com/pn/v_10/issue_17/sports_01.html (accessed 8 February 2007).

47. "Soccer Fever Appears in Panama before World Cup Qualifiers," *People's Daily Online*, 24 March 2005, http://english.peopledaily.com.cn/200503/24/eng20050324_178075.html (accessed 2 February 2007); Melissa Nova, "El 'boom' de la marea roja," *Martes Financiero*, 5 April 2005; Campo Elías Estrada, "Resumen anual: El fútbol, entre la agitación y polémica," *La Prensa de Panamá*, 12 July 1995, 31A. Sports sociologist Bottenburg describes this phenomenon as the "Boris Becker effect." "Major wins by countrymen," he argues, do not necessarily increase participation in a particular sport; however, they often "generate enormous enthusiasm" and "receive huge media coverage," becoming "incorporated into advertisements" (*Global Games*, 34–38).

48. See, for example, Abdiel Quintero, "Panamá se da a respetar," *La Prensa*, 7 September 2006, B1.

49. Luis Castillo Espinosa, "Los caminos del fútbol," *La Prensa de Panamá*, 8 June 2002.

50. Wayne Marshall, "From Música Negra to Reggaeton Latino: The Cultural Politics of Nation, Migration, and Commercialization," in *Reggaeton*, ed. Rivera, Marshall, and Hernandez, 48–60.

51. See, for example, "Historia del Reggaeton" (www.ahorre.com).

52. Lady Ann is credited in Panama for providing one of the first female songs in 1993. Many of Lady's Ann's lyrics take an openly feminist position and defy society's traditional *machista* values. See Christopher Twickel, "Reggae in Panama: *Bien* Tough," in *Reggaeton*, ed. Rivera, Marshall, and Hernandez, 86.

53. See Banton, *Vivo en el Ghetto*.

54. Lover, *Perdóname*; Nigga, *Te Quiero*; Flex, *Te Quiero*. Nigga (Félix Danilo Gómez) uses the less divisive name Flex for the U.S. market.

55. See Jaime A. Porcell, "Ascanio y una generación sin poesía," *La Prensa de Panamá*, 19 July 2002; Roberto de los Ríos, "El reggae y su influencia," *La Prensa de Panamá*, 2 April 2005; Jesús O. Picota, "Degeneración cultural musical," *La Prensa de Panamá*, 24 July 2007.

56. The national team's song was written by Papa Chan (Alfonso Ricardo Chambers Castillo), a talented *reggaesero* who died in a 2000 car accident. A remix featuring him and Comando Tiburón was a conspicuous part of the promotion for Panama's participation in the 2010 World Cup qualifying tournament. See "Marea Roja."

57. Gerardo Maloney, a Universidad de Panamá sociologist and a prominent leader within Panama's black community, seems to have played a critical role in promoting reggae and dancehall in Río Abajo. Edgardo Franco (El General) recalls visiting Maloney's home to learn more about the music and Jamaican culture and to "get records" from the professor (Edgardo Franco, interview by Christopher Twickel, November 2003, in *Reggaeton*, ed. Rivera, Marshall, and Hernandez, 99, 107).

58. Twickel, "Reggae in Panama," 82–83; Franco, interview by Twickel, 102–3.

59. The *discotecas móviles* became one of the most important entertainment venues in the 1980s. Many of the pioneers of Spanish-language reggae are tied to their emergence.

60. Aulder, interview; Rodas de Juárez, "Entrevista exlusiva"; "Biografía (Edgardo Franco)"; "Historia del Reggae Español"; Franco, interview by Twickel, 102–3.

61. See Roberto Ernesto Gyemant's excellent compilation of combo music, *Panama!*

62. Aulder, interview, "The Panamanian Origins of *Reggae en Español*: Seeing History through 'Los Ojos Café' of Renato," interview by Ifeoma C. K. Nwankwo, in *Reggaeton*, ed. Rivera, Marshall, and Hernandez, 89–98; Rodas de Juárez, "Entrevista exlusiva"; "Biografía (Edgardo Franco)"; "Historia del Reggae Español"; "Historia del Reggaeton" (mundoreggaeton.com); Franco, interview by Twickel, 103.

63. Marshall, Rivera, and Hernandez, *Reggaeton*, 9.

64. Andrews, *Afro–Latin America*, 171.

65. Maloney, "Significado," 152–71. See also Gerardo Maloney, "Sectores y movimiento negro en Panamá," in *Panamá: cien años*, 211–29; Gerardo Maloney, "Los Afroantillanos en Panamá: aportes y contribuciones a la vida nacional," in *Este país, un canal*, ed. Gólcher, 63–75.

66. Andrews, *Afro–Latin America*; 182–90; Conniff, *Black Labor*, 145–79; Priestley, "Antillean-Panamanians or Afro-Panamanians?"; Priestley and Barrow, "Black Movement," 231–32.

67. Priestley, "Antillean-Panamanians or Afro-Panamanians?" 54; Maloney, "Significado," 162–63; Priestley and Barrow, "Black Movement," 231–32. Conniff provides an insightful detail about ARENEP. The group was founded in 1974 as the Acción Reivindicadora del Chombo. Conniff insists that members "decided to emphasize the derogatory word *chombo* as a rebuke and in defiance of Latin discrimination." Later they changed the name at the urging of the Torrijos government. See Conniff, *Black Labor*, 147–53, 167–69; Andrews, *Afro–Latin America*, 185–86.

68. Conniff, *Black Labor*, 117–34, 137, 172, 175; Maloney, "Significado," 164; Priestley, "Antillean-Panamanians or Afro-Panamanians?" 51–60; Priestley and Barrow, "Black Movement," 231–32.

69. Maloney, "Significado," 165–66; Priestley, "Antillean-Panamanians or Afro-Panamanians?" 53–59; Conniff, *Black Labor*, 153.

70. Russell, *Last Buffalo*. Russell first presented his ideas at a 1995 conference organized by the Sociedad de Amigos del Museo Afro-Antillano. See also Watson's reflections on Russell's question in "Are Panamanians of Caribbean Ancestry an Endangered Species?"

71. Conniff, *Black Labor*, 165, 163–64, 169, 175; Priestley, "Antillean-Panamanians or Afro-Panamanians?," 60.

72. Nwankwo and Watson's analysis of Melva Lowe de Goodin's *De/From Barbados a/to Panamá* illustrates well this transition. First performed in 1985, the play relies on both the Spanish and English language and engages people of both Afro-Antillean and non-Afro-Antillean descent, effectively tying Caribbeanness to a broader Panamanian identity. See Nwankwo, "Art of Memory"; Watson, "Use of Language." On the growth of Afro-Panamanian identity, see also Craft, "'Una Raza, Dos Etnias.'"

73. Maloney, "Significado," 165.

74. Andrews, *Afro–Latin America*, 187.

75. Maloney, "Significado," 163–64; Maloney, "Sectores," 211; Priestley, "Antillean-Panamanians or Afro-Panamanians?" 60, 63. The First Congress of Black Panamanians was organized in 1981. The Second Congress followed in 1983.

76. Andrews, *Afro–Latin America*, 186; Priestley, "Antillean-Panamanians or Afro-Panamanians?" 60.

77. Meneses Araúz, interview; Maloney, "Significado," 167; Andrews, *Afro–Latin America*, 186.

78. In 2005, the group hosted the first Rastafari Hispanic Diaspora Summit at the old U.S. Howard Air Force Base. The conference attracted delegates from the Caribbean as well from many parts of Latin America. Ijahynya, "Report"; First Diasporic Rastafari Summit.

79. Among the most prominent of these meetings was a May 1999 gathering of the Caribbean Studies Association.

80. Maloney, "Significado," 167.

81. Priestley and Barrow, "Black Movement."

82. The 2006 report of the special commission on black ethnicity reveals many of these influential connections. The document cites the 2001 Durban conference against racism, organized by the United Nations, and it discusses Panamanian involvement in organizations such as the Organización Negra Centroamericana, which held its tenth annual meeting in Panama, the Parlamento Negro de las Américas, and the OAS's Inter-American Commission on Human Rights. Various leaders on the special commission received training or participated in international organizations related to the Afro-Panamanian cause. Comisión Especial, *Plan*, 5, 20, 22.

83. This phenomenon was especially evident in November 2003, when over twenty thousand Afro-Panamanians traveled from the United States to participate in the country's centennial celebrations. Leaders, largely from the New York community, used the occasion to organize a forum with the presidential aspirant, Martín Torrijos Espino. After presenting their concerns to the Democratic Revolutionary Party candidate, they launched a fund-raising effort on his behalf and eventually donated more than twenty thousand dollars to his campaign. See Priestley and Barrow, "Black Movement," 241. For an interesting reflection on the role of Afro-Panamanians in the United States, see Carlos Russell, "To My Paisanos y Paisanas," *Panama News*, 23 February–15 March 2003, www.thepanamanews.com/pn/v_09/issue_05/letters_01.html (accessed 8 February 2007).

84. In 2006, the Commission's name was changed to Coordinadora Nacional de las Organizaciones Negras Panameñas. See Coordinadora Nacional, "Acta de Fundación; Maloney, "Significado," 166–68; Priestley, "Antillean-Panamanians or Afro-Panamanians?" 51; Priestley and Barrow, "Black Movement," 240.

85. Ley 9 (de 30 de mayo de 2000) que declara el 30 de mayo de cada año día cívico y de conmemoración de la Etnia Negra, *Gaceta Oficial* 96, no. 24064 (31 May 2000): 37–38.

86. See articles in Etnia Negra, Archivo Vertical, Biblioteca Nacional.

87. Decreto Ejecutivo no. 89 (de 8 de mayo de 2006), por medio del cual se crea la Comisión organizadora de las actividades culturales orientadas a resaltar el Día de la Etnia Negra, *Gaceta Oficial* 102, no. 25543 (12 May 2006): 3–5.

88. Lina Vega Abad, "En honor a la diversidad," *La Prensa de Panamá*, 4 August 2003, 6A; Lina Vega Abad, "Un agradecimiento en forma de plaza," *La Prensa de Panamá*, 10 October 2003, 6A.

89. Carmen Abrego, "Inaugurarán pueblito indígena y afroantillano," *La Prensa de Panamá*, 25 November 1998; Ameilia Denis de Icaza, "Al Cerro Ancón," in *Itinerario*, ed. Ricardo Miró, 127–28. Like Sugarloaf Mountain in Rio de Janeiro, Ancon Hill rises steeply from the heart of Panama City, providing a spectacular backdrop to the capital. In 1904, the area became part of the U.S. Canal Zone and was subsequently off-limits to average Panamanians. Poet Amelia Denis de Icaza (1836–1911) wrote movingly about the annexation and effectively converted Ancon into a symbol of Panamanian nationalism. Today, an enormous Panamanian flag flies from the summit of the hill.

90. The municipal government inaugurated the "interior" Pueblito in August 1994. Its structures are intended to replicate a colonial village in the country's central provinces. Unfortunately, its displays offer no acknowledgment of slavery and ignore the interior's important African heritage. See Martí Ostrander Oller, "Mi pueblito: rincón interiorano en la ciudad," *La Prensa de Panamá*, 8 August 1994, C9.

91. Indeed, a 2006 report by Panama's special commission on black ethnicity cited the inauguration of Pueblito Afroantillano as one of the important advances in the "fight against discrimination" (Comisión Especial, *Plan*, 10).

92. Ley 25 (de 9 de febrero de 1956) por la cual se desarrolla el artículo 21 de la Constitución Nacional sobre no discriminación por razón de nacimiento, raza, clase social, sexo, religión e ideas políticas, *Gaceta Oficial* 53, no. 12960 (19 May 1956): 1.

93. Ley 11 (de 22 de abril de 2005) que prohíbe la discriminación laboral y adopta otras medidas, *Gaceta Oficial* 101, no. 25287 (27 April 2005): 2–3; Maloney, "Afroantillanos," 63–75.

94. Decreto ejecutivo no. 124 (de 27 de mayo de 2005) por el cual se crea la Comisión Especial para el establecimiento de una política gubernamental para la inclusión plena de la etnia negra panameña, *Gaceta Oficial* 101, no. 25339 (11 July 2005): 3–4.

95. Comisión Especial, *Plan*, 2; Decreto ejecutivo no. 116 (de 29 de mayo de 2007) por el cual se crea el Consejo Nacional de la Etnia Negra, *Gaceta Oficial* 102, no. 25802 (30 May 2007): 7–9. Torrijos appointed Harley James Mitchell to the Supreme Court in 2005. Graciela Dixon had occupied a seat in 1997, and she would become the first Afro-Panamanian woman to serve as the court's president in 2006. In 2008, Mitchell ascended to this same position.

96. Comisión Especial, "El clamor de grupos afrodescendientes en los Estados Unidos: El voto en el exterior," in *Plan*, 19; Artículo 4, Ley 60 (29 de diciembre de 2006) que reforma el Código Electoral, *Gaceta Oficial* 102, no. 25702 (2 January 2007): 3–4; Decreto no. 3 (22 de marzo de 2007) por el cual se reglamenta el artículo 6 del Código Electoral, *Boletín Tribunal Electoral* 29, no. 2323 (23 March 2007): 1–8.

97. Maloney, "Sectores," 214–15.

98. For a discussion of these issues, see Barrow, *No me pidas una foto*, 68–73, 121–25, 136–38.

99. On this issue of photos and "buena presencia" (good appearance), see ibid., 11–14, 27–48; Priestley, "Antillean-Panamanians or Afro-Panamanians?" 64.

100. Priestley and Barrow, "Black Movement," 240.

101. Priestley, "Antillean-Panamanians or Afro-Panamanians?" 64; Antinori Bolaños, *Informe especial*; Ley 16 (de 10 de abril de 2000) que regula el derecho de admisión, *Gaceta Oficial* 97, no. 24530 (12 April 2002): 2–6; Staff Wilson, *Género*.

102. See, for example, Eugenio Lloyd Millington Mapp, "He sido víctima de acoso policial varias veces," in Comisión Especial, *Plan*, 16.

APPENDIX

1. Yoyo Villarué, interview.

2. Chico Ruiloba Crespo, interview; Jorge Dunn, interview; Jaureguizar, interview; Héctor Sinclair, interview; Alie, interview.

3. Tordesilla, interview; Yiseira Díaz, interview.

4. Anguizola, interview.

5. Ávila, interview.

6. Barrios Bósquez, interview.

7. Bellido, interview. For popular art as a public genre, see, for example, Lora, "Pintura popular," 112.

8. "Homenaje a un arte popular"; Betancourt, interview.

9. Bush, interview; Yoyo Villarué, interview; Héctor Sinclair, interview; Bruce, interview; Ávila, interview; Cisneros, interview; Wever, interview; Jorge Dunn, interview; Camargo, interview; Errol Dunn, interview; Hernández, interview.

10. Bruce, interview; López, interview; Jorge Dunn, interview; *Concurso pictórico*, 31.

11. Lora, "Pintura popular," 116; Lay, interview.

12. *Concurso pictórico*, 6; Jaureguizar, interview; García Hudson, interview; Héctor Sinclair, interview; Hernández, interview.

13. Camargo, interview.

14. Castro de Burunga, interview.

15. Tino Fernández Jr., interview.

16. Cisneros, interview.

17. Córdoba, interview; Salazar, interview.

18. Salazar, interview; Marco Antonio Martínez, interview; "Informe preliminar (2007)."

19. *Conmemoración del Centenario de la República*, 18, 72; *Colección pictórica*, 117; *Concurso pintórico*, 9; Errol Dunn, interview; Jorge Dunn, interview; Eugene Dunn Jr., interview; Héctor Sinclair, interview; Skylight Gallery, "Our Journey"; Cooper, "Recordando."

20. Jorge Dunn, interview; *Concurso pictórico*, 9; Concurso Panarte, 1981, Archivo del Museo de Arte Contemporáneo. For articles and shows featuring Dunn, see "Jorge Dunn, Conjuring Up Landscapes and Seascapes in His Mind," *Panama News*, 8–21 May 2005; Lucero Maldonado, "La musa humana de Jorge Dunn," *La Prensa de Panamá*, 30 November 2003; Skylight Gallery, "Our Journey."

21. Erazo, interview.

22. Tino Fernández Jr., interview; Tino Fernández (father), interview.

23. Tino Fernández Jr., interview; Tino Fernández (father), interview.

24. Flores, interview.

25. "Homenaje a un Arte Popular"; Fong quoted in Ramón Oviero, "La pintura en los buses: Un arte popular," *La Prensa*, 26 August 1983; Judiño, interview; Erazo, interview; Merszthal Villaverde, interview; Salazar, interview; Lince, interview; Barrios Bósquez, interview; Hormi, interview; Tino Fernández Jr., interview; David Ernesto Rodríguez, interview; Herrera Fuller, interview; García Hudson, interview; Yiseira Díaz, interview.

26. Gaskin, interview; Bruce, interview; Sinclair, interview; Jaureguizar, interview; Franco the Great, website; Jorge Dunn, interview; Errol Dunn, interview.

27. Vergara, interview; Glady Vergara and Héctor Aníbal "Lytho" Gómez Rodríguez Photo Collection; Osvaldo "Mozambique" Quintero, interview; Tordesilla, interview; Ramón Oviero, "La pintura en los buses," *La Prensa*, 26 August 1983; Harris, *Art on the Road*, 32.

28. González Baruco, interview; Flores, interview; Ureña, interview.

29. Simón Atencio Guerra, interview; Tino Fernández Jr., interview; "Homenaje a un Arte Popular."

30. Mussa Kellman, interview; Hernández, interview.

31. Herrera Fuller, interview.

32. Hormi, interview; Tino Fernández Jr., interview; García de Paredes and Cohen, "Rótulos," 147–67; Harris, *Art on the Road*, 30–32; "Homenaje a un Arte Popular."

33. Jaureguizar, interview; Bruce, interview; Gaskin, interview; Chico Ruiloba Crespo, interview; Sinclair, interview; Jorge Dunn, interview; Errol Dunn, interview.

34. *Tailor of Panama*, chapter 1; Judiño, interview.

35. Erazo, interview; Judiño, interview; Salazar, interview; Osvaldo "Mozambique" Quintero, interview; Tordesilla, interview; Tino Fernández Jr., interview; Hormi, interview; David Ernesto Rodríguez, interview; Herrera Fuller, interview; García Hudson, interview.

36. Lora, "Pintura popular," 121, 124; Hormi, interview; Lay, interview.

37. Gaskin, interview; Chico Ruiloba Crespo, interview; Jorge Dunn, interview; Héctor Sinclair, interview; Wolfschoon, *Manifestaciones artísticas*, 375–77; *Colección pictórica*, 117; *Xerox 79*, 84; *Concurso pictórico*, 16; Lora, "Pintura popular," 111; *Víctor Lewis*; Gómez-Sicre, *Víctor Lewis*; Kupfer, "Del cincuentenario a la invasión," 46.

38. Lince, interview.

39 Vic Canel, "Obras de arte popular urbano," *Crítica Libre*, 18 February 1991; Yoyo Villarué, interview; Salazar, interview; Chico Ruiloba Crespo, interview; Jorge Dunn, interview; Reyes, interview; Judiño, interview; Jaureguizar, interview; Erazo, interview; Osvaldo "Mozambique" Quintero, interview; Marco Antonio Martínez, interview; Tordesilla, interview; Hormi, interview; Herrera Fuller, interview; Héctor Sinclair, interview.

40. Marco Antonio Martínez, interview; Osvaldo "Mozambique" Quintero, interview; Tordesilla, interview; Hormi, interview; "Homenaje a un Arte Popular."

41. Melgar, interview; "Óscar Melgar and Jesús Javier Jaime"; "Arte popular en Gran Bretaña"; Crisly Flórez, "De pintar buses a una galería," *La Prensa*, 28 September 2007.

42. Lora, "Pintura popular," 112; Meneses, interview; "Pintura del Papa fue instalada por Casinos," *Estrella de Panamá*, 5 March 1983, B1; Bruce, interview; Sinclair, interview; Chico Ruiloba Crespo, interview; Yoyo Villarué, interview; Jorge Dunn, interview; Camargo, interview; Jaureguizar, interview; Errol Dunn, interview; Marco Antonio Martínez, interview; Tordesilla, interview; Tino Fernández Jr., interview; Hormi, interview; García Hudson, interview; Hernández, interview.

43. Merszthal Villaverde, interview; Lince, interview.

44. Navarro, interview.

45. Ortega, interview.

46. Eva E. Montilla, "Dice joven artista: en Panamá no se le da importancia a la pintura popular," *La República*, 30 July 1978, G7, quoted in Briggs, "Panamanian Popular Art," 193; Ramón Oviero, "La pintura en los buses: Un arte popular," *La Prensa*, 26 August 1983; "Homenaje a un Arte Popular"; Harris, *Art on the Road*, 32; Hormi, interview.

47. Paredes, interview.

48. José Manuel Quintero, interview; Salazar, interview.

49. Osvaldo "Mozambique" Quintero, interview; Cisneros, interview; Wever, interview.

50. Reyes, interview; Tordesilla, interview.

51. Robinson, interview.

52. David Ernesto Rodríguez, interview.

53. Rodríguez Maldonado, interview.

54. Judiño, interview; Erazo, interview; Merszthal Villaverde, interview; Salazar, interview; Felipe Tejeira, interview; Lince, interview; Barrios Bósquez, interview; Tordesilla, interview; David Ernesto Rodríguez, interview; Herrera Fuller, interview.

55. Chico Ruiloba Crespo, interview; Jorge Dunn, interview; Ranfis Ruiloba Photo Collection.

56. David Ernesto Rodríguez, interview; Hormi, interview; Salazar, interview; García de Paredes and Cohen, "Rótulos," 147–51; Harris, *Art on the Road*, 30–32.

57. Héctor Sinclair, interview; Errol Dunn, interview.

58. Lora, "Pintura popular," 119; Buckley, *Música salsa*, 67–69; Revilla Agüero, *Cultura hispanoamericana*, 316.

59. Reyes, interview; Salazar, interview; Lince, interview; Tordesilla, interview.

60. Ureña, interview.

61. Danilo Villarué, interview; Yoyo Villarué, interview; García de Paredes and Cohen, "Rótulos," 134–47; "Homenaje a un Arte Popular."

62. Yoyo Villarué, interview; García de Paredes and Cohen, "Rótulos," 134–47; Wilkinson, "Arte rodante," 45–46; Harris, *Art on the Road*, 30–32; "Homenaje a un Arte Popular."

63. Yap Sánchez, interview.

BIBLIOGRAPHY

ARCHIVES AND PRIVATE COLLECTIONS

Archivo Alfaro
Biblioteca Nacional
Biblioteca Simón Bolívar
Escuela Nacional de Artes Plásticas
Grupo Experimental de Cine Universitario
Instituto de Estudios Laborales
Rubén "Chinoman" Lince Photo Collection
Museo de Arte Contemporáneo
Panama Canal Commission
David Ernesto Rodríguez Photo Collection
José Ángel "Chico" Ruiloba Crespo Photo Collection
Ranfis Ruiloba Photo Collection
Alfredo Sinclair Photo Collection
Glady Vergara and Héctor Aníbal "Lytho" Gómez Rodríguez Photo Collection
Teodoro de Jesús "Yoyo" Villarué Photo Collection

PERIODICALS

Avances, Ministerio de Gobierno y Justicia
Biblioteca Selecta
Boletín Tribunal Electoral
Crítica
ENE
Epocas
Estrella de Panamá
Expresión, Revista Chiricana de Arte y Cultura
El Flas-Lay
Gaceta Oficial
La Hora
Martes Financiero
Mercurio
Miami Herald
Mundo Gráfico
El Mundo Revista Mensual
La Nación

235

National Geographic
El Nuevo Diario
El Nuevo Heraldo
El Panamá América
Panama Canal Review
Panama News
Para Nosotros
People's Daily Online
La Prensa
La República
Siete
El Siglo
Star and Herald
El Tiempo
Time
The Visitor/El Visitante

INTERVIEWS BY AUTHOR

Alie, Alberto (son). 13 May 2008. Tumba Muerto.

Anguizola, Ian Carlos. 21 July 2006. Plaza Santa Ana.

Aulder, Leonardo Renato. 25 April 2008. Los Pueblos.

Ávila, Leonardo. 23 May 2005. Santa Ana.

Ballesteros, Ismael (administrator of the Casa Góngora, Acaldía de Panamá). 23 May 2005. Casa Góngora.

Barrios Bósquez, Félix Ernesto "Cholopuruca." 22 July 2006. Chepo.

Bellido, César. 25 July 2006. Pueblo Nuevo.

Betancourt, Héctor. 20 June 2001. Quebrada Ancha.

Bruce, Víctor. 24 June 2004, 3 July 2006. Mercado de Artesanías--Plaza 5 de Mayo.

Bush, George. 16 April 2008. Villa de las Fuentes.

Camargo, Luis. 24 July 2006. Santa Ana.

Castro de Burunga, Sixto. 25 July 2006. Pueblo Nuevo.

Cisneros, Nelson. 26 May 2005. Fire Department Headquarters.

Córdoba, César. 31 June 2001 (telephone).

Correa Delgado, Rodrigo César "Cañita." 29 April 2008. El Cangrejo.

Díaz, Yiseira. 23 July 2008. Limón, Colón.

Dunn, Errol. 8 June 2007. El Cangrejo.

Dunn, Eugene, Jr. 9 May 2008. Parque Lefevre.

Dunn, Jorge. 31 July 2002, 3 June 2004, 7, 10 July 2006. Paitilla.

Erazo, Rafael "Rafy". 9, 13 July 2006 (telephone).

Fernández, Justino "Tino" (father). 29 July 2002. Veranillo.

Fernández, Justino "Tino," Jr. 26 June 2001, 26 April 2008. La Chorrera.

Figueroa Navarro, Alfredo. 29 June 2001. Universidad de Panamá.

Flores, Yayo. 19 June 2001. Tocumen.

García Hudson, Mario. 10 May 2008. Biblioteca Nacional de Panamá.

Gaskin, Franklin "Franco the Great." 15 December 2007 (telephone), 19 February 2011, Harlem.

González Baruco, Rolando Ricardo. 19 June 2001. Tocumen.

Guerra, Simón Atencio. 22 June 2001 (telephone).

Hernández, Víctor Manuel "Chicho." 6 July 2008. Fish Market.

Herrera Fuller, Eulogio. 28 June 2001, 28 April 2008. Arraiján.

Hormi, Ramón Enrique "Monchi." 26 June 2001, 19 June 2004, 26 April 2008. La Chorrera.

Jaureguizar, Sabino (son). 12 July 2006. Juan Díaz.

Judiño, Héctor "Totín." 9, 13 July 2006. Pedregal.

Lay Ruíz, Ricardo. 14 July 2008. La Chorrera.

Lince, Rubén "Chinoman". 19 June 2001, 19 July 2006. 24 diciembre.

López, Candida B. de (subdirectora de administración y finanzas). 7 July 2006. Controlería General de la República.

Martínez, Marco Antonio. 10 June 2007. La Chorrera.

Melgar, Óscar. 23 June 2001, 19 July 2008. Juan Díaz and San Miguelito.

Meneses, Eduardo. 7 May 2008. Vía España.

Meneses Araúz, Eunice (national coordinator for Pastoral Afro-Panameña). 3 June 2007. Carrasquilla.

Merszthal Villaverde, Cristóbal Adolfo "Piri." 14 July 2006. Pacora.

Mussa Kellman, Ismael. 21 July 2006. Calidonia.

Navarro, David. 14 July 2008. La Chorrera.

Ortega, José "Piolo." 26 June 2001. La Chorrera.

Paredes, Harry. 22 June 2001 (telephone).

Quintero, José Manuel. 23 June 2001 (telephone).

Quintero, Osvaldo "Mozambique." 25 July 2006, 9 June 2007. Pueblo Nuevo.

Ramos Pérez, Aníbal. 19 June 2004. La Chorrera.

Reyes, Víctor "Cholín." 8, 9 July 2006. Santa Marta.

Robinson, Armando. 23 June 2001 (telephone).

Rodríguez, David Ernesto. 28 June 2001, 28 April 2008. Perecete and La Chorrera.

Rodríguez Domínguez, Ariel Omar. 26 June 2001. Perecete.

Rodríguez Maldonado, Víctor Hugo "Pirri." 3 July 2008. Calidonia.

Ruiloba Crespo, Gilberto. 28 July 2002. Santa Ana

Ruiloba Crespo, José Ángel "Chico." 28 July 2002. Santa Ana.

Salazar, Andrés. 27 June 2001, 15 July 2006. San Miguelito and Pedregal.

Sinclair, Alfredo. 4 July 2008. Betania.

Sinclair, Héctor. 2 August 2002, 7 May 2008. El Cangrejo and Parque Lefevre.

Tejeira, Felipe. 14 July 2006. Pacora.

Tordesilla, Buenaventura "Ventura." 11 June 2007. Calidonia.

Ureña, Félix. 19 June 2001. Tocumen.

Vergara, Glady. 23 July 2008. El Jiral.

Villarué, Danilo. 13 June 2004. San Pedro.

Villarué, Teodoro de Jesús "Yoyo." 25 June, 1 July 2001, 13 June 2004, 23 July 2006, 19 April 2008, 19 April 2009. San Pedro.

Wever, Marcos. 26 May 2005. Fire Department Headquarters.

Yap Sánchez, Pastor Isidro Sing. 21 July 2006. El Chorillo.

PUBLISHED PRIMARY SOURCES

Accidentes de tránsito: año 2003. Panama: Dirección de Estadística y Censo, 2005.

Accidentes de tránsito: año 2004. Panama: Dirección de Estadística y Censo, 2007.

Aguirre Morales, Augusto. *El pueblo del sol.* Lima: Torres Aguirre, 1927.

Alba, Manuel María. *Cronología de los gobernantes de Panamá, 1510–1932.* Panama: Imprenta Nacional, 1935.

Alfaro, Ricardo J. *Vida del General Tomás Herrera.* Barcelona: Henrich, 1909.

Altolaguirre y Duvale, Ángel de. *Vasco Núñez de Balboa.* Madrid: Patronato de Intendencia é Intervención Militares, 1914.

Anderson, C. L. G. *Old Panama and Castilla de Oro.* Boston: Page, 1914.

Andreve, Guillermo. *Consideraciones sobre el liberalismo.* 2nd ed. Panama: Casa Editorial "El Tiempo," 1931.

Antinori Bolaños, Italo Isaac. *Informe especial contra el racismo.* Panama: Defensoría del Pueblo, 2000.

Antología del Canal (bodas de plata), 1914–1939. Panama: Star and Herald, 1939.

Antología panameña: Verso y prosa. Panama: Editorial "La Moderna" Quijano y Hernández, 1926.

Arosemena, Justo. *Escritos de Justo Arosemena.* Edited by Argelia Tello Burgos. Panama: Universidad de Panamá, 1985.

———. *El Estado Federal de Panamá.* In *Fundación de la nacionalidad panameña,* edited by Ricaurte Soler. Caracas: Biblioteca Ayacucho, 1982.

———. *Justo Arosemena.* Edited by Nils Castro. Panama: Edición de la Presidencia, 1982.

———. *Justo Arosemena: Patria y federación.* Edited by Nils Castro. Havana: Casa de las Américas, 1977.

Arosemena, Mariano. *Apuntamientos históricos (1801–1840).* Panama: Ministerio de Educación, 1949.

———. *Historia y nacionalidad.* Edited by Argelia Tello Burgos. Panama: Editorial Universitaria, 1979.

———. *Independencia del Istmo.* Panama: Universidad de Panamá, 1959.

Arrocha Graell, Catalino. *Historia de la independencia de Panamá: sus antecedentes y causas.* 1933; Panama: Litho-Impresora, 1973.

———. *Semblanzas y otros temas.* San José: Imprenta Lehmann, 1973.

"Arte popular en Gran Bretaña." *Noticias, Ministerio de Relaciones Exteriores de la República de Panamá.* www.mire.gob.pa/noticias.php?id=2059. Accessed 23 August 2006.

Banton, Kafu. *Vivo en el Ghetto.* Sin Censura/Ensoproject, 2004.

Barnes, Roy. "Using Diablos Rojos to Get around Panama City." www.associatedcontenet.com/article/16612/using_diablos_rojos_to_get_around_panama.html. Accessed 26 July 2007.

Barrow, Alberto S. *No me pidas una foto.* Panama: Barrow, 2001.

Barrow, Alberto S., and George Priestley. *Piel oscura Panamá: ensayos y reflexiones al filo del Centenario.* Panama: Editorial Universitaria, 2003.

Beleño, Joaquín. "Auto-Biografía." *Lotería* 373 (July–August–September 1988): 18–19.

———. *Curundú.* Panama: Imprenta Nacional, 1963.

———. *Luna verde (Diario dialogado).* 1950; Panama: Manfer, 1991.

BID-CEPAL. "Los pueblos indígenas de Panamá: Diagnóstico sociodemográfico a partir del censo de 2000 (2005)." www.eclac.org/publicaciones/xml/7/22277/LCW20-panama.pdf. Accessed 4 June 2008.

Biesanz, John, and Mavis Biesanz. *People of Panama.* New York: Columbia University Press, 1955.

"Biografía (Edgardo Franco)." www.elgeneraltx.com. Accessed 2 July 2008.

Blades, Rubén. *Rhythm Machine, Fania All-Stars.* Columbia Records, 1977.

Blanco Fombona, Rufino. *Letras y letrados de Hispanoamérica.* Paris: Ediciones Literarias y Artísticas, 1908.

Buckley, Francisco "Bush." *La música salsa en Panamá.* Panama: EUPAN, 2004.

Cabal, Juan (José Escofet). *Balboa, descubridor del Pacífico*. Barcelona: Juventud, 1943.

Calderón Ramírez, Salvador. *Caciques y conquistadores*. Panama: Imprenta Nacional, 1926.

———. *Historia de las Indias*. Vols. 2–3. Mexico: Fondo de Cultura Económica, 1965.

Las Casas, Bartolomé de. *Historia de las Indias*. Madrid: Ginesta, 1875–76.

Castellanos, Juan de. *Elegías de varones ilustres de Indias*. Madrid: Imprenta de la Publicidad, 1850.

Castillero Reyes, Ernesto J. *La causa inmediata de la emancipación de Panamá: Historia de los orígenes, la formación, y el rechazo por el senado colombiano del Tratado Herrán-Hay*. Panama: Imprenta Nacional, 1933.

———, ed. *Documentos históricos sobre la independencia de Panamá*. Panama: Imprenta Nacional, 1930.

Castro, Nils. *Justo Arosemena: Antiyanqui y latinoamericanista*. Panama: Edición del Ministerio de Gobierno y Justicia, 1974.

Censo demográfico 1930. Panama: Imprenta Nacional, 1931.

Censos nacionales de 1950. Panama: Controloría General de la República, 1954.

Censos nacionales de 1950: quinto censo de la población. Vol. 1, *Características generales*. Panama: Controlería General de la República, 1954.

Centro de Estudio para la promoción del Desarrollo y memoria del segundo convivio de baile congo. Panama: PRODES and FIA, 2000.

Clare Lewis, Horacio. "La familia Lewis de Panamá." *Lotería* 120–21 (November–December 1965): 27–35.

"El Club Plaza Amador." www.plazaamador.net/historia.htm. Accessed 1 February 2007.

Comisión Especial para el Establecimiento de una Política Gubernamental para la Inclusión Plena de la Etnia Negra Panameña. *Plan de acción para la inclusión plena de la etnia negra panameña*. Panama: Ministerio de Desarrollo Social, 2006.

Concurso pictórico nacional soberanía. Panama: Editora de la Nación, 1975.

Constituciones de Panamá. Panama: Universidad de Panamá, 1968.

"Contrato sobre el monumento a Vasco Núñez de Balboa." *Lotería* 76 (September 1947): 21–22.

Córdoba V., Julio Ernesto, and Julio Ernesto Córdoba C. *Disposiciones legales y reglamentarias sobre el transporte terrestre en Panamá*. Panama: Pérez y Pérez, 1993.

Crespo, José Daniel. *Los bancos extranjeros en Panamá*. Panama: Star and Herald, n.d.

———. *La moneda panameña y el nuevo tratado*. Panama: Editora "La Moderna," 1936.

———. *Principios fundamentales de la nueva educación*. Panama: Imprenta Nacional, 1930.

"Cultura." http://www.visitpanama.com/html/cultura.php. Accessed 4 June 2008.

"Darién: Bunde y Bullerengue." www.youtube.com/watch?v=wwbKkcsBWjk. Accessed 5 January 2010.

Diablos rojos: los buses de Panamá. DVD. Produced by Nina K. Müller-Schwarze. CustomFlix, 2007.

Diablo Rojos Rugby Club de Panamá. Website. http://www.panamarugby.com. Accessed 22 February 2010.

Díaz del Castillo, Bernal. *Historia verdadera de la conquista de la Nueva España*. Madrid: Imprenta del Reyno, 1632.

Dirección de Estadística y Censo, Contraloría General de la República. "Algunas características de la división política-administrativa en la República de Panamá por provincial, comarca indígena y distrito: año 2006." www.contraloria.gob.pa/dec/Publicaciones/17-03-01/caracteristicas.pdf. Accessed 3 June 2008.

Dirección Nacional de Educación Secundaria. *Programa de español, primer ciclo, segundo ciclo*. Panama: Ministerio de Educación, 1973.

Directorate of Analysis and Economic Policies. *Economic Statistics 2003*. Panama: Ministry of Economics and Finance, 2003.

Driven: A Short Film about Panamanian Passion. VHS. Produced by Mark Whatmore and Adrian Moat. 1997.

Duncan, Jeptha B. *Educación y civismo*. Panama: Times, 1929.

———. *La función internacional de la escuela*. Panama: Times, 1928.

———. *El maestro de la escuela y su misión*. Panama: Times, 1929.

Duncan, Jeptha B., and José Daniel Crespo. *La democratización de las escuelas y otros discursos*. Panama: Tipografía "Diario de Panamá," 1921.

Ealy, Lawrence O. *The Republic of Panama in World Affairs, 1903–1950*. Westport, Conn.: Greenwood, 1951.

Escobar, Felipe J. *Arnulfo Arias o el credo panameñista: Ensayo psico-patológico de la política panameña*. Panama: n.p., 1946.

———. *El legado de los próceres: ensayo histórico-político sobre la nacionalidad panameña*. Panama: Imprenta Nacional, 1930.

Escofet, José. *Vasco Núñez de Balboa o el descrubrimiento del Pacífico*. Barcelona: Seix y Barral, 1923.

Espinoza, Juan Carlos. "Historia del DAU." www.deportivoarabeunido.com/history/history.php. Accessed February 1, 2007.

Extracto estadístico de la República. Vol. 3. Panama: Contraloría General de la República and Imprenta Nacional, 1943.

Extracto estadístico de la República: años 1941–1942–1943. Vol. 2. Panama: Contraloría General de la República, 1943.

Extracto estadístico de la República de Panamá, 1947–1948–1949. Panama: Contraloría General de la República, Dirección de Estadística y Censo, 1950.

Fábrega, José Isaac. *Crisol*. Panama: Star and Herald, 1936.

Fernández de Navarrete, Martín, ed. *Colección de los viajes y descubrimientos que hicieron los españoles desde fines del siglo XV*. Madrid: Imprenta Real, 1825–37.

Fernández de Oviedo y Valdés, Gonzalo. *Historia general y natural de las Indias*. Vols. 117–21 of *Biblioteca de autores españoles*. Edited by Juan Pérez de Tudela y Bueso. Madrid: Ediciones Atlas, 1959.

———. *Historia general y natural de las Indias, Islas y Tierra-Firme del Mar Océano*. Madrid: Imprenta de la Real Academia de la Historia, 1851–55.

First Diasporic Rastafari Summit in Hispanic America. http://racermind.galeon.com/diasporic.htm. Accessed 7 February 2010.

Flex. *Te Quiero: Romantic Style in da World*. EMI, 2008.

Franco the Great. Website. http://www.francothegreat.com/. Accessed 18 September 2005.

Fraser, John Foster. *Panama and What It Means*. London: Cassell, 1913.

"Gabinete aprueba leyes que mejoran la calidad de vida y aumenta las penas a los menores." 2 July 2009. http://www.presidencia.gob.pa/ver_nodo.php?cod=13. Accessed 15 November 2009.

Gaffarel, Paul. *Núñez de Balboa*. Paris: Librairie de la Société Bibliographique, 1882.

Garay, Narciso. *Tradiciones y cantares de Panamá: Ensayo folklórico*. Brussels: Presses de l'Expansion Belge, 1930.

Gómez-Sicre, José. *Víctor Lewis of Panama*. Washington: OAS, 1978.

Goytía, Víctor, ed. *Las constituciones de Panamá*. Madrid: Ediciones Cultura Hispánica, 1954.

Gracey, Bill. "Warnings or Dangers: Diablos Rojos." http://www.virtualtourist.com/travel/Caribbean_and_Central_America/Panama/Provincia_de_Panama/Panama_City-1700276/Warnings_or_Dangers-Panama_City-BR-1.html. Accessed 15 April 2008.

Guardia, Erasmo de la. *La tragedia del Caribe*. Panama: Imprenta Nacional, 1938.

Guerra M. de Rodríguez, Eva. "Educación, estudio y análisis de la vida y obra de Doctor Narciso Garay Díaz, como forjador de una conciencia nacional." *Lotería* 48 (November 1959): 9–17.

Guía Ciudad de Panamá. Spain: Unión de Ciudades Capitales Iberoamericanas and Sociedad Estatal para la Ejecución de Programas del Quinto Centenario, n.d.

Gutiérrez Urrutia, Carlos. *Vida y hazañas de Vasco Núñez de Balboa*. Santiago: Sociedad Imprenta y Litografía Barcelona, 1916.

Herrera y Tordesillas, Antonio de. *Historia general de los hechos de los castellanos en las Islas y Tierra Firme del Mar Océano*. Madrid: Imprenta Real, 1601–15.

Historia del Instituto Nacional, 20 años de labor educativa. Panama: Imprenta Nacional, 1930.

"Historia, Tauro FC." www.geocities.com/taurofc/historia.html. Accessed February 1, 2007.

"History of the U.S. Southern Command." http://www.southcom.mil/AppsSC/pages/history.php. Accessed 15 October 2006.

Huerta, José E. *Alma campesina*. Colón: Haskins News Service, 1930.

Ijahynya, Sister. "Report to the Caribbean Rastafari Organization: Rastafari Hispanic Diaspora Summit." http://www.rastaites.com/news/hearticals/panama/panama04.htm. Accessed 7 February 2010.

"Información." http://www.metrobuspanama.com/. Accessed 15 January 2010.

"Informe preliminar (2007)." www.carnavalpanama.com/informes/informe2007.pdf. Accessed 17 May 2008.

Juegos florales celebrados en Panamá en conmemoración del tercer centenario de la muerte de Cervantes. Panama: Moderna, 1917.

Jurado, Ramón H. *Itinerario y rumbo de la novela panameña: tres ensayos*. Panama: Cultura Panameña, 1978.

———. "Prólogo de la primera edición de *Luna verde*." *Lotería* 373 (July–August–September 1988): 11–13.

———. *San Cristóbal*. Panama: Imprenta Nacional, 1947.

Kevo, José. "Devilish Escapades: Los Diablos Rojos." 27 November 2006. http://www.igougo.com/travelcontent/JournalEntryFreeForm.aspx?ReviewID=1325885. Accessed 1 February 2008.

Korsi, Demetrio, ed. *Antología de Panamá (parnaso y prosa)*. Barcelona: Maucci, 1926.

Lewis, Samuel. *Apuntes y conversaciones*. Panama: Minerva, n.d.

———. *Retazos: discursos y conferencias, artículos, leyendas, y cuentos por Samuel Lewis y ofrendas póstumas a la memoria del autor*. Panama. Imprenta de la Academia, 1939.

"Lista de obras aprobadas hasta el año 2007." www.meduca.gob.pa. Accessed 17 July 2008.

López de Gómara, Francisco. *La historia general de las Indias*. Antwerp: Iuan Steelsio, 1554.

Lover, Eddie. *Perdóname*. Machete Music, 2008.

Madrid Villanueva, Nuria. *El grabado en Panamá*. Panama: Museo de Arte Contemporáneo, 2004.

"La Marea Roja (RPC Deportes)." http://www.dailymotion.com/video/x5ud1j_marea-roja-2008-rpc-deportes_music. Accessed 8 March 2010.

Martire d'Anghiera, Pietro. *De orbe novo*. Paris: Apud Guillelmum Auvray, 1587.

Materno Vásquez, Juan. "La nacionalidad panameña: concepto jurídico y concepto histórico-político." *Revista Nacional de Cultura* 9–10 (1977–78): 83–93.

———. *El país por conquistar: la tesis del país integral*. Bogotá: Internacional de Publicaciones, 1974.

Méndez Pereira, Octavio. *Bolívar y las relaciones interamericanas*. Panama: Universidad de Panamá, 1960.

———. *Breve historia de Ibero-América*. Panama: Talleres Gráficos Benedetti, 1936.

———. *Cervantes y el Quijote apócrifo*. Panama: Imprenta Nacional, 1914.

———. *Cuaderno de literatura panameña (Guía antológica), 1501–1671.* Panama: Universidad de Panamá, 1961.

———. *Ejercicios de lenguaje y gramática elemental: texto adoptado oficialmente para 3° y 4° grados.* Panama: Imprenta Nacional, 1918.

———. *Ejercicios de lenguaje y gramática elemental: texto adoptado oficialmente para 5° y 6° grados.* Panama: Imprenta Nacional, 1919.

———. *Emociones y evocaciones.* Paris: Editorial Franco-Ibero-Americana, 1927.

———. *En el surco: discursos compilados con permiso del autor por la Casa Editorial Minerva y pronunciados por aquel como Secretario de Instrucción Pública durante el año escolar 1923 a 1924.* Panama: Minerva, 1923.

———. *Fuerzas de unificación.* Paris: Editorial "Le Livre Libre," 1929.

———. *Historia y antología de la literatura hispanoamericana.* Vol. 1, *El periódo colonial.* Panama: n.p., 1952.

———. *Historia de la instrucción pública en Panamá.* Panama: Moderna, 1916.

———. *Historia de la literatura española.* Panama: Talleres Gráficos de "El Tiempo," 1922.

———. *Historia de la literatura española.* 2nd ed. Panama: Talleres Gráficos "La Unión," 1925.

———. *Historia de la literatura española.* 3rd ed. Panama: Benedetti, 1931.

———. *Un juramento académico, discurso pronunciado por el Doctor Octavio Méndez Pereira, rector de la Universidad de Panamá, en el acto de graduación de aquella casa de estudios, el 2 de marzo de 1951.* Panama: Panamá América, 1951.

———. *Justo Arosemena.* Panama: Imprenta Nacional, 1919.

———. *Literatura nueva.* Panama: Panama Times, 1930.

———. *Memoria que el Secretario de Estado en el Despacho de Instrucción Pública presenta a la Asamblea Nacional de 1924.* Panama: Imprenta Nacional, 1924.

———. "Memoria que el Secretario de Estado en el Despacho de Instrucción Pública presenta a la Asamblea Nacional de 1924." *Lotería* 367 (July–August 1987): 11–30.

———. *Núñez de Balboa, el tesoro de Dabaibe.* Madrid: Nuestra Raza, 1936.

———. *Octavio Méndez Pereira.* Edited by Matilde Real de González. Panama: EUPAN, 1987.

———. *Para la historia, la defensa de Panamá (contestando al Dr. Alfredo L. Palacios).* Panama: Imprenta Nacional, 1926.

———, ed. *Parnaso panameño.* Panama: El Istmo, 1916.

———. "Responsabilidad de la cultura superior, discurso pronunciado por el Dr. Octavio Méndez Pereira al culminar el año académico en 1943." *Lotería* 367 (August 1987): 31–42.

———. *El tesoro de Dabaibe.* Panamá: Talleres Gráficos "Benedetti," 1934.

———. *La universidad americana y la Universidad Bolivariana de Panamá.* Panama: Imprenta Nacional, 1925.

———. *Universidad autónoma y universidad cultural (discurso académico).* Panama: Editorial Universitaria, 1973.

Méndez Pereira, Octavio, Ernesto J. Castillero R., and Juan Antonio Susto. *Panamá en la Gran Colombia: informe, discurso, y conferencias de los Delegados de la Academia panameña de la historia al Congreso de historia de las naciones que formaron la Gran Colombia, reunido del 24 de julio al 5 de agosto de 1938, y a la Exposición del libro, con motive del IV centenario de la fundación de Bogotá.* Panama: Imprenta Nacional, 1938.

Méndez Pereira, Octavio, and Cirilo J. Martínez. *Elementos de instrucción cívica.* 2nd ed. Panama: Esto y Aquello, 1916.

Méndez Pereira, Octavio, and Arturo Torres Rioseco. *Historia y anotología de la literatura hispanoamericana.* Panama: n.p., 1952.

Mendoza de Riaño, Consuelo, Sylvia Jaramillo Jiménez, and Emiro Aristizábal Álvarez, eds. *Así es Panamá*. Panama: Somos, 1995.

Ministerio de Educación. *Especial: Programa oficial para las escuelas secundarias*. Panama: Ministerio de Educación, 1956.

Ministerio de Gobierno y Justicia. *El tránsito vehicular en el área metropolitana, Seminario-Taller celebrado el sábado 17 de abril de 1993*. Panama: ILDEA, 1993.

Miró, Ricardo. *Obra literaria de Miró: poesía*. Panama: Editorial Mariano Arosemena and INAC, 1984.

———. *Preludios*. Panamá: Moderna, 1908.

Miró, Rodrigo, ed. *Itinerario de la poesía en Panamá (1502–1974)*. Panama: Editorial Universitaria, 1974.

———. *Teoría de la Patria*. Panama: n.p., 1947.

Montilla, Manuel E. "Breviario del arte en Chiriquí." http://newsofcontemporaryart.blogspot.com/2008/06/manuel-montilla-sobre-la-situacion.html. Accessed 20 August 2009.

Morales, Eusebio A. *Ensayos, documentos y discursos*. Vol. 2. Panama: Editorial "La Moderna," 1928.

Moscote, José Dolores. *Actividades prácticas del maestro rural*. Panama: Talleres Gráficas Benedetti, 1936.

———. *Una experiencia: seis años de rectorado en el Instituto Nacional*. Panama: Benedetti Hermanos, 1931.

———. *Introducción al estudio de la constitución panameña*. Panama: Tipografía "La Moderna," 1929.

———. *Orientaciones hacia la reforma constitucional*. Panamá: Talleres Gráficas Benedetti, 1934.

Moscote, José Dolores, and Enrique J. Arce. *La vida ejemplar de Justo Arosemena*. Panama: Imprenta Nacional, 1956.

Murillo, José Ángel. *Panamá, tierra de contrastes*. Cali: Carvajal, 1990.

"Narciso Garay (currículum vitae)." *Lotería* 48 (November 1959): 18–24.

Nigga. *Te Quiero: Romantic Style in da World*. EMI, 2007.

Nuestro progreso en cifras. Panama: Contraloría General de la República, Dirección de Estadística y Censo, 1958.

Obarrio de Mallet, Lady Matilde de. "La pollera colonial y la moderna." *Lotería* 58 (March 1946): 13–18.

Ortega Brandao, Ismael. *La independencia de Panamá en 1903*. Panamá. n.p., 1930.

———. *La jornada del 3 del noviembre y sus antecedentes*. Panama: Imprenta Nacional, 1931.

Ortiz, Fernando. *Los negros curros*. 1926–28; Havana: Editorial de Ciencias Sociales, 1986.

"Óscar Melgar and Jesús Javier Jaime." www.bienal.com/content/programme/ArtistDirectory/article_35_27.aspx. Accessed 23 August 2006.

Palacios, Alfredo L. *Nuestra América y el imperialismo*. Edited by Gregorio Selser. Buenos Aires: Palestra, 1961.

Panama! Latin, Calypso and Funk on the Isthmus, 1965–75. Produced by Roberto Ernesto Gyemant. Soundway Records, 2006.

Panama Canal Historical Photos. Vol. 1. Balboa Heights: Administrative Services Division, 1967.

"Panamá sin diablos rojos no es Panamá." 15 May 2008. www.estudio1panama.com/?p=5452. Accessed 28 June 2008.

Pizarro y Orellana, Fernando. *Varones ilustres del Nuevo Mundo*. Madrid: Díaz de la Carrera, 1639.

Pizzurno de Araúz, Patricia, and María Rosa de Muñoz. *La modernización del estado panameño bajo las administraciones de Belisario Porras y Arnulfo Arias Madrid*. Panama: INAC, Archivo Nacional de Panama, 1992.

Porras, Belisario. *Belisario Porras: pensamiento y acción*. Edited by Jorge Conte-Porras. Panama: Fundación Belisario Porras, 1996.

———. "Discurso, 29 de septiembre de 1924." *Lotería* 106 (September 1964): 13–17.

———. "Discurso pronunciado por el Excelentísimo Señor Presidente de la República de Panamá, doctor Belisario Porras, en la inauguración del edificio de los Archivos Nacionales, el día 15 de agosto de 1924." *Lotería* 105 (August 1964): 27–30.

———. *Memorias de las campañas del istmo.* 1922; Panama: Instituto Nacional de Cultura y Deportes, 1973.

Primer certamen literario obrero nacional. Panama: INAC-IPAL, 1978.

Primer Congreso del negro panameño: memorias. Panama: Impresora de la Nación, 1982.

"Primera Dama entrega al aeropuerto de Tocumen mural pintado por niños panameños." 15 September 2006. http://www.presidencia.gob.pa/noticia.php?cod=8643. Accessed 18 March 2008.

Quintana, Manuel José. *Vidas de españoles célebres.* Paris: Baudry, 1845.

Records of the Department of State Relating to the Internal Affairs of Panama, 1910–1929. Washington, D.C.: National Archives, 1965.

"Reseña histórica." http://www.sanp.gob.pa/reseña.htm. Accessed 20 April 2008.

Roberts, George E. *Investigación económica de la República de Panamá, llevada a cabo a petición del gobierno de Panamá.* 1929; Panama: Imprenta Nacional, 1933.

Rodas de Juárez, Celeste. "Entrevista exlusiva a Edgardo A. Franco 'El General.'" 28 January 2008. www.latino.msn.com/especiales/reggaeton/article.aspx?cp-documentid=607408. Accessed 1 July 2008.

Rodríguez, Mario Augusto. *Campo adentro.* Panama: Biblioteca Selecta, 1947.

Rojas y Arrieta, Guillermo. *Reseña histórica de los obispos que han ocupado la silla de Panamá desde su fundación hasta nuestras días.* Lima: Escuela Tipográfica Salesiana, 1929.

Rojas Sucre, Graciela. *Terruñadas de lo chico.* Santiago: Imprenta de la Unión, 1931.

Roux, Raúl de. *Un capítulo de la historia Patria o Arnulfo Arias: el patriota.* Panama: n.p., 1945.

Ruíz, Temístocles. *Cuentos panameños.* Panama: Henry, 1932.

Ruíz de Obregón, Ángel. *Vasco Núñez de Balboa: Historia del descubrimiento del Océano Pacífico, escrita con motivo del cuarto centenario de su fecha (1913).* Barcelona: Maucci, 1913.

Russell, Carlos. *The Last Buffalo: "Are Panamanians of Caribbean Ancestry an Endangered Species?"* Charlotte, N.C.: Conquering Books, 2003.

Sanjur, Norris R. de. *Panamá, sus raíces, su evolución histórica, y su presente/Panama, Its Roots, Its History, and Its Present.* Panama: Lewis, n.d.

Saz, Agustín del, ed. *Nueva poesía panameña.* Madrid: Ediciones Cultura Hispánica, 1954.

———. *Panamá y la Zona del Canal.* Barcelona: Seix y Barral, 1944.

Schull, Helen Gunner, Marjorie Kingswood Woodruff, and Yolanda Camarano de Sucre. *Living at the Crossroads.* Panama: Imprenta Nacional, 1957.

Secretaría de Agricultura y Obras Públicas. *Anuario de Estadística: año 1934.* Panama: Imprenta Nacional, 1936.

Sinán, Rogelio. *Plenilunio.* 1947; Panama: Impresora Panamá, 1961.

———. "Rutas de la novela panameña." *Lotería* 23 (October 1957): 103–10.

Skylight Gallery. "Our Journey, Our Stories, Our Panama: Celebrating the Afro-Panamanian Experience, November 19, 2003–January 3, 2004." http://www.restorationarts.org/journey.html. Accessed 17 April 2005.

Smith Fernández, Alberto. "El afropanameño antillano frente al concepto de la panameñidad." *Revista Nacional de Cultura* 5 (September 1976): 45–59.

Soler, Ricaurte. *Formas ideológicas de la nación panameña.* 7th ed. Panama: Ediciones de la *Revista Tareas,* 1985.

———, ed. *Fundación de la nacionalidad panameña.* Caracas: Biblioteca Ayacucho, 1982.

———, ed. *El pensamiento político en Panamá*. Panama: Universidad de Panamá, 1986.

Solución panameña al problema del transporte público: Memoria presentada a la consideración del General Omar Torrijos Herrera. Panama: Comisión Nacional del Transporte, 1971.

Sosa, Juan B. *Panamá la Vieja, con motivo del cuarto centenario de su fundación*. 1919; Panama: Imprenta Nacional, 1955.

Sosa, Juan B., and Enrique J. Arce. *Compendio de la historia de Panamá*. Panama: Casa Editorial del *Diario de Panamá*, 1911.

Sosa, Julio B. *La india dormida*. Panama: Sosa, 1936.

Staff Wilson, Mariblanca. *Género, discriminación racial, y legislación en Panamá*. Panama: Comité Panameño Contra El Racismo, 2004.

Strawn, Arthur. *The Golden Adventures of Balboa, Discoverer of the Pacific*. London: Lane, 1929.

Susto, Juan Antonio, ed. *Decretos Leyes, 1940–1941*. Vol. 1. Panama: Imprenta Nacional, 1943.

———, ed. *Leyes expedidas por la Asamblea Nacional de Panamá*. Vol. 1. Panama: Imprenta Nacional, 1942.

———. *Panamá en el Archivo General de Indias, tres años de labor*. Panama: Imprenta Nacional, 1927.

The Tailor of Panama. DVD. Directed by John Boorman. Columbia TriStar Home Entertainment, 2001.

Tejeira, Melquíades. *Misceldneas*. Panama: El Heraldo, 1929.

Tourist Guide of Panama. Panama: Panama Association of Commerce, 1932.

Uribe, Álvaro. *La ciudad fragmentada*. Panama: CELA, 1989.

Valdés, Ignacio de J. *Cuentos panameños de la ciudad y del campo*. Panama: Editorial Gráfico, 1928.

———. *Sangre criolla (nuevos cuentos panameños)*. Panama: Imprenta Acción Católica, 1944.

Vial, Julio E. "Personas en las estampillas." *Lotería* 45 (August 1959): 85.

Villegas, George. *Estudio de transporte para la Ciudad de Panamá*. Panama: Ministerio de la Presidencia, Dirección General de Planificación, 1961.

Wafer, Lionel. *A New Voyage and Description of the Isthmus of America*. London: Knapton, 1699.

Wells, Carveth. *Panamexico*. New York: National Travel Club, 1937.

Wilson, Carlos Guillermo. *Chombo*. Alexandria, Va.: Alexander Street, 1973.

Wyoming20. "Preparing for a New Continent! Panama City Panama Travel Blog." http://www.travelpod.com/cgi-bin/guest.pl?tweb_tripID=round-the-world&tweb_UID=wyoming20&tweb_entryID=1146178140&tweb_guest_password=&tweb_PID=tpod&SHOW_ALL_THUMBS=YES. Accessed 26 October 2006.

Xerox 79, Tercer Salón Internacional Centroamérica. San Salvador: Xerox de El Salvador, 1979.

Zárate, Manuel F. "Senderos y cumbres de los festivales folklóricos en Panamá." *Lotería* 78 (May 1962): 18–24.

Zárate, Manuel F., and Dora Pérez de Zárate. *La décima y la copla*. Panama: *La Estrella de Panamá*, 1953.

———. *Tambor y socavón: Un estudio comprensivo de los temas del folklore panameño y de sus implicaciones históricas y culturales*. Panama: Imprenta Nacional, 1962.

SECONDARY SOURCES

Abrahams, Roger D. *The Man-of-Words in the West Indies: Performance and the Emergence of Creole Culture*. Baltimore: Johns Hopkins University Press, 1983.

Abrahams, Roger D., and John Szwed. *After Africa*. New Haven: Yale University Press, 1983.

Aguirre, Carlos. *Agentes de su propia libertad: los esclavos y la desintegración de la esclavitud*. Lima: Pontífica Universidad Católica del Peru, 1993.

Alemán, Carmén, and Ángela de Picardi, eds. *Cien años de arte en Panamá, 1903–2003*. Panama: Museo de Arte Contemporáneo, 2003.

Alfaro, Ricardo. *Esbozos biográficos*. Panama: Academia Panameña de la Historia, 1982.

Alfredo Sinclair: el camino de un maestro. Panama: Museo de Arte Contemporáneo, 1991.

Álvarez P., Isabel del. "El desarrollo pictórico en Panamá y su aporte al país entre los años de 1970 a 1990." Bachelor's thesis, Universidad de Panamá, 2001.

Anderson, Benedict R. O'G. *Imagined Communities: Reflections on the Origin and Spread of Nationalism*. London: Verso, 1991.

Andrews, George Reid. *The Afro-Argentines of Buenos Aires, 1800–1900*. Madison: University of Wisconsin Press, 1991.

———. *Afro–Latin America, 1800–2000*. New York: Oxford University Press, 2004.

———. *Blacks and Whites in São Paulo, Brazil, 1888–1988*. Madison: University of Wisconsin Press, 1991.

Araúz, Celestino Andrés. *La independencia de Panamá en 1821: antecedentes, balance y proyecciones*. Panama: Academia Panameña de la Historia, 1980.

Araúz, Celestino Andrés, and Patricia Pizzurno Gélos. *El Panamá colombiano (1821–1903)*. Panama: Primer Banco de Ahorros and Diario *La Prensa*, 1993.

———. *El Panamá hispano*. Panama: Comisión Nacional del V° Centenario, 1991.

Arnett, Paul, and William Arnett, eds. *Souls Grown Deep: African American Vernacular Art of the South*. Atlanta: Tinwood and Schomburg Center for Research in Black Culture, New York Public Library, 2000.

Arosemena Jaén, Roberto. *Prisma de una república: Biografía de Octavio Méndez Pereira*. Panama: Ecssa Print, n.d.

Arosemena Moreno, Julio. "Algunas consideraciones sobre los rótulos y las pinturas en los medios de transporte de la ciudad de Panamá (Un tema de folklore urbano)." *Lotería* 218 (April 1974): 11–43.

Arosemena R., Jorge. "Los panameños negros descendientes de antillanos: ¿Un caso de marginalidad social?" *Estudios centroamericanos* 5, no. 13 (January–April 1976): 9–34.

Arte panameño hoy. Santiago: Universidad de Chile and Museo de Arte Contemporáneo, 1997.

Austerlitz, Paul. *Dominican Music and Merengue: Dominican Identity*. Philadelphia: Temple University Press, 1997.

Bancroft, Hubert Howe. *History of Central America, 1801–1887*. Vol. 3. San Francisco: History, 1887.

Barahona G., Marisol. "Evolución histórica del uso del transporte público como medio de publicidad exterior en Panamá desde 1940–1970." Bachelor's thesis, Universidad de Panamá, 1997.

Bartra, Eli. *Crafting Gender: Women and Folk Art in Latin America and the Caribbean*. Durham: Duke University Press, 2003.

Beckles, Hillary McD., and Brian Stoddart, eds. *Liberation Cricket: West Indies Cricket Culture*. Manchester: Manchester University Press, 1995.

Belgrave, Lionel H. "El servicio de autobuses en la Ciudad de Panamá." Bachelor's thesis, Universidad de Panamá, 1958–59.

Benedetti, Adolfo Alberto. *Arnulfo Arias: el caudillo*. Panama: Humanidad, 1963.

Benítez Rojo, Antonio. *The Repeating Island: The Caribbean and the Postmodern Perspective*. 2nd ed. Durham: Duke University Press, 1996.

Bennett, Herman L. *Africans in Colonial Mexico: Absolutism, Christianity, and African-Creole Consciousness, 1570–1640*. Bloomington: Indiana University Press, 2003.

Bernal, María. *El pintor panameño ante la sociedad*. Panama: Los Ángeles, 1983.

Berrian, Brenda F. *Awakening Spaces: French Caribbean Popular Songs, Music, and Culture*. Chicago: University of Chicago Press, 2000.

Bernier, Celeste-Marie. *African American Visual Arts: From Slavery to the Present*. Chapel Hill: University of North Carolina Press, 2008.

Black Art Ancestral Legacy: The African Impulse in African-American Art. Dallas: Dallas Museum of Art, 1989.

Blier, Suzanne, ed. *A History of Art in Africa*. New York: Abrams, 2001.

Bottenburg, Maarten van. *Global Games*. Urbana: University of Illinois Press, 2001.

Brenes, Gonzalo. "El Teatro Nacional." *Lotería* 334–35 (January–February 1984): 29–59.

———. "El Teatro Nacional, casa de cultura, 1908–1958." *Lotería* 35 (October 1958): 40–56.

Brett, Guy. *Through Our Own Eyes: Popular Art and Modern History*. Philadelphia: New Society, 1987.

Briggs, Peter S. "Panamanian Popular Art from the Back of a Bus." *Studies in Latin American Popular Culture* 1 (1982): 187–95.

Brown, David H. *Santería Enthroned: Art, Ritual, and Innovation in an Afro-Cuban Religion*. Chicago: University of Chicago Press, 2003.

Burns, E. Bradford. "Ideology in Nineteenth-Century Latin American Historiography." *Hispanic American Historical Review* 58, no. 3 (August 1978): 409–31.

———. *The Poverty of Progress: Latin America in the Nineteenth Century*. Berkeley: University of California Press, 1980.

Burton, Richard D. E. *Afro-Creole: Power, Opposition, and Play in the Caribbean*. Ithaca: Cornell University Press, 1997.

Butler, Kim D. *Freedoms Given, Freedoms Won: Afro-Brazilians in Post-Abolition São Paulo and Salvador*. New Brunswick: Rutgers University Press, 1998.

Cáceres Vigil, Agustín. "Principales características del transporte colectivo urbano de pasajeros de la ciudad de Panamá." Bachelor's thesis, Universidad de Panamá, 1978.

Castillero Calvo, Alfredo. "Fundamentos económicos y sociales de la Independencia de 1821." *Tareas* 1 (May 1960), 3–25.

———, ed. *Historia general de Panamá*. Panama: Comité Nacional del Centenario, 2004.

———. "La independencia de Panamá de España—factores coyunturales y estructurales en la capital y el Interior." *Lotería* 192 (November 1971): 4–18.

———. "El movimiento anseatista de 1826: Primera tentativa autonomista de los istmeños después de la anexión a Colombia." *Tareas* 1, no. 4 (May–July 1961): 3–25.

———. *Los negros y mulatos libres en la historia social panameña*. Panama: n.p., 1969.

Castillero Pimentel, Ernesto. *Panamá y los Estados Unidos*. Panama: n.p., 1954.

Castillero Reyes, Ernesto. "La efigie de Balboa en la moneda nacional." *Lotería* 124 (March 1966): 74–78.

———. *Historia de Panamá*. 9th ed. Panama: Renovación, 1986.

———. *El Palacio de las Garzas*. Panama: Secretaría de Información de la Presidencia, 1965.

———. "Panamá y sus estatuas." *Lotería* 215 (January 1974): 47–55.

———. "Los panameños y los estudios históricos." *Lotería* 3, no. 27 (February 1958): 20–29.

Castro, Juan E. de. *Mestizo Nations: Culture, Race, and Conformity in Latin American Literature*. Tucson: University of Arizona Press, 2002.

Daley, Mercedes Chen. "The Watermelon Riot: Cultural Encounters in Panama City: April 15, 1856." *Hispanic American Historical Review* 70, no. 1 (February 1990): 85–108.

"El centenario de Miró." *Lotería* 332–33 (November–December 1983): 3–4.

Céspedes, Francisco S. *La educación en Panamá*. 3rd ed. Panamá: Presidencia de la República, 1991.

Chong, M. Moisés. "Estudio filosófico sobre el poema 'Patria' de Ricardo Miró." *Lotería* 332–33 (November–December 1983): 11–21.

Clarke, Duncan. *African Art*. New York: Crescent, 1995.

Colección pintórica del Banco Nacional de Panamá, 90 obras. Panama: Banco Nacional de Panamá, 1998.

Conmemoración del Centenario de la República, 1903–2003: una muestra commemorativa al Centenario de la República, cincuenta obras selecionadas de la colecciones pictóricas del Banco Nacional de Panamá y la Caja de Ahorros. Panama: Comité Nacional del Centenario, 2003.

Conniff, Michael. *Black Labor on a White Canal: Panama, 1904–1981*. Pittsburgh: University of Pittsburgh Press, 1985.

———. *Panama and the United States: The Forced Alliance*. Athens: University of Georgia Press, 1992.

Conte-Porras, Jorge. *Réquiem por la revolución*. Tibás, Costa Rica: LIL, 1990.

Cooper, José. "Recordando al maestro Eugenio Dunn, 1917–1999." www.afropanamachamber.com. Accessed 23 August 2006.

Coordinadora Nacional de las Organizaciones Negras Panameñas. "Acta de Fundación de la Coordinadora Nacional de las Organizaciones Negras Panameñas." http://www.etnianegrapanama .org/AsuntosVarios.html. Accessed 18 July 2008.

Cornejo, Bertha, and Pedro Flores. "Evaluación y análisis del transporte público en el area metropolitana de Panamá." Bachelor's thesis, Universidad de Panamá, 1997.

Craft, Alexander. "'Una Raza, Dos Etnias': The Politics of Be(Com)ing/Performing 'Afropanameño.'" *Latin American and Caribbean Ethnic Studies* 3, no. 2 (July 2008): 123–49.

Crook, Larry, "Black Consciousness, Samba Reggae, and the Re-Africanization of Bahian Carnival Music in Brazil." *World of Music* 35, no. 2 (1993): 90–108.

Cruz, Abelardo de la. "Historia del fútbol chorrerano." Bachelor's thesis, Universidad de Panamá, 1982.

Cuestas, Carlos H. *Soldados americanos en Chiriquí*. Panama: n.p., 1990.

Cuevas, Alexander. "El movimiento inquilinario de 1925." *Lotería* 213 (October–November 1973): 133–61.

Díaz, Antonio. "Zárate, paladín de nuestro folklore." *Lotería* 48 (January 1969): 38–39.

Diaz Espino, Ovidio. *How Wall Street Created a Nation: J. P. Morgan, Teddy Roosevelt, and the Panama Canal*. New York: Four Walls Eight Windows, 2001.

Díaz Szmirnov, Damaris. *Génesis de la ciudad republicana*. Panama: Universidad de Panamá, 2001.

Diez, Luis A. *Los cimarrones y los negros antillanos de Panamá*. 2nd ed. Panama: n.p., 1981.

Drewal, John Henry, and John Pemberton. *Yoruba: Nine Centuries of African Art and Thought*. 3rd ed. New York: Center for African Art and Abrams, 1989.

Duke, Dawn. "Black Movement Militancy in Panama: SAMAAP's Reliance on an Identity of West Indianness." *Latin American and Caribbean Ethnic Studies* 5, no. 1 (March 2010): 75–83.

Dunn, Christopher. *Brutality Garden: Tropicália and the Emergence of a Brazilian Counterculture*. Chapel Hill: University of North Carolina Press, 2001.

Earle, Robert E., and Sergio Alvarado. "Estudio sobre el transporte colectivo en la ciudad de Panamá." Bachelor's thesis, Universidad de Panamá, 1963.

Fabre, Geneviève, and Robert O'Meally, eds. *History and Memory in African-American Culture*. Oxford: Oxford University Press, 1994.

Fábrega, Augusto. *Por los senderos de la Patria y más allá*. Panama: Universal Books, 2002.

Farrington, Lisa E. *Creating Their Own Image: The History of African-American Women Artists*. Oxford: Oxford University Press, 2005.

Feldman, Heidi Carolyn. *Black Rhythms of Peru: Reviving African Musical Heritage in the Black Pacific*. Middletown, Conn.: Wesleyan University Press, 2006.

Fernandez, Raul A. *From Afro-Cuban Rhythms to Latin Jazz*. Berkeley: University of California Press, 2006.

Ferris, William, ed. *Afro-American Folk Art and Crafts*. Boston: Hall, 1983.

Figueroa Navarro, Alfredo. *Dominio y sociedad en el Panamá colombiano (1821–1903)*. 3rd ed. Panama: EUPAN, 1982.

Flores Rugel, Manuel Eduardo, and Raúl Puertas Blades. "Organización y desarrollo del primer campeonato de fútbol no aficionado en la República de Panamá." Bachelor's thesis, Universidad de Panamá, 1993.

Fortune, Armando. *Obra selecta*. Edited by Gerardo Maloney. Panama: Instituto Nacional de Cultura, 1994.

Foster Steward, Noel. *Las expresiones musicales en Panamá*. Panama: Editorial Universitaria, 1997.

Franceschi, Víctor M. "El hombre blanco en la poesía negra: ¿y los negros de Panamá?" *Lotería* 44 (July 1959): 134–39.

Freedman, Arnold Michael. "The Independence of Panama and Its Incorporation into Gran Colombia, 1820–1830." Ph.D. diss., University of Florida, 1978.

Frigerio, Alejandro. "Re-Africanization in Secondary Religious Diasporas: Constructing a World Religion." *Civilisations* 51 (2002). http://civilisations.revues.org/index656.html. Accessed 18 May 2009.

Fukuyama, Francis. *The End of History and the Last Man*. New York: Free Press, 1992.

Gálvez Barsallo, Lesbia. "Sinopsis analítico de las obras premiadas en el concurso literario obrero del Instituto Nacional." Bachelor's thesis, Universidad de Panamá, 2005.

García, José Ramón. "El Instituto Nacional." *Lotería* 340–41 (July–August 1984): 6–42.

García Canclini, Néstor. *Transforming Modernity: Popular Culture in Mexico*. Austin: University of Texas Press, 1993.

García de Paredes, María Dolores, and Sandra Cohen. "Los rótulos y la pinturas en los medios de transporte colectivo en la Ciudad de Panamá." Bachelor's thesis, Universidad de Santa María la Antigua, 1991.

Gasteazoro, Carlos Manuel. "Presentación de Narciso Garay." *Revista Nacional de Cultura* 23 (January–March 1991): 94–99.

Gasteazoro, Carlos Manuel, Celestino Andrés Araúz, and Armando Muñoz Pinzón. *La historia de Panamá en sus textos*. Vol. 2, 1903–68. Panama: EUPAN, 1980.

Gasteazoro, Carlos Manuel, and Eduviges Vergara M. "Aproximación a Octavio Méndez Pereira." *Lotería* 340–41 (July–August 1984): 59–66.

Gates, Henry Louis, Jr. *The Signifying Monkey: A Theory of African-American Literary Criticism*. New York: Oxford University Press, 1988.

Gayle, Addison, Jr., ed. *The Black Aesthetic*. Garden City, N.Y.: Doubleday, 1971.

Gellner, Ernest. *Nations and Nationalism*. Oxford: Blackwell, 1983.

Gilroy, Paul. *The Black Atlantic: Modernity and Double Consciousness*. Cambridge: Harvard University Press, 1993.

Giulianotti, Richard. *Football: A Sociology of the Global Game*. Cambridge: Polity, 1999.

Gólcher, Ileana, ed. *Este país, un canal: encuentro de culturas*. Panama: Banco Nacional de Panamá, 1999.

Gómez, Juan Antonio. "Aporte de Mario Augusto Rodríguez al cuento de tema campesino." *Lotería* 350–51 (May–June 1985): 100–107.

González, José Luis. *Puerto Rico: The Four-Storeyed Country and Other Essays*. Maplewood, N.J.: Waterfront, 1990.

Goytía, Víctor F. *Los partidos políticos en el Istmo*. Panama: n.p., 1975.

Graham, Richard, ed. *The Idea of Race in Latin America, 1870–1940*. Austin: University of Texas Press, 1990.

Greene, Julie. *The Canal Builders: Making America's Empire at the Panama Canal*. New York: Penguin, 2009.

Griffith, Glyne, ed. *Caribbean Cultural Identities*. Lewisburg, Pa.: Bucknell University Press, 2001.

Guardia, Ernesto de la, Jr. "Del Instituto Nacional." *Lotería* 44 (July 1959): 10–17.

Guardia, Roberto de la. *Los negros del Istmo de Panamá*. Panama: INAC, 1977.

Guerra, Lillian. *Popular Expression and National Identity in Puerto Rico: The Struggle for Self, Community, and Nation*. Gainesville: University Press of Florida, 1998.

Guerra, Luis Antonio, Jr., and Víctor de Gracia. "Evolución del fútbol en la Provincia de Chiriquí." Bachelor's thesis, Universidad de Panamá, 1979.

Gutiérrez, Samuel A. *Arquitectura panameña, descripción e historia*. Panama: Editorial Litográfica, 1966.

Guttman, Allen. "Sports, Politics, and the Engaged Historian." *Journal of Contemporary History* 38, no. 3 (July 2003): 363–75.

Hackett, Rosalind I. J. *Art and Religion in Africa*. London: Cassell, 1996.

Hale, Charles A. *The Transformation of Liberalism in Nineteenth-Century Mexico*. Princeton: Princeton University Press, 1989.

Hanchard, Michael George. *Orpheus and Power: The Movimento Negro of Rio de Janeiro and São Paulo, Brazil, 1945–1988*. Princeton: Princeton University Press, 1994.

Harris, Moira F. *Art on the Road: Painted Vehicles of the Americas*. St. Paul, Minn.: Pogo, 1988.

Harrison, Paul Carter, Victor Leo Walker II, and Gus Edwards, eds. *Black Theater: Ritual Performance in the African Diaspora*. Philadelphia: Temple University Press, 2002.

Hebdige, Dick. *Cut 'n' Mix: Culture, Identity, and Caribbean Music*. London: Comedia, 1987.

Heckadon Moreno, Stanley. "Pintores del ambiente popular." *Lotería* 344–45 (November–December 1984): 93–100.

Herold, Erich. *African Art*. London: Hamlyn, 1990.

Herskovits, Melville J. *The Myth of the Negro Past*. New York: Harper, 1941.

"La historia del Reggae Español." www.reggae.com.pa/artistas/historia_del_reggae/index.htm. Accessed 1 July 2008.

"Historia del Reggaeton." http://www.ahorre.com/reggaeton/musica/lyrics/historia_del_reggaeton/. Accessed 9 March 2010.

"Historia del Reggaeton." www.mundoreggaeton.com/docs/historiareggaeton.htm. Accessed 1 July 2008.

Ho, Christine G. T., and Keith Nurse. *Globalization, Diaspora, and Caribbean Popular Culture*. Kingston: Randle, 2005.

Hobsbawm, E. J. *The Age of Empire, 1875–1914*. London: Weidenfeld and Nicolson, 1987.

Howe, James. *A People Who Would Not Kneel: Panama, the United States, and the San Blas Kuna*. Washington, D.C.: Smithsonian Institution Press, 1998.

Hoy, Anne, ed. *Testimony: Vernacular Art of the African-American South*. New York: Abrams, 2001.

Hutchinson, John, and Anthony D. Smith, eds. *Nationalism*. Oxford: Oxford University Press, 1994.

Ingram, Jaime. "La creación musical en Panamá en la era republicana." *Lotería* 450–51 (2003): 245–59.

———. "Música en la República de Panamá." *La Antigua* 60 (June 2003): 67–122.

"El Instituto Nacional: cincuenta años de actividad." *Lotería* 41 (April 1959): 3–5.

Irving, Washington. *The Life and Voyages of Christopher Columbus to Which Are Added Those of His Companions*. New York: Putnam, 1869.

Jaén Suárez, Omar. *La población del Istmo de Panamá*. Madrid: Ediciones de Cultura Hispánica, 1998.

Jaén Vargas, Manuel, and Nidia Esther Mendoza. "Interés del fútbol en las areas rurales del Distrito de Penonomé." Bachelor's thesis, Universidad de Panamá, 1983.

Kautsky, John H., ed. *Political Change in Underdeveloped Countries: Nationalism and Communism*. New York: Wiley, 1962.

Kedourie, Elie, ed. *Nationalism in Asia and Africa*. New York: World, 1970.

Kemp, Martin, ed. *The Oxford History of Western Art*. Oxford: Oxford University Press, 2000.

Kennedy, Randall. *Nigger: The Strange Career of a Troublesome Word*. New York: Pantheon, 2002.

Kerchache, Jacques, Jean-Louis Paudrat, and Lucien Stéphan. *Art of Africa*. New York: Abrams, 1993.

Knight, Franklin W. *The Caribbean: The Genesis of a Fragmented Nationalism*. 2nd ed. New York: Oxford University Press, 1990.

Kupfer, Monica E.. *A Century of Painting in Panama*. Washington, D.C.: Inter-American Development Bank Cultural Center, 2003.

Kutzinski, Vera. *Sugar's Secrets: Race and Erotics in Cuban Nationalism*. Charlottesville: University Press of Virginia, 1993.

LaFeber, Walter. *The Panama Canal: The Crisis in Historical Perspective*. 2nd ed. New York: Oxford University Press, 1979.

Lee Escala, Leopoldo A., and Luis Saldaña. "Fútbol de veteranos de La Chorrera." Bachelor's thesis, Universidad de Panamá, 1991.

Lent, John A., ed. *Caribbean Popular Culture*. Bowling Green, Ohio: Bowling Green State University Popular Press, 1990.

Lewis, Lancelot S. *The West Indian in Panama: Black Labor in Panama, 1850–1914*. Washington, D.C.: University Press of America, 1980.

Lindsay-Poland, John. *Emperors in the Jungle: The Hidden History of the U.S. in Panama*. Durham: Duke University Press, 2003.

Livingston, Jane, and John Beardsley. *Black Folk Art in America, 1930–1980*. Jackson: University Press of Mississippi, 1982.

López M., María del Carmen. "Empresas de transporte terrestre en Panamá." Bachelor's thesis, Universidad de Panamá, 1955–56.

Lora, Silvano. "La pintura popular en Panamá." *Lotería* 208 (April–May): 109–24.

Major, John. *Prize Possession: The United States and the Panama Canal, 1903–1979*. Cambridge: Cambridge University Press, 1993.

Mallon, Florencia. *Peasant and Nation: The Making of Postcolonial Mexico and Peru*. Berkeley: University of California Press, 1995.

Manuel, Peter, Kenneth Bilby, and Michael Largey. *Caribbean Currents: Caribbean Music from Rumba to Reggae*. Philadelphia: Temple University Press, 2006.

Marrero Lobinot, Francisco. *Nuestros ancestros de las antillas francesas*. Panama: n.p., n.d.

Martínez, Carlos Alberto. "Fútbol panameño y el surgimiento de la ANAPROF." www.critica.com .pa/archivo/historia/f13-51.html. Accessed 1 February 2007.

———. "Historia del fútbol en Panamá." www.geocities.com/colosseum/stadium/1367/historia .html?20071. Accessed 1 February 2007.

————. "La 'Lega Eshpañola' está en Panamá I." www.todosports.com/inicio/artículos/gente/318 .aspx. Accessed 12 July 2008.

————. "La 'Lega Eshpañola' está en Panamá II." www.todosports.com/inicio/artículos/gente/326 .aspx. Accessed 12 July 2008.

Martínez Montiel, Luz María, ed. *Presencia africana en Centroamérica*. Mexico: Consejo Nacional para la Cultura y las Artes, 1993.

Mason, Tony. *Passion of the People? Football in South America*. London: Verso, 1995.

McAlister, Elizabeth. *Rara: Vodou, Power, and Performance in Haiti and Its Diaspora*. Berkeley: University of California Press, 2002.

McGuinness, Aims. *Path of Empire: Panama and the California Gold Rush*. Ithaca: Cornell University Press, 2008.

Mellander, G. A. *The United States in Panamanian Politics: The Intriguing Formative Years*. Danville, Ill.: Interstate, 1971.

Minority Rights Group, ed. *No Longer Invisible: Afro–Latin Americans Today*. London: Minority Rights, 1995.

Mintz, Sidney W., and Richard Price. *The Birth of African-American Culture: An Anthropological Perspective*. Boston: Beacon, 1976.

Mintz, Sidney W., and Sally Price, eds. *Caribbean Contours*. Baltimore: Johns Hopkins University Press, 1985.

Miró, Rodrigo. *Cuatro ensayos sobre la poesía de Ricardo Miró*. Panama: Editorial Universitaria, 1983.

Mitchell, Tony, ed. *Global Noise: Rap and Hip-Hop outside the USA*. Middletown, Conn.: Wesleyan University Press, 2001.

Molina, Gerardo. *Las ideas liberales en Colombia*. Vol. 1. Bogotá: Tercer Mundo, 1979.

Moore, Robin. *Nationalizing Blackness: Afrocubanismo and Artistic Revolution in Havana, 1920–1940*. Pittsburgh: University of Pittsburgh Press, 1997.

Moreno Davis, Julio César. "Octavio Méndez Pereira y la universidad." *Lotería* 354–55 (September–October 1985): 55–74.

Moscote, Rafael. "En los cincuenta años de la primera graduación del Instituto Nacional de Panamá." *Lotería* 87 (February 1963): 17–23.

Mosquera, Gerardo. "Africa in the Art of Latin America." *Art Journal* 51, no. 4 (Winter 1992): 30–38.

Murray, Bill. *The World's Game: A History of Soccer*. Urbana: University of Illinois Press, 1996.

Nairn, Tom. *The Break-Up of Britain: Crisis and Neo-Nationalism*. 3rd ed. New York: World, 1970.

Newton, Velma. *The Silver Men: West Indian Labour Migration to Panama, 1850–1914*. Mona: University of the West Indies, 1984.

"Notas editoriales." *Lotería* 106 (September 1964): 3–4.

Nunley, John W., Judith Bettelheim, and Barbara A. Bridges, eds. *Caribbean Festival Arts: Each and Every Bit of Difference*. St. Louis: St. Louis Art Museum and University of Washington Press, 1985.

Nwankwo, Ifeoma C. K. "The Art of Memory in Panamanian West Indian Discourse: Melva Lowe de Goodin's *De/From Barbados a/to Panamá*." *PALARA* 6 (Fall 2002): 3–17.

Olmedo Ramos, Doris A., and Ludgardys Concepción S. "Análisis de los programas de televisión en Panamá y su influencia en el público." Bachelor's thesis, Universidad de Panamá, 1984.

O'Reggio, Trevor. *Between Alienation and Citizenship: The Evolution of Black West Indian Society in Panama, 1914–1964*. New York: University Press of America, 2006.

Ortega y Gasset, José. *The Revolt of the Masses*. 1930; New York: Norton, 1957.

Ortiz, Fernando. "La cubanidad y los negros." *Estudios Afrocubanos* 3 (1939): 3–15.

Panamá: 50 años de República. Panama: Junta Nacional del Cincuentenario, 1953.

Panamá: cien años de república. Panama: Comisión Universitaria del Centenario de la República, 2004.

Pérez, Víctor Manuel, and Rodrigo Óscar de León Lerma. *El movimiento de Acción Comunal en Panamá.* Panama: El Arte, n.d.

Perez-Venero, Alex. *Before the Five Frontiers: Panama from 1821–1903.* New York: AMS, 1978.

Pinho, Osmundo. "Etnografias do brau: corpo, masculinidade, e raça na reafricanização em Salvador." *Revista Estudos Feministas* 13, no. 1 (2005): 127–45.

Pizzurno Gelós, Patricia, and Celestino Andrés Araúz. *Estudios sobre el Panamá republicano (1903–1989).* Panama: Manfer, 1996.

Poupeye, Veerle. *Caribbean Art.* New York: Thames and Hudson, 1998.

Powell, Richard. *Black Art: A Cultural History.* 2nd ed.. London: Thames and Hudson, 2002.

———. *The Blues Aesthetic: Black Culture and Modernism.* Washington, D.C.: Washington Project for the Arts, 1989.

Priestley, George. "Antillean-Panamanians or Afro-Panamanians? Political Participation and the Politics of Identity during the Carter-Torrijos Treaty Negotiations." *Transforming Anthropology* 12, nos. 1–2 (January 2004): 50–67.

———. *Military Government and Popular Participation in Panama: The Torrijos Regime.* Boulder, Colo.: Westview, 1986.

Priestley, George, and Alberto Barrow. "The Black Movement in Panamá: A Historical and Political Interpretation." *Souls* 10, no. 3 (July 2008): 227–55.

Pulido Ritter, Luis. "Joaquín Beleño: el fracaso del proyecto democrático de la modernidad ¿El facismo neocolonial?" *Istmo: Revista Virtual de Estudios Literarios y Culturales Centroamericanos* 11 (July–December 2005). http://collaborations.denison.edu/istmo/n11/artículos/joaquin.html. Accessed 4 December 2007.

———. "Lord Cobra: Del cosmopolotismo decimónico y del folklorismo al cosmopolotismo diaspórico." *Istmo: Revista virtual de Estudios Literarios y Culturales Centroamericanos* 20 (January–June 2010). http://collaborations.denison.edu/istmo/n20/artículos/22.html. Accessed 20 November 2010.

Rader, Benjamin G. "The Quest for Subcommunities and the Rise of American Sport." *American Quarterly* 29, no. 4 (Autumn 1977): 355–69.

Rama, Ángel. *La ciudad letrada.* Hanover, N.H.: Ediciones del Norte, 1984.

Ramos, Julio. *Divergent Modernities: Culture and Politics in Nineteenth-Century Latin America,* Durham: Duke University Press, 2001.

Real de González, Matilde. "Octavio Méndez Pereira, una figura cumbre en la literatura panameña." *Lotería* 45 (August 1959): 22–40.

Revilla Agüero, Ángel. *Cultura hispanoamericana en el Istmo.* Panama: ECU, 1987.

Ríos Mojica, Jesús, and Jorge V. Jiménez M. "Acumulación, gestión, y operacionalización del sistema de transporte público de la Ciudad de Panamá." Bachelor's thesis, Universidad de Panamá, 1990.

Rivera, Raquel Z., Wayne Marshall, and Deborah Pacini Hernandez, eds. *Reggaeton.* Durham: Duke University Press, 2009.

Rodríguez, Ana Patricia. *Dividing the Isthmus: Central American Transnational Histories, Literatures, and Cultures.* Austin: University of Texas Press, 2009.

Rowe, William, and Vivian Schelling. *Memory and Modernity: Popular Culture in Latin America.* London: Verso, 1991.

Rubio, Ángel. *La ciudad de Panamá.* Panama: Banco de Urbanización y Rehabilitación, 1950.

———. "Monumentos históricos y arqueológicos de Panamá." *Lotería* 16 (March 1957): 68–84.

———. "Monumentos históricos y arqueológicos de Panamá, documentos, historia de legislación." *Lotería* 18 (May 1957): 17–38.

Sansone, Livio. *Blackness without Ethnicity: Constructing Race in Brazil.* New York: Palgrave Macmillan, 2003.

Saona de Bscheider, Adriana. "Análisis estilístico de 'Patria' de Ricardo Miró." *Lotería* 41 (April 1959): 62–71.

Schildkrout, Enid, and Curtis A. Keim. *African Reflections: Art from Northeastern Zaire.* Seattle: University of Washington Press, 1990.

Sepúlveda, Mélida Ruth. *Harmodio Arias Madrid: el estadista, el hombre, y el periodista.* Panama: Editorial Universitaria, 1983.

Shaw, Harry B. *Perspectives of Black Popular Culture.* Bowling Green, Ohio: Bowling Green State University Popular Press, 1990.

Simmons, Kimberly Eison. *Reconstructing Racial Identity and the African Past in the Dominican Republic.* Gainesville: University Press of Florida, 2009.

Sisnett, Manuel Octavio. *Belisario Porras o la vocación de la nacionalidad.* Panama: Imprenta Universitaria, 1972.

Siu, Lok C. D. *Memories of a Future Home: Diasporic Citizenship of Chinese in Panama.* Stanford: Stanford University Press, 2005.

Skidmore, Thomas. *Black into White: Race and Nationalism in Brazilian Thought.* Durham: Duke University Press, 1993.

Smith, Christian, and Joshua Prokopy, eds. *Latin American Religion in Motion.* New York: Routledge, 1999.

Soler, Ricaurte. *Formas ideológicas de la nación panameña.* 7th ed. Panama: Ediciones de la *Revista Tareas*, 1985.

———. "El hispanoamericanismo en la independencia panameña de 1821." *Lotería* 190 (September 1971): 1–13.

———. "La independencia de Panamá de Colombia." *Lotería* 400 (December 1994): 57–59.

Sommer, Doris. *Foundational Fictions: The National Romances of Latin America.* Berkeley: University of California Press, 1991.

Staff, Héctor I. *Historia y testimonios de la radiofusión en Panamá.* Panama: Universidad de Panamá, 1985.

Susto, Juan Antonio. "Disposiciones legales sobre lugares y monumentos históricos, estatuas, bustos, retratos, y placas." *Lotería* 50 (January 1960): 98–103.

———. "Doce panameños ilustres." *Lotería* 36 (November 1958): 10–12.

———. "En el cincuentenario de la inauguración del Instituto Nacional." *Lotería* 41 (April 1959): 7–13.

———. "Narciso Garay Díaz." *Lotería* 48 (June 1960): 19.

———. "Orígen del balboa." *Lotería* 17 (April 1957): 32–35.

Szok, Peter. *La última gaviota: Liberalism and Nostalgia in Early Twentieth-Century Panamá.* Westport, Conn.: Greenwood, 2001.

Tapia, Lola C. de. "Figuras de proscenio: Narciso Garay Díaz." *Lotería* 202 (September 1972): 91–93.

Thompson, Robert Farris. *African Art in Motion: Icon and Act in the Collection of Katherine Coryton White.* Los Angeles: University of California Press, 1974.

———. *Flash of the Spirit.* New York: Vintage, 1983.

Torchía M., Gamal A. "Precedente histórico del Club Sporting Colón en el fútbol colonense." Bachelor's thesis, Universidad de Panamá, Centro Regional de Colón, 1995.

Toribio Medina, José. *El descubrimiento del Océano Pacífico*. Santiago: Imprenta Universitaria, 1913–14.

Torrijos, Dora, and Irma Dámaris Barrio. "Complejo educacional y artístico del Instituto Nacional de Cultura en la Ciudad de Panamá." Bachelor's thesis, Universidad de Panamá, 1977–78.

Valencia Chala, Santiago. *El negro en Centroamérica*. Quito: Centro Cultural Afro-Ecuatoriano, 1986.

Vasto, César del. *Historia de la televisión panameña, 1960–2006*. Panama: Imprenta Artística, 2007.

Vega Franceschi, Eduardo, and José Luis Chung Martínez. "Condiciones del transporte urbano colectivo en la ciudad de Panamá." Bachelor's thesis, Universidad de Panamá, 1991.

Vélez, María Teresa. *Drumming for the Gods: The Life and Times of Felipe García Villamil, Santero, Palero, and Abakuá*. Philadelphia: Temple University Press, 2000.

Vianna, Hermano. *The Mystery of Samba: Popular Music and National Identity in Brazil*. Chapel Hill: University of North Carolina Press, 1999.

Víctor Lewis: Pintura primitiva. Panama: INAC and Zona Libre de Colón, 1975.

Villalobos de Alba, César Alberto. "El bolero un género de comunicación." Bachelor's thesis, Universidad de Panamá, 1997.

Villarreal, Paula G. "Historia de la televisión por cable en Panamá." Bachelor's thesis, Universidad de Panamá, 2001.

Villarué, Magalys Argelis Mona, and Missely Guebetty Rodríguez Moreno. "La pintura decorativa de buses: Un arte popular en las rutas urbanas de la ciudad de Panamá." Bachelor's thesis, Universidad de Panamá, 2004.

Vlach, John Michael. *By the Work of Their Hands: Studies in Afro-American Folklife*. Charlottesville: University of Virginia Press, 1991.

Wade, Peter. *Blackness and Race Mixture: The Dynamics of Racial Identity in Colombia*. Baltimore: Johns Hopkins University Press, 1993.

———. *Music, Race, and Nation: Música Tropical in Colombia*. Chicago: University of Chicago Press, 2000.

Walcott, Derek. "The Caribbean: Culture or Mimicry." *Journal of Interamerican Studies and World Affairs* 16, no. 1 (February 1974): 3–13.

Walker, Daniel. *No More, No More: Slavery and Cultural Resistance in Havana and New Orleans*. Minneapolis: University of Minnesota Press, 2004.

Wassing, René S. *African Art: Its Background and Traditions*. New York: Abrams, 1968.

Watson, Sonja Stephenson. "Are Panamanians of Caribbean Ancestry an Endangered Species? Critical Literary Debates on Panamanian Blackness in the Works of Carlos Wilson, Gerardo Maloney, and Carlos Russell." *Latin American and Caribbean Ethnic Studies* 4, no. 3 (November 2009): 231–54.

———. "Nationalist Rhetoric and Suppression of Black Consciousness: Literary Whiteness in Poems by Federico Escobar and Gaspar Octavio Hernández." *Afro-Hispanic Review* 29, no. 1 (Spring 2010): 169–86.

———. "The Use of Language in Melva Lowe de Goodin's *De/From Barbados a/to Panamá: A Construction of Panamanian West Indian Identity*." *College Language Association Journal* 49, no. 1 (September 2005): 28–44.

Watts, A. Faulkner. "Perspectivas sobre el afro-panameño." *Lotería* 234 (August 1975): 36–48.

Weeks, John, and Phil Gunson, *Panama: Made in the U.S.A.* London: Latin American Bureau, 1991.

Westerman, George. *Los inmigrantes antillanos en Panamá*. Panama: Westerman, 1980.

Wilkinson, Mary Louise. "Arte rodante panameño." *Américas* 39, no. 2 (March–April 1987): 44–47.

Willet, Frank. *African Art*. 2nd ed. London: Thames and Hudson, 2002.

Wolfschoon, Erik. *Las manifestaciones artísticas en Panamá*. Panama: Universidad de Panamá, 1983.

Wright, Winthrop. *Café con Leche: Race, Class, and National Image in Venezuela*. Austin: University of Texas Press, 1990.

Zolov, Eric. *Refried Elvis: The Rise of the Mexican Counterculture*. Berkeley: University of California Press, 1999.

INDEX

CPSIA information can be obtained
at www.ICGtesting.com
Printed in the USA
JSHW050755240123
36737JS00002B/76